QuickTime™

Making Movies with Your Macintosh

Second Edition

Other Prima Computer Books

Available Now!
Computers Don't Byte
Create Wealth with Quicken
Cruising America Online
Free Electronic Networks
Internet After Hours
Mac Tips and Tricks
PageMaker 5 for the Mac: Everything You Need to Know
A Parent's Guide to Video Games
The Slightly Skewed Computer Dictionary
The Software Developers Complete Legal Companion
SuperPaint 3: Everything You Need to Know

Upcoming Books
The CD-ROM Revolution
KidWare: The Parent's Guide to Software for Children
Searching Cyberspace: Your Survival Guide to Research on the Internet
Word 6 for the Mac: The Visual Learning Guide

How to Order:
For information on quantity discounts contact the publisher: Prima Publishing,
P.O. Box 1260BK, Rocklin, CA 95677-1260; (916) 632-4400. On your letterhead include
information concerning the intended use of the books and the number of books you
wish to purchase. For individual orders, turn to the back of the book for more information.

QuickTime™

Making Movies with Your Macintosh
Second Edition

Robert Hone

P **Prima Publishing**
P.O. Box 1260BK
Rocklin, CA 95677-1260

Prima Computer Books is an imprint of Prima Publishing, Rocklin, California 95677.

Managing Editor: Paula Munier Lee
Acquisitions Editor: Sherri Morningstar
Project Editor: Stefan Grünwedel
Cover Production Coordinator: Anne Flemke
Storyboard Illustrator: John Kirkpatrick
Production: Shawn Morningstar
Indexer: Brown Editorial Service
Cover Artist: Ocean Quigley
Cover Designer: Page Design, Inc.

QuickTime is a trademark of Apple Computer, Inc.

Prima Publishing and the author have attempted throughout this book to distinguish proprietary trademarks from descriptive terms by following the capitalization style used by the manufacturer.

Information contained in this book has been obtained by Prima Publishing from sources believed to be reliable. However, because of the possibility of human or mechanical error by our sources, Prima Publishing, or others, the Publisher does not guarantee the accuracy, adequacy, or completeness of any information and is not responsible for any errors or omissions or the results obtained from use of such information.

ISBN: 1-55958-634-6
Library of Congress Catalog Card Number: 94-66732
Printed in the United States of America
95 96 97 98 RRD 10 9 8 7 6 5 4 3 2 1

CONTENTS

15 Video and Interactive Multimedia 435

FOREWORD

The appearance of Apple's QuickTime is an important event for those of us who believe our desktop computers have more value to offer us than we have yet realized. Regardless of our jobs or the applications we use, the real value of computers is that they help us communicate—far more quickly, efficiently, and persuasively than we could a decade ago. The communicative abilities of computers have steadily improved, making high-quality digital typefaces and extraordinary graphics available to everyone.

But computer access to motion and sound has been slower to arrive. Without them, the computer's promise has only been partially fulfilled. We live in an age dominated by television, and there can be no doubt that video is the most persuasive of all communication technologies. QuickTime at last gives us a solid platform for computer-based video.

Anyone interested in exploring this exciting new technology, beginner or professional, should find Robert Hone's *QuickTime: Making Movies with Your Macintosh, Second Edition* a superb resource. The novice will appreciate Hone's lucid explication of the principles of QuickTime and video editing, as well as his evaluations of available hardware and software. Especially helpful is the book's step-by-step guidance through the many steps involved in creating QuickTime movies with Adobe Premiere.

Experienced video professionals will also find many stimulating ideas here, ranging from advice on technical topics (such as the use of special effects, music, and audio mixing) to useful suggestions on planning, shooting, and recording source video, as well as assembling specific features such as group discussions and product demonstrations. Common sense and experience are evident on every page.

And therein lies the true value of this book. In the next few years, as faster boards and more powerful application software appear, we will still need to ask the right questions and make the right decisions to create compelling results. Bob Hone's goal is to teach us more than how to make movies; he wants us to make movies that people will respond to. A successful documentary filmmaker, Bob Hone knows that technology is the means to an end, and that end is communications.

John Warnock
Chairman and Chief Executive Officer
Adobe Systems Incorporated

ACKNOWLEDGMENTS

Few people are fortunate to have a friend, an editor, a business partner, and a lifelong companion rolled into one person. But I am that lucky. This book would have remained a dream unfulfilled had it not been for the warm support, careful guidance, and unflagging patience of my wife and partner Margy Kuntz. Thank you.

I would also like to thank the folks at Prima Publishing—Ben Dominitz, Roger Stewart, Stefan Grünwedel, and Debbie Parisi—for taking a chance on this book. Your constant encouragement and enthusiasm kept me going more times than you know. And I'd like to thank John Kirkpatrick for his clear and helpful illustrations throughout the book.

Many thanks to Matt Wagner, my agent at Waterside Productions, for pulling the deal together and getting Prima Publishing involved in the project.

Special thanks to the technical editors of the book, Herb Ferrette and James Locker, who caught the mistakes so the readers wouldn't have to suffer through them. Many thanks to Paul Shain, Greg King, Tay Vaughan, and Robert May for reviewing the manuscript and providing helpful suggestions and advice.

I would especially like to thank the QuickTime team at Apple Computer. You guys have started a revolution. I'm just tossing in a few comments from the gallery. In particular, I would like to thank Michael Mills, Eric Hoffert, and Mark Krueger for taking the time to review the book and offer advice.

Many thanks to the programmers at Adobe Systems, VideoFusion, and CoSA for creating some dazzling programs, although having to rewrite the book three times to keep up with you guys and your new products got a little frustrating.

I would like to thank Ben Jamison of Radius, Carrie Coppe and Scott Rawlings of RasterOps, and Cathy Galvin of SuperMac for providing review copies of their hardware products.

Many thanks to Steven Kirsh and Stacy Russell for taking part in the video production for this book and for lending their images to the project.

Special thanks to the video producers, directors, camera operators, writers, and, most of all, the editors, whom I've had the good fortune to work with over the years: Herb Ferrette, John Nutt, Paul Shain, Georgia Smith, Ray Telles, Joey Kwong, John Claiborne, Greg King, Brad Cochrane, Michael Chin, Michelle Riddle, Jennifer Gilbert, John Andretti, Laurie Simms, Bill Swan, Helen Silvani, Joan Saffa, Michael Tobias, Ken Ellis, Michael Schwarz, Spencer Michels, Robert Hillman, Tom Levenson, Michael Katz, and Michael Conford. All that I know about the video business, I've learned from you.

A very special thanks goes to Pete Behr, one of the few people who believed that a young chemical engineer could become a television producer and a writer.

I would also like to thank Tack and Ann Kuntz for their encouragement and support.

And lastly, I would like to thank my father, Jack, and my brothers, John and Rich, for their caring and support all these years. You have been a source of never-ending strength.

INTRODUCTION

W e are witnessing the convergence of two influential technologies: computers and video. Powerful and increasingly inexpensive semiconductor chips have made it possible to capture and manipulate video images on a Macintosh. QuickTime has provided a standard for digital video, allowing companies to provide numerous QuickTime products, such as video-editing programs and special effects products.

It is as if it's 1986, and desktop publishing has just gotten off the ground: so many tools to work and play with! But although the tools are new, the craft of communicating with moving images has a tradition stretching back 80 years. The language of the moving image, the language of film and television, has its own rules, its own grammar. The goal of this book is to give you a sense of that grammar and how to use the power of the video medium to communicate your ideas and concepts.

The book consists of 15 chapters organized into three main parts. Part I provides a basic overview of video, QuickTime, and QuickTime editing programs. Part II, chapters 6 through 10, delves more deeply into the craft of video editing. Advanced topics in video production and QuickTime editing are covered in Part III, Chapters 11 to 15. The chapters break down as follows:

Chapter 1, "Working in the Visual World," provides an overview of the craft of video editing and the impact of QuickTime.

Chapter 2, "Getting Started with QuickTime," covers the basics of working with QuickTime.

Chapter 3, "Editing Your Movies," explains how to use Adobe Premiere to edit QuickTime movies.

Chapter 4, "Beyond the Basics," covers intermediate editing techniques in Adobe Premiere.

Chapter 5, "Special Effects Wizardry," covers the bewildering array of visual special effects possible with Adobe Premiere.

Chapter 6, "The Grammar of Visual Storytelling," explores the world of visual storytelling and the language of film.

Chapter 7, "Tricks of the Trade I—Editing a Group Discussion," is a step-by-step explanation of how to edit a QuickTime movie of a group discussion.

Chapter 8, "Tricks of the Trade II—Producing a Short Product Demonstration," provides a detailed explanation of how to produce a short QuickTime movie that incorporates video, music, and animation.

Chapter 9, "Montages and Mixed Formats," explores the use of impressionistic editing techniques to produce evocative video segments.

Chapter 10, "Advanced Special Effects," explores the power of Premiere, VideoFusion, and After Effects.

Chapter 11, "Advanced Audio-Editing Techniques," explains how to edit an elaborate soundtrack to complement a video segment.

Chapter 12, "Getting Good Stuff to Work With," is an extensive primer of basic video production techniques.

Chapter 13, "Going to Tape," discusses the many different ways you can produce a videotape version of a QuickTime movie

Chapter 14, "Working with Digital Video—Compression, Input, and Final Format," provides a detailed look at how to work with digital video.

Chapter 15, "Video and Interactive Multimedia," explores the use of QuickTime movies in interactive multimedia.

The chapters can be read in sequential order or at random. You might want to have the manuals for specific software products nearby because not all the features of these products are covered in full detail.

This book is targeted to help the great many users of Adobe Premiere for the Macintosh, not all of whom may have yet upgraded to version 4.0. Although we cover the basic new features of version 4.0, we have omitted some of its more advanced features, which—while extremely useful—are generally designed for more professional editors.

PART I

VIDEO-EDITING BASICS

To get started making QuickTime movies, you should know two basic things: (1) how to work with QuickTime and (2) how to edit those shots together with a QuickTime editing program. This part of the book starts with an overview of QuickTime and how you can use it to manipulate digital video. The next chapters then explain how to edit step-by-step with a QuickTime editing program.

Working in the Visual World

Welcome to the world of visual storytelling. This field, the playground of television and film professionals, used to require a lot of money (usually someone else's) and a lot of skill. But with the advent of Apple's QuickTime software and the introduction of low-cost video-editing programs, you can now make your own video clips and even edit sophisticated video segments right on the computer for a lot less money.

This chapter briefly explains some of the basic elements of QuickTime as well as the importance of editing in the video production process.

Video Production (Before QuickTime)

The high cost of professional video equipment made it nearly impossible for the average person to learn the basics of video production. Not only were cameras expensive but so were the editing systems used to create the final programs.

Until recently, working with video meant big bucks—really big bucks. Professional video cameras cost at least $30,000. Add to that a set of lights and some sound-recording equipment, and the cost of a

complete video production package goes up to $40,000 or more. Just renting this equipment for a single day can set you back $700.

Top-of-the-line camcorders, which produce pictures almost as good as professional cameras, now cost less than $2,500. Lower-end models can be bought for about $1,000. These advances have given millions of people the chance to shoot their own home videos.

But a key part of the video production process has remained difficult and expensive—editing. Standard video-editing systems, which consist of two high-end videotape machines and an edit controller, cost about $20,000. A more sophisticated editing system can run from $50,000 to $200,000.

This has meant that few people have had the opportunity to learn the skills of video-editing. People who work in the television industry either took classes at a college or university or picked up the necessary skills on the job. Unless you worked at a TV station or video production company (or were independently wealthy), you simply didn't have access to video-editing equipment.

The QuickTime Advantage

QuickTime has changed all this. Now with a Macintosh II or Quadra-level computer, a digitizing board, and a software editing program, you have all the necessary equipment to edit video segments yourself. You can shoot scenes on an inexpensive camcorder, transfer the shots to your computer, and then insert the video clips into word-processing documents, spreadsheets, or databases. You can also edit them together to produce a video segment. Adding dazzling special effects like the ones you see on television isn't very hard, either. You can even send your movies to your friends or business colleagues—on a couple of floppies, a removable hard drive, or CD-ROM—and they will be able to view the movies on their computers.

The type of computer you have affects how your QuickTime movies appear on the screen: The faster the machine, the better they will look. Therefore, a Quadra is recommended, though a PowerMac is even better. You also need a large hard drive—a *very large* hard drive. As you'll see in Chapter 14, QuickTime does a clever job of reducing the amount of memory required to store video on your hard drive, but even so, a minute of video can take up as many as 20MB of storage on your hard drive. If you are going to work with many QuickTime movies, you'll probably need at least a 300MB hard drive. The good news is that memory keeps getting cheaper.

The Revolution Has Started (Almost)

Unfortunately, your videos won't look like the programs you see on television, at least not for a while. There are several reasons for this. First, as you've probably seen, QuickTime movies are still not full-screen. This will change as video hardware boards that can produce full-screen movies get more powerful and less expensive. The second reason is a little less obvious and has to do with the nature of the video medium itself.

Although QuickTime allows you to cut and paste video clips with ease, having this ability doesn't make you an expert video editor anymore than having a menu of fonts makes you a graphic designer. Working with moving images is unlike anything you've done before. A video editor is a storyteller who weaves his or her tale with pictures—and not just any pictures. The editor must choose among hundreds, sometimes thousands of different video clips. The choices he or she makes determine whether the final production is a finely crafted program or looks like the highlight reel from someone's home video collection.

The Role of Editing

It's not uncommon for filmmakers or video producers to shoot 10 or 20 times more material than they need. This gives video editors lots of options once they start editing the material. The editor filters out the boring or slow-moving portions of a scene and focuses on the key elements that tell the essence of the story. This is called *editing for peak effect*.

One reason why someone else's home videos are often so boring is that they are unedited: you get to see all the mistakes and have to sit through boring scenes that seem to last forever. Viewers have grown accustomed to videos that move quickly from one action to another. They are not used to seeing an event last as long on television as it does in real life.

Removing Dead Time

Many events that take place in real life actually consist of a lot of *dead time*. Consider this situation: A car drives up to a house; the driver

parks the car, turns off the ignition, gets out, closes the car door, walks up the front walk, and rings the doorbell. In real time, these actions would take about a minute. But an edited version of the situation could go like this:

Shot of the car driving up (five seconds)

Shot of the car door closing (three seconds)

Shot of the person's finger pressing the button of the doorbell (three seconds)

With these three shots, the editor conveys the key elements of the scene. The viewer fills in the rest of the action (the dead time). This *conceptual compression* is one of the main ways editors make video segments move along quickly. In this case, an action lasting 60 seconds is compressed to 11 seconds.

Here's another example: A woman walks into the ground floor of a skyscraper, waits for the elevator, goes up to the 25th floor, walks down a long hall, and then enters her office. You could shorten this scene a number of ways. Here's one option:

Shot 1: Woman walks into the building (four seconds).

Shot 2: Woman walks out of the elevator on the 25th floor (three seconds).

Shot 3: Woman strolls into her office (three seconds).

In this case, an event that could take three minutes or more (depending on how long she has to wait for the elevator) is shortened to just 10 seconds. The edited segment is almost 20 times shorter than the real situation, but again, the key ideas are conveyed. In fact, the edited version is more interesting because all the slow, unnecessary parts have been removed.

Manipulating Time

If you've ever watched baseball on television, you know how slow the action can be. Everybody waits around for 20 or 30 seconds until the pitcher hurls the ball to the plate. The following example shows how editing can both compress and expand time. The batter has just swung and missed; it's now bases loaded, three balls, two strikes, two out in the bottom of the ninth:

Shot 1: Pitcher gets the ball back from the catcher (two seconds).

Shot 2: Batter kicks the dirt out of his shoes (two seconds).

Shot 3: First baseman yells encouragement to the pitcher (three seconds).

Shot 4: Pitcher raises his arms over his head to start his windup (two seconds).

These four shots condense the slow part of the game. Now comes the key moment—the pitch—and the style of editing changes to expand time and heighten the drama:

Shot 5: The batter wiggles his bat waiting for the pitch (two seconds).

Shot 6: The pitcher continues his windup (one second).

Shot 7: The first baseman crouches down, ready to field a ball hit his way (one second).

Shot 8: The batter steadies his bat (one second).

Shot 9: The pitcher completes his windup and throws the ball (one second).

Shot 10: Close shot is given of a tense expression on the first baseman's face (one second).

Shot 11: Batter swings and hits the ball (one second).

Shot 12: Pitcher's head turns as the ball flies toward first base (one second).

Shot 13: First baseman leaps up and catches the ball (two seconds).

Shots 5 to 13 take 11 seconds to show an action that lasts less than 6 seconds. All together, the edited sequence (shots 1 to 13) lasts about as long as the actual event, but the emphasis is shifted—away from the slow parts and onto the peak moment of the confrontation between the pitcher and the batter.

This is one of the main elements of effective video editing—emphasizing the key aspects of your story and removing or de-emphasizing the nonessential parts. When you think about it, this process is not all that different from writing, where you have to choose the words and phrases that stress the important part of your message. The analogy goes even further. To communicate well with words, you need to present your ideas in a way that other people can understand. That is, you

follow the rules of punctuation and grammar, such as using periods, giving each sentence a subject and verb, and not switching tenses in the middle of a paragraph.

Over the last 80 years, the film industry and, more recently, the video industry, have developed their own *grammar*—a set of conventions that both editors and viewers understand.

The Grammar of Video Editing

The language of visual storytelling, the language of video and film, is a fairly recent invention. Until motion pictures were invented near the turn of the century, the world consisted of continuous images. That is, there were never any abrupt changes in what a person saw from one moment to the next.

But once events could be recorded on film and then put together with other images, a new reality emerged, one where the rules of cause and effect no longer held. A person could be in one place and then a split second later be somewhere else.

When silent films using the newly discovered technique of editing first appeared back in the early 1900s, it took awhile for audiences to get the hang of this new reality with all its jumps and abrupt changes in background. But over the last 80 years, viewers have become increasingly sophisticated. Let's go back to the example of the car and the house. People watching the edited segment wouldn't wonder how the driver got out of the car or how he moved to the front door. The fact that these details don't even enter their minds shows that viewers have learned to accept certain conventions or visual shortcuts.

No one convention applies to every situation. But the grammar of video editing provides a set of guidelines that editors follow as they build their visual stories. Underlying the grammar are two basic tenets:

- **Avoid confusing the audience**. You are creating an illusion of reality and you should avoid making any edits that break the illusion.

- **Make the editing invisible, or transparent, to the viewers**. If the viewers notice an edit, then they've stepped out of the reality you've created and are seeing the video segment for what it actually is—a series of separate clips.

Beyond these two general rules, there are a number of other guidelines that can help you make transparent edits and produce coherent video segments. These guidelines deal with the kinds of shortcuts and visual tricks you can use in telling a particular story or conveying a certain message. There's nothing special or concrete about these rules or conventions. In fact, no one ever sat down and said, "This is the way it will be done." Instead, the rules of video grammar are the end result of years of experimentation by editors in film and television. This book, therefore, won't tell you the "right way" to edit any specific scene. The goal, instead, is to give you some guidelines that can help you produce interesting video segments on your Macintosh. With a firm understanding of the basic rules, you'll have a solid background to begin your own experimentation.

Wrap-Up

This chapter has discussed how the advent of QuickTime has given you access to one of the most powerful and influential techniques known—video editing. With this technology in the hands of perhaps millions of people, who knows what will be created and what new forms of communication will arise? One thing is for sure, many people are going to have a lot of fun trying to find out.

Getting Started with QuickTime

Apple's introduction of QuickTime has opened the door to inexpensive desktop video. QuickTime allows you to create, display, and manipulate video images in real time on your computer. This chapter provides an overview of QuickTime, describes how it works, and demonstrates how you can use QuickTime to manipulate video segments on your computer.

The first thing to realize about QuickTime is that it isn't an application program like Microsoft Word or MacroMind Director. It's system software that sits in your system folder, working its magic behind the scenes. QuickTime's job is to handle all the complex details of showing video and sound on your computer screen. This is no small feat considering that different types of Macintosh computers have vastly differing abilities to display video.

System Requirements

To work with QuickTime, you need a computer system that meets or exceeds the following requirements:

- A 68020 or higher central processing unit (CPU): Macintosh LC II or III, IIsi, IIci, IIfx, and any Quadra or PowerMac

■ System 6.07 or higher

■ At least 4MB of random-access memory (RAM)

This is the minimum you need. To do serious work with QuickTime, you should be running under System 7 on at least a Macintosh IIci with 8MB of RAM and lots of space on your hard disk. A 300MB hard drive just to store QuickTime movies is not out of the question. A large optical drive is not a bad idea either (although you'll still want to run your QuickTime movies from your hard drive; see Chapter 14). The simple fact is that even with QuickTime, video is a memory hog. A one-minute segment of QuickTime video can take up 20MB of disk space or more.

Acquiring and Installing QuickTime

There are several sources where you can get a copy of QuickTime for free. You can download it from CompuServe or AppleLink for the cost of online access time. On CompuServe, the QuickTime software is located in the Mac Developers Section. On AppleLink, it is located in the Software Sampler Section. You should also get a copy of the MoviePlayer program if it is available. This program allows you to view and manipulate QuickTime movies.

If you have a CD-ROM player, you might consider buying the QuickTime Starter Kit from Apple Computer. This CD-ROM contains not only the newest version of QuickTime but also a number of utilities and samples of QuickTime movies.

Installing QuickTime is simply a matter of moving the QuickTime file into one of your system folders. If you're running under System 7, the QuickTime file is considered an extension and is put into the extension folder. If you're running under System 6.07, then just drop the file anywhere in your system folder. That's it! Just restart your computer and you're QuickTiming.

Because QuickTime is system software, it is automatically loaded during startup. In fact, you won't have to worry about the QuickTime file after installing it unless you want to upgrade to a newer version.

An Inside Look at QuickTime

Although you can use QuickTime without knowing how QuickTime does its job, an overview of the way QuickTime works can help you understand how to work with video on your Macintosh.

The main job of QuickTime is to coordinate the display of the video and audio on your computer. Video and audio must be kept synchronous, or *in synch*; otherwise, the video will be a jumbled mess of sounds and images, like a badly dubbed foreign film in which the actor's mouth keeps moving after the lines have been spoken.

Keeping video and audio in synch is difficult because today's computers aren't really fast and powerful enough to display video and sound in real time. QuickTime gets around this problem by handling video in several clever ways. To appreciate what the QuickTime team managed to accomplish, let's first take a look at what makes up a video image.

The Video Image

At its most basic level, video is a series of still images, or *frames*. Each frame is displayed for just $^1/_{30}$ second, but by showing 30 frames each second, video produces the illusion of a continuous image.

To make matters more complex, each frame of video is made up of two *fields*. An image on a television screen is created by a stream of electrons (produced by the picture tube) that race along the 525 horizontal lines that make up the screen. For a variety of reasons (none of which concern us here), the electron beam traces the odd-numbered lines first (creating the *odd field*). Once the beam gets to the bottom of the screen, it goes back to the top and traces the even-numbered lines (the *even field*). This constant switching between the odd lines and even lines is called *interlacing* and is invisible to the viewer. But because of it, each frame of video contains one odd field and one even field.

On a computer screen, however, the entire screen is redrawn, or refreshed, from top to bottom, every $^1/_{60}$ second. When you want to show video on a computer screen, you have to convert the interlaced video images into *noninterlaced* images that the computer can understand.

In addition, before an analog video signal can be processed by a computer, it has to be *digitized*; that is, broken up into a collection of individual *pixels*. A digitized frame of video contains 307,200 pixels (640 lines by 480 pixels across). If you are working in 8-bit color, then the computer assigns one byte (8 bits) of information for each pixel. This means that to display just one frame of raw video (that is, without QuickTime), the computer has to process 307,200 bytes of information. Thirty frames of *raw video* (one second's worth) amount to about 9.2MB of data, and 10 seconds of video amount to 92MB. It adds up awfully fast. If you are working with 24-bit color, then multiply all the numbers above by three because it takes three bytes to describe each pixel on the computer screen (instead of one byte per pixel in 8-bit color mode).

Besides eating up every last byte on your hard disk, raw video puts a tremendous strain on your computer. Every second, it has to process and display more than 9MB of data. This is way beyond the capacity of any of today's Macintosh computers.

Video Compression

Computer designers and computer chip makers have been aware of this problem for a long time, so they've developed a solution known as *compression*, which reduces the amount of information needed to show a frame of video. Whereas a second of raw video would take up 9.2MB, a compressed version of the same one second of video might take up only 500K or less. When it comes time to show the compressed images on the computer screen, the images are *decompressed* before they are sent to the monitor.

There are number of different ways of compressing and decompressing video. QuickTime offers several different compression-decompression schemes. For your purposes, Apple's video compressor will meet most of your needs. A detailed discussion of video compression can be found in Chapter 14.

QuickTime uses several other methods to reduce the size of digital video files. One method is to decrease the amount of work your computer has to do to display video by reducing the size of the video that appears on the screen. Typically, when you view a QuickTime movie, you see the video in a small window measuring 120 by 160 pixels (about 2 inches by 2.5 inches), which is roughly $^1/_{16}$ the full screen on

a 13-inch monitor. If you enlarge the size of the video window, you'll notice that the quality of the picture is reduced.

At this time, even with the small window size, QuickTime still isn't able to show every frame of video (30 frames per second). Instead, it shows every other frame or every third frame, depending on the speed of your computer.

Let's step through the process of playing a segment of compressed video on a Quadra 650 computer to show how QuickTime handles this. Internal to the computer, the compressed video is stored as a series of images, often at 30 images per second (Figure 2-1). The audio is stored along with the video and, unlike the video images, is stored as one continuous stream of data. Because you can't drop out pieces of the audio without completely ruining the sound, QuickTime plays the audio at regular speed.

After the program determines how much computer power is needed to play the audio, QuickTime then displays the appropriate video frames so that the video and audio stay in synch (Figure 2-2). Which video frames are shown depends on the speed of your computer and the extent of video compression. A highly compressed frame takes longer to decompress, which forces the computer to grab a later video frame to stay in synch. For a more detailed discussion of compression, please see Chapter 14.

Generally speaking, on the Quadra 650, every other frame is displayed. If the frames of the compressed video are numbered (1, 2, 3, etc.), then only the odd frames (1, 3, 5, 7, etc.) are shown in the QuickTime movie.

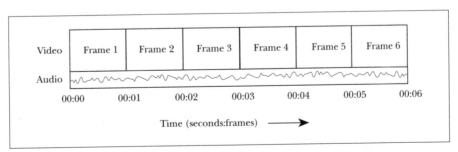

Figure 2-1. Format of video and audio: Video is stored as individual frames. There are 30 frames per second. Audio, however, is stored as a continuous stream of data.

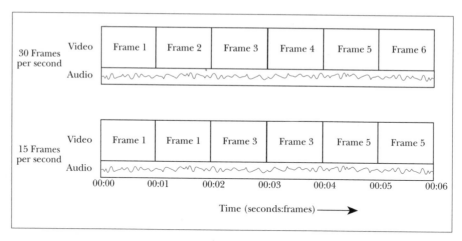

Figure 2-2. Displaying every other frame: When a video-audio clip is played at 15 frames per second, every other frame of video is displayed twice, but the audio track remains the same.

On a slower machine, such as the IIsi, only every third frame or every fourth frame is shown. Although this might seem like a complicated way of showing video, it is actually one of the more brilliant aspects of QuickTime. It means that QuickTime movies can be played on any Macintosh II machine that is QuickTime compatible (having at least a 68020 CPU and running QuickTime). It doesn't matter if you created your movie on a PowerMac, it will still run on a IIci or IIsi, even an LCII, albeit at a lower quality (fewer frames per second).

Working with QuickTime Movies

Along with the QuickTime software, you should have gotten a copy of the MoviePlayer program. This program allows you to open QuickTime movies in a small window and play them. You can also cut and paste sections of video, similar to the way you would with text or graphics.

Playing QuickTime Movies

Unlike QuickTime, MoviePlayer is an application program, so you need to launch it by double-clicking on its icon or filename. Once the

program is running, open a QuickTime movie by selecting the Open option under the File menu. A dialog box appears that lists the QuickTime movies stored on your hard disk. If no movies are listed, use the pull-down menu at the top of the dialog box to open the folder holding your QuickTime movies:

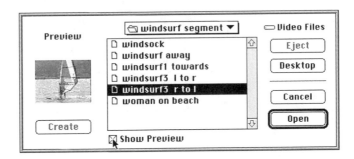

At the bottom of the dialog box sits the Show Preview check box. If the square isn't filled with an ×, click on this square to activate the preview function. Click once on one of the movies listed and then click on the Create button. This creates a small picture, or *preview*, of that movie on the left side of the dialog box. Now, whenever you click on the listing of that movie, you see the preview.

Click on the Open button to open the movie you want to play. As in Figure 2-3, a window appears that displays the QuickTime movie and a control panel containing several icons. Click on the Play button (the small triangular icon located toward the bottom-left corner of the screen) to play the movie.

MoviePlayer Controls

The human-interface team at Apple carefully designed the controls for MoviePlayer, so they work similarly to the way the controls work in other Macintosh programs. You could probably figure out how to work all the controls by yourself, but here's a description of each one just in case.

Play/Pause Button The small triangle on the bottom-left side of the window is used to start the movie. Once the movie is playing, this icon switches to an icon showing two vertical lines. Clicking this icon stops the movie.

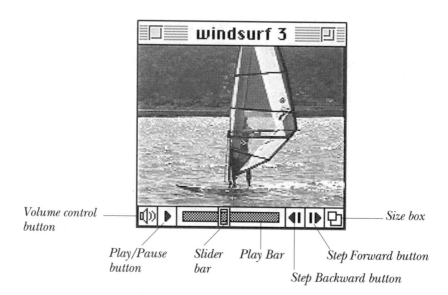

Figure 2-3. MoviePlayer controls in QuickTime

Slider Bar/Play Bar The slider at the bottom of the window, sitting in the Play Bar, is similar to the scroll bars in any Macintosh window, except that when you move the slider bar you move through different parts of the movie instead of moving the picture around the window. By dragging the slider bar to the right, you move to a later point in the movie (time advances from left to right). Drag the slider bar left, and you go backward through the movie. You can also click at any point along the Play Bar to move to that point; for example, to get to the beginning of the movie, click at the far-left side of the Play Bar.

Step Forward/Step Backward Buttons The small buttons on the bottom right of the screen move the movie forward or backward one frame at a time. The button with the triangle facing right moves the movie forward, and the triangle facing left moves it backward. These controls are more accurate than the slider and, therefore, are useful for finding a particular spot in a movie.

Volume Control The speaker icon in the bottom-left corner of the window lets you adjust the volume of the audio.

Size Box You can resize the window by grabbing the bottom-right corner of the window and dragging it down and to the right (to enlarge it) or up and to the left (to reduce its size). You can even stretch and distort the video image by making the window tall and narrow or short and wide.

You can resize the window more accurately using the options listed under the Movie menu. The Double Size and Full Screen options enlarge the width and height of the window proportionately so that the image scales up without distortion. After you alter the window size, you can reset the window to its normal size by choosing the Normal Size option.

You can control the size of the video window with commands from the keyboard. For example, by pressing ⌘–1, you set the window size to Normal. The other keyboard equivalents for controlling MoviePlayer are listed next to the commands under the Movie menu.

Enlarging or distorting the window often reduces the picture quality of the movie. The frame rate can also decrease because the computer has to work harder to display a movie in a larger window.

If you hold down the shift and control keys while clicking on the step foward button, a variable speed control slider will appear. This undocumented feature ("Easter Egg") allows you to play the movie backwards or forwards at different rates of speed.

Manipulating QuickTime Movies

So far, you've gotten to play QuickTime movies forward and backward and move around them. Now the fun begins. QuickTime movies can be cut and pasted just like text or graphics. You simply select the portion you want to work with, copy it, and then paste it into a new spot.

Selecting a Portion of a QuickTime Movie

You can select the entire movie by choosing the Select All option under the Edit menu. But more than likely, you'll want to work with just a portion of a movie.

1. Position the slider bar at the beginning of the portion you want to select. If you have a particular point you want to start at, use the Step Forward/Backward buttons to set the starting point precisely.

2. Hold the [Shift] key down while you drag the slider bar until you get to the point in the movie where you want to end, then release the [Shift] key. The portion of the slider box between the start point and the end point turns black to show you that it has been selected:

You can also use the Step Forward/Backward buttons (while you hold down the [Shift] key), to select a portion of the movie.

3. If you want to adjust the end point, just hold down the [Shift] key and click the cursor near the end of the blackened portion of the slider box. The slider bar appears where you clicked. You can now set a new end point by dragging the slider bar to the right or left. The start point can be adjusted the same way.

4. You can check to see if you selected the right portion by choosing the Play Selection Only option under the Movie menu.

Copying, Cutting, and Pasting

Now that you've selected a portion of the movie, you can move it around using the Copy, Cut, and Paste options under the Edit menu. The following example demonstrates the use of each of these options:

1. Select a portion of the movie using the method described in the previous section.

2. Copy this portion by choosing the Copy option from the Edit menu ([⌘]–[C]).

3. Click the cursor at the far right of the Play Bar (this is the end of the movie.)

4. Choose Paste from the Edit menu (⌘–Ⓥ). This pastes the copied portion onto the end of the movie.

5. Play the movie to see what you created. If you did it correctly, the movie looks the same as before until you get to the end and then you see the portion of the movie you added.

6. Now select the portion you just pasted by positioning the slider bar at the point where the pasted portion begins and then drag the slider bar to the end of the movie.

7. Choose Cut from the Edit menu (⌘–Ⓧ).

8. Play the movie again. The pasted section is gone, and you're back to where you started.

Creating and Saving QuickTime Movies

It's a good idea to make a copy of a QuickTime movie before you make any major changes to it. That way, you'll be able to go back to the original in case you make a mistake and delete something you need. Choose the Save As option under the File menu and give the copy a new name. You now have a duplicate copy of the original movie, which you can cut, paste, and otherwise mangle without worrying about your original.

You can also create a new movie based on just a portion of your original movie. Select the portion you want, copy it, create a new movie using the New command under the File menu, and then paste the movie portion into the new movie.

You can then store the new movie on your hard disk, using the Save option under the File menu. A dialog box appears that contains two check boxes: Save Normally and Make Movie Self-Contained. The Make Movie Self-Contained option saves the entire movie. The Save Normally option saves only the changes and modifications you made to the original movie in creating the new one. If you get rid of the original QuickTime movie, then the new version will be useless.

The advantage of the Save Normally option is that it takes a lot less storage space to save just the changes (as you can see from the storage estimates listed below each option).

If you want to be able to play your movies on a PC-compatible computer, click on the Make Playable on Non-Mac Machines checkbox. This converts the movie to a format that can be played using QuickTime for Windows. You can still play these converted movies on your Macintosh.

Other QuickTime Tricks

There are a couple of interesting tricks you can do with MoviePlayer:

Looping

You can set the movie to play over and over again by choosing the Loop option under Movie menu (\mathbb{H}–\boxed{L}). The movie continues to loop until you turn this option off by choosing it again. You can also have the movie automatically rewind once it gets to the end and then restart when it gets to the beginning by choosing the Loop Back and Forth option from the Movie menu.

Multiple Movies

You can make several copies of a movie, arrange them on your screen, and then play them all at once (Figure 2-4). The individual movies won't play very fast, but it's an interesting effect anyway—especially if your movie contains animation.

Figure 2-4.

Playing multiple versions of a movie at once is an interesting trick that MoviePlayer can do.

Working with QuickTime 2.0

The newest version of QuickTime, version 2.0, is a major upgrade that contains a number of important improvements and new features. One of the most exciting features allows you to play bigger movies on your computer. Essentially, the QuickTime code has been streamlined, which makes the computer more efficient when playing your movies. The end result is that you can now play larger movies at faster frame rates than before

Another useful addition is the ability to enlarge a movie and play it against a black background. This is accomplished by choosing the Print to Video option under the File menu. This brings up a dialog box that allows you to play the movie at normal size, twice as large, or even large enough to fill the entire screen:

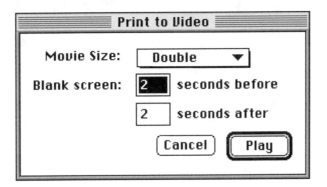

You can blank the screen for several seconds before and/or after the movie plays by typing in the appropriate number of seconds. Then, when you click on the Play button, the screen will become black, the movie will play at the designated size and then the screen will remain black for a few seconds. This is a useful technique when showing other people your movies. The blank screen before the movie helps get people's attention.

MoviePlayer can now also be used to convert PICT graphics into QuickTime movies. Simply choose the Import option under the File menu and then choose a PICT graphic. MoviePlayer automatically creates a QuickTime movie, which contains the PICT graphic. You can then copy and paste the graphic into another QuickTime movie (to add a title, for example).

 If you paste portions of one QuickTime movie into another movie that has a different size (horizontal by vertical), MoviePlayer will either fill in the missing space (if the pasted movie is smaller), or enlarge the movie you're pasting into, so that the combined movies have the same size. If you want to insert only a small part of a movie (a small rectangle) into another movie, you have to use an editing program such as Premiere or AfterEffects.

QuickTime 2.0 includes a number of additional improvements, most of which involve more advanced issues and will be explained in different chapters of the book.

Creating QuickTime Movies from Videotapes

So far, you've been playing with samples of QuickTime movies created by other people. But the real adventure begins when you start working with your own material. Depending on your computer, you may need additional hardware that converts video into QuickTime movies. Apple's A/V computers (Quadra 660A/V, 840A/V, and A/V PowerMacs) come with video and audio digitizing capabilities. All other Apple computers require a *video capture board* and *audio digitizer* to digitize video segments and store them as QuickTime movies.

New boards are coming out almost monthly but the most popular as of mid-1994 are the VideoSpigot from Supermac Technology (although at this writing Supermac has been bought by Radius and the future of the Spigot is unclear); RasterOps' family of STV Video Adapters; and Movie, Movie from Sigma Designs.

The basic setup is shown in Figure 2-5. You need a source of video, such as a VCR or a camcorder. The output from the video source is sent by a cable to the input jack of the video capture board. A standard video cable with an RCA plug is sufficient (these can be bought at any electronics supply store, such as Radio Shack).

Depending on your equipment, you may need to use a separate sound-digitizing device such as MacRecorder (from Macromedia) to transfer sound from your VCR into the computer. If this is the case,

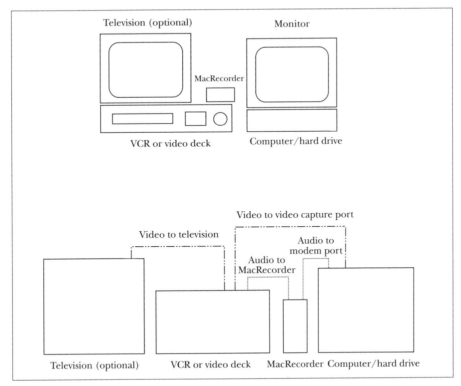

Figure 2-5. Typical equipment layout: The basic components for working
with video on your Macintosh are the computer, a source of
video (VCR), a video-digitizing board, and an audio-digitizing
device. Sometimes the video- and audio-digitizing devices are
contained in the same device.

you will need to connect the audio output from the VCR into the
MacRecorder, which itself is connected to the modem port on your
Macintosh.

It's also handy to have a standard television hooked up to your VCR
while you're digitizing (most VCRs have two output ports). This allows
you to look at the video images on a full screen before you digitize
them.

Each of the video capture boards comes with its own software pro-
grams that allow you to choose which video segments to transfer. The
programs also allow you to choose how you want to save your
QuickTime movies and at what level of compression. Unless you are
running out of room on your hard disk, it's a good idea to save them at

the highest-quality setting (i.e., with the lowest-possible compression). This gives you the option of using any kind of compression scheme later on without having to go back and transfer from videotape again.

Wrap-Up

In this chapter we covered the basics of QuickTime and how you can use the MoviePlayer to cut and paste digital video clips. To make more complicated combinations of video clips you need to use a video editing program, which is the subject of the next chapter.

Editing Your Movies

Making a movie involves more than getting the right kind of shots with a camera. You need to choose which shots to use and which shots to leave on the cutting room floor or, in your case, the Macintosh trash can. Editing also involves putting shots into a particular order so that they convey your idea.

An Overview of the Editing Process

There are many different steps to the editing process, but they can be grouped into four basic activities: collecting the video shots you want to work with; digitizing the shots to produce clips of digital video, selecting a particular *cut*, or portion, from each video clip; and assembling the cuts in a particular order to make a movie.

Collecting the Clips

The first step in editing is to collect all the video material and graphics you'll incorporate into a movie. This can be video you've shot yourself, videotapes from someone else, or digitized video clips from a CD-ROM. The graphics can be animations or still images. You should collect more material than you need, so you won't have to spend time looking for extra material while you edit. If you're planning to include

shots of nature scenes, don't just find five or six shots, find 20 or 30. You don't necessarily know what will work until you start arranging the shots into the movie.

Once you collect all your material, you should create a list of what you have and where it's located. For example, let's say you recorded shots for several scenes of two people walking and talking in a forest. You also recorded some shots of the forest itself on a different video-tape. All together, you have 60 minutes of material on two different videotapes. You need to write down which shots (the couple walking by the lake, shots of the birds, etc.) are on which tape. You also need to write down where each shot is located on each tape (how many min-utes from the beginning). This way, you'll be able to find any particular shot quickly. You also need to write down where any predigi-tized shots, still images, and/or graphics are stored on your computer (or CD-ROM).

By looking at your logs, you should then create a list of shots to be digitized. This list won't be as long as your log, but it should include a variety of shots to give yourself some flexibility when editing. Let's say you're going to create a two-minute movie from the 60 minutes of material you shot of the nature scenes. Your digitizing list might include five minutes of material. That's a lot less than 60 minutes but still a lot more than the two minutes of the final piece.

Digitizing the Shots

After you create the digitizing list, transfer the shots to your computer using a digitizing board. You should make sure to leave a little bit extra at the beginning and end of a shot when digitizing to give yourself options when editing (a detailed description of how to digitize video can be found in Chapter 14). Once a shot is digitized and stored on your computer, it is called a *clip*.

Because you'll be storing a large number of video clips on your hard disk, try to make the file labels for the clips as descriptive as possible: for example, "couple at lake" as opposed to "couple #2" or, even worse, "clip #5." It might take a little bit longer to type in a descriptive label when you're digitizing the clip, but it will save you a lot of time later on.

Picking the Cuts

Each clip is a segment of digitized video lasting anywhere from $^1/_{30}$ second (one frame) to several minutes. In working with any particular clip, you might not want to use the entire clip in the final movie. For example, let's say you have a clip of a salesman demonstrating a new product, and the clip is 10 seconds long (Figure 3-1). And let's assume that you only want to use a three-second cut from this clip. Which three seconds—the first three, the last three, maybe something in the middle?

 In this book, the words *shot*, *clip*, and *cut* have particular meanings. A shot is a piece of videotape showing a particular scene or action. When a shot is digitized and stored on a computer (or CD-ROM), it becomes a clip. A portion of a clip that is used in a movie is called a cut.

Because this situation comes up so often in editing, video editors long ago coined specific terms to describe the beginning and end of a cut. The *In point* is where the cut starts; the *Out point* is where the cut ends.

If you want to use the first three seconds of the salesman clip, you set the In point, or simply the In, at the beginning of the clip (Figure 3-2). You then set the Out at the three-second point of the clip (03:00—3 seconds, 0 frames).

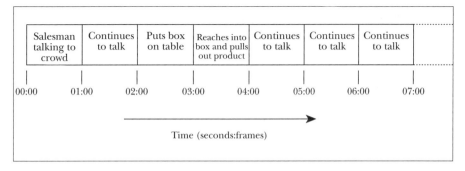

Figure 3-1. Timeline view of a shot of a salesman demonstrating a product. Each box represents one second of time.

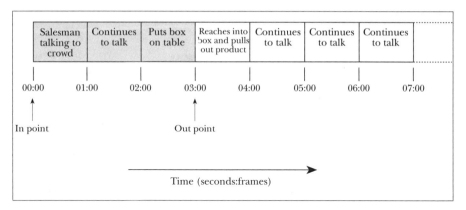

Figure 3-2. The shaded area indicates the position of a three-second cut that starts at the beginning of the shot.

If you want to choose a cut in the middle of the clip to focus on the point where the salesman pulls out the product, set the In at the 2:15 point of the clip (2 seconds, 15 frames) and the Out at the 5:15 point (Figure 3-3). Although this cut has different In and Out points than the previous cut, the duration of the cut (how long it lasts on the screen) is still three seconds.

To look at this another way, imagine you're editing this sentence with a word-processing program:

```
This is a test of the emergency video-editing system.
```

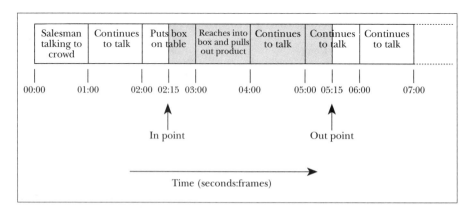

Figure 3-3. The shaded area indicates the position of a three-second cut that starts in the middle of the shot.

You want to pick out 15 characters from this sentence (letters and spaces). One way is to start with the word *test*, so you select characters starting with the *t* in *test*:

```
This is a test of the emergency video-editing system.
          test of the emerg
```

In this case, the In point is the first *t* in *test*; the Out point is the *g* in *emergency*. A different way is to start the 15-character cut with the first *e* in *emergency*, which gives you:

```
This is a test of the emergency video-editing system.
                      emergency video
```

Now, the In point is the first *e* of *emergency*, and the Out point is the *o* in *video*.

Of course, it doesn't make much sense to work with text this way, but it is almost exactly what you do when you select a cut from a video clip. The video clip is the whole sentence; the cut is the 15-character portion.

A cut of video can be as long as the entire video clip or as short as one frame. It depends on the situation. On MTV, the cuts generally last no longer than a second. In a documentary, a single cut might last 30 seconds or more.

Assembling the Cuts into a Movie

If you're already familiar with an editing program, it might be a good idea at this point to put down the book and try setting a few In and Out points on your own video clips (it's sometimes easier to learn by doing than by reading). This is a basic part of editing, and the quicker it becomes second nature, the faster you'll move on to the fun part of editing—telling visual stories.

Several software packages allow you to edit video cuts on your Macintosh. They range in price from a few hundred dollars to several thousand (the more expensive ones usually come with additional hardware). Almost all the programs, however, use the same basic methods for editing video.

In most programs, you build your movie by manipulating icons on a timeline (Figure 3-4). The icons represent the cuts you've selected from particular clips. The length of the icon indicates the duration of

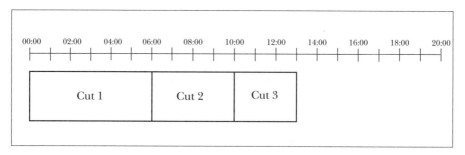

Figure 3-4. Editing the program timeline

the cut in the final movie. An icon can change its appearance as you lengthen or shorten the cut (by changing its In and Out points), but that's just window dressing. The important point is the length of the icon. An icon that is twice as long as another on the timeline lasts twice as long in the final movie.

The position of an icon on the timeline determines when it appears in the final movie. Time runs from left to right, with the beginning of the movie starting at the far left side and the end of the movie at the far right side; so, the first cut of a movie is placed to the far left. The second cut is positioned immediately to the right of the first one, and so on.

Because you're working with digital video (as opposed to videotape; see the note on page 34), it's easy to change the order of cuts. All you have to do is change the positions of the icons on the timeline. For example, let's say you are working with the following cuts:

Cut 1: Medium shot of the audience looking bored

Cut 2: Close-up of salesman pulling the product out of a box

Cut 3: Medium shot of the audience looking on in anticipation

You could build the movie by positioning these cuts in order (Figure 3-4). Another way to edit these cuts together would be to show cut 3 first, then cut 2, then cut 1. To make these changes, you simply move the icon for cut 1 over to the right of cut 3 (Figure 3-5), move the icon for cut 3 all the way to the far left of the timeline (Figure 3-6), and then slide the icon for cuts 2 and 1 next to the icon for cut 3 (Figure 3-7).

Of course, this gives the scene an entirely new meaning because the audience's bored expressions now mean something completely different (i.e., the product is boring). But we're getting ahead of ourselves.

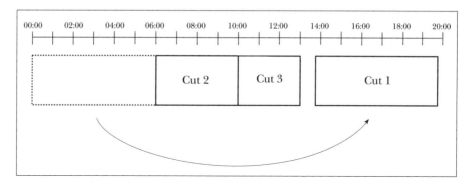

Figure 3-5. To switch the positions of cuts 1 and 3, you first move cut 1 to the end of the segment.

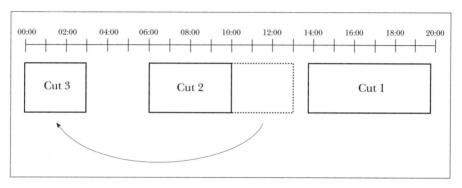

Figure 3-6. Cut 3 is then moved to the beginning of the segment.

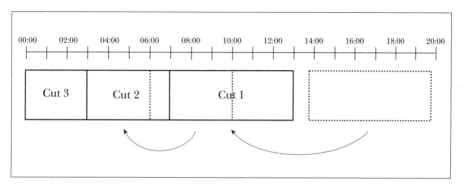

Figure 3-7. The process is completed by sliding the cuts together to remove any gaps.

The craft of visual storytelling is discussed in Chapter 6, after we cover the technical aspects of working with editing programs.

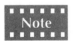 **There are advantages to nonlinear editing. If you've had the opportunity to edit on a traditional, linear videotape-editing system, you'll notice that with digital editing, you don't have to set the In and Out points for the record machine. The really great thing about digital-editing systems is that they allow you to edit nonlinearly, like film. If you want to change one edit in the middle of a long sequence, all you have to do is change that edit. All the edits after that one are automatically changed. You don't have to re-edit them.**

Editing Movies with Adobe Premiere

Adobe Premiere was one of the first, low-cost, video-editing programs that were introduced following the release of QuickTime. It is not the only low-cost option, but it's a good example of a well-constructed program. The following sections describe some of the basic features of Premiere version 3.0 (brief notes are included that cover some of the new features in version 4.0). If you are interested in descriptions of all the bells and whistles, please refer to the *Premiere User's Guide*.

Getting Started with Premiere

There are two parts to making a movie with Adobe Premiere: first you set up a *project*, then you create a movie. A project is a kind of working area where you make all your decisions (which clips to use, how long the cuts should be, what order do they go in, etc.). All these instructions are stored in the project file. When you actually want to see what you've created, you tell Premiere to follow these instructions and make a movie.

The project file doesn't store the actual clips or cuts. It only stores information about which cuts are used and what their order is. This helps reduce the size of the project file. A movie, however, is made up of the actual cuts specified by the project. The project is like a recipe, and the movie is the actual cake.

Therefore, you can send a copy of a movie to a friend, and he or she can view it provided that he or she has QuickTime. If you send a friend a project, you also need to send all the video clips that are used in it. However, if you want to modify a movie, you can do so easily by opening the project for that movie, making your changes, and then creating a new version of the movie.

 Because a project doesn't contain the actual clips themselves (only pointers to them), you must keep the video clips on your hard drive while you're working with a particular project. If you remove the clips, the project won't have anything to point to.

Making Edits with Premiere

Premiere uses three windows to handle the various activities discussed earlier in this chapter. The Project window holds all the clips for a particular movie (Figure 3-8). The Clip window is where you set the In and Out points for a clip. You actually design the movie in the Construction window. Other windows (such as the Transitions, Info, Controller, Locking, etc.) are described in Chapter 4.

Unlike a word-processing program or a spreadsheet, with Premiere you typically have several windows open at once while you work on a particular project. This allows you to move quickly between windows.

To demonstrate how to make a movie with Premiere, we'll use several sample video clips that come with Premiere. Each window in Premiere will be explained as we go through the steps of making a movie.

The Project Window

To start working on a new movie, you must first create a project with the New Project command under the Project menu. Then, you can start collecting the video clips for the project in the Project window.

After choosing the Import command under the Project menu, you see a dialog box showing a list of video clips. Click on the clip named Hands. You see a small still image preview of the clip. When you are working with your own material, you can create a preview by clicking on the Create button.

Import the Hands clip by clicking once on its name to select it (if it isn't already selected) and then click the Open button.

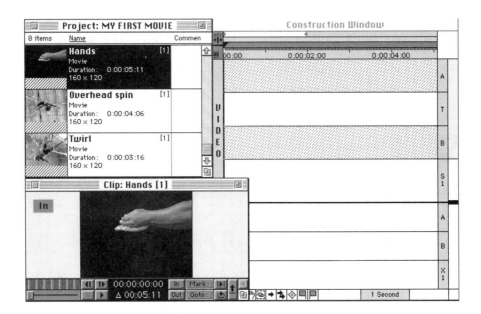

Figure 3-8. The windows used in Adobe Premiere

You can also add clips to the Project window by choosing the Open command (under the Project menu) and then selecting the Add This Clip command. This way, you can review the entire clip before deciding whether to import it into a project.

When the Hands clip is imported into the Project window, Premiere creates a *thumbnail* of the clip, which is similar to the first frame of the clip (Figure 3-9). You also see a description of the clip (movie), its duration (5:11), the size of the clip (240 × 180 pixels), and any comments attached to it.

Figure 3-9.

The Project window

Next, import the clip called Twirl, following the steps just described. You now have two clips in the Project window to work with.

The Clip Window

The Clip window is where you set the Ins and Outs for a particular clip. It's similar to the MoviePlayer in that you can play the clip backward and forward, but Premiere provides a number of additional controls that make it easier to move around a clip.

Double-click on the thumbnail for the Hands clip in the Project window, and the Clip window appears. By using the controls (as shown in Figure 3-10), you can move to different parts of the clip to decide where to set the In and Out points. Play with the various controls for a while to get the hang of them. As you move through the clip, notice that the frame indicator changes to show your exact point within the clip (the format for the frame indicator is *hours:minutes:seconds:frames*).

By default, Premiere sets the In point at the beginning of the clip and the Out point at the end. For this example, you're going to set your own In and Out points. Use the Clip window controls to move to the 00:26 frame of the clip (0 seconds, 26 frames) and then click the In button (Figure 3-11). You see a small box labeled In at that frame. Next, set the Out point by moving to the 4:15 frame in the clip, and clicking the Out button (Figure 3-12). The duration counter then shows that the duration of the cut is 3:20—the amount of time between the In and Out points plus one frame (read the note).

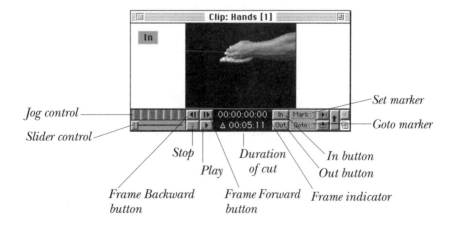

Figure 3-10. The Clip window showing controls

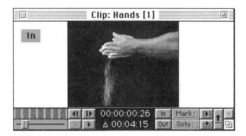

Figure 3-11.

An In point is set by clicking the In button at the desired frame. A small In label is then placed at that frame in the Clip window.

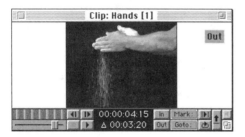

Figure 3-12.

An Out point is set by clicking the Out button at the desired frame. A small Out label is then placed at that frame in the Clip window.

Note

The duration in this example is 3:20 instead of 3:19 because of the way Premiere handles In and Out points. The In point is set at the beginning of a frame, while the Out point at the end of a frame. In other words, both the 00:26 frame and 4:15 frame are included in the duration.

That's it for the Hands clip. Now open the Twirl clip in the Clip window by double-clicking on its thumbnail in the Project window. Set the In point of this clip at the beginning and the Out point at the 3:03 frame.

The Construction Window

The Construction window is where your movie takes shape. Click on the Construction window to make it active. (If the Construction window isn't open, choose the Construction option from the Windows menu). This window displays, on a timeline, all the cuts in your movie and the point at which each cut begins and ends.

The window has seven rows, or *tracks*, which hold various types of clips (Figure 3-13). There are two video tracks (A and B), three audio tracks (A, B, and C), a transition track (T), and several superimpose tracks (S1, S2, etc.). Because you're working with just video clips, only the video tracks matter at this time; the other tracks are discussed later

in this book. Most of the time, you'll be working on video track A, the primary video track. Track B is used when you want to use transitions or perform complicated edits.

Click and drag the thumbnail of the Twirl clip from the Project window into the Construction window and place it in the top row (Figure 3-14). You see three slightly different thumbnails of the cut and a little fragment on the right edge. Each thumbnail represents one second, and because the Twirl cut lasts three seconds and three frames, there is a little bit left over, which is shown by the remaining fragment.

 The view of Construction Window in Figure 3-14 is a bit different than in Figure 3-13 because we have not included all the tracks in the figure, only the important ones.

Near the top of the window is the *time ruler*, which is the timeline for the project. The scale of the time ruler determines how much time is represented by each thumbnail. You can change the scale of the ruler by adjusting the *time-unit selector*, located in the bottom-left corner of the window. By default, Premiere sets the time unit to one second.

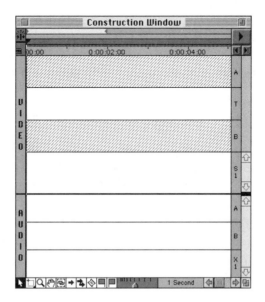

Figure 3-13. The Construction window

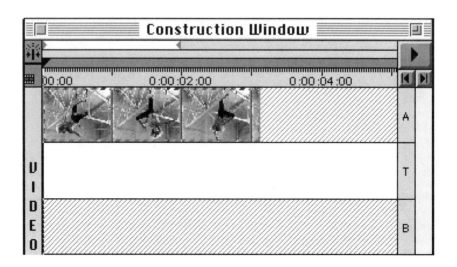

Figure 3-14. The Twirl cut displayed in the Construction window

Try setting the unit to two seconds by clicking to the right of the selector. Notice that the cut now appears half as long. This is because the scale of the ruler is twice as large, and each thumbnail represents two seconds instead of one (Figure 3-15). If you set the time unit to shorter periods of time, the length of the cut increases accordingly (more thumbnails, each representing a shorter period of time).

Going back to the example, drag the Hands clip into the Construction window and place it against the right edge of the Twirl cut:

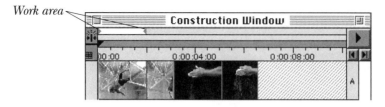

Set the time unit to two seconds (if you haven't done so already), so you can see both cuts in the Construction window. Because time moves from left to right, the Hands cut appears after the Twirl cut in the movie.

Time ruler

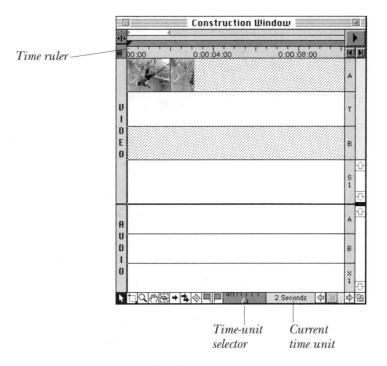

*Time-unit
selector*

*Current
time unit*

Figure 3-15. The time-unit selector is adjusted by clicking the pointer to the
right or left of the selector. Clicking to the left sets a smaller time
unit (greater resolution); clicking to the right sets a larger time
unit (less resolution).

Even though it might not look like it, you've just made an edit. To
actually see the edit, you need to preview the movie.

Previewing puts together all the cuts that are in the *work area*, which
is set by the yellow bar sitting just above the time ruler. You can drag
the bar to any part of your movie; you can also increase the size of the
work area by dragging the ends of the yellow bar. Only those cuts that
lie under the yellow bar are assembled during a preview. This allows
you to preview only a portion of the movie instead of the whole thing.
Drag the right edge of the yellow bar until it reaches the right edge of
the Hands cut, then press [Return]:

Work area

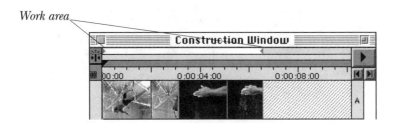

After assembling the cuts, Premiere displays your edit in the Preview window. Depending on your machine, the motion in the video cuts may look a little jumpy. That's because a preview is a rough approximation of what the final movie will look like. If you like the preview, you'll love the movie.

You can also view your edit by positioning the cursor ontop of the timeline in the Construction window (a downward arrow will appear) and then dragging the cursor along the timeline:

This technique, called *scrubbing,* allows you to view edits much faster than with the Preview command. However, because the speed of the scrub is set by how fast you move the mouse, scrubbing doesn't give you a good sense of the pacing in a particular portion of your movie.

The decision to put the Twirl cut first and the Hands cut second was just one example. You can easily switch the orders of the cuts. Click on the Construction window to make it active. Drag the Twirl cut to any point in track A that is to the right of the Hands cut:

Then drag the Hands cut to the far left side of the track:

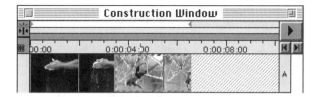

and put the Twirl clip against the Hands cut, as shown next:

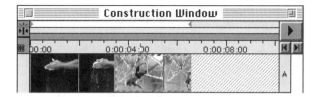

Preview the movie by pressing [Return]. You now see the Hands cut first, followed by the Twirl cut.

You can add more cuts to your movie by following the steps you just took:

1. Import the video clip into the Project window with the Import command.

2. Open the clip in the Clip window and set the In and Out points.

3. Drag the clip from the Project window into the Construction window, and put it in video track A in whatever position you want.

4. Set the work area to include the new cut and preview the edits.

Making the Movie

Once you're satisfied with your project, you can take the next step and create an actual QuickTime movie. This can be a time-consuming process, so it's a good idea to preview your project several times before you take this step.

Choose the Make Movie option under the Project menu. A dialog box appears that asks you to name the file. As mentioned before, try to make the name as unique as possible so that you can find it easily later on.

Click on the Output Options button; a new dialog box appears with several different parameters you can set (Figure 3-16). Please refer to the Premiere manual for a detailed description of these parameters. The main ones that concern you are the video frame rate, the audio rate, and the image quality.

Generally speaking, you should try to have as high a video frame rate as possible. On an 030 Macintosh (IIci, LCIII) you are usually limited to between 10 and 20 frames per second (fps) for a window size of 160 by 120 pixels. However, a fast Quadra (650) can handle 30 fps. A larger window size reduces the frame rate.

 With QuickTime 2.0 you can achieve a higher frame rate with the same file on the same computer.

Another way to increase the frame rate (and reduce the file size of the movie) is to reduce the quality of the movie. Clicking on the Compression command under the Make menu brings up the Compression dialog box (Figure 3-17). The slider bar in the Compression box lets you set the quality of your movie (the range is from 1 to 5, with 5 being the highest quality). Make a few movies with each setting so that you get a sense of the different settings.

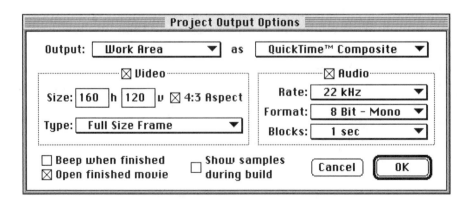

Figure 3-16. The Project Output Options dialog box lets you set many parameters for outputting your movie.

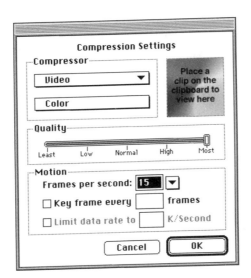

Figure 3-17.

Moving the slider bar allows you to set the quality of the movie as you wish, and affect the frame rate accordingly.

There is a trade-off between quality and frame rate that has to do with how QuickTime compresses video. This is covered in detail in Chapter 14. For now, the main thing to understand is that a low compression setting means lower quality and a smaller file size. Vice versa, a high compression setting means higher quality and a larger file size.

Saving the Project

You should now save the project you created so that you can make changes later on. Choose the Save option under the File menu. Give your project a name (such as **My First Project**), then save it.

Wrap-Up

This chapter covered the basics of performing video edits with an editing program. But this is just the beginning. In the next chapter, you'll learn how to include audio in your movie, and how to use transitions to make smooth transitions between different cuts as well as a few other tricks.

Beyond the Basics

One of the best things about software editing programs is that they allow you to work with video in complex ways—at a fraction of what it would cost you if you were only working with videotapes. This chapter reviews some features found in most editing systems that can improve the look of your movie and increase its impact. Adobe Premiere is again used as the example, but many other editing programs have these features—as well as some others of their own.

Clips in Motion

Chapter 3 covered the basic steps in assembling a movie:

1. Import clips into the Project window.
2. Select a cut from a video clip by setting In and Out points.
3. Position the cuts along the timeline in the Construction window.
4. Make the movie.

You'll continue to use those four steps for most of your editing, but at times you will want to make changes to a project. Premiere has a number of features that make it easy to manipulate cuts once they're in the Construction window.

Lengthening and Shortening a Cut

If you saved the project (My First Project) you created in Chapter 3, open it with the Open command under the File menu. Otherwise, follow these steps:

1. Choose New Project from the File menu.
2. Import the Hands and Twirl clip using the Import command.
3. Open the Hands clip in the Clip window.
4. Set the In point at 00:26 and the Out point at 4:15.
5. Open the Twirl clip in the Clip window.
6. Set the In point at the beginning of the clip and the Out point at 3:13.
7. Click on the Construction window to make it active.
8. Drag the Hands thumbnail from the Project window and place it on the far-left side of the Construction window.
9. Drag the Twirl thumbnail from the Project window and place it flush against the right edge of the Hands cut.

Preview the project by pressing the ⌷Return⌷ key. Now, let's say you wanted to include more of the Twirl clip. You could open the cut in the Clip window and change the Out point, but there's an easier way. Drag the Twirl cut to the right so that there is a small gap between the two cuts (at least one second's worth). Then position the cursor over the right edge of the Hands cut. The cursor shape changes to a *stretch pointer*.

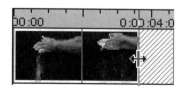

Click and drag the right edge of the cut to the right until it won't stretch any further. You've just lengthened the cut by dragging the edge of the thumbnail to extend the Out point. Double-click somewhere in the middle of the Hands cut to open it in the Clip window. Go to the end of the cut, and you can see that the Out point is now set at the end of the cut instead of at the 4:15 point.

You can go directly to the Out point by pressing the Go To button in the Clip window and then choosing the Out option.

Click on the Construction window to make it active, and position the pointer over the right edge of the Hands cut again. This time, drag it to the left. This shortens the cut by setting the Out point to an earlier point in the clip. You can confirm this by opening the cut in the Clip window.

Changing the In and Out points only affects which cut, or portion, of the video clip appears in the Construction window. You can change the Ins and Outs as much as you like—the video clip itself remains unchanged.

The advantage of changing the length of a cut with this method is that it's fast—but it's not particularly accurate. If you want to set the Out point at a particular point in the clip, use the Clip window. But if precision isn't required, change the length of a cut with the stretch pointer.

You can also increase the duration of a cut by stretching the beginning of a cut. Move the Hands cut to the left so that there is some space between it and the beginning of the Construction window. Position the pointer over the left edge of the Hands cut. When the stretch pointer appears, drag the left edge of the Hands cut to the left until it won't move anymore:

This lengthens the cut by setting the In point to an earlier point in the clip. In this case, the cut doesn't change much because the In point was already near the beginning of the clip. You can use the Info window to see exactly by how much you are extending a cut. Choose the Info Window option under the Windows menu. A small window appears that indicates the duration of the cut:

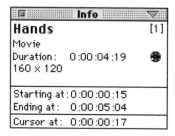

Position the pointer over the left edge of the Hands cut again and watch the duration indicator in the Info window as you stretch the cut. The numbers on the bottom of the Info window indicate where the cut starts on the timeline. This is particularly helpful when you are aligning cuts on different tracks (which you get to do later in this chapter).

There are a number of other basic commands for manipulating clips in the Construction window.

Deleting a Cut

Removing a cut from the Construction window is easy. Just click on it to select it, then press the [Delete] key. You can also choose Clear from the Edit menu to do the same thing.

Copying and Pasting Clips

Once you've selected a cut in the Construction window by clicking on it, you can create a copy of that cut by using the Copy/Paste commands under the Edit menu. First copy the cut, click on an open area of track A, and then paste the cut. The new cut will appear in both the Construction and Project windows to indicate that you're now working with two versions of the same clip. You can set unique In and Out points for each version. With several versions of the same clip sitting in the Construction window, it can get confusing as to which version you're actually working with. Double-click on the cut in question and it will appear in the Clip window. At the top of the Clip window next to the name of the clip is a number in parentheses that indicates the version:

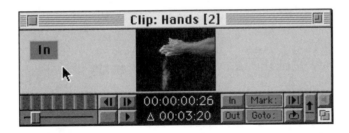

Save your project at this point with the Save command. If you haven't saved the project yet, name it **My First Project**.

Using Other Premiere Controls

When you're first getting started, you'll do most of your work by setting In and Out points in the Clip window or by using the Stretch pointer in the Construction window. But Premiere provides a number of other valuable tools that make editing easier—particularly as you start working with more complicated effects. We won't use all the tools right away but we'll describe them just so you know they're there. You select an editing tool (the set is located in the bottom-left corner of the Construction window) by simply clicking on it:

We'll step through each one in order starting from the left:

Selection Cursor (Keyboard equivalent: \boxed{S} key) This is the standard cursor. It allows you to select and move clips in the Construction window.

Range Select Tool (\boxed{E} key) [Premiere 4.0 only] This tool lets you select several clips in the Construction window and move them as a group. Use this tool when you want to move a number of clips to a different portion of your movie.

Zoom Tool (\boxed{Z} key) The zoom tool allows you to zoom in on a particular portion of the Construction and view an edit or a clip with

greater time resolution. It is similar to adjusting the time unit slider. To zoom back out, hold down the (Option) key and click on a track in the Construction window. With Premiere 4.0, this tool lets you select a portion of the Construction window (by clicking and dragging). Your selection then fills the current Construction window (with the time unit adjusted accordingly). This tool is very useful when adjusting the In and Out points with the Stretch pointer. Zooming in gives you greater control over exactly where you set the In and Out points for a clip.

 Hand Tool (H **key)** This tool lets you scroll the contents of the Construction window to find a particular clip. Click on a portion of the window and then drag to the left or right to see a different portion of the window. The advantage of this tool is that it's faster than using the bottom scroll bar (and it does exactly the same thing).

 Block Select Tool (B **key)** This tool allows you to create a "virtual clip" consisting of a portion of the Construction window. All tracks are combined into a new video clip and an accompanying audio clip. To create a virtual clip, you choose this tool and then click and drag to define a portion of the Construction window. Then you click in the middle of the area you just defined and drag to an open track in the Construction window. We discuss virtual clips in greater detail in Chapter 10.

 Track Tool (T **key)** The track tool lets you move some or all of the clips in a track to the left or right. Simply choose the track tool, click on the first (leftmost) clip you want to move, and then drag to the left or right to move the group of clips. This tool only moves one track so use it with caution when working with clips that have associated audio tracks (see the multitrack tool, described next). The tool is essential when you switch the positions of clips within a group of clips or need to create room for several new clips.

 Multitrack Tool (M **key)** This tool lets you move all the clips in all of the tracks in the Construction window. Use it when moving a group of clips that have associated audio tracks. Choose the tool and then click on the first (leftmost) clip of the group of clips you want to move.

Then drag to the left or right to move them. You can remove one or more tracks from the selection by holding down the [Shift] key and clicking on the unwanted track. This tool is really valuable when you need to make some room in the middle of a group of clips to incorporate new material.

 Razor Tool ([R] key) The razor tool allows you to split a clip into two new clips—just as if you were cutting a piece of film with a pair or scissors or a razor blade. The two new clips combined are actually the same as the original (uncut) clip. The first frame of the new clip #2 immediately follows the end of the new clip #1. (Just think about cutting a piece of film and it makes sense.) This tool is great when you're working with filters or motion (see Chapter 5).

 In Point Tool ([I] key) This tool lets you set the In point of a clip at a particular point in the Construction window. Simply choose the tool and then click where you want the clip to begin. This will change the In point of the clip. If you want to have a clip start at a different point in the Construction window, don't use this tool; simply move the clip. The In point tool is helpful where working with very long clips in the Construction window. Quite often, you won't be able to see the beginning of the clip in the Construction window and will have to scroll back to find it before you can use the stretch pointer to change the In point. With the In point tool, you don't need to find the beginning of the clip; simply click on where you want the clip to start.

 Out Point Tool ([O] key) The Out point tool works the same way as the In point. Select the tool and then click on the point where you want the clip to end. It's identical to using the Stretch pointer to change the Out point of a clip. Even more than the In point tool, this tool is essential when working with long clips. I often use it to cut off the back end of a long clip. Then I use the stretch pointer to set the Out point.

Building a Sequence of Clips

Now that you've got a few more tools in your tool chest, let's build a series, or *sequence*, of clips. Import the following clips into the Project:

Closeup, Cross Position, Fall Forward, and Final Bow. Add the clips to the Construction window:

1. Click on the Twirl click and move it a few seconds later in the Construction window.

2. Double-click on the Fall Forward clip in the Project window. Set the Out point to 3:12.

3. Drag the Fall Forward clip into the Construction window and place it in the gap you created between the Hands and Twirl cuts.

4. Slide the Twirl cut to the left to eliminate any gaps in track A:

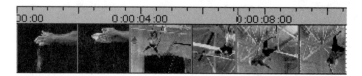

5. Drag the Cross Position clip from the Project window and place it after the Twirl clip in track A.

6. Drag the Final Bow clip from the Project window and place it after the Cross position cut.

Save your project, if you haven't already do so. Set the work area bar to include all the cuts in track A, and press the return button to preview the sequence of cuts. The cuts play one after another in a sequence.

Let's add another clip to the sequence, the Closeup clip. Select the Track tool by clicking on it (see description above). Position the arrow cursor at the beginning of the Fall Forward cut in track A:

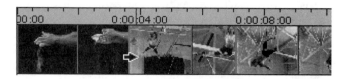

Click down and drag the cursor to the right about three seconds. Notice that the Fall Forward cut and all the cuts after it move as a group. Next, drag the Closeup clip from the Project window and place it in the gap you've created between the Hands and Fall Forward cuts:

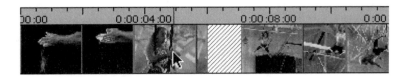

Use the Track tool again to drag the Fall Forward cuts and all those after it back to the left to remove any gap in track A.

Reset the work area to include all the clips and preview the sequence. You've just added a cut to the middle of a sequence (ah, the beauty of non-linear editing!).

Save your project at this point because we'll be using it later.

Working with Place Markers

Sometimes you're not sure where you want to start or end a cut because there are several possibilities. Premiere allows you to set *place markers* at any point in a clip, which let you mark these options as possible In and Out points.

Setting Place Markers

Let's say you want to mark several possible Out points for the Hands cut. Open the cut in the Clip window by double-clicking on the cut (in either the Project or Construction window). Using the slider bar, go to the end of the cut, set the Out point there, then use the Step Backward button to move back to the 4:25 frame. Click the Mark button that is next to the In button. A pop-up menu appears with a list of numbers, 0 to 9. Choose 1 for this place marker.

Premiere indicates that you marked this frame by putting a bullet next to the marker number in the pop-up menu and putting a place marker with the selected number in the middle of the cut. This marker appears not only in the Clip window but also in the Construction window.

Next, use the Step Backward button to move to the 4:20 frame of the clip. Set a place marker at this point with the Mark button. This time, choose 2. Then move back to the 4:10 frame and mark this frame

with place marker 3. You now have four different options for the Out point: the current Out point at the end of the cut and three place markers at frames 4:25, 4:20, and 4:10, respectively.

Using Place Markers

Now use the Go To button to shift between your different place markers and the Out point. This lets you review the various possible Out points quickly. Place markers are stored with the cut, so you can easily find a place marker after you preview the cut in the Construction window. To switch the Out point to one of the place markers, open the cut in the Clip window, click the Go To button to move to that place marker, and then set this frame as your Out point with the Out button.

Because place markers are shown with the clip in the Construction window, you can use the Stretch pointer to choose one of the options for the Out point.

This works best when you choose the Snap to Edges option in the Construction Windows Options dialog box (under the Windows menu).

Using place markers to keep track of possible In and Out points is just the tip of the iceberg. As you'll see in the next section on working with audio, you'll often want to change the level of an audio track in the middle of a cut. Where you want that change to occur is often determined by what is happening in the video cut.

For example, let's say you have a video clip of a door slamming, but for some reason you don't have the audio for that piece of video. You can fix this by adding an audio clip of a door slamming at precisely the same moment as the door closes. A place marker at that point in the video makes it a lot easier to synchronize, or *synch* (pronounced "sink"), the video and audio cuts at the proper point in time.

Adding Sound—A Crucial Step

When most people first get their hands on editing equipment, they are seduced by the visuals and don't pay enough attention to sound. But

any Hollywood director will tell you that the proper soundtrack is essential for a good movie.

There are four main types of sound: voices (either dialog or narration), background sound (also known as *ambience*), music, and sound effects. The basic steps of working with audio in Premiere are the same for all four types.

So far, we've been working with video clips that don't have audio attached to them. If you're using a digitizing board that can also digitize sound, or you are working on an A/V machine, then most of your video clips will have audio. If you're working with someone else's material or with *clip media* (prepackaged sets of video clips), you might need to create your own digital audio files.

A number of products allow you to convert normal, analog audio into digital files. Techniques for digitizing audio are covered in more detail in Chapter 14. For now, the main thing to know is that Premiere (or any editing program) can only work with digital audio files that are stored in one of the standard audio formats (AIFF, snd, SoundEdit, SoundDesigner, etc.).

Importing Audio Clips

Let's work with the Circus audio clip that comes with the Premiere software to see how working with audio is different than working with video. First, open the Project you saved before (My First Project) if you haven't already done so.

You import an audio clip in the same way that you import a video clip—with the Import command under the Project menu. Use this command to import the Circus audio clip. When the clip shows up in the Project window, instead of a picture, there's a little line called a *waveform*. Under the name of the audio clip is the duration of the clip and some technical information about how the clip is digitized.

Setting Ins and Outs

Open the audio clip in the Clip window by double-clicking on its thumbnail in the Project window. As in the Project window, there are some subtle differences to working with an audio clip in the Clip window compared to working with a video clip:

- The Step Forward and Step Backward buttons work the same way, except that the audio isn't broken into distinct chunks of time, or *frames*, as video is. To account for that, Premiere draws a black vertical bar through the waveform that indicates the length of one frame.

- You can expand or condense the waveform by clicking on the waveform control button at the left end of the scroll bar (Figure 4-1). This allows you to set very precise In and Out points for audio clips.

Use the slider bar to move through the clip. Notice that the clip has no sound when the waveform is flat; sound is indicated by the vertical lines in the waveform.

Working with Audio Clips in the Construction Window

Click on the Construction window to make it active, then drag the Circus audio clip from the Project window into audio track A and position it under the cuts in video track A:

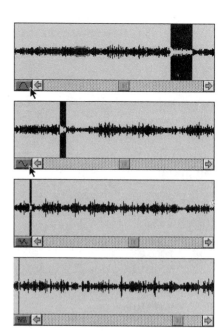

Figure 4-1.

You can view the audio portion of a QuickTime movie at different time resolutions by clicking on the Wave Form Control button in the audio Clip window.

Reset the time ruler to two seconds, so you can see all the cuts in the Construction window, and then reset the work area to include the Circus audio and video cuts Preview the work area by pressing ⌈Return⌋. You will hear the Circus audio as the video cuts play one after the other. Notice, however, that the music plays after the video cuts have stopped. There are two possible solutions to this problem: either shorten the audio cut so that it ends at the same time as the video cuts, or add another video cut.

In this case, shortening the audio cut might not work very well because we would cut off either the beginning or end of the audio cut—which for this audio cut would sound kind of abrupt (try it and find out!).

Instead, we'll add another video cut—the Overhead Spin clip. First, Import it into the Project window. Now let's figure out where we want to put it in the sequence. It might be good to have it start at a particular point in the Circus audio. Open the Circus audio cut in the Clip window. Play the cut until you reach the beginning of the second stanza (at about the 9:00 point in the clip). Set a place marker "1" at this point to mark that point in the audio clip. Click on the Construction window and you'll notice a small "1" arrow in the audio cut. This marks where you want the Overhead Spin clip to start in track A.

First, we have to make room for the Overhead Spin clip. Use the track tool to move all the all cuts after the Fall Forward cut to the right about five seconds:

Next, use the Stretch pointer to set the end of the Fall Forward cut to match the "1" marker in the audio cut:

Drag the Overhead Spin clip into track A and place it next to the Fall Forward cut. Use the Track tool to move the all cuts to the right of the Overhead Spin cut back to the left to eliminate any gaps in track A. Set the work area to include the first four cuts in track A and preview your work. The Overhead Spin clip starts just as the second stanza begins.

 This is one of the major uses of place markers—synching an edit in the video track with a particular point in an audio cut. We'll get into this is greater detail in Chapter 7.

Set the time-unit selector to four seconds so you can see all the video cuts in the Construction window. You can see that the video cuts extend past the Circus audio cuts. No problem; simply shorten the next-to-last video cut (with the stretch pointer) until the video and audio cuts end at the same time.

Adjusting the Volume of an Audio Cut

Under the waveform for each audio cut is a *fade control*, which lets you adjust the volume, or level, of the cut. Position the pointer cursor over the line in the center of the fade control, and a *finger cursor* appears:

Click the mouse to create a handle, which is shown as a small black dot. By dragging the handle up and down, you can change the volume of the audio cut at that point—higher is louder, lower is quieter.

You now have all the basic tools for working with audio in your movies. A more detailed discussion of how and when to incorporate audio can be found in Chapter 11.

Incorporating Graphics

In addition to working with video and audio, you can also insert still images and titles into your movies. The images can be of any size (although you need to have the correct aspect ratio—four units horizontal for three units vertical). The files must be in either PICT or Photoshop formats. Premiere also provides a very useful titling feature that you can use to create titles and simple graphics for your movies. We'll discuss working with PICT and Photoshop graphics first.

 Although you can use any size graphic, it is a good idea to make the size of the graphic match the size of your movie. So if your movie is the standard size (240 by 180 pixels), then your graphics should be that size as well. The quality of the graphic is better because you aren't forcing Premiere to resize the image.

Working with PICT or Photoshop Graphics

Let's say you've created a graphic in Photoshop that displays the credits for your movie. Import the graphic using the Import command, as you would with a video or audio clip. By default, a still image is assigned a duration of one second when it's imported. You can change the default duration by choosing the Preferences option (under the File menu) and then changing the still frame duration in the Still Image dialog box.

Drag the thumbnail of the graphic from the Project window into the Construction window and place it in video track A next to the end of the Final Bow video cut. Extend the Credit cut using the stretch pointer to make the cut last three seconds:

Change the work area (by moving the red arrows) so that it covers just the Final Bow video cut and the graphic, then preview the work area. You'll notice that the change, or *transition*, from the Final Bow cut to the graphic seems fairly abrupt. We'll fix this problem in the next section, which covers transitions, but first let's review several other types of graphics you can use in a movie.

Making PICT Images from a Video Clip

You can create a PICT image of any specific frame in a video cut—essentially taking a snapshot of that frame—and then use that image in your movie as you would any other graphic. Open the Final Bow video cut in the Clip window and go to the Out point. Make a PICT image of this frame with the Save Frame As PICT command under the File menu. Then save the image as **FinalBow.pict**.

Import the PICT image you just created into the Project window with the Import command. Slide the Credit graphic to the right so that there is roughly a two-second gap between the Final Bow video cut and the Credit graphic. Drag the FinalBow.pict thumbnail from the Project window and place it in the gap and against the right edge of the Final Bow video cut. Extend the right edge of the FinalBow.Pict graphic so that it fills the gap (using the stretch pointer):

Set the work area to cover just the Final Bow video cut and the FinalBow.Pict graphic, and preview the work area. By making a PICT

image of the last frame of the Circus video cut and then tacking it on to the end of the video cut, you have created a *freeze frame*. These are particularly useful when you want to extend a cut, but the video clip isn't long enough.

Adding a Colored Background

Sometimes you need to add a graphic made of a solid color. These can be used as elements or backgrounds for special effects. Choose the Add Matte option under the Project menu. A color wheel appears that lets you choose the color of the graphic (Figure 4-2). For this example, let's use white. Drag the slider (located to the right of the color wheel) to the top of the scroll bar. This sets the middle of the color wheel to pure white. Click the OK button and give the matte a name (such as **White Matte**).

 You can use a different type of color picker (the Premiere picker) by selecting Preferences from the File menu, then choosing the General option and selecting the Premiere color picker in the dialog box.

Figure 4-2. By adjusting the scroll bar on the background matte color table, you can adjust the brightness of the matte. You can also select a particular color by clicking anywhere inside the wheel.

A thumbnail for your new graphic shows up in the Project window. Click on the Construction window to make it active, then slide the Credit graphic to the right to create about a one-second gap between it and the FinalBow.Pict graphic. Drag the thumbnail of the White Matte into the Construction window, and place it in the gap you just created:

Move the Credit graphic so that it sits flush against the White Matte. Set the work area to cover the Final Bow video cut, the FinalBow.Pict graphic, the White Matte, and the Credit graphic, and then preview the work area. What you should see is the Final Bow video moving, then freezing, then one second of a plain white screen, then the Credit graphic.

Creating Titles

Recent versions of Premiere include a title and drawing utility that allows you to create titles specifically for use in your movies. Choose the New command under the File menu. In the pop-up menu that appears, choose the Title option to launch the utility. A drawing window appears in which you can create your titles (Figure 4-3).

This utility allows you to create different shapes as well as titles. For this example, we'll create a new credit title that is set in front of a colored rectangle.

First, let's select a color for the rectangle. Double-click on the foreground color selector:

Figure 4-3.

The titling window in Adobe Premiere allows you to create titles and backgrounds for your movies.

Select a color from the color picker. Next, click on the shaded rectangle to select the filled rectangle tool. Click in the upper-left portion of the drawing area (the white box) and drag the cursor down and to the right to draw a box:

Now let's add the credit text on top of the colored rectangle. First, we need to choose another color for the text so that it stands out from the background. Double-click again on the foreground color selector and choose a new color (it should be lighter or darker than the colored rectangle). Then click on the "T" to select the text tool. Choose a font using the Font menu and a font size using the Title menu (in this example we're using 20-point Helvetica). Click somewhere in the drawing area and start typing. When you've finished the title, click

anywhere in the drawing area and the text will be set against the background. If you want to move the title, simply click inside the gray boxes that mark the end of the text and drag the title to a new spot:

 You can center any object (graphic or text) exactly by choosing the Center Horizontally and Center Vertically options under the Title menu.

Save your title using the Save command and then add the title to your project using the Add This Clip option under the Project menu (in Premiere 3.0 this command is under the Clip menu).

Let's replace the other credit graphic with the new one by clicking on the old graphic (in the Construction window) and then deleting it by pressing the Delete key on the keyboard. Then drag the new title from the Project window and put it at the end of the movie. Set the work area to include the last three cuts and preview the end of your movie. The cuts are in the right order, but the edits are still a bit too abrupt.

 The titling feature in Premiere allows you to do much more than we've described here. Please refer to your manual for a complete description of this feature.

Playing with Transitions

Until now, you made edits by putting one cut directly next to another. In film and TV parlance, this type of edit is called a *cut*. If the images

aren't all that different or there is some kind of movement in the video shot, the transition between one cut and the next isn't particularly noticeable. But as you saw in the previous section, sometimes a simple edit just doesn't make it.

A transition allows you to make a smoother jump from one video cut to another. It is like an audio cross-fade—one video cut fades out while another fades in—except that you have more options in how the video fades in and out.

If you open the Transitions window by choosing that option from the Window menu, you'll see that you have a dizzying array of transitions to choose from (Premiere 4.0 has 70 different transitions, while version 3.0 has 63). Each provides a different kind of transition from one video cut to another (Figure 4-4). Use the scroll bar to scan the entire list of transitions. The animated icons next to the various transitions indicate what the effect looks like in the final movie. The letter *A* in the icon refers to video track A, the letter *B* to video track B.

In this example, you will use the Cross Dissolve effect as a transition from the FinalBow.Pict graphic to the White Matte. Click on the Construction window to make it active, then drag the White Matte graphic from video track A to video track B and position it so that it ends at the same point as the FinalBow.Pict graphic (see next page).

Transitions

Additive Dissolve
Image A fades into image B.

Band Slide
Image B slides over Image A in horizontal or vertical bars.

Band Wipe
Image B is revealed under Image horizontal or vertical bars.

Barn Doors
Image B is revealed under Image from the center outwards.

Center Merge
Image A splits into 4 parts and s to the center to reveal image B.

Center Peel
Image A curls from the center, v shaded back, revealing image B.

Center Split
Image A splits into 4 parts and s to the corners to reveal image B

Channel Map
Selected Channels from images A B are mapped to the output.

CheckerBoard
Two sets of alternating boxes w reveal image B under image A.

Clock Wipe

Figure 4-4.

The icon for each transition indicates the visual effect it creates.

Click on the Cross Dissolve transition, drag it into the Construction window, and place it in the track labeled "T" between the FinalBow.Pict graphic and the White Matte graphic:

The small arrow on the left side of the transition icon, called the *track selector button,* indicates which way the transition is going. A downward arrow means that the transition is from the video cut in track A to the cut in track B; an upward arrow means the opposite.

Make sure that the Cross Dissolve transition begins at the same point that the White Matte begins and ends where the FinalBow.Pict graphic ends. Use the stretch pointer to line up the ends of the transition with these cuts:

Set the work area so that it covers the FinalBow.Pict graphic and the White Matte, and preview the work area. FinalBow.Pict should fade away into a blank white screen. Unfortunately, transitions don't show up well in previews (unless you have a very fast machine, such as a Quadra). To see what it really looks like, you have to actually make the movie.

As with a graphic or video cut, the length of a transition icon affects how long the transition lasts. If you want a quick transition, make the icon shorter with the stretch pointer. For a longer transition, make the icon longer. There is no correct length for any particular transition; it depends on the situation. Try out a few different transitions at different lengths and see what you like.

Back to the example. You'll now use another transition to introduce the Credit graphic. Extend the White Matte graphic with the stretch pointer so that its duration is two seconds long (use the Info window to see the duration). Then slide the Credit graphic to the left so that it overlaps the White Matte by about 20 frames—no need to be exact at this point:

Click on the Transitions window and scroll down the window until you see the Zoom effect. Drag the icon for the Zoom effect to the T track between the White Matte and the Credit graphic. Line up the beginning of the effect with the beginning of the Credit graphic.

Complex transitions, such as the Zoom effect, can be modified in several ways. We're not going to review all the different modifications you can do to transitions in this book; they are handled well enough in the Premiere manual. For this example, click on the Track Selector button to make the arrow point upward, and leave the other controls as they are. Shorten the transition with the stretch pointer so that the transition ends at the end of the White Matte graphic.

Set the work area to cover the Final Bow video cut, the FinalBow.Pict graphic, the White Matte, and the Credit graphic. This time, make a movie of the work area, so you can see the transitions in all their glory.

Open the movie you just made and review it. You should see the Final Bow video, see it freeze, watch it dissolve into a white screen, and then see the credits zoom in. If you're happy with the way the transitions look, make a movie of the entire project. First reset the movie

output options. Choose the Make Movie option under the Project menu and then click on the Output Options button at the bottom of the dialog box (Figure 4-5). Then choose the "Entire Project" option in the Output pull-down menu:

Output: Entire Project ▼

Give your movie a name, and click on the OK button. You might want to go get a cup of coffee at this point because it takes a while for Premiere to assemble your movie. When Premiere is done, open the movie and review your work.

Wrap-Up

This chapter introduced many new commands and tricks, so here's a quick review of what we covered.

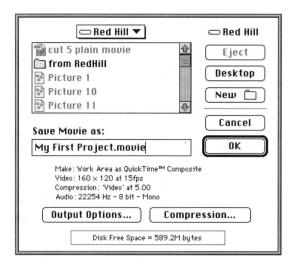

Figure 4-5.

Clicking on the Output Options button in the Make Movie dialog box allows you to change the parameters for making the movie.

Modifying Video Clips

- You can change the length of a cut with the stretch pointer.

- You can use the Info window to determine the exact length, or duration, of a cut.

- You can split a single cut into separate cuts using the razor blade tool by holding down the (Control) key.

- You delete cuts by selecting them with the pointer and pressing the (Delete) key.

- You can move a whole group of cuts by holding down the ⌘ key as you move them.

- You can set place markers in a cut to mark alternative In and Out points.

Working with Audio

- Audio clips can be manipulated the same way as video clips, except that you can't set place markers in them.

- You can change the level of an audio cut by creating a handle in the Fade Control box and moving the handle up and down with the finger pointer.

- You can mix two sounds by placing them on separate audio tracks.

Incorporating Stills and Graphics

- You can import graphics into your movie as long as they are stored in the PICT or Photoshop format.

- You can change the length of a graphic only by using the stretch pointer (you can't set In and Out points in the Clip window).

- You can create a PICT image from a video clip and use it as a freeze frame.
- You can create solid-color graphics with the Make Matte command.
- You can create titles using the Titling window.

Transitions

- Transitions allow you to introduce a new video cut in subtle or eye-catching ways.
- You can change the length of a transition by using the stretch pointer.
- The direction of the transition is set by the track selector button on the transitions icon.

As mentioned before, this isn't a complete list of the things you can do with Premiere; there's much more to explore. The next chapter introduces the wild world of special effects, filters, superimposing, and other methods for creating intriguing video clips and segments.

Special Effects Wizardry

Working with video on your Macintosh can be a bit of a pain. It takes up lots of memory, it often doesn't run as fast as you would like, and the window isn't big enough (yet). But having video on your computer in digital form opens up a world of possibilities. Because it's digital information, you can change the image just as you would any other image on your Macintosh. You can bend it, stretch it, change the colors, move the image around the screen, almost anything you can think up.

This isn't the first time people have been able to play with digital video. High-end post-production houses have offered digital video technology, such as the Harry and Paintbox systems from Quantel, for a number of years. But these devices by themselves rent for $200 or more an hour. And you have to rent the online editing system as well (another $250/hr). So spending just one day fooling around with these systems can cost you upward of $4,000.

With QuickTime and Premiere, however, you have the capability of performing nearly all the same special effects of the more expensive professional systems. In this chapter, we review a number of different tricks and techniques you can use to create dazzling and mind-bending effects.

 Creating special effects in other editing programs such as VideoFusion and After Effects is covered in Chapter 10.

Creating Special Effects with Premiere

There are two basic kinds of special effects: those that work with two clips (transitions and superimposing) and those that affect only a single clip, such as filters.

Making New Tricks with Transitions

In earlier chapters, we examined how a transition can create a smooth and interesting transition between two video clips. Here, we're going to look at some other ways that transitions can be used.

Using Several Transitions in a Row

Sometimes you have a set of video clips that you'd like to join together through transitions. You could use the same transition between each pair of clips, but a more interesting method would be to use a group of transitions that complement each other.

For example, let's say you are producing a CD-ROM that contains a huge number of different video clips. You want to create a short introductory segment that displays portions of several clips to give the user an idea of what's on the rest of the disk.

Here's how you could use different variations of the Push transition (in Premiere) to combine the clips into a dynamic segment:

1. Import the clips you want to use and move them into the Construction window. We're using only four clips in this example, but you can use as many as you like. Here, the clips are each about three seconds long, and the overlap between each pair of clips is one second:

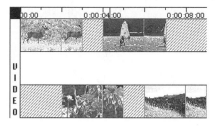

2. Add a Push transition between clips 1 and 2. By default, it pushes from left to right.

3. Add another Push transition between clips 2 and 3. Double-click on the effect to set the track selector and the edge direction as shown here:

This makes the clip in track A push up from the bottom.

4. Add a third Push transition between clips 3 and 4. Set the track selector and edge direction so that the transition is from track A to track B, and the push happens from right to left:

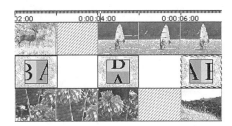

5. Preview the work area. The new clips should come in from different sides (left, bottom, and then right).

There are a number of other combinations of transitions that work well together:

- A succession of revealing transitions such as Barn Door, Iris, and Split (the combination draws the viewer's eye farther into the segment)

- A succession of Radial Wipes, with each one starting at a different corner in a rotating pattern

- A succession of Clock Wipes

- Matching Spin Away effects

Making Incomplete Transitions

So far, we've been using special effects to perform complete transitions; that is, the transition starts with the video in one track and ends with the video in the other track. But by changing the parameters of a special effect, you can perform incomplete transitions (i.e., start with the clip in track A, and end with a combination of the clips in tracks A and B).

For example, you can set up a half dissolve to blend two images together, say, a clip of a windsurfer and a clip of a cloud:

1. Import both clips and position them in the Construction window, then place a Cross Dissolve transition between the clips as shown here:

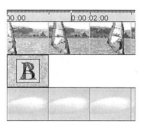

2. Double-click on the effect to call up the Transitions dialog box. Move the slider bar under the End box until it reaches the 66% point. This means that when the effect ends, the screen is made up of 66 percent of clip B and 34 percent of clip A (Figure 5-1).

3. Go back to the Construction window and put another Cross Dissolve transition immediately after the existing one. Set the effect's duration so that it ends with the clips.

4. Double-click on the transition and set both the start and end sliders to 66%. This freezes the transition in that position (Figure 5-2).

5. Preview the work area.

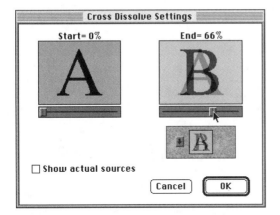

Figure 5-1.

By setting the end position of a transition to a partial value (in this case 66%), you create an incomplete transition. In this example, the transition is a cross dissolve, so the incomplete transition gradually superimposes one video cut on top of another.

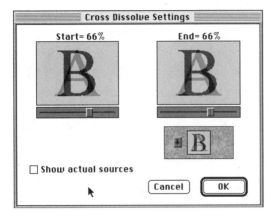

Figure 5-2.

Setting the start and end positions of a transition to the same partial value (66%) freezes the transition. In this example, the incomplete transition superimposes one video cut on top of another.

The preview starts with the image of the windsurfer, then the image of the cloud fades in until both images can be seen, then the combined image of both clips continues to the end.

This is similar to superimposing one clip on top of another, which is described in "Superimposing Images" later in this chapter.

You can also use an incomplete Wipe transition to combine two clips side by side. By stopping the wipe before it's finished, you break the screen into two parts, one part for each clip. The trick is to figure out what you want the combined image, the *split screen*, to look like and then work backward:

1. Import two clips into the Construction window and position them with an overlap, as shown:

2. Open clip 1 and find the position you want to end on for the split screen. The main subject of the clip should be on the left half of the screen. Set this as your Out point.

3. Do the same for the other clip, with the exception that the main subject should be on the right half of the screen.

4. Make a freeze frame of the last frame of clip 1 using the Export Frame as PICT command. Import the freeze frame and place it next to clip 1 in track A. Extend the freeze frame to match the end of clip 2:

5. Place a Wipe transition in the overlap between clip 1 and clip 2. Extend the Wipe so that it covers most but not all of the overlap, as the next illustration shows:

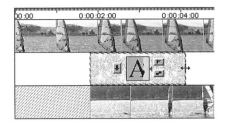

6. Double-click on the transition and set the end position to 50% and the Wipe direction so that the Wipe moves right to left:

7. Place a second Wipe effect in the remaining overlap and set its start and end positions to 50%.

8. Preview the work area.

The preview starts off with just clip 1, then clip 2 should start to wipe in from the right side. As clip 2 continues to move in toward the center, clip 1 freezes. Then the wipe finishes (stops moving) and clip 2 plays to its end (Figure 5-3).

Tip Notice that although this movie contains several events—an incomplete Wipe, a freeze frame, and a frozen Wipe—none of them starts at the same time. The Wipe starts before clip 1 freezes, then the Wipe freezes, then clip 2 ends. By making these events happen at different times, we smooth out the effects. Keep your eyes open for ways to use this technique in other situations where you are combining transitions and edits.

Figure 5-3.

A split-screen is created by performing an incomplete Wipe. The second video clip comes in from the right. The Wipe then freezes when it reaches the middle point.

Working with Filters

Filters alter the video image in the same way a filter works in Adobe Photoshop—it performs a transformation on some or all of the pixels in the image. The difference with video filters is that because the image changes over time, the effect of the filter can change as well.

Most video-editing programs allow you to use Photoshop filters. We use Premiere as the example in this section, but the techniques described can be used in any of the leading programs, such as VideoFusion.

In Premiere, you apply a filter to a clip by selecting the clip in the Construction window and then choosing the Filters option from the Project menu. Click and drag a filter you want to apply from the Available list on the left side of the dialog box to the Current list on the right side:

To remove a filter, click the filter you want to remove from the Current list, and drag it to the trash can. You can add more than one filter to a clip. For example, you can add several Blur filters to make the clip extra blurry, or you could combine a Sharpen filter with a Color Pass filter.

Premiere offers a bewildering array of filters, too many to go into detail on each one of them here. The best advice is try them all yourself so that you have an idea of what they do (or you can refer to the Premiere manual). Test them on a title, grid, or color bars so that you can clearly see their effects.

The following discussion covers the filter capabilities of Premiere 3.0. A review of the new dynamic filtering capabilities of Premiere 4.0 is covered later in this chapter.

There are two basic types of filters: *static filters*, whose effects remain constant through the course of the entire clip, and *dynamic filters*, whose effects change over time.

Static Filters

There are several static filters you might use fairly regularly to correct for differences in lighting and camera quality:

- **Color Balance:** This filter reduces the intensity of one or more of the three colors that make up the video image. If the image has a greenish cast, you can reduce the tint by moving the green slider to the left. However, this reduces the overall brightness of the image, so you may have to offset the reduction with the Brightness & Contrast filter.

- **Brightness & Contrast:** This is really two filters (brightness and contrast) that work the same way as the brightness/contrast adjustments on your television. These filters are good for increasing the overall intensity of the image.

- **Gamma Correction:** The gamma correction can enhance a picture by changing the brightness levels of the *midtones* (pixels with a medium level of intensity).

Dynamic Filters

With dynamic filters, the image changes over time. There are two types: *constant-effect filters*, in which the image changes over time, but the level, or amount, of the effect remains constant; and *progressive-effect filters* in which you can increase or decrease the level of the filter's effect over the course of the clip.

Constant-Effect Filters Constant-effect filters distort the image based on a transformation that varies over time. The transformation is usually based on a mathematical formula, such as a sine wave. Examples include Bend, Wave, and Ripple.

Progressive-Effect Filters With progressive filters, you can vary the level of the effect over the course of the clip. This allows you, for instance, to apply the filter at the beginning of the clip and gradually reduce its level, so that by the end of the clip, the filter effect is gone. Premiere offers two different progressive-effect filters:

- **Mosaic Filter:** This progressive filter segments the image into a number of squares and then averages the colors and intensities of the pixels within each square. You set the number of squares for the beginning and the end of the clip, and the program makes a gradual transition between the two:

- **Mesh Filter:** This is a powerful progressive filter that allows you to distort an image in an almost infinite number of ways. Upon selecting this filter, the beginning and ending frames of the clip are shown with grids laid over them, as shown in the top boxes in Figure 5-4. By moving the points of the grids on the upper boxes, you distort the image. The effect of the distortions is shown in the bottom boxes in Figure 5-4.

 The distortion gradually changes from the beginning setting to the end setting over the course of the clip:

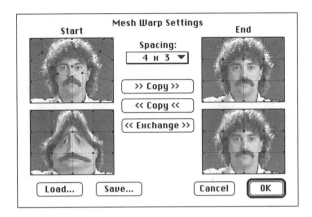

Figure 5-4. The Mesh filter allows you to stretch and contort a video cut over time. By moving the small white squares, called *handles*, on the start or end frames, you create a gradual transition between the two settings.

Making Your Own Progressive Filters

It is often useful to fade in or fade out a filter. You can start a clip with the filter applied and gradually fade it out. The reason for this technique is that it can be difficult to interpret a video clip when some of the more exotic filters are applied. By applying the filter at the beginning and then fading it out, you get to add an artistic touch to the clip yet still allow the viewer to understand the clip as more than an abstract art form.

With progressive filters, you already have the capability to increase or decrease the intensity of the filter. By combining the Cross Dissolve special effect with a static filter, you can create an interesting effect similar to a progressive filter.

There are two different methods: *simple dissolve* and *incremental progression.*

Simple Dissolve

Let's say you want to apply the Blur More filter to the beginning of a video clip of a windsurfer and then gradually fade the effect out so that at the end, the clip is seen clearly. Here's how you do it:

1. Place the video clip of the windsurfer in video track A.

2. Make a copy of the clip, put the copy in video track B, and align it with the original clip in track A:

3. Apply three Blur More filters to the clip in track A.

4. Place a Cross Dissolve special effect between the clips in tracks A and B.

5. Set the work area to include both clips and preview the work area.

At the beginning, the clip appears blurry and then becomes gradually clearer over the course of the clip:

This technique works for some of the less complex filters (such as Blur, Color Balance, and Black & White). For more complex filters (such as Crystallize or Pointilize), it is sometimes better to change the filter's effect over a freeze frame of the first or last frame of the

video clip. That way, the image isn't moving while the filter effect is changing.

For example, you could make a freeze frame of the first frame of a video clip of a windsurfer (using the Export Frame as PICT command). Import the freeze frame back into Premiere. Place it in video track A, and make an aligned copy in track B. Repeat the steps described earlier for the Blur More dissolve effect, using the one Crystallize filter instead. Then put the video clip of the windsurfer after the freeze frame in track A. The end result: the crystallizing effect fades away, revealing the still image of the windsurfer, which then moves.

Incremental Progression

If you want to change the effect of a complex filter while the video clip is playing, then you need to change the effect of the filter in small, incremental steps. This is similar to the way animators represent motion by breaking up a movement into separate steps. In this case, you are adding or taking away a filter in small steps.

Let's say you want to apply the Spherize filter to a video clip of a person's face, then gradually fade the effect out:

1. Import the video clip, and place it at the beginning of track A.

2. Put an aligned copy of the freeze frame in track B.

3. Set the time ruler to one second.

4. Use the razor blade icon to split the clip in track A. In this example, we split it at the one-second point on the timeline. This creates two new clips, one that lasts for one second, another that is three seconds long:

5. Apply the Spherize filter to the first clip in track A. Set the Spherize amount to 100 in the dialog box shown next:

6. Use the razor blade icon to split the clip in track B at the two-second point on the timeline.

7. Apply the Spherize filter to the first clip in track B. Use a setting of 75 for this clip.

8. Add a Cross Dissolve special effect between the first clips in tracks A and B:

9. Repeat these steps for the second clips in tracks A and B, reducing the amount of the filter by 25 each time and inserting a Cross Dissolve effect between the clips. The track selectors for the effects should be set so that the tracks alternate: track A, track B, track A, etc.

Note When you are combining filters with transitions, the preview doesn't usually provide a good representation of what the final movie looks like, so you should go ahead and make a movie.

The movie starts with a rather strange face, then gradually transforms into a normal-looking face (Figure 5-5).

You can make the change more gradual by increasing the number of steps. Here we used four one-second steps, but we also could have used eight steps, each 15 frames long. Of course, this means twice as much work.

Tip If you try this technique on your own material, you might notice that the rate of filter fading is a bit uneven. You can smooth out the fading by clipping out four frames before and after the points of the original edits: 1:00, 2:00, and 3:00.

Slide the remaining clips back together. The fade should be much smoother.

Changing Filter Values over Time

One of the more helpful additions in Premiere 4.0 is the capability of changing filters over time. The Filters dialog box includes a Settings area that allows you to vary the intensity of a filter from the start of the clip to the end of the clip. (Figure 5-6)

Figure 5-5.

Progressive filtering with the Spherize filter. The cut starts out with the image of the face looking like it is stretched over a ball. The filter is then gradually removed until the image is unfiltered (looks normal) at the end of the cut.

Figure 5-6. The Filters dialog box in Premiere 4.0 includes a Settings area that allows you to vary the amount of a filter throughout the duration of the clip.

First, click on the Vary check box. Then click on the Start button and set the amount of the filter for the beginning of the clip:

Click the OK button in this dialog box and then click on the End button and set the amount of the filter for the end of the clip:

When you play this clip, the amount of the filter will gradually change from the start value to the end value over the course of the clip.

Some of the new filters provided with Premiere 4.0 have dynamic controls built into them (such as the Mosaic filter). For example, the Camera Blur filter allows you to set the start and end values for the filter:

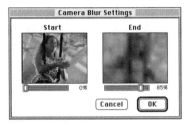

 The Wave dynamic filter cannot be varied over time.

Superimposing Images

In superimposing, you're basically combining one image with another. The superimposed image could be a title and the other a video clip, or it could be two different video clips.

The key step is determining which parts of the superimposed image to use. You do this by making the parts you don't want transparent. It's like making a stencil. You're cutting out the parts of the superimposed image in which you want the main video (in track A and/or B) to show through.

Setting the Transparency

There are a number of different ways to set the transparency. You can specify a particular part of the superimposed image or a particular range of colors.

In Premiere, there are 14 different options for superimposing an image: a None option that lets you specify a particular area of the image as transparent and 13 options, called *keys,* in which you specify the transparency based on a range of colors or intensities or on a particular matte.

We use a video clip of a windsurfer as the main video and a title consisting of the word *Windsurfing* as the superimposed image. The images are imported into the program and placed in the Construction window, as shown in Figure 5-7.

None Option The simplest way to superimpose an image is to use a garbage matte, which sets a particular region in the superimposed clip as transparent. Click once on the image in the superimpose track and then choose the Transparency option under the Clip menu.

In the middle of the dialog box that appears is the Key Type pull-down menu (Figure 5-8). We'll get to other options in a minute. For now, let's just work with the None option.

There are four small squares in the Sample box (upper-right corner). These squares define which parts of the images are transparent.

Click the square in the top-left corner of the Sample box and drag it down until it is just above the word *Windsurfing*. Click and drag the square in the top right until it is level with the square on the left side. Then, click anywhere in the Sample box to make the transparent parts of the image appear black:

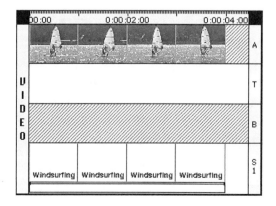

Figure 5-7.

Superimposing a title over a video cut. The title cut is placed in the Super track and lined up with the video cut.

Figure 5-8. Key type choices in Premiere 3.0. Each option lets you set a different portion of the clip as transparent.

This sets the garbage matte that specifies the parts of the image that will be transparent. In this case, only the long, flat rectangle containing the title will be superimposed. The remaining black area will be transparent and will show the clip of the actual windsurfer.

Click the OK button, then set the work area to include just the two clips and preview the work area. The word *Windsurfing* appears against a white background:

Notice that at the bottom of the superimposed clip in the Construction window is a thin horizontal line. This is the fade control for the superimposed image. If you move the pointer onto the line, it turns into a finger. Click the finger on the line to create a handle, then drag the handle down to fade the image out and up to fade the image in:

This is similar to the way you fade audio in and out.

Preview the work area again. This time the superimposed image fades in, and then after a couple of seconds it fades out (Figure 5-9).

This technique of fading in and out a superimposed image, or *super*, can be used with any of the transparency options.

Chroma Key The Chroma option sets a color or a range of colors in the superimposed image to be transparent.

Using the pull-down Key Type menu in the Transparency dialog box, select the Chroma option. Move the cursor into the Color box. As the next illustration shows, the pointer turns into an eye dropper that you use to pick the color you want to be transparent:

Figure 5-9.

Fading a superimposed title in and out.

Because we want to use white as the transparent color, click any-where in the white areas of the image in the Color box (white is the default color, so you don't actually have to use the eye dropper in this case). Then click anywhere in the Sample box to see the regions of transparency:

 Make sure the squares for the garbage matte are in their initial positions (one at each corner).

Click OK and preview the work area. This time, only the letters of the word *Windsurfing* are superimposed, along with some spaces around the letters:

It would be nice to just have the letters superimposed and not the spaces between them. Open the Transparency dialog box. Under the Key Type menu, there is the Similarity slider bar. This sets how broad a range of colors you want to be transparent. A None, or zero, similarity means that only the color selected with the eye dropper is transparent. A medium similarity means that colors similar to the selected color are transparent.

Move the Similarity slider to the right, and notice what happens in the Sample box (make sure the transparent areas appear black). As you move the slider farther to the right, less and less of the space between the letters is visible, which means they will be transparent in the assembled movie (Figure 5-10).

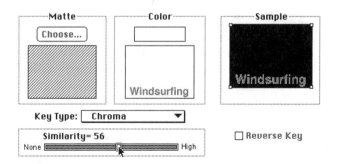

Figure 5-10. Setting the similarity for a Chroma key. Increasing the similarity expands the range of colors in the superimposed image (in this case the title) that is set as transparent.

Click OK, and preview the work area. Now only the letters appear:

Let's look at another example that demonstrates the features of the Chroma key in greater detail. Instead of a title on a white background, use a video clip of a person standing against a blue background.

Open the Transparency dialog box and use the eye dropper to select the blue background as the transparency color (the key). Adjust the similarity setting until just the person appears in the Sample window. You might also want to adjust the position of the Blend slider to smooth any rough edges (Figure 5-11).

Preview the work area. You should see the image of the person appearing in front of the windsurfer (Figure 5-12).

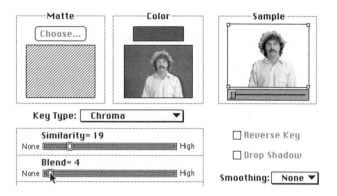

Figure 5-11. The Blend slider smoothes out abrupt changes in color. Increasing the blend amount helps remove rough edges around superimposed objects.

Figure 5-12.

Person superimposed over a video clip using a Chroma key. The person was shot against a blue screen, which was then made transparent using a Chroma key. The timing of the superimposed image was set so that the person appears to turn his head to follow the windsurfer.

This technique, called *blue screening*, is used extensively in television, for example, to project an image of a weather map behind a weather forecaster. The person is actually standing in front of, and pointing at, a blank, blue screen. The weather maps are then added to the image electronically. A particular color, *chroma blue*, is used for the screen because human skin does not contain that shade of blue. The person, however, should not wear a blue shirt; otherwise, the weather map (or whatever the video clip is) will appear through his or her shirt.

RGB Key This key sets a range of colors and intensities (brightnesses) to be transparent. It is a bit more specific than the Chroma key, which does not take into account how bright a color is, only its hue.

Luminance Key The Luminance key sets a range of intensities (brightnesses) to be transparent. You can use this key to add texture to the main video clip.

Alpha Channel This is a useful key when working with graphics produced from a graphics program that creates an *Alpha channel* for the graphic (such as Adobe Photoshop). An Alpha channel is a custom mask that matches the contours of the graphic.

Let's use another title on a white background to demonstrate this key. With the Alpha Channel key, the sliders for Similarity and Blend are disabled. That's because the Alpha channel matches the borders of the title, so no adjustment is needed:

The Alpha Channel key also lets you reverse the transparency, making the title itself transparent:

Now the main video, the windsurfer, shows through the letters of the title:

White Matte This matte is used when you've created a graphic against a white background. It removes the halo that often appears because of anti-aliasing. This is a standard key type used when working with titles built in the Premiere Titling window.

> **Note** Anti-aliasing is a standard technique for smoothing the jagged lines produced by a pixel display (such as a computer monitor). It works by blending the pixels next to a jagged line with the background. Unfortunately, the blended pixels cause problems when setting a transparent color, hence the value of the Black Matte option.

Black Matte This matte is similar to the White Matte except that it is used for graphics set against a black background (with anti-aliasing).

Image Matte This matte specifies a certain part of the superimposed image as transparent. That part could be a letter or an abstract shape. It's like a cookie cutter that cuts out a part of the superimposed image and plays the main video through that part. You can also reverse

the transparency so that the cut-out part of the superimposed image is laid over the main video.

Difference Matte The Difference Matte selects the difference between the superimposed image and another clip. For example, if you have a shot of a person standing in front of a background and a separate shot of the background without the person, then the Difference Matte selects just the image of the person and superimposes it over the main video.

 Premiere 3.0 and 4.0 offer a number of other key types that are discussed in Chapter 10.

Superimpose Controls

You can modify the superimposed transparency in a number of ways. The Similarity and Blend controls have already been discussed. You can use the Threshold and Cutoff sliders to increase or decrease the presence of shadows in the superimposed image (available only on the Luminance and Chroma keys).

The Reverse check box allows you to make the transparent portions of the superimposed image nontransparent, and vice-versa. This option is available only for the None, Alpha Channel, Image Matte, and Difference Matte key options.

The Drop Shadow check box allows you to add a drop shadow to the superimposed image. This is available only for the RGB and Difference key options.

The Smoothing pull-down menu lets you reduce rough edges in the transparent areas by averaging the pixels along the edges. This is useful when attempting to blue screen a person into a background.

Moving an Image around the Screen

One of the more interesting features in Premiere is the ability to move, or fly, a clip around the QuickTime window. You can move the entire clip in any direction: left, right, up, down, toward the viewer, or away from the viewer. A quick example should make this feature clearer.

Select a clip in the Construction window, then choose the Motion option from the Clip menu to call up the Motion Settings dialog box (Figure 5-13).

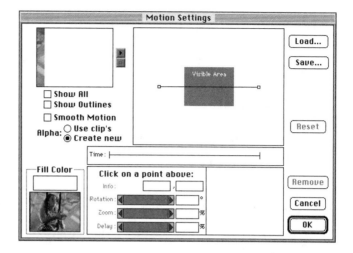

Figure 5-13. The Motion Settings dialog box. The Motion feature allows you to move a video cut around the QuickTime window. You can also increase or decrease the size of the image, as well as distort it.

The two small squares, called *handles*, on either side of the large box set the position of the clip image at the start and end of the clip. In a sense, they set the clip's trajectory through the QuickTime window. Move the left handle, the start handle, and drag it to the top-left corner of the box. Then drag the end handle (on the right) to the bottom-right corner:

This sets a diagonal trajectory for the clip. Click OK and preview the clip. The clip image starts in the upper-left corner, then slides across the window down to the lower-right corner:

The video in the clip image continues to play as the image moves across the screen.

There are two basic ways you can use the Motion command to move a clip around the window: two-dimensional (2-D) moves and three-dimensional (3-D) moves.

Creating 2-D Moves

In 2-D moves, the clip can be slid in any direction along the plane of the screen. It's like sliding a piece of paper on a desk. The difference is that the video clip keeps playing regardless of where you move it. The diagonal move we discussed earlier is an example of a 2-D move.

Two-dimensional moves are great for moving a superimposed title across a video clip. For example, let's say we want to slide the word *Windsurfing* across the bottom of a video clip of a windsurfer. Here's how it is done:

1. Import the windsurfer video clip and the Windsurfing title and place them in the Construction window, as shown:

2. Click on the title clip, choose the Transparency option from the Clip menu, and set the key type to Alpha Channel (if the title graphic has an Alpha channel), White Matte, or Black Matte.

3. Back in the Construction window, click on the title clip to select it (if it isn't already selected), and choose the Motion option from the Clip menu.

4. Drag the start handle so that the title clip appears just to the left of the bottom-left corner of the Sample window. Then drag the end handle so that it is at the same height as the start handle but just past the right edge of the window:

5. Preview the work area.

As the next illustration shows, the title moves across the screen from left to right as the video clip plays:

To make the title move from right to left, simply reverse the positions of the start and end handles in the Motion Settings dialog box.

The previous example uses a straight trajectory, but you can create any trajectory you want. By clicking on the middle of the line between the start and end handles, you create a new handle, which you can move to any point:

The clip then follows the trajectory you laid out:

You should try to make the movement of the title match the action in the clip, unless you want to achieve a random effect.

On the left side of the Motion Settings dialog box are several controls that let you manipulate the moving clip in a number of ways:

- **Rotate** allows you to rotate any point in the trajectory a certain number of degrees. The program automatically figures the correct amount of rotation for each frame. This feature allows you to spin a clip in the window. For example, setting the start handle with –90°, a middle handle with 0°, and the end handle with 90° looks like this:

- **Delay** lets you add a pause anywhere in the trajectory. In the previous example, you could have the title pause in the middle of the trajectory (so you could read it better) by adding a delay to the middle point.

- **Zoom** lets you enlarge or shrink an image. This is used to create 3-D moves, which are described in the next section.

- **Distortion** allows you to contort the clip at any point along the trajectory. Use the four handles to create a new shape (this can also be used to create 3-D moves; see the next section).

 You can save a trajectory for use with another clip by choosing the Save option on the upper-right part of the Motion Settings dialog box. All the points of a trajectory and their attributes (rotate, delay, speed, zoom, etc.) are then saved in a library. Maintaining a library of favorite moves can save you a lot of time, particularly for complicated trajectories.

The Motion Settings dialog box contains a number of other controls and parameters that affect the appearance and motion of the clip:

- **Show Source** displays the actual, moving clip in the dialog box.

- **Show Outlines** displays an outline for each point on the trajectory.

- **Smooth Motion** smoothes the trajectory, rounding any abrupt turns or changes in direction.

- **Transparent Fill** creates a transparent fill around the clip when you superimpose a video clip (as opposed to a title). Use Alpha Channel for the key type.

- **Fill Color** lets you specify the background for the moving clip.

All the techniques just described work with video clips as well as titles. You can move a video clip against a solid-color background (using the Fill Color option). In combination with the Superimpose command, you can move a video clip across another video clip. The possibilities are endless.

Premiere 4.0 provides a feature, called *subpixel positioning*, that lets you set the positions of clips precisely. By typing fractions into vertical and horizontal boxes, you can specify exactly where you want a clip to appear:

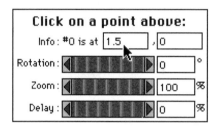

Creating 3-D Moves

With 3-D moves, you can zoom the clip toward or away from the viewer. You can also flip and spin the clip (with 3-D perspective) using the distortion feature.

Zooming a Clip You can set the size of a clip at any point along a trajectory. This lets you make it seem as if the clip is zooming toward or away from the viewer.

Let's use the earlier example of a title flying over the clip of a windsurfer to show how this works. We start with the title coming in from the left side, rising to the top-middle part of the screen, then descending and leaving the window on the right side:

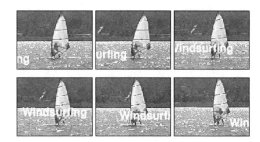

We decrease the size of the start and end handles to make the title zoom in, then zoom out:

1. Click on the start handle to make it active.
2. Click on the Zoom button, and choose 25% from the pop-up menu.
3. Click on the end handle to make it active.
4. Set the Zoom button to 25%.

The title zooms in as it rises from the lower left to the top middle, then zooms out as it descends to the right edge:

You can combine zooms with 2-D moves to create your own custom special effects for transitions. Here's one example that zooms in a video clip in a spiral pattern until it fills the window (a kind of zoom/spiral transition):

1. Put the first clip in video track A and the second clip in the superimpose track.
2. Cut the second clip into two parts with the razor blade tool. The first part of clip 2 should be the same length as clip 1.

3. Set the transparency of the second clip to Alpha Channel.

4. Choose the Motion command, and set a spiral trajectory for the second clip:

5. Set an increasing Zoom value for each point in the trajectory, starting at 10% and ending at 100%.

6. Save the trajectory and name it **Zoom/Spiral Trajectory**.

7. Preview the work area.

The second clip zooms in from the right side in a spiral pattern and then fills the screen:

You should try to make the direction of the trajectory match the action in the video clip. In this case, the windsurfer is moving left to right, as does the second half of the trajectory.

To do this type of transition in the traditional video world requires an expensive device called a DVE—an impressive-sounding acronym. All it means, however, is Digital Video Effects, which is what you're doing on your Macintosh.

Distortion The distortion feature lets you twist and turn an image at any point in a trajectory. That can be interesting in and of itself. But if you plan a set of distortions that shows the image in perspective, you can rotate the image in three dimensions. We use the two windsurfing clips from the previous example to demonstrate the technique:

1. Open the Motion Settings dialog box and load the Zoom/Spiral Trajectory if it isn't already loaded.
2. Click on the start handle.
3. Use the handles in the Distortion box to flip the clip horizontally (left to right).
4. Press the ⌈Tab⌉ key to select the second point in the trajectory.
5. Use the handles in the Distortion box to flip the clip with a bit of perspective:

6. Continue with steps 4 and 5 for the rest of the points in the trajectory, setting the distortion as shown in the previous illustration.
7. Save the trajectory.
8. Make a movie of the work area (so you can see the effect clearly). The second video clip should rotate one turn while it zooms in following a spiral path (Figure 5-14).

If you aren't happy with the trajectory, go back into the Motion Settings dialog box and change the point that seems out of place. You can step through the points on the trajectory with ⌈Tab⌉. If you thoroughly distort the clip beyond recognition, you can click the Reset button to remove all zoom, rotate, and distortion adjustments.

Figure 5-14.

Making a custom transition with the Motion feature. A second cut is zoomed in and rotated until it fills the window.

 You should try to make the rotation match the action in the video clip. The thing to watch for is the most visible edge. In this case, it is the right edge of clip 2, which is moving left to right, matching the movement of the windsurfer.

This type of complicated move usually works best for clips lasting at least four seconds. With a shorter clip, there might not be enough frames of video between each point in the trajectory to produce a smooth motion.

The examples described in this section are just the tip of the iceberg. Watch any sports program on television, and you'll see a bunch of 2-D and 3-D moves. Try to note where the effect starts and ends and the rotations or distortions involved. Then, try to recreate that effect on your Macintosh. Remember to save your trajectories in stages (spiral, spiral with zoom, spiral with zoom and rotate). That way, you have several different trajectories to choose from.

Static Resizing

Another use of the Zoom feature is to change the size of a clip without zooming in or out. For example, you could make a clip one-fourth the

size of the window, so you could put several clips on one screen. Here's how you do it:

1. In the Motion dialog box, set the zoom value of the start handle to 50%.
2. Move the start handle to the upper-right corner of the screen.
3. Set the delay to 100%. This makes the motion stick on the start point and ignore the end point.
4. Save the trajectory.

The clip appears in the upper-right corner of the screen:

You can add another quarter-size clip to the upper-left corner, putting another clip in the superimpose track. Use an Alpha Channel key and check the Transparent Fill check box in the Motion dialog box. Move the start and end handles to the upper-left corner, and set their zoom values to 50%. The two clips now appear side-by-side:

To add more clips, you need to make a movie, then use that movie as a clip in another movie. This technique, called *compositing*, is discussed in Chapter 10.

Slowing Down (or Speeding Up) a Clip

Sometimes you need a clip to be just a little bit longer to match a piece of music or a particular special effect. With the Speed option under the clip menu, you can slow the rate at which the clip plays so that is lasts longer. For example, if you set the speed of a two-second clip to 0.5, the modified clip lasts four seconds. You can also speed up a clip by setting a speed value greater than 1.0. A value of 2 makes the clip play twice as fast.

 The frame rate isn't really changed when you change the speed. The program creates a virtual clip based on the new speed value, then selects the appropriate frame from the original clip for each frame of the speed-adjusted clip. This can produce uneven motion if you slow down or speed up the clip using irregular values (i.e., 0.27 or 1.6). Regular values form common fractions or integers, so 0.25 is equal to $^{1}/_{4}$, which means each frame is used four times. At speed value 3, every third frame is used.

Wrap-Up

The techniques described in this chapter have barely scratched the surface of what is possible. We didn't even discuss how you can use separate effects from different programs (such as Premiere, VideoFusion, and Morph) on the same piece of video. And we covered only briefly the extremely powerful technique of rotoscoping.

It's all too easy, however, to get seduced by all the digital gadgetry and effects and lose sight of the main goal—delivering a message. The effects you use should work with, not against, the message of your piece. Don't just throw in one effect after another. Have a reason. Your piece will not only look better, but it may also affect your viewers more deeply and memorably.

PART II

INTO THE CUTTING ROOM

There are two parts to editing: the physical task of putting separate cuts of video together and the conceptual task of conveying a scene or an idea. Part I of this book dealt with the physical means of stringing several cuts into a video segment. This part of the book uses those same skills to explain the larger task of using images to express ideas and tell stories. Chapter 6 discusses the language of film and television. Chapters 7, 8, and 9 lead you through the processes of weaving a visual story and creating montages. Chapter 10 shows you how to add spark to your productions with advanced special effects.

The Grammar of Visual Storytelling

L earning to edit is not unlike learning to play hockey. First, you have to learn how to skate, then you can start learning how to play the game. Likewise, you need to get comfortable with the basic steps of editing before you can begin to work on the conceptual level of telling stories.

Three Styles of Editing

All the various types of video segments fall into one of three categories: those created with *continuity editing*; those with *montage editing*; and those produced with a mixture of techniques, loosely called *mixed format editing*. Continuity editing is used to tell visual stories, but montage editing involves the use of a collection of images to convey an emotion or idea. Mixed-format editing borrows techniques from both montage and continuity styles to convey ideas and stories.

In continuity editing, the emphasis is on telling a story that contains characters and action. There is usually a clear sense of progression—a beginning, middle, and end. The story develops through the interactions of the characters with their surroundings and each other.

As the editor, you are trying to create a reality that the audience will believe; so, special care must be taken to present scenes so that they are understandable and seem normal to the viewer. There are plenty of examples of continuity editing. In fact, most of the editing you see in feature films, television movies, and sitcoms is of this type because these presentations are telling a story.

In montage editing, the emphasis is on conveying an idea or concept. The images are chosen for their conceptual and emotional value, not for the way they convey a scene. There generally isn't a plot, dialog, or a storyline, although a well-edited montage builds several ideas into a larger concept.

Montage editing is the easiest kind of editing to do because you are not constrained to assemble shots into a scene, as you are in continuity editing. Any one shot can go before or after any other. But montage is the hardest type of editing to do well, because you don't have the structure provided by a storyline. You are dealing only in concepts.

Examples of montage editing are found in impressionistic television commercials and music videos and some sports segments. The appeal of montages is that they operate on an emotional level, not an intellectual one. They can also present an idea quickly. The disadvantage is that the idea can't be too complex or elaborate and still reach a large percentage of the audience.

Mixed-format editing is like montage editing in that the basic goal is to convey ideas; there's no attempt to fabricate a reality. But a mixed-format piece is less impressionistic than a montage. It can often include dialog and/or descriptive narration. Elements of a story can be included (without distinct continuity). Examples of mixed-format pieces are political commercials, most product commercials and music videos, and informational videos.

You already edited in the montage style when you edited the examples in Chapters 3 and 4 (although if you look back you see that the cuts weren't linked by any concept); so in a sense, you know the basics. A more involved discussion of montage and mixed-format editing is given in Chapter 9 after we cover the basics of continuity editing.

Continuity Editing—Fabricating Reality

The central goal of continuity editing is to create an artificial world in which your story takes place. This world is artificial because you, the

editor, decide how the world is put together. You can have someone drive from one part of a town to another in seconds (even though in reality the locations are separated by 20 miles). You can slow down and speed up time. You can rearrange the order of cuts and completely change the meaning of a scene. You can create a scene where two people are talking to each other by telephone, yet in reality, they are in the same room. You can combine elements of the real world with animation and still make it believable.

Sound like fun? It is. But there's a catch. You have to make this world believable to the viewers. If the viewers don't buy the world you've fabricated, or they become lost and confused, then you've wasted your time (and probably a lot of money).

The easiest way to make sure your world is believable to make it exactly match reality—one to one. That is, in fact, how the first filmmakers operated.

The first silent films were made by simply placing a camera at an event and then rolling the film. The camera captured the action from one perspective in its entirety (or until the film ran out). The film was a verbatim recording of the event from the viewpoint of an onlooker.

Then, around the turn of the century, a new form of film emerged that showed reality, not as it was but as the director-editor wanted to portray it. *The Great Train Robbery* (1903) by Edwin Porter was one of the first films to connect seemingly dissimilar shots into a unified story. Porter combined three scenes: a band of robbers riding away on their horses, a bound-and-gagged telegraph operator, and a group of townspeople swarming to form a posse. Without sound (these were still the days of silent films), Porter conveyed the drama and excitement of the story—a story that existed nowhere but in the final film.

D. W. Griffith took this new editing technique a step further in his film *The Birth of a Nation* (1915), which used different camera angles of the same scene (in essence, different perspectives) to heighten the drama of Lincoln's assassination. By interweaving these different perspectives, Griffith was able to manipulate time to increase the tension of the scene.

These landmark films and those that have followed in that tradition (i.e., most films and television programs) present a new reality—one created by the combination of individual, dissimilar images, a reality that is unlike anything else in the real world.

The real world around us is continuous; that is, there are no abrupt changes. Events proceed smoothly in time; people don't suddenly

appear and disappear. But in the reality of film or video, the viewers are confronted with abrupt changes at every edit. The reason this style of presentation works at all is that the human brain is capable of looking past the edits (if they're done correctly) and assembling the individual cuts into a larger story.

The goal of continuity editing, therefore, is to add continuity to these discontinuous images so that the viewers can create the story in their heads. Many times, the images themselves don't tell the whole story, so the viewer fills in the gaps with his or her own experiences and knowledge of the world.

Taking Apart an Edited Scene— Car and Driver

Let's go back to one of the examples mentioned in Chapter 1 to see how a series of shots can tell a story. The scene of the man driving up to the house involved three shots:

Shot 1: Car driving up (five seconds)

Shot 2: Car door closing (three seconds)

Shot 3: Close-up of a man's finger pressing the button of the door-bell (three seconds)

When a viewer watches this scene, he or she subconsciously fills in the parts not shown (the driver turning off the ignition, opening the car door, walking up the front walk) to complete the story. Figure 6-1 shows how the real situation is compressed in the edited segment and then recreated when the viewer watches the video.

If these shots were edited in a different order—for example, the car driving up, the doorbell being pushed, then the car door closing—a different story would be told. (If the driver is already out of the car, who closed the door?) The images are the same, but the viewer fills in the gaps with other information to make sense of the shots (i.e., there was someone hiding in the back seat).

So it's not just the information in the images but their placement within a scene that creates the story. One of the most useful means for keeping the viewer in tune with your story is providing a sense of progression with the shots.

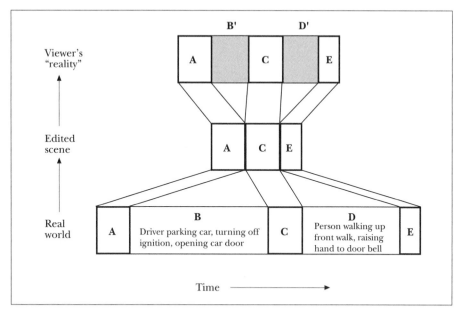

Figure 6-1. Editing condenses a scene down to its key parts. As viewers watch the edited scene, they recreate the story in their minds.

Taking Apart an Edited Scene 2— Baseball Game

The baseball game example discussed in Chapter 1 also illustrates the use of progression, so we take another look at it here.

In this example, time is compressed in the beginning of the scene, but because the action is boring (the pitcher walking around the mound), there isn't much for the viewer to fill in. Still, each shot moves the story along so that the viewer doesn't get bored. Figure 6-2 shows the camera positions for this scene, and Figure 6-3 shows the view from each camera:

Shot 1 (camera 2): Pitcher gets the ball back from the catcher.

Shot 2 (camera 1): Batter kicks the dirt off his shoes.

Shot 3 (camera 3): First baseman yells encouragement to the pitcher.

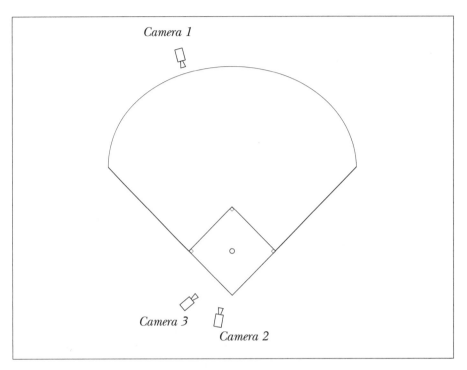

Figure 6-2. Camera layout for baseball example

Shot 4 (camera 2): Pitcher raises his arms over his head to start his windup.

Now, several different perspectives of the same event (the pitch and hit) are combined to slow the action down. Even though the shots don't actually follow the real sequence (see Figure 6-4), their placement in the edited scene shows a sense of progress:

Shot 5 (camera 1-A): The batter wiggles his bat waiting for the pitch.

Shot 6 (camera 2-A): The pitcher continues his windup.

Shot 7 (camera 3-A): The first baseman crouches down ready to field a ball hit his way.

Shot 8 (camera 1-B): The batter steadies his bat.

Shot 9 (camera 2-B): The pitcher completes his windup and throws the ball.

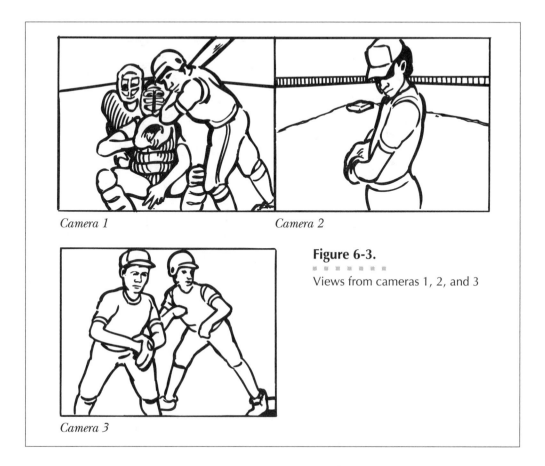

Camera 1 Camera 2

Camera 3

Figure 6-3.

Views from cameras 1, 2, and 3

Shot 10 (camera 3-B): Close shot shows the tense expression on the first baseman's face.

Shot 11 (camera 1-C): Batter swings and hits the ball.

Shot 12 (camera 2-C): Pitcher's head turns as the ball flies toward first base.

Shot 13 (camera 3-C): First baseman leaps up and catches the ball.

Compare the editing diagram of the second part of this scene (Figure 6-4) with the one for the man and car scene (Figure 6-1). In this case, several simultaneous perspectives are interwoven, or *intercut*, to produce the story.

There are several things to note in this baseball scene. Some of the shots could be deleted without ruining the story (e.g., shots 10 and 12);

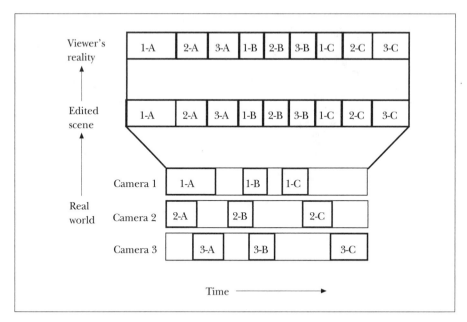

Figure 6-4. By intercutting among three views of the same scene, the editor can expand time and increase the drama of a scene.

they merely increase the tension. Other shots could be moved into a different place (e.g., swap shots 9 and 10). The overall effect would not be all that great. These are subjective choices that each editor makes.

Another thing to notice is that the scene depends on the viewer understanding the basic layout of a baseball diamond and the respective positions of the pitcher, batter, and first baseman. If you were editing this scene for people who didn't know baseball, you would need to add a full shot of the infield to establish the scene, then show a similar example of a pitch so that the viewer understands the climax.

Creating Continuity with One Camera

Few people can afford the luxury of using several cameras to shoot a scene. The common alternative is to shoot a scene several times (several *takes*) from different camera angles. However, this introduces the problem of matching the motions or positions of people from one take to the other.

Continuity of Position

Figure 6-5 shows the layout for a scene of a man and a woman talking at a table. There are five basic shots that can be taken from the three camera positions:

Camera Position 1:
A full shot that establishes the scene (Figure 6-6a)

Camera Position 2:
A medium shot of the man showing a bit of the woman's shoulder (Figure 6-6b)
A close-up of the man (Figure 6-6c)

Camera Position 3:
A medium shot of the woman showing a bit of the man's shoulder (Figure 6-6d)
A close-up of the woman (Figure 6-6e)

Figure 6-7 shows how four of these shots might be edited together to form a scene:

Shot 1 (camera 1): Full shot of man talking and woman listening

Shot 2 (camera 2): Medium shot of man talking

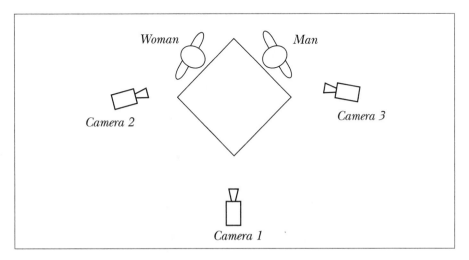

Figure 6-5. Camera layout for conversation example

(a)

(b)

(c)

(d)

(e)

Figure 6-6.

Five shots can be taken from three camera positions: (a) two-shot of man and woman from camera 1, (b) medium shot of man from camera 2 (this shot often includes a portion of the person in the foreground, in this case, the woman), (c) close-up of man from camera 2, (d) medium shot of woman from camera 3, and (e) close-up of woman from camera 3.

Figure 6-7.

The edited scene for the man and woman conversation starts with a two-shot to establish the scene. With shots 2 and 3, the editor moves the viewer closer to the action. Shot 4 shows the man's reaction to the woman's comments.

Shot 3 (camera 3): Close-up of woman listening and then talking

Shot 4 (camera 2): Close-up of man's reaction

In the baseball scene, you were always *cutting*, or editing, from one person to a different person (i.e., pitcher to batter). In this case, you are cutting between different shots of the same person; for example, the man is seen in both shot 1 and shot 2 but from different angles.

For this edit to work, for the viewer to accept it and not get confused or distracted, the man must be in about the same position; that is, there has to be continuity of position. If he is resting his arm on the table in shot 1, then shot 2 must show the same thing.

If instead, he has raised his hand to his chin in shot 2 (Figure 6-8a), then when the shots are edited together, the man's hand jumps from the table to his chin (Figure 6-8b). This type of edit, called a *jump cut*, distracts the viewer and should be avoided in continuity editing.

The best way to avoid jump cuts is to choose shots where the position of the main character doesn't change. The positions of secondary characters don't matter (the position of the woman's shoulder in shots 1 and 2 isn't particularly important because she isn't the center of attention).

Note

In continuity editing, the editor is dependent on the director getting the right footage (having enough different angles, making sure people are in the same positions in different shots, etc.). If you are acting as your own director, you'll have the good fortune of suffering with all your directing mistakes as you try to edit your footage. I say "good fortune" because that's the fastest way to become a better director.

Figure 6-8. Maintain continuity of position by avoiding jump cut: (a) man changing his position by placing his hand on his chin and (b) jump cut caused by a change in the man's position.

There are a few general rules regarding which kinds of shots can be edited together. These rules have as much to do with how shots are directed as how they are edited. Here are two of the main ones.

You shouldn't cut from one shot of a person talking to a shot of the same person from the same camera position and framing (focal length). This is invariably a jump cut (people never remain in exactly the same position). This is why it's important to shoot the scene from different angles. If the shot changes enough (different angle, background, etc.), the viewer won't notice subtle differences in a person's position.

Another jump cut occurs if you cut from a medium shot of a person directly to a close-up of the person taken from the same camera angle. Although this type of cut is done often in television news pieces, you should try to avoid it. Television camerapersons are under tremendous time pressures and sometimes don't have the option of shooting several takes from different angles. If you want to use a medium and close-up from the same angle, insert a shot of the same person from a different angle between the two shots.

You can cut from a long shot of a person talking to a close-up shot of him or her. The framing is different enough that the slight jump of the person's head position between the shots won't be noticed.

Continuity of Motion

When people move during a shot, maintaining continuity is a bit more difficult. However, this doesn't mean you should avoid having your characters move—far from it; video loves motion. It's one of the things this medium does better than any other. And it turns out you can use the motion to your advantage when editing.

Let's change the scene with the man and woman to introduce some action. This time, after the woman is talking for a while, the man gets up and gestures (Figure 6-9). One way of editing this scene is shown in Figure 6-10:

Shot 1 (camera 1): Full shot of man talking and woman listening

Shot 2 (camera 2): Medium shot of man talking

Shot 3 (camera 3): Close-up of woman listening and then talking

Shot 4 (camera 1): Medium shot of man starting to stand up

Shot 5 (camera 2): Close-up shot of man finishing the action and gesturing

The scene includes the additional shot from camera 1 (shot 4) to show the beginning of the man's action. The action is split up and shown in two shots because this makes the edit smoother: The motion attracts the viewer's eye and de-emphasizes the edit (Figure 6-11). In Chapter 7, we'll go into the details of how to match motion between two cuts. The main thing to realize here is that the motion must appear smooth when viewed in the edited scene.

Figure 6-9.

Frames from a medium shot of the man standing up, from camera 2's position

Figure 6-10.

In this edited scene, we cover the man's movement with two shots (4 and 5).

Using Cutaways

The previous two sections discussed how to maintain continuity when the same person is shown from two different angles. If for some reason you can't match a person's position or motion between two shots, then insert a shot of someone or something else to hide the problem.

In the first version of the man and woman scene (Figure 6-7), the shot of the woman (shot 3) comes between two shots of the man (shots 2 and 4). In this case, you wouldn't have to worry if the man moved his hand from the table to his chin. Because of the intervening shot of the woman, the viewer won't remember exactly what the man's position was in shot 2 and won't notice the change. This is a very common way of getting around continuity problems.

Figure 6-11.

Matching the movement of the man in shots 4 and 5 creates a smooth edit because the movement attracts the viewer's eye.

Note We've all seen the shot of a television news reporter listening intently to a person being interviewed. Chances are that shot is being used to hide a jump cut (like 90 percent of the time). The shot of the reporter allows the editor to connect two different quotes, or *sound bites*, and then hide the edit with the cutaway of the reporter. These shots are so useful for editing interviews that it's standard for television producers to shoot a reporter cutaway even if they don't think they'll use it. Sometimes, these cutaways are shot without the person being interviewed even in the room! A production assistant substitutes for the interviewee, and the reporter looks at and listens to the assistant. The reporter can also ask questions of the speaker-assistant. When edited with the interview, the question seems natural (that is, if the reporter is any good at acting, which most of them are).

When there is motion in the scene, and you have continuity problems in matching the motion, you can use the actions of other characters to solve the problem. To go back to the second version of the man and woman scene (Figure 6-10), let's say the woman looked up as the man stood up. This would allow us to edit the scene in the following way:

Shot 1 (camera 1): Medium shot of man talking and woman listening

Shot 2 (camera 2): Medium shot of man talking

Shot 3 (camera 3): Close-up of woman listening; then talking; and after a few seconds, looking up

Shot 4 (camera 2): Medium shot of man finishing the action of standing up

The motion of the woman's eyes and head indicates that the man stood up. This unseen but implied action is completed in shot 4. Because the motion is implied, you can make actions happen faster than they typically would. The trick is to include some part of the motion in the final shot to complete the action.

Continuity of Place

The man-and-woman scene starts off with a full shot showing both characters. This is called an *establishing shot* because it lays out, or establishes, how the characters are positioned in their surroundings and with respect to each other. This helps orient the viewer, which is why most scenes start with an establishing shot.

Once you establish the scene, you then have to stick to that layout. If the man appears on the right side of the screen and the woman on the left, as in Figure 6-6, then they have to appear that way in all the shots for that scene (or until you reestablish the scene). Notice that even though shots 2 through 5 (Figures 6-6b, c, d, and e) were taken from a different angle than shot 1, the man is still on the right and the woman is still on the left.

Defining the Line of Interest

The man and woman stay on the same side of the scene because all the different camera positions lie on the same side of the *line of interest*, an imaginary line running through the central characters in a scene (Figure 6-12). Every scene has a line of interest; once you select a camera position, all other camera positions must lie on the same side of the line. Moving the camera to the other side of the line of interest, *crossing the line*, causes the characters to switch sides (onscreen) and that confuses the viewer. For example, let's say you added another camera position (camera 4 in Figure 6-13). A shot from this angle would show the woman on the right and the man on the left:

If you were to edit this shot together with a shot from camera position 1, the man and woman's positions would suddenly flip.

Staying on the same side of the line of interest is particularly important when there's movement in the scene. Let's say you're editing a scene from a football game (the camera positions are shown in Figure 6-14). Shots from camera 1 show the red team on the right and the blue team on the left (Figure 6-15a) Shots from cameras 2 and 3 show the same orientation, but the shots from camera 4 show their positions reversed (Figure 6-15b).

Now, let's say the red team quarterback heaves a long pass. You start with a shot from camera 1, with the ball traveling from right to left. Then, you cut to a shot from camera 4. Which direction is the ball traveling? From left to right. In shot 1, it was traveling right to left. Besides violating

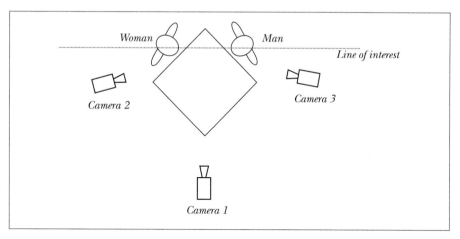

Figure 6-12. The line of interest is an imaginary line that determines the geometry of a scene. Once you've picked a camera position on one side of the line, all other camera positions must be on the same side of the line of interest.

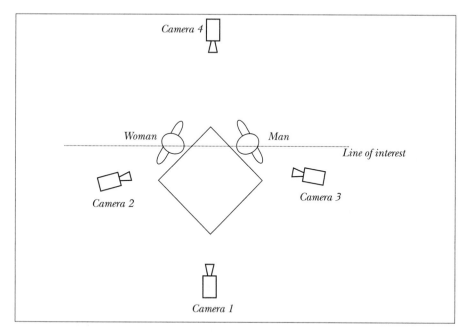

Figure 6-13. Crossing the line with camera 4 confuses the viewer because the man and woman suddenly switch positions on the screen.

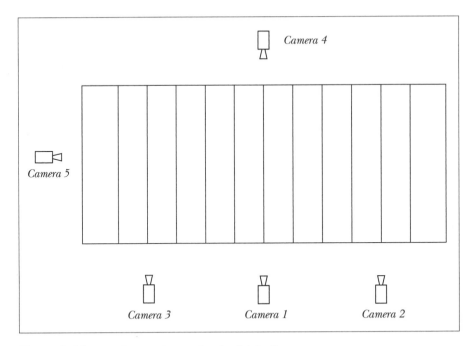

Figure 6-14. Camera layout for the football sequence
■ ■ ■ ■ ■ ■ ■ ■

From left to right. In shot 1, it was traveling right to left. Besides violating the laws of physics, this thoroughly confuses the viewer.

If you happen to watch football games, you've probably noticed the words *reverse angle* **appearing on the screen during replays. Television directors put these words up on the screen to signal that they've crossed the line and that the directions are reversed. The reverse-angle shots are taken with a camera on the opposite side of the field, like the camera in position 4 (Figure 6-15b) in this example.**

Using a Neutral Shot

Fortunately, there is a way to cross the line without confusing the viewer and that is to use a *neutral shot,* a shot that lies right along the line of interest. The shots from camera 5 (Figures 6-14 and 6-15c) are neutral in that the red team and blue team aren't on any particular side (they're on the top and bottom of the screen). This allows you to cut to any of the other cameras and reestablish the scene on the same side

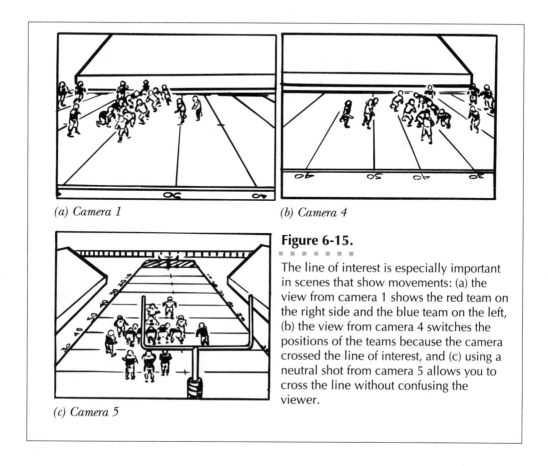

(a) Camera 1

(b) Camera 4

(c) Camera 5

Figure 6-15.

The line of interest is especially important in scenes that show movements: (a) the view from camera 1 shows the red team on the right side and the blue team on the left, (b) the view from camera 4 switches the positions of the teams because the camera crossed the line of interest, and (c) using a neutral shot from camera 5 allows you to cross the line without confusing the viewer.

of the line of interest (cameras 1, 2, or 3) or on the opposite side (camera 4). Here's how the scene might be edited:

Shot 1: Camera 1

Shot 2: Camera 3

Shot 3: Camera 5

Shot 4: Camera 4

Shot 5: Camera 5

Shot 6: Camera 2

The shots from camera 5 act as transitions between the shots on opposite sides of the line of interest.

Neutral shots are invaluable when editing material shot by a director who doesn't know about the line of interest. If you are going to be working on someone else's stuff, look for neutral shots, and remember where to find them.

Editing for Peak Effect—Choosing the Right Shots

If you follow the grammar laid out in the previous sections, your videos will be understandable and coherent to the viewer, but they won't necessarily be exciting. It's the same thing with writing—a grammatical sentence isn't enough to inspire the reader.

Creating an exciting video segment involves making lots of decisions, most of them subjective, about which pieces of video to include. The grammar of editing spells out what edits you can't make (i.e., jump cuts), but that still leaves you with a lot of options.

A general rule is that, when possible, a shot should include motion or emotion. A shot of someone talking blandly gets boring after a few seconds; a shot of a person fighting back tears holds the viewer for 20, maybe even 30 seconds. Likewise, a scenic outdoor shot, although it's interesting, holds the viewer's attention a lot longer if there is some kind of action in it.

This applies to almost all shots. If you are using a shot of a person listening to someone else, choose a cut where the person is moving his or her head (even subtly) or where he or she shows some emotion. If you using an establishing shot of people at a table, start the cut when one of the people moves in some way (raises his or her arm, leans back, etc.). Every time you have to decide which part of a shot to use, which cut to take, look for motion or emotion. The final video segment will be much more interesting.

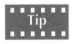

Another way to introduce motion into an otherwise boring shot is to move the camera. This is one reason why Hollywood directors go to such lengths to make the camera move (by putting it on a car, using cranes, etc.).

Becoming a Better Editor

At this point, you're probably not an expert editor, but you are an expert watcher, and all those years of staring at the boob tube are now going to pay off. But first, you have to learn a new way of watching television (or movies for that matter).

Try the following exercise sometime while you're watching a television movie (or a sitcom):

1. Record the movie as you're watching it.
2. Get a piece of paper, a pencil, and a watch.
3. Rewind the tape to any particular section of the movie.
4. Play the movie and make a mark on the paper each time a new shot appears. Don't look at the paper while you make the marks, or you'll miss what's happening on the screen. (The marks don't have to be beautiful, only clear.) Don't try to follow the story; you're looking for edits.
5. Do this for two minutes, then count the number of marks on the paper and divide that number by two. The result is the average number of edits per minute. Depending on what you're watching, the edit rate can vary from 10 to 30 or higher.
6. Calculate how long the average cut lasts by dividing the average number of edits per minute into 60 (60 seconds per minute). If the edit rate is 30 edits per minute, then the average cut is only 2 seconds long.

You'll probably be surprised at how short an average cut lasts. That's because when you're casually watching television, you are following the story that's being created in your head, not the individual shots that help create that story.

Now rewind the tape and watch the same section again, only this time don't make any marks. Instead, try to notice each edit and try to follow the story. It's hard at first, but it gets easier with practice.

Congratulations, you're now analyzing the video instead of just watching it—one of the first steps toward becoming an expert editor! You've broken the illusion and are seeing the individual parts that make up the story.

Practice this new way of viewing television by looking for the different kinds of shots used in a scene. Try to notice the editing pattern used. Look for the establishing shot and try to pick out what the line of interest is. They're all there; they've always been there. Only now, you have the skills to pick them out.

Wrap-Up

This chapter covered some of the basic rules of video-editing grammar and showed a few short examples of how the rules are used. The next two chapters show you, step by step, how to edit several real-world situations.

Tricks of the Trade I— Editing a Group Discussion

How many times have you suffered through lengthy meetings where only one or two really good points were made? Well, now you have the ability to separate the wheat from the chaff, so to speak, through editing. This chapter uses a fictitious example of a company meeting to demonstrate how this is done.

Your company is developing a new database product that incorporates QuickTime. The head of the software group recently met with two outside consultants who had tried out the new package. The meeting was taped, and you have been asked to produce a short QuickTime movie of the meeting so that it can be distributed to the rest of the software team. Your boss, the head of the software group, has given you a rough idea of the parts of the meeting he wants included in the QuickTime movie. There's about one hour of material on videotape, and you've got to shorten it to about four minutes. First, we look at how to edit two sentences together, then we tackle the larger task of editing the two-minute segment.

The Problems with Talking Heads

This assignment involves three main tasks: picking the right sections of video to use, editing the segments together, and covering any jump

cuts that arise. Because you are only working with footage of people talking (known in the TV industry as *talking heads*), you don't have many options, so you have to get fairly creative in your choice of video sections.

One of the first things you might notice when you listen closely to the tape of a person talking is that people don't talk the way they write. They pause, they insert *um*s and *ah*s, they ramble, and they often don't talk grammatically. For example, in the videotape of the meeting, the boss starts off with the following comments:

> *Boss*: Thank you for coming in to talk with us today about the new database software product we've developed. As you know, ah, or as you've seen, this product will allow people to add or put QuickTime movies into any record in their databases, ah, so they can quickly access visual information tied to particular data. We've been working on this for nearly, um, nearly two years or so and um, it's been pretty challenging to stay up on the changes going on, you know, the introduction of Quicktime and all the hardware advances. Well, we're pretty excited about it and wanted to get your comments.

Believe it or not, this is how most people talk. We don't notice these little imperfections in real conversation, but they stick out like sore thumbs in a video segment. With editing, you can clean up a person's speech, taking out all the *um*s and repeats.

In addition, the final QuickTime movie is only going to be a few minutes long, so each quote, or *sound bite*, has to be succinct. Remember, time is a precious quantity in video, so you don't want to waste it on meaningless material. So how do you decide which pieces of video and audio to use, which sound bites? By focusing on the message you want to convey and remembering what your audience needs and wants.

In this example, the audience (the software team) already knows about the product, so you don't need to include the boss' description of the product in the movie. All you really want is a quick introduction, which can be achieved with the following two sound bites:

> *Boss*: Thank you for coming in to talk with us today about the new database software product we've developed. / we're pretty excited about it and wanted to get your comments.

The slash (/) indicates where the edit was made. This reminds you that there will be a jump cut when you edit these quotes together. Notice that the edited version doesn't contain all the ideas of the original quote—only the ones important to the audience.

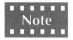 **Short sections of speech usually work best in video; a sound bite lasting 10 to 15 seconds is fairly common. Occasionally, you have a long sound bite, but it's not a good idea to keep the same person's face on the screen too long (the viewers will get bored).**

Once you decide which sound bites to use, your next goal is to make these two sentences sound like they are not separate cuts, that is, as if they were said together in the first place. The main trick is to put the correct amount of pause in between the sentences. Let's take a look at how this is done using the meeting example and Adobe Premiere. The techniques shown here can be applied to your specific situation as well.

 You can get a rough idea of how long a sound bite lasts by formatting the transcript of a person's interview in the following way: Use a monospace font (such as Courier) with a 10-point type size. Set the left margin at 3 inches and the right margin at 6 inches. With this formatting, each line represents roughly two seconds.

Editing Two Sentences Together

The first step is to digitize the boss' introductory comments and store them on your computer. Although you might be tempted to digitize the entire introduction, remember that the middle sentences won't be used; they would take up precious space on your hard drive. Instead, locate the sentences you need, in this case:

- ```
 Thank you for coming in to talk with us today about the
 new database software product we've developed.
  ```

- ```
  . . . we're pretty excited about it and wanted to get
  your comments.
  ```

Now, digitize these sentences. Before each transfer, write down where on the tape the material comes from (how far from the beginning of the tape in minutes and seconds), so you can find it if you need it again.

Make sure to digitize at least an extra half-second of material at the beginning and end of each sentence. This gives you flexibility later on when editing. Also, digitize the material at the highest possible frame rate. This helps you find the proper In and Out points more easily.

Once the material is digitized, import both clips into the Project window of Premiere using the Import command. Then, open clip 1 in the Clip window by double-clicking on the thumbnail of the clip in the Project window.

Listen to the clip several times. After you get a sense of the flow of the sentence, move to the beginning of the sentence, and use the Step Forward and Step Backward buttons to find the point where the first word of the sentence starts. Then, move back (earlier) five frames using the Step Backward button and set this as your In point. This sets a five-frame *pad* that prevents the sound of the boss talking from starting right at the beginning of the clip.

Now move to the end of the sentence and find the point where the last word of the sentence stops. Step forward seven frames and set this as your Out point. The pad at the end of the sentence is longer than the pad at the beginning because people tend to start sentences cleanly but often extend the last word of a sentence.

The five-frame pad at the beginning of the clip and the seven-frame pad at the end are only initial starting points. Don't kill yourself trying to figure out exactly where the sentence starts and stops—just get close. You'll probably change the In and Out points later anyway after you preview the edit.

Open the next clip (the last sentence of the boss' introduction) and follow the same steps to set the In and Out points. Then move both cuts into the Construction window (by dragging them from the Project window). Place cut 2 directly after cut 1 as shown next:

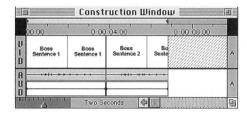

Set the work area to include both cuts, then press the [Return] key to preview the edit.

 This section is written as if you were actually working with the video clips from the meeting. Of course your meeting will be different. Most of the techniques demonstrated in the example, however, will apply to your particular situation.

Fixing Unnatural Pauses

If you're really lucky, the edited piece will sound perfectly fine. But most of the time the pause between the sentences won't sound natural: It will be either too short or too long.

Shortening a Long Pause

The problem here is that there is too much time (or space on the timeline) between the two sound bites (Figure 7-1). There are two possible causes: there is too much pad at the end of cut 1 or there is too much pad at the beginning of cut 2. We start by assuming that there is too much pad in cut 1. To fix this, perform the following steps:

1. Open cut 1 in the Clip window.
2. Use the Go To button to go to the Out point.
3. Step backward two frames and set this point as your new Out point.

By shifting the Out point earlier, you move closer to the end of the first sentence (Figure 7-2), which reduces the pad.

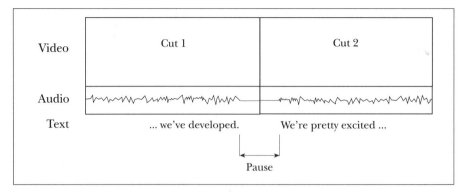

Figure 7-1. A long pause between two sentences is caused by too much pad on either the end of the first sentence or the beginning of the second sentence.

Go back to the Construction window. Notice that there is a small gap between the two cuts that formed when you made cut 1 shorter. To fix this, drag cut 2 to the left to eliminate the gap.

Preview the edit by pressing the (Return) key. If the pause is still too long, try reducing the pad on cut 2 with the following steps:

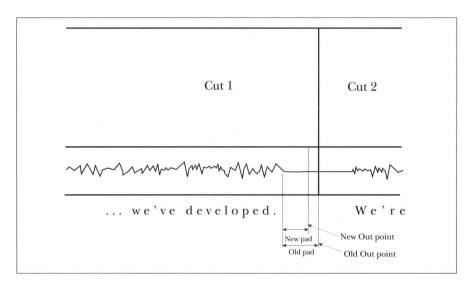

Figure 7-2. You can shorten a long pause by setting an earlier Out point for the first sentence. This decreases the amount of pad at the end of the first sentence, which reduces the duration of the pause.

1. Open cut 2 in the Clip window.

2. Use the Go To button to move the In point.

3. Step forward two frames and set this point as your new In point for cut 2.

By shifting the In point later, you move closer to the beginning of the second sentence (Figure 7-3), which decreases the pad in cut 2.

Go back to the Construction window, drag cut 2 to the left to eliminate the gap, and preview the edit.

If you get tired of switching between windows, try using the stretch pointer in the Construction window to change the In and Out points for the cuts as follows:

1. Set the time ruler indicator to four frames (you need a lot of resolution because you are changing the In and Out points by at most four or five frames.

2. You might also find it helpful to open the Info window, which displays the actual timing of the In point.

3. Find the point where the two cuts meet (the edit point).

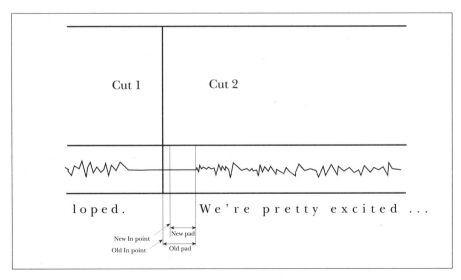

Figure 7-3. You can shorten a long pause by setting a later In point for the second sentence.

4. Use the stretch pointer to move the In point of cut 2 later (to the right) or the Out point of cut 1 earlier (to the left).

5. Use the time ruler at the top of the Construction window or the Info window to see how much you are changing the In or Out point.

6. After you change the In and Out points, drag cut 2 to the left to eliminate any gaps.

Lengthening a Short Pause

In this case, the problem is that there isn't enough time (space on the timeline) between the two bites (Figure 7-4). You need to increase the time between the cuts and, as with a pause that is too long, you have two distinct options: You can increase the pad at the end of cut 1 or increase the pad to the beginning of cut 2.

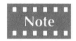 **You can't solve this problem by simply moving the cuts apart. Although you can set the correct amount of pause between the two sentences, there is a disconcerting absence of sound during the gap. This is because a gap in the audio track, unlike pad, does not contain any of the ambience, or low-level background sound, that is present in almost every room.**

For this example, we increase the pad at the end of cut 1 with the following steps:

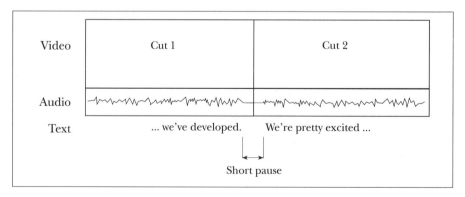

Figure 7-4. A short pause between two sentences is caused by too little pad on either the end of the first sentence or the beginning of the second sentence.

1. While still in the Construction window, move the cuts apart so that you can reset the In and Out points.
2. Open cut 1 in the Clip window.
3. Use the Go To button to move to the current Out point.
4. Set a marker at the current Out point so that you can find it later.
5. Step forward three frames and set this point as your new Out point.

By moving the Out point later (Figure 7-5), you moved farther away from the end of the first sentence, thereby increasing the pad.

 There is nothing special about three frames. If the pause between the two sentences is very short, you might need to add five frames, maybe even seven frames. After a while, you can tell how much pad you need to add just by listening to the edited section.

Go back to the Construction window, and drag cut 2 to the left to eliminate any gap that remains. Then, preview the edit. If the pause

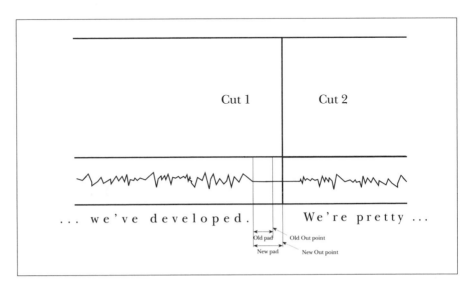

Figure 7-5. You can lengthen a short pause by setting a later Out point for the first sentence. This increases the amount of pad at the end of the sentence, which increases the duration of the pause.

still doesn't sound natural, continue to add pad to cut 1 until the sentences seem to flow together.

If you can't seem to change an In or Out point in the Clip window, go back to the Construction window and make sure there is a gap separating the two cuts. Premiere won't let you extend a cut if there isn't room to do so.

When you keep adding pad to the end of the first cut, you'll run into the next sentence, which you don't want to use (Figure 7-6). If this happens, you need to reset the Out point of cut 1 to an earlier point (if you marked a previous Out point with a marker, then go to that marker and reset the Out there.) You then increase the pad at the beginning of cut 2, as follows:

1. Open cut 2 in the Clip window.
2. Use the Go To button to move to the current In point.
3. Set a marker at the current In point, so you can find it later.
4. Step backward several frames and set this point as your new In point.

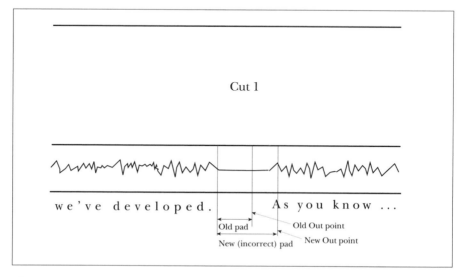

Figure 7-6. If you keep setting a later Out point for the first sentence, you will run into the next sentence on clip 1.

By moving the In point earlier, you move farther away from the beginning of the second sentence (Figure 7-7), which increases the pad.

If the two sentences you're working with don't have enough pad at the beginning and end of the sound bites, you can still lengthen the pause by moving the cuts apart on the timeline, then filling the gap you created with a short cut of ambience. Just find a small section of audio from the videotape where no one is talking. Digitize it and place it in the gap. That fixes the pause and prevents the sound from dropping out.

When you're satisfied that the two sentences sound natural, you're ready to move on to the next step—covering up the jump cut in the video.

Hiding the Edit

If you have been previewing the edits in audio-only mode, reset the preview options so you can see the video as well. Although the audio sounds correct, there is an abrupt change, or jump cut, in the video

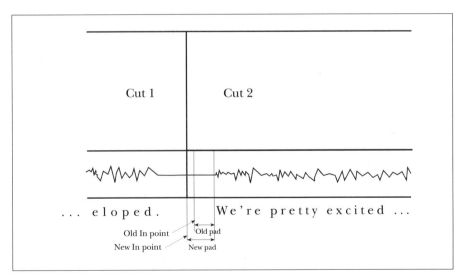

Figure 7-7. You can lengthen a short pause by setting an earlier In point for the second sentence.

portion. You can fix this by replacing part of the video with a cutaway of someone (or something) else, which hides the jump cut.

Choosing a Cutaway

At this point, you need to go back to the videotape and look for a shot of one of the consultants listening to your boss. The main thing to look for is a shot where the consultant looks interested and shows some movement. The consultant has to be looking at the boss for the cutaway to work.

Don't choose this shot haphazardly. It can dramatically affect the message of the final piece. In a sense, you are adding an editorial comment. If the person in the cutaway looks interested, then the boss' comments are interesting. If the person in the cutaway looks bored or isn't paying attention, then you make that comment about the boss' introduction. The cutaway is a crucial element of the visual story; in some cases, it's more important than the video of the main speaker.

Adding the Cutaway to the Sequence

After selecting the shot you want to use as the cutaway, digitize it and then import the digitized clip into Premiere. Drag the clip from the Project window into the Construction window and place it in video track B (Figure 7-8). The cutaway is positioned so that it straddles the edit between cuts 1 and 2. We want the cutaway to last for two seconds, so adjust the length of the cutaway to two seconds using the stretch pointer and the Info window. If necessary, reposition the cutaway after adjusting its length.

Figure 7-8.

Editing together two sentences from the same person often causes a jump cut. You can hide the jump cut by adding a cutaway.

You don't always have to center the cutaway over the edit point, but some part of the cutaway must cover the edit point. Try moving the cutaway to different positions to see what works best.

You don't want to use the audio portion of the cutaway, only the video, so delete the audio portion by clicking on it and pressing the Delete key.

Now we need to tell Premiere how and when to switch from the video of the boss in video track A to the cutaway in track B. We don't want to use a fancy transition between the two, so we just use a special effect known as the *Direct effect* which simply swaps tracks A and B.

Open the Special Effects window, scroll down, and select the Direct effect by clicking on it. Drag its icon into the Construction window, and place it in the T track so that it sits above the cutaway:

Adjust the length of the Direct effect using the Stretch pointer, so that it matches the length of the cutaway:

As you preview the work area, you first see and hear your boss speaking the first part of sentence 1. Then you continue to hear the boss, but you see the consultant listening. This cutaway lasts two seconds, after which you see the boss finish speaking the second sentence. The insertion of the cutaway hides the jump cut.

Adjusting the Length of a Cutaway

Sometimes, you will want to increase or decrease the duration of the cutaway, for example, to show a particular reaction from one of the listeners. Adjust the duration of the cutaway by varying the length of both the cutaway and the Direct effect in unison. Here's how you create a longer cutaway:

1. Increase the length of the cutaway in track B using the stretch pointer until its duration is three seconds (use the Info window to see its exact duration).

2. Position the cutaway so that it straddles the edit point.

3. Extend the Direct effect so that it matches the length of the cutaway and sits directly over it:

Now, when you preview the work area, the cutaway lasts three seconds instead of two.

To shorten a cutaway, you need to only decrease the size of the Direct effect because that determines how long the video in track A is replaced by the video in track B.

The More the Merrier—Group Discussions

Now that you've gotten the hang of cutting words together, known also as *dialog cutting*, you're ready to build a larger piece that includes several people talking. Although group discussions are trickier to edit than an individual talking, the task involves the same three steps: choosing the right sound bites and images, putting the sound bites together, and covering up the edits with cutaways.

The main difference between editing a group discussion and editing one person talking is that you want to develop a sense of flow within the

edited piece. You don't want to just put several sound bites together. Real conversations don't usually occur that way. Instead, people ask questions, they pause after someone has said something interesting, and they talk over each other. The more you can introduce these elements into the edited piece, the more realistic your piece will be.

Choosing the Right Sound Bites

The best sound bites work on two levels: *what* a person says and *how* he or she says it; that is, (1) whether what the person is saying (the information) is interesting and an important part of the overall message or story and (2) whether they say it with emotion or at least convincingly.

Unfortunately, the two don't always go hand in hand. You can have sound bites that look great in a transcript but seem flat and boring in the video. Other times, a quote that seems to make little sense in the transcript comes to life when you see how the person uses pauses and facial expressions when saying it. One way to track the quotes that fulfill both needs, the visual and the content, is to log the tape, noting the best sound bites and where they occur in the tape.

Logging the Tapes

You're not going to transfer all the material shot of the consultant's meeting, so you have to decide which sections to include. You could start at the beginning of the tape and transfer anything that looks interesting, but you might fill up your hard drive before you get through just one tape.

A better way is to *log* the entire tape, noting the parts that seem interesting and where they are located (how far from the beginning of the tape in minutes and seconds; many video cassette players have a counter that displays this). This way, you can review the log of the whole tape and then decide which parts to include before you actually do the transfers.

Although it can be tedious, it's important to write down how far into the tape a particular section resides. This allows you to find it quickly when it comes time to transfer it.

If you're not working with a transcript of the meeting, you should note good sound bites and where they occur. You can then go back and transcribe the bites after you finish logging the tape (see the discussion in the next section on why transcripts are helpful).

Using Timecode

If you are working on a large project with several videotapes, you might want to consider using a special numbering system called *timecode*, which assigns a specific number to each frame of video.

The timecode signal is placed either in one of the audio channels or as part of the video signal. Some videotape machines and most software editing programs can decipher this signal and display it.

 You may hear people talk about SMPTE Time Code, or just SMPTE (pronounced "simptee"). SMPTE is the acronym for the Society of Motion Picture and Television Engineers, which established the Time Code system.

There are several advantages to the timecode system, but the one that interests us here is that when you log a tape, it allows you to write down the exact position of a particular shot without having to reference how far into the tape it is. When you're working with several tapes, this makes it a lot easier and faster to find the shots you want. Let's look at a typical situation and compare the benefits of timecode and non–timecode logging.

First, let's look at working without timecode. You made your log and noted that a good listening shot occurs 10 minutes and 15 seconds into the tape. The next day, you put the tape into the machine and notice that it's at the end. Now you have to rewind the tape to the beginning and then advance 10 minutes and 15 seconds to find the shot.

Let's look at the same situation using timecode. On your log, you noted that the listening shot occurs at 10:15 (10 minutes, 15 seconds). As before, when you put the tape into the machine, you notice that it's at the end. But this time, you also see the timecode for your current position, for example, 30:15 (30 minutes, 15 seconds). All you have to do is rewind 20 minutes, and you are at exactly 10:15.

The full format for Time Code is *hours:minutes:seconds:frames* (e.g., 3:22:15:12). Each tape is assigned an arbitrary hour when you add Time Code. For example, in this case we might have assigned the tape with the listening shot to hour 1. The full Time Code for the listening shot would then be 1:10:15:00, or 1 hour, 10 minutes, 15 seconds, and 0 frames. Because the log is only intended to be a guide to the material on the tape, it's not necessary (in fact, it's quite tedious) to mark down the frame numbers for particular shots. Because the hour is set for the

entire tape, it's not necessary to write down the hour either; so 1:10:15:00 becomes 10:15, as before.

There are several other advantages to working with timecode; these are discussed in Chapter 13.

Selecting the Sound Bites

If you have the luxury of having someone transcribe your tapes for you, great! Otherwise, you need to do it yourself. A transcript makes it easier to select the sound bites you want because you can read faster than you can listen. In addition, you can jump to different parts of an interview or a meeting much faster on paper than you can on video-tape. If the transcript was prepared before the log, mark on the transcript which sound bites you'd like to use and then note where these bites occur as you log the tape.

 Which sound bites to use depends on the situation and the message or story you're trying to present. If you are not using narration, then the sound bites need to fit together to create a sense of a conversation. It often helps to imagine that you're reading the script for a movie and read the sound bites aloud as you assemble them. After a while, you'll be able to just look at two sentences and tell if they fit together.

Remember that the sound bites need to be succinct, so you should look for ways to shorten a sound bite or pull out the essential material. For instance, going back to the example of the boss' introduction, the unedited version lasts about 36 seconds. The edited version lasts only 10 seconds or so.

Making a Paper Cut

Although it's tempting to dive right in and start editing, a better and more efficient way to proceed is to first spend some time planning the video segment on paper. It's easier and quicker to change your mind on paper, which encourages you to try different options.

The standard way of planning an edited segment on paper is to create what's called a *paper cut*, which is a rough outline of the sound bites and shots you're going to use. The usual format for a paper cut is

shown in Figure 7-9. Descriptions of video shots are put in the left-hand column, and audio clips are put on the right. The column margins are set so that there are about 35 characters per line for the audio, which translates to about 2 seconds per line in the edited segment (Courier font with 10-point type size, 3 inches left margin, 6 inches right margin). The tape locations (or timecode) of the video and audio clips are also noted so that you can find them later on.

One of the main advantages of creating a paper cut is that you can review it with someone, say your boss, before you spend a lot of time transferring the video material and editing it. After a while, you'll be able to spot potential problems (such as difficult jump cuts or potentially boring sections) by looking at the paper cut. This helps you prepare for problems before you start editing.

Figure 7-10 shows an example of a paper cut for the software meeting example. This isn't the complete paper cut; it only covers a little

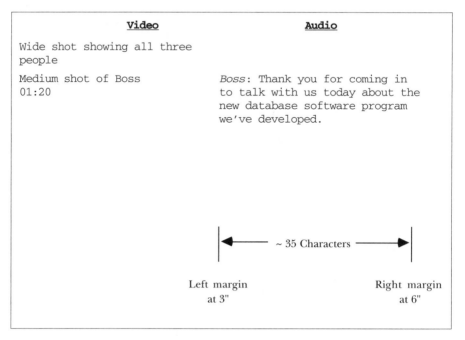

Figure 7-9. Formatting for a paper cut, which is a rough outline of the sound bites and shots you're using

less than two minutes. The paper cut for the entire video segment, which lasts four minutes, would be nearly twice as long.

A lot of decisions went into this paper cut, so we go through it step by step. The transcript for this section is shown in Figure 7-11 for reference.

Shot 1—Wide Shot

It's important to establish the scene, so the first shot of the piece is a wide shot showing all three people. Notice that there isn't any audio planned for this video shot. You could use music here to introduce the piece. Another option (which we explore later) is to start the movie with a title that fades out over the first shot.

Wide shot showing all three people	
Medium shot of Boss (01:20)	*Boss*: Thank you for coming in to talk with us today about the new database software program we've developed.
Medium shot of Boss (01:50)	*Boss*: We're pretty excited about it and wanted to get your comments.
Medium shot of Consultant 1 (02:20)	*Consultant 1*: It seems like a pretty good product, the commands seem straightforward, the organization is fairly clear, although I've got some questions about how you handled certain situations.
Close shot of Consultant 1 (03:10)	*Consultant 1*: Take, for example, after I replace a movie in a record with a newer movie, what happens to the old movie, the old version? It seems as though it just hangs around, taking up space on my hard drive.
Close shot of Boss (retake) (57:30)	*Boss:* We've wrestled with that one for a while. Did you try using the Archive command?
Close shot of Consultant 1, then a zoom out to two-shot of Boss and Consultant 1 (03:32)	*Consultant 1*: Yeah, I did, but it seems, well, couldn't you somehow ask the user whether or not he wanted to keep the old

Figure 7-10. Paper cut for the software consultant meeting

```
                                    movie during the Replace proce-
                                    dure?
(previous shot continues)           Boss: We've thought about that
A zoom in from two-shot of          ... but we were afraid that
Boss and Consultant 1 to            that would make it too easy for
medium shot of Boss (03:42)         someone to delete a file by acci-
                                    dent.

Camera moving at the beginning      Consultant 2: What if you modi-
of shot, then close shot of         fied the Archive command in
Consultant 2  (04:10)               some way ...

Close shot of Consultant 2          so that the user could quickly
(04:18)                             glance over a list of the old
versions before deleting them.

Close shot of Consultant 2          Maybe you could stack them up
(04:26)                             in order, like a flip book ...

Close shot of Consultant 2          and then the person would sim-
(04:32)                             ply have to choose Save or
                                    Delete.

Close shot of Boss                  Boss: Mmmm, sounds interesting.
(04:50)                             I'll have Cheryl, one of our
                                    programmers, look into that.
```

Figure 7-10 Paper cut for the software consultant meeting
(continued).

Shots 2 and 3—Boss Talking

These are the two clips from the boss' introduction we edited together before. Because there isn't a video shot separating them (at least not yet), there is a jump cut.

Shot 4—Consultant 1 Talking

If you refer to the transcript, you'll notice that the first part of his comments were left out. Although it's nice to get compliments, we included the important part of his first paragraph—his critique.

Shot 5—Consultant 1 Talking

Again, if you refer to the transcript, you'll see that the boss' question and the first part of the consultant's answer were left out. One reason for doing this is to save time, the other (which you can't see from the transcript, only the log) is that the camera was still moving from a shot

Boss: Thank you for coming in to talk with us today about the new database software product we've developed. As you know, ah, or as you've seen, this product will allow people to add or put QuickTime movies into any record in their databases, ah, so they can quickly access visual information tied to particular data. We've been working on this for nearly, um, nearly two years or so and um, it's been pretty challenging to stay up on the changes going on, you know, the introduction of Quicktime and all the hardware advances. Well, we're pretty excited about it and wanted to get your comments.

Consultant 1: Thanks for bringing me in on this project. I think you guys should be commending for trying to get the product out so quickly, it's obvious you've put a lot of time and energy into this. It seems like a pretty good package, the commands seem straightforward, the organization is fairly clear, although I've got some questions about how you handled certain situations. Of course, I've only had a few days to look it over.

Boss: What situations did you have a problem with?

Consultant 1: Well, I wouldn't really call them problems, it's just, well, take, for example, after I replace a movie in a record with a newer movie, what happens to the old movie, the old version? It seems as though it just hangs around, taking up space on my hard drive.

Boss: Yes, we've wrestled with that one for a while. Did you try using the Archive command?

Consultant 1: Yeah, I did, but it seems, well, couldn't you somehow ask the user whether or not he wanted to keep the old movie during the Replace procedure?

Boss: We've thought about that ... but we were afraid that that would make it too easy for someone to delete a file by accident.

Consultant 1: Yes, I can see how that might be a problem but the current way doesn't seem easy enough to me yet.

Consultant 2: I had the same question. What if you modified the Archive command in some way, I'm not exactly sure how you'd do it, but modify it somehow, so that the user could quickly glance over a list of the old versions before deleting them, instead of calling them up one by one. Maybe you could stack them up in order, like a flip book or something like that or maybe like a slide carousel, and then the person would simply have to choose Save or Delete.

Boss: Mmmm, sounds interesting. I'll have Cheryl, one of our programmers, look into that. Any other comments, good or bad?

Figure 7-11. Transcript of the software consultant meeting

of the boss to a shot of the consultant as the consultant responded. By losing the beginning of the consultant's response, we avoided having to use a shot where the camera is in the middle of a move.

Shot 6—Boss' Response

Notice that the tape position for this shot is 57:30. This means that it was shot after the meeting was over. What happened was that the camera operator knew that the boss' response hadn't been captured on camera (the camera was still pointing at the consultant when the boss responded.) The camera operator asked the boss to repeat his question after the meeting was over so that it could be recorded.

Shots 7 and 8—Consultant and Boss Talking

These are really two parts of the same continuous shot; they are separated here to indicate when a new person is speaking. The camera technique shown here—a close shot of one person, a zoom out to a two-shot when the first person stops talking, then a zoom in to the second person as he's talking—is a common way of shooting two people. If done correctly, it allows you to switch from one person to another without having to perform an edit.

Shots 9, 10, 11, and 12—Consultant 2 Talking

These are small chunks of consultant 2's comments, which convey a complete idea when put together. The main reason for "cutting her up" is to save time. The other reason is that by eliminating the less important words and phrases, we increase the impact of what the consultant is saying.

Making the First Cut

Now that you have a detailed paper cut, assembling the first version of the video segment, or the *rough assembly*, is fairly easy. First you transfer the footage from the videotape into digital files on your hard disk. Then you assemble the clips in the Construction window, setting In and Out points for each clip.

Transferring the Footage to Disk

Digitize the sections you want, using the time markings shown on the paper cut. Be sure to transfer a little bit of extra material at the beginning and end of each shot. This gives you more flexibility when you start editing.

 You don't need to transfer the video sections to your hard disk in any particular order, but be careful to give each file a distinctive name so you can pick out a specific clip later on. A neat trick is to put a small *a* before the description of your first shot, a small *b* before the description of the second shot, and so on. For example, label shot 1 as *a.establishing shot.* This way, when you import the clips into your editing program, they will appear in the same order that you will use them in the QuickTime movie.

Launch Adobe Premiere if it isn't already running. Create a new project using the New command under the File menu. Then import the clips into the Project window using the Import command. You can import all the clips at one time or as you go along, whichever seems easier to you.

Assembling the Cuts

Because you worked out most of the problems in the paper cut, all you need to do is simply set the proper In and Out points for each clip and lay the clips end to end. If you're not sure how to edit sound bites together, please refer to the discussion earlier in this chapter that covers this topic.

As you assemble the cuts in the Construction window keep in mind the following points:

- Each cut should be placed in video track A.

- Don't worry about jump cuts; we'll fix them later.

- If you are trying to fix the pause between two sound bites, set the Preview option so that you are only previewing the audio. Remember to click the Video Preview check box back on when you want to preview the video portion.

- There should be a slightly longer pause between sound bites from different people. For example, you might want to have a pad of about 15 frames between shot 3 (boss' sound bite) and shot 4 (consultant's sound bite).

- Reset the work area so that you only preview the portion of the movie that you're currently working on.

- If you can't seem to adjust the In and Out points for a cut in the Clip window, make sure there is a gap between that cut and other cuts in the Construction window.

- Save the project every now and then so that you won't lose what you've done if the computer goes down or locks up.

Once you place all the cuts down in the Construction window and set the In and Out points for each clip, the Construction window should resemble Figure 7-12.

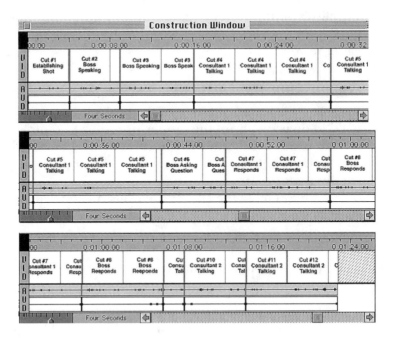

Figure 7-12. Rough assembly for the software consultant video segment

 Note Because you are working with different clips for your example, the Construction window for your project won't be the same as Figure 7-12, but the basic features (a string of video and audio cuts laid down from beginning to end) should be the same.

Because the rough assembly won't be the final version of your movie, you should set the output options to minimize the size of the movie you create. Choose the Output Options command under the Project menu. Set the frame rate to 10 frames per second (fps). Set the quality adjustment inside the box labeled Compression to low. Adjust the audio rate to the lowest setting (5 kHz). Then choose the Make Movie option from the Project menu to create the rough assembly.

Brace yourself and then watch the movie. It will not be pretty— there will be lots of jump cuts. Then play the movie again with your eyes closed. Does it sound right? Does it sound like a conversation?

If it does, then you're ready to move on to the next step—fixing the video. If it doesn't sound right—if there's a pause that's a little too short—you should go back and fix that edit in the Construction window and make a new copy of the movie (you might want to get rid of the old copy and empty the trash can, just to make sure there is enough room on your hard disk).

Fixing the Video

If the audio part of the rough assembly works (sounds fine), then it's time to fix any jump cuts or video problems in the movie.

Creating a Fix List

Play the movie and keep a *fix list* of when jump cuts occur and which cuts are involved. Also, note if the camera moves during any of the sound bites. For this example, the list looks like this:

1. Jump cut, cuts 2 and 3, boss

2. Jump cut, cuts 4 and 5, consultant 1

3. Camera move, beginning of cut 9, consultant 2

4. Jump cut, cuts 9, 10, 11, and 12, consultant 2

Finding Suitable Cutaways

Go back to your tape log and find the cutaways you need to fix these problems. Use the list you just created to determine which person should be shown in the cutaway. There are a few basic rules that can help you decide which shots to use as cutaways:

- The cutaway has to show someone other than the person who's talking.

- The person shown in the cutaway should be looking at the speaker and seem interested in what the speaker is saying.

- It helps to have a little motion in the shot; i.e., the person shifts position in his or her chair, moves his or her hands, or makes a facial expression of interest (raising eyes).

- The facial expression of the person in the cutaway should match what the speaker is saying; i.e., if the speaker tells a joke, then the cutaway should show a person laughing.

- Successive cutaways should not be of the same person—alternate who is shown in a cutaway.

- Don't lose a person. If you haven't seen one of the speakers on camera in a while, show that person in a cutaway.

In this example (the meeting between the boss and the consultants), the following cutaways would be digitized and used in the movie:

Consultant 1 looking at the boss

Consultant 2 looking at consultant 1

Consultant 1 shifting his attention from the boss to consultant 2

Boss looking at consultant 2

Adding the Cutaways to Fix the Movie

We now look at how each cutaway would be used to fix the jump cuts and video problems on the fix list. Remember that cutaways are placed in video track B, and their audio portions are deleted.

Fix 1—Jump Cut between Cuts 2 and 3 Insert a shot of consultant 1 looking at the first speaker:

VIDEO	Cut #2 Boss Speaking	Cut #2 Boss Speaking	Cut #2 Boss Speaking	Cut #3 Boss Speaking	Cut #3 Boss Speaking	A
			B			T
			Cutaway 1 Consultant 1 listening to the boss	Cutaway 1 Consultant 1 listening to the boss		B

Use the Direct effect to cut to the cutaway. You could use a shot of consultant 2 but because the viewer hears consultant 1 talk next, this cutaway helps set that person up.

Fix 2—Jump Cut between Cuts 4 and 5 Insert a shot of consultant 2 looking at consultant 1:

VIDEO	Cut #4 Consultant 1 Talking	Cut #4 Consultant 1 Talking	Cut #4 Consultant 1 Talking	Cut #5 Consultant 1 Talking	Cut #5 Consultant 1 Talking	A
			B			T
		Cutaway 2 Consultant 2 listening to consultant 1	Cutaway 2 Consultant 2 listening to consultant 1	Cutaway 2 Consultant 2 listening to consultant 1		B

We haven't seen consultant 2 since the establishing shot (cut 1), so it's a good idea to remind the viewer that she's there.

Fix 3—Camera Moving at the Beginning of Cut 9 This fix is a bit more difficult to do because it takes a while for the camera to become steady. Therefore, you need to use a cutaway that lasts longer (about five seconds) and still seems interesting. The easiest way to do this is to use a shot that has a lot of movement in it.

Within this scene, however, there isn't a whole lot of movement in the first place—a few head nods, people tapping pencils, etc. That's okay. What you need is a shot that has more motion relative to the average shot for the scene. In this case, a shot of consultant 1 moving his head and shifting his attention from the boss to consultant 2 is different enough and has enough motion to keep the viewer interested.

But this shot introduces a new problem. Until now, there has been no connection between the cutaway and the audio playing underneath. However, in this case, you need to synch the movement of the consultant's head with the audio edit between the boss talking and

consultant 2 talking. If consultant 1 moves his head too soon, before consultant 2 starts talking, the video and audio won't make sense together (how did he know she was going to start talking?).

There are several ways to synch the video and audio, but the simplest way is by trial and error. Set the time ruler indicator to 15 frames. Then, find the thumbnail of the cutaway in which consultant 1 starts to move his head (Figure 7-13). Line up the beginning of this thumbnail with the audio edit point in audio track A. This gets you close to being in synch.

Set the work area so that it includes part of cut 8, the cutaway, and part of cut 9, and preview the work area.

If consultant 1 is moving his head too early with respect to the audio, drag the cutaway to the right. If consultant 1 is moving his head too late, drag the cutaway to the left. Preview the work area again. Keep adjusting the cutaway's position until the audio and video are in synch.

Because we know that there is a jump cut between cuts 9 and 10, we can eliminate the camera move problem and that jump cut by covering cut 9 completely with one cutaway. Simply extend the cutaway of consultant 1, using the stretch pointer, until the end of the cutaway lines up with the beginning of cut 10. As shown in the illustration at the top of page 163, set the position of the Direct effect to that point as well:

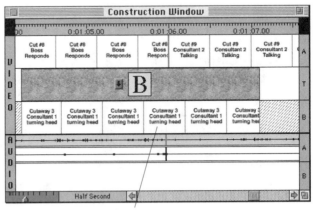

Frame where consultant starts to turn his head

Figure 7-13. For certain cutaways, you have to match the motion of the person seen in the cutaway with the audio from the shots you are covering. Here, we are matching the movement of consultant 1's head with the beginning of the audio from consultant 2.

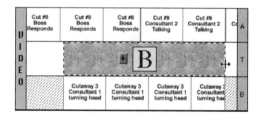

Now you won't see the video portion of cut 9 in the movie, although you will hear its audio (consultant 2 talking).

Fix 4—Jump Cuts between Cuts 9, 10, 11, and 12 We've already fixed the jump cut between cuts 9 and 10. Because cut 11 is short, we can use a cutaway to cover it completely. This eliminates the jump cut between cuts 10 and 11 and the jump cut between cuts 11 and 12. We just used consultant 1 in a cutaway, so we use a shot of the boss this time:

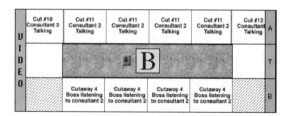

 In this example, we end cutaways at the earliest possible point (when the jump cut is eliminated). You can extend the cutaway to make the cut seem smoother.

Reviewing Your Work

Once you put in all the cutaways and fix all the jump cuts, you're ready to review your work. If you've changed the output options since you created the rough assembly, set the compression quality to low and the audio rate to the lowest setting (5 kHz). You should also set the frame rate to 15 fps. Then choose the Make Movie option and create a new version of your movie.

 If you have enough room on your hard disk, you may want to keep a copy of the rough assembly around for comparison with the new version.

If you aren't satisfied with the cutaways you added, go back and fix them before proceeding. As mentioned before, the final, edited video segment is about four minutes long. What we covered is about 1 minute and 40 seconds.

On a movie this large, you might find it useful to break it into two parts and assemble each part in a separate Premiere project. You've already completed the first part, so all you have to do is open a new project with the New command under the File menu and continue where you left off.

When you're satisfied with both parts, you can combine them by opening the project for part 1 and importing the movie for part 2. When you make a new movie, it includes both parts 1 and 2.

Adding the Finishing Touches

At this point, you've completed the assignment: You condensed a 60-minute meeting into a four-minute QuickTime movie. But you can take it a step further and use the tools provided by Premiere (or other editing programs) to spice up the movie with some extra touches.

Adding an Opening Title

You might want to add a title to the beginning of the movie so people know what they're watching. First, you have to create the title in a paint or draw program and store it as a PICT or Photoshop file.

When creating a title, set the size of the title graphic to the same size you use in your QuickTime movie (usually 240 by 180 pixels). This way, the title won't change much when you import it into Premiere. It's also a good idea to use a sans-serif font, such as Helvetica, with a fairly large type size (at least 20 point or larger) so that the title is readable. You should also make sure that there is a lot of contrast between the foreground (the title) and the background. Light-colored letters on a dark background work well.

Create another graphic, a *background graphic*, that contains just the background you used for the title.

Open the project for your movie and import the title and background graphics using the Import command. Drag the title graphic into the Construction window, place it in video track B, and position it under the first cut in video track A:

| Cut #1 Establishing Shot | Cut #1 Establishing Shot | Cut #1 Establishing Shot | Cut #1 Establishing Shot | Cut #2 Boss Speaking | A |

One way to use the title is to fade in the title, then cross-dissolve between the title and the establishing shot. Here's how this is accomplished with Premiere:

1. Shorten cut 1 (the establishing shot), using the stretch pointer, so that there is a two-second gap between the beginning of the movie and cut 1:

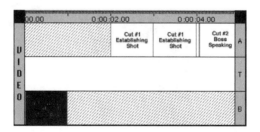

2. Lengthen the title graphic with the stretch pointer so that its duration is four seconds. You might want to use the Info window to determine when you've set the correct duration:

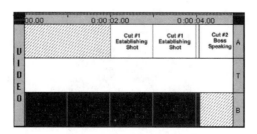

3. Drag the background graphic from the Project window into the Construction window and place it in the gap to the left of cut 1.

4. Extend the background graphic so that it fills the gap:

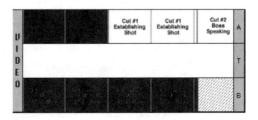

5. Open the Special Effects window and select the icon for the Cross Dissolve effect. Drag the effect into the Construction window, place it in the T track, and position it at the beginning of the movie.

6. Shorten the effect with the stretch pointer until its duration is 30 frames:

7. Make a copy of the Cross Dissolve effect with the Copy and Paste commands. Position effect 2 so that it starts at the beginning of cut 1:

8. Adjust the length of effect 2 so that its right edge lines up with the right edge of the title graphic:

9. Change the direction arrow for effect 2 so that it points upward.
10. Set the work area to cover just the first eight seconds of the movie and preview the work area.

There's quite a bit going on in the first six seconds, so let's step through it. The movie starts off with the background graphic in video track A. The title graphic (in video track B) immediately starts to fade in. The title graphic runs by itself for one second. Next the establishing shot starts to fade in as the title fades out. Then there are two seconds of the establishing shot before the boss' introduction begins.

This is only one of many possible ways to use a title to introduce a movie. You can use different effects. You can fade the title in and out over a background graphic and then fade in the first cut. Play around and see what you can come up with.

The ability to experiment with transitions and special effects is one of the truly amazing benefits of QuickTime and Macintosh-based editing systems. If you were working with videotape to experiment with visual effects like these, you would have to rent what's called an online editing system. These systems rent for about $250 an hour. With the meter ticking that loudly, it's hard to get into an experimenting mood.

Adding Ending Credits

Now let's wrap up the QuickTime movie by fading out the last cut and putting up the credits. This is similar to what you did in Chapter 4, so we go through it quickly here:

1. Using a paint or draw program, create a credits graphic and save it as a PICT or Photoshop file.

2. Create another graphic with the same background as the credits graphic, and save it as a PICT or Photoshop file.

3. Import the credits graphic into Adobe Premiere.

4. Go to the end of the movie in the Construction window using the slider bar at the bottom of the window.

5. Drag the background graphic into video track B in the Construction window, and position it to start right after the end of the last cut:

6. Extend the right edge of the background graphic so that its duration is six seconds. You might want to use the Info window to determine the duration.

7. Open the Special Effects window and select the Cross Dissolve effect. Drag its icon into the Construction window, place it in the T track, and position it after the last cut:

8. Set the duration of the effect to one second using the stretch pointer.

9. Position the effect so that its left edge lines up with the right edge of the last cut.

10. Extend the right edge of the last cut so that it lines up with the right edge of the effect:

11. Drag the credits graphic from the Project window into video track A in the Construction window, and position it about 15 frames after the end of the last cut (you may want to set the time ruler indicator to half a second to increase the resolution of the Construction window):

12. Extend the right edge of the credits graphic so that its duration is three seconds.

13. Open the Special Effects window and choose any special effect you want. Drag the icon for that effect into the Construction window, place it in the T track, and position it so that it begins when the credit graphic begins:

14. Set the duration of effect 2 to one second using the stretch pointer.

15. Click on the effect direction arrow to make the arrow point upward (you might have to extend the effect to see the direction arrow and then readjust its length after you set the arrow).

16. Go back to the Special Effects window and choose another special effect at random. Drag the icon for that effect, place it in the T track, and position it so that it ends when the credit graphic ends.

17. Set the duration of effect 3 to one second with the stretch pointer. Make sure that effect 3 ends when the credit graphic ends:

18. Set the work area to include just the last 10 seconds of the movie, and preview the work area.

What you see is that the last cut fades out, leaving just the background graphic. Then the credits appear, using whichever special effect you chose. The credits run for two seconds and then disappear through whichever special effect you chose.

When you're satisfied with the changes you made to the beginning and end of the movie, choose the Output Options command. Set the compression quality level to normal and the audio rate to 11 kHz. Then set the frame rate to the maximum allowed by your machine (10–15 fps for a IIsi, 15–30 fps for a IIci, and 30 fps for a IIfx or Quadra).

Choose the Make Movie option and go out and get some lunch. It might take Premiere as long as 20 minutes to compile the movie.

If you want to reduce the size of the movie file, reset the Output Options to reduce the frame rate or compression quality.

Wrap-Up

Although this chapter is long, it really covers only three main tasks: selecting the best sound bites, editing the sound bites so that they sound natural, and covering jump cuts with cutaways. Along the way, we covered a few skills that can help you do these tasks—namely, logging your tapes and using transcripts—and we discussed a few techniques for using cutaways.

These skills allow you to edit any scene in which people are talking. In addition to meetings, these include interviews, lectures, and dramatic pieces, such as skits and plays. The techniques covered in this chapter also come in handy when producing and editing a product demonstration tape—the subject of the next chapter.

Tricks of the Trade II— Producing a Short Product Demonstration

I n the last chapter, you worked with one type of footage— talking heads. But one of the great advantages of video is that you can incorporate many different types of imagery into the same piece. In this chapter, you learn how to combine animation, talking heads, audio voice-overs, and illustrative footage into an informative product demonstration piece. We continue the example discussed in Chapter 7, a new database program, to cover these new topics.

The new database is getting ready to be released. It's been through beta testing and most of the bugs have been worked out. Your boss raved about the piece you did on the consultants' meeting, and now he wants you to create a new movie for a small conference coming up. The movie should describe and demonstrate the product, and run by itself on a computer in the booth. He wants it to last about two minutes, and he's given you a small budget that covers the costs of one day of shooting.

An Overview of the Phases of Production

The main problem you face when producing a piece is deciding what to do—what should be put in and what should be left out. Fortunately, you have a bit of a shooting budget, so you can plan the project out first, shoot the material you think you need, and then edit together the final piece. These tasks correspond to the three phases of production: pre-production, production, post-production.

Pre-Production

In the pre-production phase, you try to plan the project in as much detail as possible. The more time you spend researching the topic, thinking about the script, and determining what kind of footage you need to shoot, the fewer mistakes you'll make during production. Pre-production planning increases the chances that you'll have the right material when it comes time to edit the piece.

Many producers and directors use a three-step process in planning a production:

1. Create a rough outline of the project that answers a few basic questions: What are you trying to say? What are the main points you want to get across? What do you want the viewer to come away with after watching the piece?

 This outline, sometimes called a *treatment*, should also include rough estimates for the amount of time and money you expect to spend on research, shooting, animation or graphics, and editing. It can be as short as one page or as long as 10 pages, depending on the length and cost of the final piece.

2. Write a very rough draft of the script. This draft, often called a *shooting script*, helps you decide what footage you need to shoot. Don't spend a lot of time struggling over the script at this point, as it will probably change when you start editing. But simply going through the steps of putting words to your production forces you to think about the footage you need for particular parts of the piece.

3. Draw rough sketches, or *storyboards*, for individual scenes. If you are working on a large or complicated project, you will want to take this step, but for most of the work you do with QuickTime movies, a detailed shooting script suffices.

Again, don't agonize over every line of the script or plan out every camera angle in detail. The whole point of this process, of these three steps, is to make you think out the project before you pick up a camera.

 Even Hollywood is QuickTiming. All major motion pictures are laid out with a storyboard for each shot and every camera angle. Hollywood directors are using QuickTime and Premiere to turn these storyboards into animated previews of the movie. The storyboards are shot with a camcorder, digitized, and edited together with Premiere. Stephen Spielberg used this technique to review the opening segment for his film *Jurassic Park*.

Production

The production phase can be the most exciting and the most frustrating part of making a video segment. Even armed with a good shooting script, you still have to make countless decisions. You need to discuss with the cameraperson (or decide for yourself) how to light a scene and which shots to take. If you are working with actors or interview subjects, you need to direct them (telling them where to stand or sit, what to do, and when to start). You are often on a tight schedule and sometimes have to decide, on the fly, which shots you won't get because you don't have time.

 A basic guide to lighting, shooting, and directing can be found in Chapter 12.

Directing isn't for everyone. If you're an adrenaline junkie and enjoy being under pressure, you'll love the challenge. However, if the thought of having to make 30 or 40 decisions in one day gives you nightmares, you might want to think about finding a director to handle the actual production phase.

 Given all these pressures, it's really important to have a well–thought-out shooting script to fall back on when things need to be changed.

Post-Production

Post-production is where it all comes together. In a simple project, like the one you did in Chapter 7, the main tasks are writing and editing. But in many projects, post-production also includes a number of other tasks, such as:

- Logging the tapes
- Acquiring additional footage or stills from outside sources
- Acquiring or producing music and sound effects
- Getting clearance to use acquired material that is copyrighted (footage, stills, music, and effects)
- Creating graphics or animation
- Transferring footage from videotape to QuickTime format
- Writing the script
- Editing a rough assembly
- Rewriting the script
- Recording narration
- Editing a rough cut
- Adding music
- Adding sound effects
- Creating the final movie

Each production includes some subset of this list. The project you'll work on in the next section covers all these steps, except acquiring footage, getting clearance, and adding sound effects (some of which are covered in Chapter 11).

Pre-Production for a Product Demonstration Movie

Now that you've got the basic idea of what's involved in producing a video piece, let's return to the software demo your boss asked you to produce. The final piece will be about two minutes long, so you don't

have a lot of time to deliver your message. You could shoot one scene that lasts the entire two minutes, but a better idea might be to use several different elements to make your points.

Because you're going to be a spending a lot of time on this project (and a bit of money), you probably want to make sure your boss is going to like the project when it's finished. The easiest way to do this is to keep him informed at various stages of the development (as opposed to daily reports). The first stage is the treatment.

Writing the Treatment

Write one sentence that sums up what you are trying to say—one sentence, that's it. If you feel like you can't express your concept in one sentence, then you haven't refined the idea enough yet. For example, let's say you are trying to write the summary for the software demo piece and manage to boil it down to the following three sentences:

```
This QuickTime movie will start with a flashy animation to
attract attention. Then it will demonstrate the features of
our product. It will end with testimonials from current cus-
tomers praising the product.
```

That's close, but it's describing what the movie will look like, not what it's message will be. A better summary would be:

```
This QuickTime movie will show how our product combines the
power of QuickTime with advanced database technology, pro-
ducing a comprehensive database solution.
```

This sentence gives the main message: The movie will show how our product offers exciting new features. Describing how you do that comes later; you first need to have a clear idea of what your goal is.

Once you've got the central idea, you can hang all the other details—how you show the features, what images and footage to use, etc.—onto this central idea. A sample treatment for the software demo project is shown in Figure 8-1.

Note that all the various content elements fit into the central idea (you may sometimes describe particular elements in more detail). There's now a bit more shape to the project; you can even get a rough idea of how much it will cost. Try to be realistic when you estimate the costs. Better to scale back your grand ideas now rather than in the middle of production.

Software Demonstration QuickTime Movie
Treatment

Summary
This QuickTime movie will show how DataQuick combines the power of QuickTime with advanced database technology, producing a comprehensive database solution.

Content Elements
Opening animation that ends with product logo
Salesperson introducing product on-camera
Brief demonstration of software
 Basic features
 Real-world examples
 Customer testimonials (2)
 Real estate broker
 Corporate communications manager
Salesperson closing the piece
Closing animation

Production Elements
One day of shooting
 Salesperson intro and wrap-up
 Software demonstration
 Customer testimonials
Animation
 Opening animation
 Closing animation

Budget

Pre-production (3 days, in-house producer)	$ 900
Production (2 days, in-house producer)	$ 600
One day of shooting (Hi-8 camera package, crew)	$ 1,000
Animations (2 days, in-house computer artist)	$ 600
Transfer and Editing (2 days, in-house producer)	$ 900
Misc. (tape, crew lunch, other)	$ 100
Approximate Cost	$ 4,100
Out-of-pocket costs (1 shooting day & misc.)	$1,100

Figure 8-1. Treatment for the software demonstration project. All the ideas for the movie, including the cost, are summarized at a glance.

If you're part of a committee that's developing a project like this, try to get everyone to agree on the central idea, write it down in a memo, distribute it, and try to get people to sign off on it. Then, you have something concrete to rely on when someone wants to change the production.

Writing a Shooting Script

A *shooting script* is similar to the paper cut you created in the last chapter in that it describes the video and audio parts of the piece (Figure 8-2). The main difference is that the shooting script is a plan, a blueprint for the piece. It's a way for you to think ahead about the kinds of footage you need to shoot.

The shooting script shown in Figure 8-2 describes one way of organizing the piece and a fairly standard one at that. You might approach it in a different way. That's the subjective judgment each producer gets to make. But the sample illustrates basic techniques that apply to most shooting scripts.

Notice in the shooting script that most of the piece can be scripted; that is, because you are using an actor (or a colleague) to promote the product, you can specify exactly what he or she says.

Let's step through each part of the shooting script to see how it was created.

Opening

We want to grab the viewer's attention at the beginning, so we decided to use a flashy animation that ends with the product logo.

Introduction

We want to say the name of the product and give a brief introduction. We could do this with some footage of the product, but the casual viewer usually pays closer attention to a talking head (at least for five or ten seconds).

Product Demonstration

If you still have the viewers' attention—if they haven't wandered off to the next booth—they're ready for some specific examples of your product. In this example, we decided to show a person using the software on a computer before focusing on specific features. A narrator

Software Demonstration QuickTime Movie	
Shooting Script	
1. Opening Animation	Music
2. Salesperson on-camera (OC)	DataQuick—A revolutionary database package that combines state-of-the-art database technology with the visual power of QuickTime.
3. Woman typing at computer	(Salesperson voice-over [VO]) Now you can create powerful, integrated solutions ...
4. Shot over woman's shoulder ing at computer screen	to your most difficult data look-management problems.
5. Extreme close-up of computer screen showing menu selection	With easy-to-use commands, you can quickly add ...
6. Close-up of computer screen: QuickTime movie appears on the screen	QuickTime movies to individual records in your database.
7. Close shot of woman's face	The possibilities are limited only by your imagination.
8. Close-ups of screen: Real estate example	Real estate ...
9. Manufacturing example	Manufacturing ...
10. Corporate communications example	Corporate communications ...
11. Ima Buyer, real estate agent on-camera	Buyer—DataQuick gives me a powerful edge in the competitive real estate market. When clients come into my office, not only can I show them a list of houses they might want to buy, I can also show them what the houses really look like, inside and out. That's a tremendous benefit for them and a real advantage for me.
12. Les S. More, corporate communications manager on-camera	More—I had been working with QuickTime for just six months, and my hard drive was already littered with QuickTime movies I desperately needed to not

Figure 8-2. Shooting script for the software demonstration project. Here you can see what scenes need to be shot and what the actors will say.

	only organize the movies but also track where they came from, who held the copyright, and so on. DataQuick was the answer to my dreams.
13. Salesperson on-camera	DataQuick—The QuickTime solution that solves your current needs and opens up new possibilities for the future.
Closing animation	Music

Figure 8-2 (continued). Shooting script for the software demonstration project

describes the basics of the program. This is called a *voice-over* because the narrator's voice is heard over the pictures.

In a scene such as this where we are writing narration to match the video, we need to think about both the pictures and the words. We step through each shot in the scene to demonstrate the process:

Shot 3 (Opening shot): It's a good idea to introduce the scene with an establishing shot; in this case, a woman typing at a computer. Because we aren't showing any details of the program, the narration deals with generalities.

Shot 4 (Over the shoulder): This shot serves as a bridge between the opening shot and a shot of the computer screen. We are gradually moving the viewer's attention from the overall scene to the computer screen. Again, we aren't showing the details of the program, so the narration is general.

Shot 5 (Close-up of the screen—Menu): Here, we're matching the pictures to the words, showing the viewer what the narrator is talking about.

Shot 6 (Close-up of the screen—QuickTime movie): Again, we're matching pictures to words.

Shot 7 (Close shot of woman's face): The last two shots were of the computer screen, so we want to introduce a different shot for variety's sake. Here, the picture (shot of the woman) and the words (your imagination) work together to make the change.

Shots 8-10 (Series of examples): Now, we go back to the computer screen to show several examples of the things a person can do with the product.

Customer Testimonials

Using customer testimonials is a tried and true way of establishing credibility for a product. Of course, because you're editing the piece, only good, positive testimonials will be shown; so, it's a kind of a contrived credibility—but it works anyway. You don't know beforehand what the person will say exactly, but for the purposes of a shooting script, you can just make it up. This also helps you guide the person during production to say something that fits into the piece.

Salesperson Wrap-Up (or Outro)

Because we used a shot of the salesperson on camera to introduce the product, we'll use a similar shot to wrap-up the piece.

Closing Animation

Because this piece may run in a continuous loop, we'll close the piece with an animation whose ending matches the beginning of the opening animation.

Production for the Demo

There are four main production elements for this piece: the salesperson's intro and outro, the product demo, and the two testimonials. We'll talk about the nitty-gritty details of production in Chapter 12, but here are some thoughts about how the elements for this piece would be shot, which may be applicable to your situation.

Salesperson Intro and Outro

The salesperson should be looking directly at the camera because you want him or her talking to the viewer.

Because the salesperson has to look good—i.e., confident—and say the right words, it's a good idea for you to watch his or her delivery and have an assistant review the script as the person is talking. After each take, the assistant tells you whether the salesperson said the right words.

Product Demo

Establish a line of interest and stay on one side of it. In this case, the line of interest runs between the woman at the computer and the computer screen.

Get extra shots of the woman, such as her typing on the keyboard and glancing up and down from the keyboard to the screen, so that you have several options when you are editing. A shooting script is only a guide; you should always cover yourself with extra shots and cutaways.

Use a tripod when shooting the computer screen. Most likely you'll be zooming in to get the close-ups, and it's difficult to keep the camera steady for these shots without a tripod.

Customer Testimonials

The standard format for customer testimonials is to have the customer talk to someone off-camera, that is, someone (yourself) who is not seen. This way, they do not look directly into the camera, which helps distinguish them from the salesperson.

Because you are using two testimonials, it's a good idea to shoot the interviews so that each person appears on a different side of the screen; i.e., customer 1 is on the left side of the screen and customer 2 is on the right side. Figure 8-3 shows how these interviews would be shot.

Post-Production for the Demo

Now all you have to do is put the piece together. Of course, as you start building the piece, problems may arise, so be prepared to deviate from the shooting script. After all, what matters is not how well you follow your plans but how the final piece looks.

Preparing for the Edit

In this case, we followed the shooting script fairly closely, so a paper cut isn't necessary. This is generally true for heavily scripted productions—that is, productions where you specify beforehand what you want people to say and do.

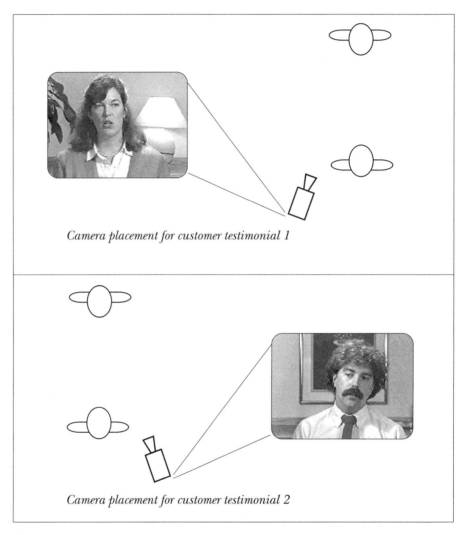

Camera placement for customer testimonial 1

Camera placement for customer testimonial 2

Figure 8-3. When shooting two interviews that will be placed one after another in the edited video segment, it is often a good idea to shoot them so that the people face different ways.

Creating the Opening and Closing Animation

Let's say we've built a simple but elegant opening animation in Macro-Mind Director (Figure 8-4). The name of the product, DataQuick, is split into two words (*Data* and *Quick*), which fly in from opposite sides, cross each other, and form the word *DataQuick*.

Figure 8-4.

The opening animation for the software demonstration starts with a simple animation showing the product's name. This animation was created in MacroMind Director by splitting the name into two parts and moving them across each other from opposite sides of the screen.

When building animations to include in QuickTime movies, there are a number of things you should keep in mind:

- You should make the horizontal and vertical dimensions of the animation match the size of the QuickTime movie. In this case, the QuickTime movie is 240 by 180 pixels, so the animation is built to fit that window size. This reduces the possibility of introducing artifacts when you convert the animation to a QuickTime movie.

- You should make sure there is an extra second at the beginning and end of the animation. This will allow you to use special effects to introduce the animation. In this case, there is one second of a blank white screen at the beginning and three seconds of the DataQuick title at the end. You remove the extra material once you import it into the editing program.

- Before animation can be used in a QuickTime movie, it needs to be converted to an animation file format, such as PICS. This is usually accomplished with an Export command within the animation program. The exporting process makes a copy of each frame of the animation and stores the copies in one file. When imported into the editing program, each frame of the animation lasts for one frame of video. This means that you should set the *tempo*, or speed, of your animation (within the animation program) to 30 frames per second. Otherwise, the speed of your animation changes when you use it in a QuickTime movie.

Note Many animation programs now export animations as QuickTime movies. You should use a lossless compression method (such as Animation at the High or Most settings) so that you don't introduce compression artifacts.

In this case, the closing animation is going to be the same as the opening one, except played in reverse (the word *DataQuick* splits into two parts, which then cross and fly off the screen). In Director, this is accomplished by reversing the animation and then exporting the modified animation as a separate PICS file.

If you are going to be using narration to explain the elements of an animation segment, it's a good idea to break the animation into several parts. Add extra time at the beginning and end of each part, and export them as separate PICS files. This allows you to, in a sense, pause the animation to make it match the words of the narration.

Logging the Tapes

This production involves a variety of different elements (saleperson's intro, customer testimonials, etc.), and you need to be able to find any particular element quickly. In editing, organization is not a virtue, it's a necessity. The standard way of organizing your material is by *logging* the videotapes (logging was covered in detail in Chapter 7).

As you go through the tape of the salesperson's intro and outro, you should note the best versions, or *takes,* and where they occur on the tape. The only part that requires some tricky editing is the product demo. You should therefore write a detailed log of that footage (the woman at the computer and the screen shots), describing each shot and its location on the tape. Review the tape of the customer testimonials and note the location of the best takes.

Transferring the Material

At this point, you should have identified the key footage for the piece. Digitize the footage, making sure there is a little extra at the beginning and end of each shot. Transfer each product demo shot separately; this makes it easier to find a particular shot later on. Remember to provide descriptive titles for each shot, so you can identify the file without having to view it.

Precede the descriptive title with a letter of the alphabet in ascending order (*a* for the first shot, *b* for the second shot, *b2* for a second version of the second shot, etc.). That way when you import them into your editing program, the shots will be listed in the order you want to use them.

Recording the Scratch Narration

Using a sound digitizer, record the narration that will be used as voice-over material. You could record the salesperson's final voice-over now, but you would have to record it again if you change the script. A better idea is to record a *scratch narration* (or *scratch track*) of yourself reading the voice-over. This allows you to change the script and rerecord the narration easily, without having to involve another person. Then, when the piece is finished, you can record the salesperson and replace the scratch narration with the real one.

 Narrators usually talk more slowly than normal so that viewers can understand their words clearly. Therefore, be careful to talk slowly when recording scratch narration; otherwise, the real narration will be longer and you'll have to re-edit the movie to fit it in.

When recording the scratch narration, record each chunk of narration separately. This allows you to move small pieces of narration around to fit the pictures. A huge piece of narration can't be manipulated that way. A chunk of narration covers one idea and ends in a definite way; for example,

```
Now you can create powerful, integrated solutions
```

is not a chunk of narration because although it is a complete idea, it is leading into the next phrase. The whole chunk is

```
Now you can create powerful, integrated solutions to your
most difficult data management problems.
```

In this example, there are seven different chunks of narration:

- Now you can create powerful, integrated solutions to your most difficult data management problems.
- With easy-to-use commands, you can quickly add QuickTime movies to individual records in your database.
- The possibilities are limited only by your imagination.
- Real estate ...
- Manufacturing ...
- Corporate communications ...
- DataQuick—The QuickTime solution that solves your current needs and opens up new possibilities for the future.

Chunks 4, 5, and 6 consist of only one or two words, but they're still chunks because they convey an entire thought. The use of chunks will become clearer once you start editing.

Editing the Rough Cut

Now we step through the process of editing the rough cut. Because most of the piece was scripted, all we have to do is drop in the best takes of each section. The only detailed editing we do is in the product demo section.

 We're using Adobe Premiere to demonstrate the process, but the basic steps would be similar in VideoShop or other editing programs. Your particular video piece would involve different video clips and most certainly would be edited differently. But many of the techniques described in these sections are applicable to your situation.

Importing the Clips

To get started, we import into Premiere all the clips we digitized. This includes the opening and closing animations, the video clips, and the chunks of scratch narration. The video and audio cuts used in this example are listed in Table 8-1.

Adding the Opening Animation

The animation clip is dragged from the Project window and placed at the beginning of the movie. We then use the stretch pointer to remove the pad at the beginning of the animation cut until the timing seems right (as seen in a preview). The Out point is set so that the title stays on for two seconds. We changed the beginning of the cut, so we drag the cut to the beginning of the movie again.

Adding the Salesperson's Intro

As the following illustration shows, the video clip of the salesperson's intro (cut 2) is dragged into video track B of the Construction window so that we can create an overlap with the animation of 15 frames (see page 190).

Table 8-1. Video and Audio Cuts Used in the Product Demonstration Segment

Cut	Description
Cut 1	Opening animation
Cut 2	Salesperson intro
Cut 3	Establishing shot of woman typing at computer
Cut 4	Over-the-shoulder shot of the woman at computer
Cut 5	Computer screen—menu selection
Cut 6	Computer screen—QuickTime movie
Cut 7	Woman's face
Cut 8	Computer screen—real estate example
Cut 9	Computer screen—manufacturing example
Cut 10	Computer screen—corporate communications example
Cut 11	Customer testimonial 1
Cut 13	Customer testimonial 2
Cut 13	Salesperson outro
Cut 14	Closing animation
Audio cut 1	Now you can create powerful, integrated solutions to your most difficult data management problems.
Audio cut 2	With easy-to-use commands, you can quickly add QuickTime movies to individual records in your database.
Audio cut 3	The possibilities are limited only by your imagination.
Audio cut 4	Real estate ...
Audio cut 5	Manufacturing ...
Audio cut 6	Corporate communications ...
Audio cut 7	DataQuick—The QuickTime solution that solves your current needs and opens up new possibilities for the future.

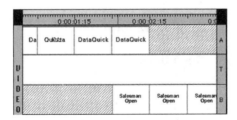

 The figures for this section were cropped to focus on the important elements. Your screen might look a bit different.

We open cut 2 in the Clip window and set the In and Out points with a five-frame pad at the beginning and end of the cut. The In point is then set 15 frames earlier so that the salesperson doesn't start talking until the transition between the animation and the salesperson's intro is finished.

The next step is to open the Transitions window and drag the Cross Dissolve effect into the T track in the Construction window. We position the effect and modify its length with the stretch pointer so that it matches the overlap between the animation and salesperson cuts.

Editing the Product Demo Scene

Okay, now for some detailed editing. In this scene, we need to edit the shots so that they fit the words and create a sense of progression visually. The first two shots of the scene are the most difficult, so we'll look at those two in detail.

Cutting on Movement As mentioned in Chapter 6, when editing scenes in which there is some kind of movement, it's often a good idea to put part of the movement in one shot and the rest of the movement in a second shot. The continuity of the motion across the edit attracts the viewer's eye and de-emphasizes the edit.

In this case, we want to edit the establishing shot of the woman (cut 3) and the over-the-shoulder shot (cut 4). We edit the two shots so that the movement of the woman tilting her head down from the screen to the keyboard and back up again starts in cut 3 and ends in cut 4. Here's how that would be done in this example.

The establishing shot of the woman sitting at the computer (cut 3) is dragged from the Project window into video track B in the Construction window and placed right next to the salesperson intro cut. The audio portion of the clip automatically goes into audio track B.

 Editors often refer to a particular cut as a "shot." Therefore, the words *cut* and *shot* are used interchangeably in this section.

Next, the over-the-shoulder shot (cut 4) is dragged into the Construction window and placed next to the establishing shot, as shown in the following illustration:

man open	Cut 3 Establishing Shot of woman	Cut 3 Establishing Shot of woman	Cu Es Sh	Cut 4 Over the Shoulder	Cut 4 Over the Shoulder	

What we want to do now is set the Out point of cut 3 and the In point of cut 4 so that part of the movement of the woman's head appears in cut 3 and the rest of the motion appears in cut 4. To find the correct Out point for cut 3, we open it in the Clip window. We won't worry about the In point right now; we'll set it later when we add the narration. Playing the cut, we stop at the point where the woman tilts her head down. The Out point is set at the frame where her head has stopped moving downward:

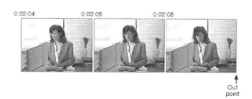

The Clip window is kept open.

We then open cut 4 in the Clip window and scroll through the cut until we see the woman tilt her head down. The In point for this clip is set where her head stops moving downward:

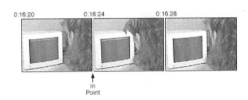

By referring back to cut 3 in the Clip window, we can confirm that the woman's head is in about the same position in both cuts.

Because we've changed the length of both cuts, we go back to the Construction window and drag cut 4 to the left so that it sits against cut 3. When the cuts are previewed, the woman's head should start down in cut 3; then in cut 4, it should pause briefly and then move back up to the screen.

One reason for editing these two cuts together this way, besides making the edit smoother, is that the motion of the woman's head from the keys to the screen in cut 4 leads the viewer to the screen, which is shown in the next shot, cut 5.

If, in your situation, the motion seems too abrupt or jerky, either set the Out point of the first cut later or the In point of the second cut earlier. If there seems to be too much of a pause, then either set the Out point of the first cut earlier or the In point of second cut later.

Now that we've got the visual edit the way we want it, we add the narration.

Matching the Video Edit to the Words Cuts 3 and 4 should last the same amount of time as the voice-over cut, which lasts about seven seconds. At this point, the video cuts are much too long and probably not in the correct position. The question is, Where should the change of shot (the edit) occur in relation to the voice-over?

A general rule is to change shots during a pause in the audio. In this case, there is a pause between the words "solutions" and "to" in the sentence, "Now you can create powerful, integrated solutions to your most difficult data management problems."

We need to change the length of cut 3 so that the video edit occurs between the words "solutions" and "to." The first audio cut is opened in the clip window. We set the In and Out points. There should be a five-frame pad at the beginning and end of the cut. The cut is then

played at normal speed to find the pause between the words "solu-tions" and "to." A place marker is set at this point:

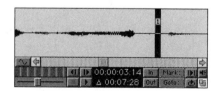

Dragging the clip into the Construction window, we place it in audio track A underneath video cuts 3 and 4 and align the place marker with the edit between the video cuts:

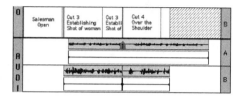

The part of the narration before the place marker doesn't last long enough to cover all of video cut 3. We don't want to leave such a large gap in the audio track, so we shorten video cut 3 with the stretch pointer so that it begins at the same time as the audio cut:

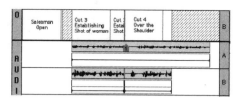

Then we slide video cuts 3 and 4 and the audio cut to the left to remove the gap in the video track:

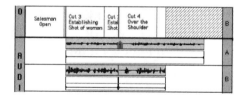

You can use the multi-track selector to move several tracks to the left or right.

Cut 4 is then shortened by using the stretch pointer on the end of the cut and dragging it to the left. The end of cut 4 should line up with the end of the voice-over cut:

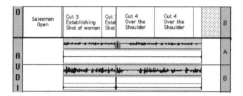

By previewing the cuts, we see the establishing shot while we hear the first part of the voice-over; then, after the word "solutions," the shot changes to the over-the-shoulder shot, and we hear the rest of the voice-over.

In this case, the background sound (*ambience*) for cuts 3 and 4 is so loud that we can't hear the voice-over clearly. This problem is fixed by reducing the volume of the background sound with the audio fade control located at the bottom of the audio cuts:

This might seem like a lot of work for two shots, but adding subtle touches like editing on movement makes the final piece much smoother and easier to follow.

Matching Actions with Words Whenever possible, you should try to match an action in a shot with a particular word in the audio track. In this case, the first screen shot shows a pull-down menu appearing, someone choosing an item from the menu, then the item flashing as it is selected:

To match this action with the word "commands" in the phrase "with easy-to-use commands you can quickly add," we take the following steps.

Voice-over cut 2 (chunk 2) is dragged into the Construction window and placed in audio track A. We position voice-over cut 2 about a second to the right of the current end of the movie (to give us a little room to work):

We open it in the Clip window and set its In and Out points with five frames of pad at the beginning and end. Then by listening to the cut, we find the point where the word "commands" starts. A place marker is set at this point.

Now we go back to the Construction window and drag the menu-selection clip (cut 5) into video track B and position it just after cut 4. The cut is then opened in the Clip window and we can find the frame where the "Add Movie" option is first highlighted. We set a marker at this frame.

Going back to the Construction window, we position the cursor directly over the marker in cut 5, click on the mouse, and drag the cut to the right until the video marker is aligned with the marker in the audio clip:

Cut 5 extends before the beginning of the audio cut, so we use the stretch pointer to align the beginning of cut 5 with the beginning of audio cut 2. We then slide both cuts to the right to eliminate any gaps:

The item should be highlighted just as the word "commands" is heard.

Covering the Rest of the Voice-Over Cut Now let's say we want to add a new shot to cover the part of the voice-over from the words "digital video" to the end of the sentence. We again match an action in the video with a particular word in the audio track. In this case, the action is the digital video clip appearing and the word is "movies."

First we shorten cut 5 so that it ends after the word "add." We open voice-over cut 2 in the Clip window and place a marker (2) at the pause between the words "add" and "digital."

Going back to the Construction window, we use the stretch pointer to adjust the end of cut 5 until it lines up with marker 2:

The next cut, cut 6, shows a digital video clip appearing in a database record. We want to match this action with the word "movies." We open cut 6 in the Clip window, find the frame where the video clip first appears, and place a marker (3) at that point. We open voice-over cut 2 in the Clip window and find the point where the word "movies" begins and set a marker (3) there.

Cut 6 is dragged into the Construction window and placed in video track B. We set a later In point for cut 6 so that we have room to align the markers. Then we align the marker in cut 6 with marker 3 in the voice-over cut 2:

We then use the stretch pointer to eliminate any gap between cuts 6 and 5 and to match the end of cut 6 to the end of voice-over cut 2:

For this example, these cuts would look as follows:

- We see the menu bar appear as we hear the phrase "with easy-to-use."
- As we hear the word "commands," we see the item flash.
- As the item finishes flashing, we hear the phrase "you can add."
- After the word "add," the shot changes and we see a database format and hear the word "QuickTime."
- As we hear the word "movies," we see the QuickTime movie appear and then hear the rest of the voice-over "to individual records in your database."

Although all this seems a bit complicated (on the written page), once you try it a few times yourself, you should be able to get the hang of it.

We follow the same steps for adding video cuts 7–10 and voice-over cuts to the movie. The basic steps are:

1. Drag the voice-over cut into the Construction window.
2. Set the In and Out points in the Clip window, remembering to add five frames of pad to the beginning and end (you might want to have a 15-frame pad for short voice-overs, such as numbers 4, 5, and 6).

3. Pick a word to match the action in the video cut and set a marker at that point.

4. Drag the video cut for that voice-over into the Construction window and place it next to the last video cut in the movie.

5. Open the video cut in the Clip window, find the action you want to match to the audio, and set a marker at that point.

6. Align the markers in the video and audio cuts. You may have to set a later In point on the video cuts to give yourself room.

7. Use the stretch pointer to remove any gap between the video cuts.

8. Use the stretch pointer to match the end of the video cut with the end of the voice-over cut.

9. Reduce the background sound of the video cut so that you can hear the voice-over clearly.

Tip

Remember to save your project every now and then so you don't lose all your work if the computer goes down.

Add Customer Testimonials

Adding the customer testimonials is easy compared to what we've just been through. Essentially, all we have to do is set the In and Out points and add them to the end of the movie.

The only wrinkle is that we're going to add a little flash by using a special effect for the transitions into and between the customer testimonials.

The first testimonial (cut 11) is dragged into the Construction window and placed in video track A (so we can overlap it with cut 10, which is in track B). We open the cut in the Clip window and set the In and Out points so that there are 30 frames (one second) of pad at the beginning and end of the cut. We need these large pads because we want the transitions to occur before and after the cut, not during the cut itself.

Going back to the Construction window, we increase the resolution of the time ruler so we can line up the cuts more precisely.

We position cut 11 so that it begins at the end of cut 10:

Using the stretch pointer, we extend the end of cut 10 so that it overlaps cut 11 by 30 frames as shown by the next illustration:

We then open the Transitions window and locate the Push transition. Its icon is dragged into the Construction window and placed in the T track between the overlap of cuts 10 and 11 (Figure 8-6).

The reason we used 30 frames of overlap for this transition is that the Push effect moves too quickly if the overlap is shorter.

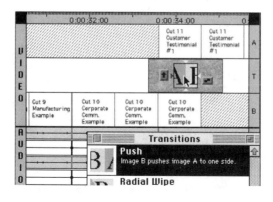

Figure 8-6.

Placing the Push transition in the overlap between cuts 10 and 11

Let's make a couple of adjustments now to customize the transition. First, we click on the track selector arrow to make it point upward (from track B to track A). Next, we click on the left edge selector to set the effect, so that track A pushes in from left to right:

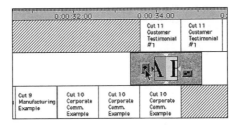

Then, the length of the transition is adjusted to match the length of the overlap:

Okay, that's it for the first testimonial. Now, we add the second one using the same steps, but we place the second testimonial in track B:

This time, we click on the right edge selector of the Push transition, so that cut 12 pushes in, moving from right to left.

Previewing the last few cuts, we see the first testimonial push in from the left, and then, when it ends, the second testimonial pushes in from the right.

Adding the Salesperson Outro and Closing Animation

Now we use another transition for the transition from the second testimonial into the salesperson outro.

The salesperson outro (cut 13) is dragged into the Construction window and placed in video track A after the end of cut 12. We open it in the Clip window and set the In point with 20 frames of pad and the Out point with 15 frames of pad. Now we go back to the Construction window and position cut 13 so that it overlaps cut 12 by 20 frames, as shown by the following illustration:

We drag the Cross Dissolve transition from the Transitions window and place it in the overlap between cuts 12 and 13. The Track Selector arrow is adjusted so that it points upward. We then adjust the length of the effect to match the overlap.

Now we drag the closing animation (cut 14) into the Construction window and place it in video track B. Opening it in the Clip window, we set the In point with 15 frames of pad and the Out point with 10 frames of pad.

Going back to the Construction window, we position cut 14 as shown next so that it overlaps cut 13 (salesperson outro) by 15 frames:

We add a Cross Dissolve transition as we did in the previous step, except that we change the Track Selector arrow so that it points down this time.

Previewing the last few cuts, we see the first testimonial push in from the left, then the second testimonial push in from the right. This shot then dissolves into the salesperson outro, which then dissolves into the closing animation.

We've used fairly standard transitions in this section but feel free to play around with others. A word of caution: You shouldn't use too many different kinds of effects within a short section of a movie unless you're trying to confuse the viewer.

All the cuts are assembled in their correct places in the Construction window, so we can make a movie of the project using the Make Movie command under the Project menu.

You might want to adjust the Output Options (under the Project menu) to reduce the quality, and therefore, the size of the movie, so it doesn't take up too much space on your hard drive. You then increase the quality setting when you make the final movie.

Editing the Final Cut

Going back to our fictitious example . . . you've shown the rough cut to your boss, and he loves it. There are only a few minor changes he wants you to make:

- He'd like you to switch the order of the shots at the end of the voice-over, so the real estate example is last.

- He wants you to add music to the beginning of the piece and have it last until the customer testimonials, then begin again under the salesperson's outro, and continue to the end of the piece.

Based on all the work you put into this project, these are fairly minor changes. Maybe showing him the shooting script worked after all. Let's step through each change in order.

Switching the Order of Shots

This change involves six cuts, cuts 8, 9, and 10 and their associated voice-over cuts. We aren't changing the length of any of the shots, so all we have to do is switch the order of the cuts—they should fit back into the same space in video track B and audio track B. Here's how it's done:

1. We adjust the time ruler so that we can see all three cuts.
2. Cut 8 (real estate example) is selected and dragged into video track A (Figure 8-7).
3. The audio portion of cut 8 is dragged into audio track C. We don't have to line it up with the video portion because we'll be moving it again soon.
4. We drag cut 9 to the left until it rests against cut 7.
5. We drag cut 10 to the left until it rests against cut 9 (Figure 8-8), then reset its length to two seconds.
6. The video portion of cut 8 is dragged from track A and placed in the gap in video track B (created when we moved cut 10).
7. The audio portion of cut 8 is dragged from audio track C and placed in the gap in audio track B (created when we moved the audio).
8. We extend cut 8 so that it overlaps cut 11 by 20 frames.
9. We switch the order of the voice-over cuts (using audio track C) so that they match the video cuts.

In this example, the cuts appear as shown in Figure 8-9. You should note that the Cross Dissolve transition (formerly between cuts 10 and 11) is now between cuts 8 and 11. You don't have to reset the transition.

Figure 8-7.

Switching the order of cuts— Step 1. Cut 8 is placed temporarily in video track A to create space for cut 9. The audio for cut 8 is placed temporarily in audio track C.

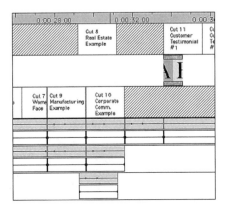

Figure 8-8.

Switching the order of cuts—
Step 2. Cuts 9 and 10 are slid
to the left.

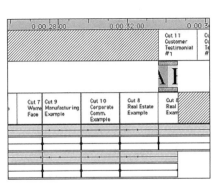

Figure 8-9.

Switching the order of cuts—
Step 3. Cut 8 is dragged from
video track A and placed to the
right of track 10. The audio cut
for cut 8 is moved from audio
track C and placed under cut
8. Now the order of cuts is cut
9, cut 10, and then cut 8.

Adding Music

You were going to add music anyway, but you wanted to give your boss
the satisfaction of making changes, so you didn't bring that up. You
have a friend who's a musician, and he's given you some samples of his
work that you can use.

**If you want to use copyrighted music in your piece, you must get permis-
sion first. How do you know if it's copyrighted? If you can buy it in a
store, it's probably copyrighted. Look on the label. Using copyrighted
material without permission is against the law, and you could wind up get-
ting sued. If you are really dying to use a particular piece of music that's
copyrighted, contact the owner of the copyright, and ask for the right to
use it (this process is called *getting the rights*). The fees can range from a
few bucks to a few thousand dollars. An attractive alternative is to look for
collections of clip music. You can usually purchase the rights to use this
kind of material for a hundred dollars or so—and you'll never have to
worry about getting tangled up in legal battles.**

We are using music in two different sections of the video piece, so we need to pick two separate pieces of music. For the beginning of the video, we want a section of music that begins cleanly. For the end of the piece, we want something that either has a definite end or something we can fade out nicely, such as a rhythmic pattern.

In case you were thinking that we could match the music at the end of the piece with the beginning so that it could loop when the piece starts again, be forewarned that it is difficult to do because our ears are good at picking out edits in music. It's much easier to simply fade up at the beginning and fade out at the end. Silence is easy to match.

Once we select the sections of music we want to use, we digitize them, making sure we have a few extra seconds at the beginning and end of each clip to give us some flexibility in editing. The clips are imported into Premiere. Music cut 1 is dragged into audio track C and placed at the beginning of the movie.

The music is faded in under the opening animation by using the audio fade control located at the bottom of the music cut. By clicking the pointer on the middle line of the audio fade control, we create a *handle* at about the 15-frame point on the timeline:

This handle sets the end of the audio fade in; that is, the music is at the normal level within 15 frames of the beginning. We then click on the handle located the beginning of the cut and drag this handle down to the bottom of the box:

We also want to reduce the volume of the music while people are talking; so, we need to create a handle at the beginning of cut 2:

Then we create another handle about 20 frames later and drag this handle down about halfway between the middle line and the bottom:

 We could also have the music fade up only to the background level used during clip 2—as opposed to fading up to normal level and then back down.

Now we want to make the music last until the beginning of the customer testimonials. To see the whole piece, we reset the time ruler to 10 seconds. Then we extend the music cut with the stretch pointer so that it reaches the end of cut 8.

To set the music at the same level throughout the salesperson and voice-over sections, we find the end of the music cut. We then create a handle in the music cut about 20 frames before the end of cut 8 and drag this handle down to about the same point as the previous handle:

This point is also where we want to fade the music out so that we don't hear it over the customer testimonials. To do this, we click on the handle at the end of the music cut and drag it to the bottom of the audio fade control box:

These two handles set a 20-frame audio fade out. If we want a longer fade out, we should set a new handle farther back (to the left) and drag the middle handle down to make a smooth fade from the new handle to the end of the cut.

Adding the second section of music is done the same way with two exceptions:

- We should fade the music in to a low level because the music comes in under the salesperson's outro.
- We should fade up to full volume at the beginning of the animation.

Replacing the Scratch Narration

We're almost there. All we have to do is record the narrator and replace the scratch narration. To make sure you don't have to re-edit a piece because the real narration is longer or shorter than the scratch narration, you should go through the movie (either in the Construction window or in the movie itself) and write down how long each chunk of narration lasts (next to its position in the script). Then, record the narrator, using a stopwatch to time each chunk, and have the narrator redo each chunk until it matches the time on the script. This way, you know each chunk fits.

Back to our example: The new chunks of narration, the final narration, are imported into Premiere. Then each piece of scratch narration is replaced with the final narration using the following steps:

1. A new chunk of narration is opened in the Clip window. The In and Out points are set with five frames of pad.

2. The corresponding chunk of scratch narration is selected and then deleted by pressing the ⌈Delete⌋ key.

3. The new chunk of narration is dragged into the Construction window and placed where the scratch narration was.

4. The stretch pointer is used to eliminate any gaps.

We work our way through the movie, replacing each piece of narration as we go. When we're done, we preview the entire movie to make sure there aren't any mistakes.

Then, the Output Options settings are reset to the highest-quality settings, and the final movie is created using the Make Movie command.

Wrap-Up

If you work on a project like this, it will probably look a lot different because it will contain different elements than the example used in this chapter. But the basic techniques used in pre-production, production, and post-production are similar for most video projects. As a quick review, the basics steps are listed below:

Pre-Production

- Writing the treatment
- Writing the shooting script

Production

- Shooting the necessary footage, making sure to get enough extra shots and cutaways

Post-Production

- Logging the footage
- Writing the script (in this example, the script didn't change)
- Preparing for the edit, transferring the footage and audio clips
- Editing the rough cut
- Editing the final cut

This example concludes the discussion of continuity editing. We're now going to move on to a freer form of editing—montage cutting. But as you'll find out, freer doesn't necessarily mean easier.

CHAPTER 9

Montages and Mixed Formats

T he previous three chapters discussed continuity editing. This chapter examines the more impressionistic and subjective world of montage and mixed-format editing.

Comparison of Editing Styles

Visual storytelling through the use of continuity editing is an extremely powerful way to deliver a message. By creating or fabricating a reality, you provide the viewer with a detailed context for the message. You can convey specific information, facts, opinions, etc., using dialog or narration to support the visual story.

In addition, it's a comfortable style to watch because it's a facsimile of reality. The pacing is often leisurely, so the viewer can absorb the information and follow the story. This is why continuity editing is used for a wide range of video formats, from news reports and documentaries to sitcoms and full-length movies.

In contrast, the objective of montage and mixed-format editing is to convey an impression or a feeling.

A *montage* consists of a series of short, disconnected shots and conveys its message primarily through imagery and often music. Examples of

. .

209

montage include certain types of commercials, impressionistic MTV segments (where the singers aren't shown singing the song), and video art pieces. If used in documentaries or movies, montages are usually short segments that support the central theme of the piece, show a passage of time, or enhance the emotional message of a particular segment.

A *mixed-format* piece is similar to a montage in that it is a series of short, disconnected images, but it differs from a montage in that it can include shots with dialog. It often delivers specific information in narration. Examples include most commercials (either for products or politicians), sales promotions, and movie previews.

The advantage of these editing styles is that they can deliver their messages quickly. This makes them an attractive method for editing commercials and other types of short video segments. The disadvantage is that video segments edited in these styles are not rooted in a story or along a narrative line, so it's hard for viewers to stay connected for long periods of time. Eventually, most viewers want some kind of structure.

If you've read the previous chapters, then you already have most of the physical editing skills to cut pieces in any of the formats. The mechanics of putting the shots together and timing them to music is fairly straightforward. The more difficult part is making sense of what you're doing, which is the subject of this chapter.

Montage Basics

In a montage, the individual shots don't matter as much as the overall effect. You are trying to convey a feeling, an impression, which is created by the combination of images more than by the images themselves. For example, consider the visual elements described in Figure 9-1. The shots, which show various aspects of San Francisco, don't tell a story. There aren't any characters and there isn't a plot. But if you saw this series of shots on television, you'd probably come away with a general impression of San Francisco as an interesting, fun, and beautiful city.

The shots used in a montage differ from those of a narrative segment in several ways. Generally speaking, they rarely last longer than a few seconds. This keeps the montage moving along, preventing the viewer from dwelling on any particular shot (which might detract from the overall effect). Another difference is that shots in a montage usually do not show someone talking on camera. If there is narration, it is not

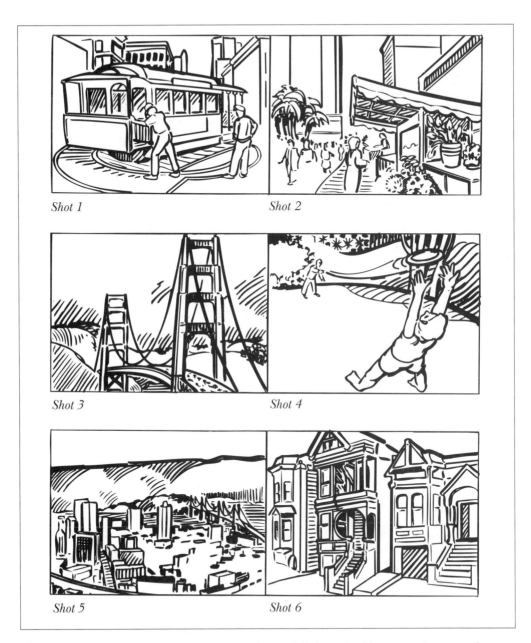

Figure 9-1. San Francisco montage. Shot 1: full shot of cable car turning around. Shot 2: long shot of shoppers wandering along an outdoor market. Shot 3: extreme long shot of Golden Gate Bridge. Shot 4: long shot of people playing frisbee. Shot 5: extreme long shot of San Francisco skyline. Shot 6: long shot of "Painted Ladies" houses in the Haight district.

tied to any one shot because the shots don't appear on the screen long enough for the viewer to make a connection.

 You may notice that there are few hard-and-fast rules with montage editing; i.e., "the shots are usually this or that" and "generally speaking, the shots do this or that." This isn't ambivalence on the part of the author, it's an indication that montage editing is very subjective. What works for you might not work for someone else. The general rules are just that—general rules—and should be deviated from as often as warranted.

The visual and audio clips used in a montage are rarely linked or in synch. The video clips don't necessarily have an audio component, and the audio components generally don't include a video component. The video and audio tracks are linked through editing, and through the pacing and timing of the video and audio edits.

This unlinking of the video and audio tracks can be a bit disconcerting at first because of all the options it allows. But the flip side of this unlinking is a tremendous creative freedom. As you edit more and more montages, you will develop your own personal style. But in the beginning, it's a good idea to start off with some basic concepts and then deviate from them as you develop more confidence.

Types of Montages

There are two loose categories of montages: those in which the various images support and supplement each other, and those that use contrasting imagery to produce conflict and, through that conflict, convey a message not inherent in the images themselves.

Montages with Supporting Imagery

This type of montage conveys its message or impression through the compilation of similar shots; that is, shot 1 plus shot 2 plus shot 3 plus shot 4 convey the idea. Each shot adds a little bit to the overall impression. The montage of San Francisco images discussed previously is one example of this type of montage.

There are many different ways of using a set of supporting images to convey a larger concept or impression. A few common methods are discussed in the next sections.

Progression in Space or Time

A common technique for using similar shots in a montage, which has fallen into disfavor of late, is to convey a sense of movement in space or time. For example, Figure 9-2 describes several shots that show different points in a person's travel from Chicago to New Orleans. In a way, these shots tell a story, so they don't fit the strict definition of a montage. But because they don't include dialog and are not linked by spatial continuity, the sequence is considered a montage.

There isn't one correct set of shots for this montage. Anything that conveys the sense of movement or progression works. If, however, you are trying to convey two movements—the physical travel and an emotional transition corresponding to the trip—then the shots must satisfy both progressions.

For example, if you want to convey the sense that the person is dreading his or her arrival in New Orleans, then the early shots would likely show the person looking normal or rested, while the later shots would show him in an agitated state (tapping his fingers, looking pensively out the window, etc.).

Notice that this example also contains a second type of progression—passage through time—that can be used by itself. For example, the shots shown in Figure 9-3 convey the often frantic and hectic life of a TV director. The early shots show the director in command, upright in his chair, his actions crisp. Over the course of the montage, he looks increasingly tired until finally he slumps in his chair and closes his eyes.

Again, this montage is telling a story, so it doesn't fit the strict definition of a montage. But here the basic rules of continuity are broken on almost every edit—the director jumps from one position to another (a dissolve is used to soften the edits). This is not a reality that can exist. It is an impression, an artistic compression of that person's experience.

The freedom from having to maintain continuity is one of the strongest reasons for using a montage. You can condense time to a greater extent in a montage than in a segment edited for continuity. In addition, you can change camera angles at will to impart a surrealistic quality to the montage.

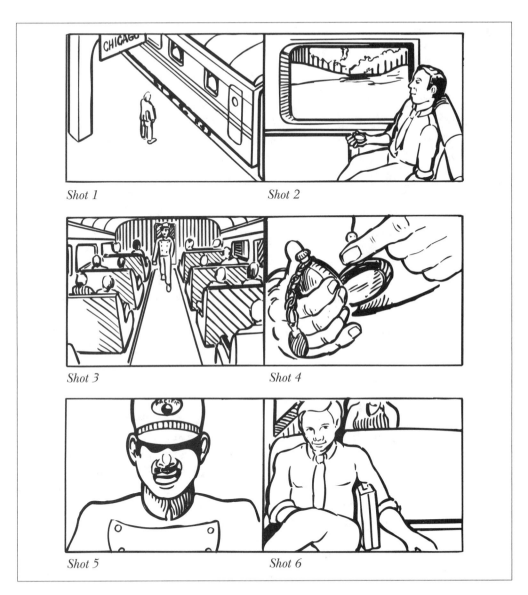

Shot 1

Shot 2

Shot 3

Shot 4

Shot 5

Shot 6

Figure 9-2. Trip montage. Shot 1: overhead wide shot showing station name (Chicago), main character, and train. This shot lays a base for the montage. Shot 2: medium shot of man on train indicates that the main character is going somewhere. Shot 3: long shot of railroad car with conductor indicates the start of the journey. Shot 4: close-up of watch hints at the passage of time. Shot 5: medium shot of conductor announcing the arrival at another station indicates a passage of time and progression. Shot 6: medium shot of main character shows that he is taking a long journey.

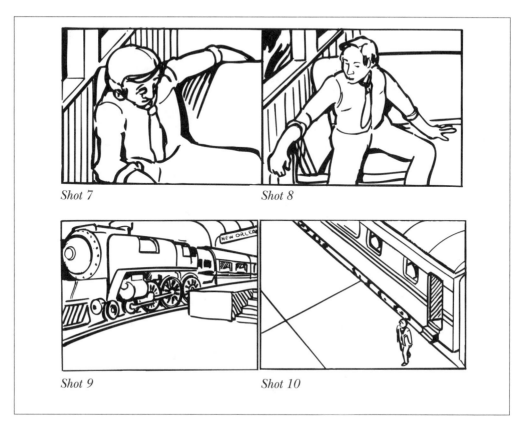

Shot 7 Shot 8

Shot 9 Shot 10

Figure 9-2 (continued). Shot 7: medium shot of main character sleeping implies that this is a long, long journey. Shot 8: medium shot of man acting restless shows that he is getting impatient. Shot 9: long shot of train arriving in New Orleans sets up the conclusion of the montage. Shot 10: overhead shot of main character leaving the train matches the first shot of the montage and provides closure.

Preponderance of the Evidence

Did you ever have a friend who argued by spouting one fact after another until he or she won the argument with the sheer weight of his or her knowledge? You can do the same with a montage.

Let's say you want to discuss (in a video piece) recent positive reviews of your product. You could interview an industry pundit who praises your product, or you could take shots of the headlines from the articles

Figure 9-3. Progression—day in the life of a TV director. Shot 1: wide shot of control
room shows the characters and the location. Shot 2: over-the-shoulder
shot of director focuses attention on him. Shot 3: medium shot of director
in profile narrows the focus. Shot 4: dissolve to medium shot of director at
a later time. This shot is from a different angle to contrast it with the
previous shot. Shot 5: dissolve to a medium shot of director at a still later
time (from a different angle). Director is looking more and more tired. Shot
6: dissolve to another medium shot of director from another angle. The
camera is moving around the director to create a sense of progression.
Shot 7: dissolve to another medium shot of director, opposite profile. The
camera angle has moved 180° around the director, which provides a sense
of closure to the montage. This sets up the end of the montage. Shot 8: full
shot of director shows him asleep at the control panel.

about your product and edit them into a montage (Figure 9-4). By doing the latter, you deliver an even more powerful message—in just 10 seconds, you've shown the viewer that many critics like your product.

This is a particularly powerful technique when you want to show a sensitive or controversial topic. A montage of shots of different homeless children living on the street can often convey a more powerful message than a shot of just one child. In contrast to the previous type of montage (sense of progression), this type of montage works because the shots are so similar. They make their argument by showing how widespread something is.

But there is a flip side to this type of montage: Viewers are smart, and if they think they are being manipulated, they quickly turn on you and become skeptical of the images. You must, therefore, walk a fine line between a potent delivery and overkill.

Different Facets of the Same Idea

Another common use of montages is to show different facets or parts of a place, person, or idea. The montage of San Francisco described earlier in this chapter is an example of this type of montage.

Another montage of this type is shown in Figure 9-5. In this case, the shots depict different parts, or facets, of a manufacturing plant. Because each shot contains some kind of action, the overall impression is one of bustling activity. You could build a sequence that has continuity between the various pieces of equipment, but your goal here is not to describe the actual manufacturing process but to convey the more general sense of bustle and motion.

You could use this type of montage to give credit to all the people who worked on a particular product. For example, if you use a two-second shot of each person, you'd give recognition to everyone on a small team in 20 or 30 seconds. Put a piece of triumphant music underneath the montage, and you'd give the team a nice plug.

 As mentioned in Chapter 6, it often helps to analyze television and movies to see how the experts do it. For montages, two of the best places to look are MTV and sports programs. Both of these formats use montages extensively. You don't have to copy their styles, but analyzing them might give you ideas about your own montages.

Figure 9-4. Product review montage. Shot 1: close-up of product review. Angle shot to convey energy and action. Shot 2: close-up of product review. Opposite angle adds action to the montage. Shot 3: extreme close-up of product review delivers specific information about a critic's review. Shot 4: quick pan of headline that includes the word "DataQuick" adds motion to the montage. Shot 5: extreme close-up of product review delivers more specific information about the review. Shot 6: medium shot of magazine showing the product on the cover pulls viewers back out of specific text and prepares them for the end of montage.

Shot 1 Shot 2

Shot 3 Shot 4

Shot 5 Shot 6

Figure 9-5. Factory montage. Shot 1: medium shot of circuit board spinning in front of camera. Shot 2: medium shot of robot arm moving down changes the direction of motion. Shot 3: full shot of factory floor shows a variety of movements. Shot 4: medium shot of circuit boards moving toward the camera on a conveyor belt. This shot again changes the direction of movement and places the viewer in the middle of the action. Shot 5: robot arm swings across the scene. This shot keeps the viewer close to the action. Shot 6: extreme close-up of circuit board. The last shot of the montage should match the beginning of the next scene. In this case, a person is going to talk about a new kind of microprocessor that is selling very well; hence this shot.

Montages with Conflicting Imagery

In most of the preceding examples, a rough idea of the overall concept of the montage could be guessed from any one of the individual shots—not so in the case of a montage built from conflicting images. In this type of montage, the overall impression is created by the collision of several images. The juxtaposition produces tension that is relieved to some extent by the synthesis of a new concept—the main point of the montage.

Generally speaking, these montages work when the conflict is fairly obvious, as in the montage comparing winners and losers in a sports contest depicted in Figure 9-6 (pp. 222–223). This doesn't mean you shouldn't try to make comparisons on a subtle or subliminal level, but you might not reach as many people with that type of approach.

Because the message of this type of montage lies in the collisions between dissimilar imagery, one group of shots can be used in two different montages to different effect. For example, consider the images of wealth and poverty in Figure 9-7 (pp. 224–225). The overall effect of this montage is to contrast haves with have-nots. This montage can make the viewers feel guilty or angry, or can be used to prod the viewers into helping the poor.

But if the same shots of the homeless man are interwoven with shots of a hard-working auto mechanic (Figure 9-8, pp. 226–227), the overall message changes. In this case, you might summon up feelings of resentment toward the homeless.

A real-life example of this duality involves the footage of the 1992 Los Angeles riot. This footage has been used by liberal reformers to call for more financial assistance for inner city neighborhoods. The same footage has been used by conservatives to call for more law and order.

As mentioned before, bold, powerful montages can backfire if the viewers feel manipulated. The longer a montage lasts, the greater the chance the audience will tire of the message and become distant or, worse, skeptical.

Tapping the Power of Images

Montages work when people can extract meaning from the images themselves. The images do not need interpretation. In fact, sometimes the

image taps into the context of the viewers' lives and produces an impression deeper and richer than the information carried by the image itself. For example, consider each of the following separate images:

- A man searching through the wreckage of a burned-down house
- A mother cuddling her newborn baby
- Neil Armstrong stepping off the lunar module
- President Nixon getting into a helicopter, waving good-bye
- Looters running through the streets of Los Angeles
- Dan Quayle smiling

All these images trigger a chain of ideas. Just what kind of ideas are triggered depends on the type of image. Some images are universal; that is, they evoke similar thoughts and impressions in all people. In other cases, the connection is limited to a particular part of society, a particular time, or a specific place.

Universal Images

Everyone can understand universal images because they deal with common human experiences, such as life, death, health, sickness, hunger, and poverty. Although montages consisting of just these types of images might seem a little empty or lightweight because they're not presenting anything new, these types of montages, used within the context of a narrative video segment, can establish a mood or add emphasis. Usually, the emphasis only applies to a concept or a message already established within the narrative section of the video segment.

Context-Dependent Images

Some images produce an impression only within a certain group of society—people of a certain age, background, or vocation. But what these images lack in reach, they make up in power. Images that depict specific actions, places, or people can evoke more powerful associations.

For example, let's say you are marketing a new personal computer, and the audience for the video you are making is already familiar with personal computers. The images of the IBM and Apple logos are all that's needed to depict the competition. If you are building a new word process-

Shot 1

Shot 2

Shot 3

Shot 4

Figure 9-6. Contrasting images—winners and losers. Shot 1: medium shot of player spiking ball in the end zone signals a touchdown. Shot 2: medium shot of a fallen opponent sets up the contrast between winners and losers. Shot 3: full shot of players from the winning team hoisting the player in panel 1 on their shoulders shows that the game is over. Shot 4: medium shot of players on the losing team looking sad provides contrast.

ing program, the image of Bill Gates produces the same effect. You don't need to explain what these companies are or who Gates is—your audience knows. And by using just these images, you give the viewers plenty of room to add their own interpretations and associations to the images.

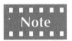
Note **In a way, this is similar to the conceptual compression used in building visual stories with continuity editing, but in this case, you are using specific images to represent larger ideas as opposed to compressing time.**

Figure 9-6 (continued). Shot 5: full shot of fans cheering reinforces the euphoria of the winning side. Shot 6: extreme close-up of losing player crying heightens the emotional drama. Shot 7: overhead shot of losing coach with no one else around stresses the difference between solitary sadness and group celebration. This shot follows another shot of the losing team so that the montage ends on the winning team. Shot 8: full shot of winning team and coach celebrating wraps up the montage. If you were rooting for the losing side, then you could switch the order of shots 7 and 8 to end on "your" team.

You can also get the advantage of letting the viewer "in on the joke." Images that tap into concepts that are targeted at the viewer help the viewer identify with the video piece. But an inside joke is only good for insiders. That's the disadvantage of specific images—they must be geared for particular audiences.

Shot 1 *Shot 2*

Shot 3 *Shot 4*

Figure 9-7. Contrasting images—wealth vs. poverty. Shot 1: full shot of large, expensive car cruising up to the entrance of a fancy restaurant. Shot 2: zoom in as chauffeur opens the rear door to focus on wealthy couple. Shot 3: medium shot of homeless man on street. Shot 4: close shot of homeless man as he clutches one of his few possessions in the world.

Here's another example: An image of Bobby Kennedy giving a speech or of an antiwar protester sticking a flower in the muzzle of a soldier's gun means different things to people born in the 1950s and those born in the 1970s. In one case, the audience lived through turmoil of the 1960s; in the other case, they might have only read about it.

A picture of Dan Quayle means different things to people of varying political persuasions. To liberals, a picture of the vice-president might call up memories of his various gaffes and blunders. To conserv-

Shot 5 *Shot 6*

Shot 7 *Shot 8*

Figure 9-7 (continued). Shot 5: wealthy couple drinking champagne inside fancy restaurant. Shot 6: homeless man getting his dinner at a soup kitchen. Shot 7: wealthy couple preparing for bed in their spacious bedroom. Shot 8: homeless man preparing to go to sleep under a bush.

atives, they see a put-upon, nice guy who champions their causes. His image is also time dependent. Fifteen years from now, people might not remember who he was or what he did. (Quick, who was Gerald Ford's vice-president?)

So if you're going to use specific, context-dependent imagery, make sure the central message of the montage is clear. This can be done in a narrative section preceding the montage, with narration or lyrics during the montage, and/or universal images interspersed within the montage.

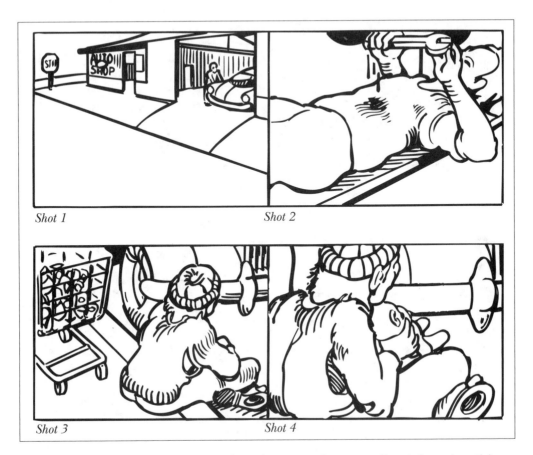

Figure 9-8. Contrasting images—homeless vs. working man. Shot 1: long shot of the exterior of an auto mechanic's shop. Shot 2: medium shot of auto mechanic working underneath a car. Shot 3: medium shot of homeless man on street. Shot 4: close shot of homeless man as he clutches one of his few possessions in the world.

As in continuity editing, the ultimate goal is delivering a message to the viewer, in this case, an idea or impression. With specific images, you need to take extra care to tailor the piece to the audience.

The Importance of Music and Pacing in Montages

A montage without a sound track can seem empty. In contrast, adding a piece of music, particularly one with lyrics, can transform the images

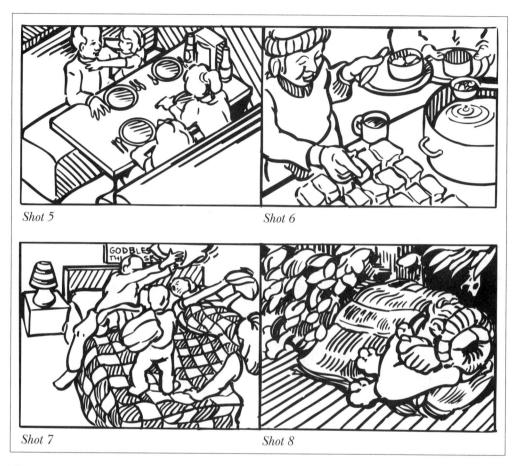

Shot 5

Shot 6

Shot 7

Shot 8

Figure 9-8 (continued). Shot 5: working man eating dinner with his family. Shot 6: homeless man getting his dinner at a soup kitchen. Shot 7: working man playing with his family in the bedroom. Shot 8: homeless man preparing to go to sleep under a bush.

into an interesting, sometimes powerful piece of video. For example, consider the following short montage:

- Shot of a young girl just learning to walk
- Shot of the young girl (age 5) with her family at a carnival
- Shot of the girl (age 8) throwing a ball to her dad
- Shot of the girl (age 12) with several friends
- Shot of the girl (age 17) getting her high school diploma

Now, try to remember the music and words to the songs "Born in the U.S.A." or "My Home Town" by Bruce Springsteen. Once you've got the words in your head, read through the list of shots again. The lyrics help tie the shots together.

Let's combine the same shots with a different piece of music—the current theme music for the United Airlines commercials ("Rhapsody in Blue" by George Gershwin). In this case, if you hear that music and see those pictures, you probably expect to see a shot of an airplane next and then a sales pitch.

Again, same shots, another piece of music—the title soundtrack from the movie *Jaws*: A bizarre selection, I'll admit, but it does add a strange wrinkle to the montage. Now, you might wonder what catastrophe is about to occur.

 Music, like specific images, works for only particular audiences. If you didn't watch much TV or listen to the radio, then you wouldn't be familiar with the United Airlines TV ads and their use of Gershwin's music.

The whole point of the previous exercise is to point out that music can influence a montage in powerful ways. It can support the message of the video (Springsteen), de-emphasize the video by drawing attention to the music (United Airlines), or put the video in a different context (*Jaws*).

You can also set up a contrast between the music and the montage. For example, using "America the Beautiful" with pictures of poverty and crime creates a strong sense of irony and cynicism.

These are extreme examples primarily because the music clips are well known. But even generic music adds a distinct flavor and tone to a video segment. Because music can have such an impact, you should match the music to the style and the message of the montage.

Matching Music to the Montage Style

If you are working with similar images that support each other, you generally want to use rhythmic music that has a melody. This type of music helps tie the images together and does not call attention to itself. If the music has lyrics, then the words of the song should work in concert with the images. This doesn't mean they have to describe the people and places shown in the video. In fact, it's better not to make

such literal connections, but there should be something in common between the words and pictures.

For example, the shots listed earlier about family life would be enhanced by a rock-and-roll ballad but probably not by a piece of avant-garde jazz.

If your montage consists of conflicting images, then a piece of music with a strong beat can help call attention to the conflicts. For example, a piece of rap music could turn a montage showing the rioting in Los Angeles into a powerful call for reform.

Next time you watch a movie, try to pick out each piece of music. Editors of feature films use music extensively to set the mood of scenes, and you'll probably be surprised at how often music has been added. If edited well, the music sits in the background, subtly setting the mood. You should also note how different styles of music are used (active vs. slow, simple vs. complex, major chords vs. minor chords) to match the visual and emotional content of the montage.

Setting the Pace with Music

If you are using music, then the pacing of the montage is often determined by the tempo of the music. In fact, you generally add the music to the audio track first and then edit the shots to match the music.

A piece of music with a quick beat, such as a rock-and-roll song, calls for short shots with lots of action. A graceful section of new age music calls for longer shots. This means you need to think about the mood and the tempo of the music when you are picking a song for your montage.

You might have to try many different pieces of music before you find one that works with the images you want to use. One way to shorten your search time is to assemble the shots for the montage into a rough cut and then test the music against the rough cut. Then, once you find a piece of music that works, go back and edit the montage again, this time matching the shots to the beat of the music.

Matching Special Effects to Music and Visuals

Few montages are edited together with simple cuts; often, some kind of special effect is used to smooth out the transition (dissolve, wipe,

etc.). Because different special effects affect a montage in different ways, you should use effects that match the mood of the music and the style of the montage.

Flowing Music

When you use classical or new age music (soft, flowing pieces), you might want to use dissolves between shots. These types of music usually don't have a strong beat, so the gradual transition produced by a dissolve matches the flow of the music.

For example, let's say your montage consists of the nature shots shown in Figure 9-9. A piece of flowing classical music would add a sense of serenity to the montage, which is accentuated by the dissolves.

Here's another example: Let's say you want to create a montage that portrays a factory in an ominous way. The shots for the montage are shown in Figure 9-10. You choose a dark piece of music—one with a slow tempo, lots of low notes, and in a minor key. If you simply edit the shots together with cuts, the abrupt shot changes work against the flow of the music. Dissolves de-emphasize the transitions between the shots and match the music better.

Active Music

When you use a piece of music with a strong beat, you generally want to use more active transitions, such as *pushes* (where one image pushes the other image off the screen) or wipes.

 In some situations, a simple cut works fine. Try the edit as a cut first, then experiment with transitions.

For example, let's say you are creating a montage of shots from a baseball game. You decide to use a fast-paced, rock-and-roll song (such as "Centerfield" by John Mellencamp). You could use dissolves between each shot, but you'd fit the action of the shots and music better if you used active special effects (such as pushes and wipes) for the transitions.

 When editing montages with active transitions, you should try to match their motion to the action in a shot. For example, if you're adding an effect between a shot of a catcher throwing a ball to second base, and a shot of a base runner running from right to left toward second base, you'd want to use a push left to match the runner's motion.

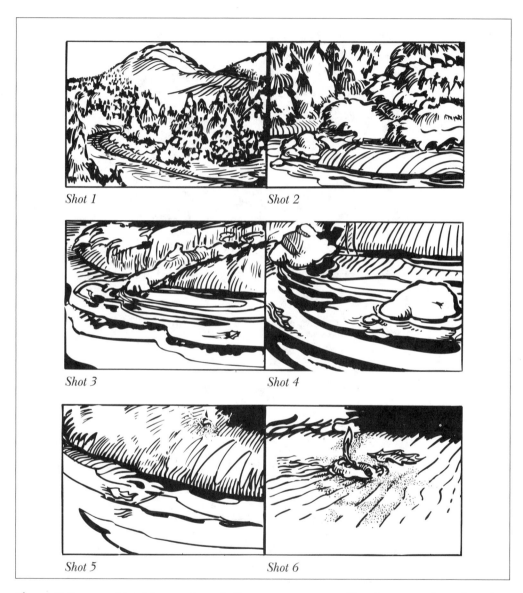

Shot 1 Shot 2

Shot 3 Shot 4

Shot 5 Shot 6

Figure 9-9. Matching music and effects—nature scene. Shot 1: extreme long shot of a forest and stream establishes the scene. Shot 2: dissolve to long shot of forest and stream from slightly different angle. Shot 3: dissolve to medium shot of stream showing dead log. This shot emphasizes the death of a tree in the forest. Shot 4: close shot of leaf floating downstream represents the flow of nutrients from the dead log. Shot 5: close shot of stream bank showing leaf represents the movement of nutrients from the dead log to other plants. Shot 6: close shot of sprout. Life reborn.

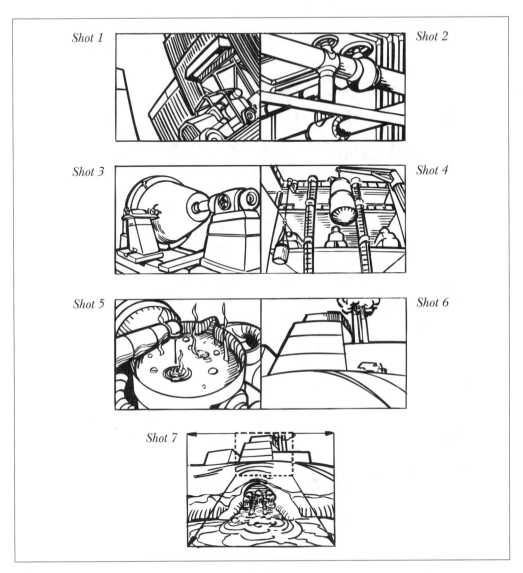

Shot 1 *Shot 2* *Shot 3* *Shot 4* *Shot 5* *Shot 6* *Shot 7*

Figure 9-10. Matching music and effects—ominous factory. Shot 1: angled long shot of truck and factory. The angle of the shot adds tension to the scene. Shot 2: medium shot of pipes criss-crossing the screen. Shot 3: full shot of a large piece of equipment. The shots aren't describing how the pipes and equipment are connected, which provides a sense of mystery. Shot 4: long shot looking up at factory. The camera angle emphasizes the size and complexity of the factory and makes it appear imposing. Shot 5: medium shot of boiling vat adds to the mystery. Shot 6: long shot of factory exterior. Shot 7: zoom out to reveal sewer pipes releasing chemicals into stream.

Extremely Active Music

If the music you're working with has a driving beat, such as a rap song, you might not need to use a special effect at all—a simple cut might suffice. But you need to time the shot changes (the edits) so that they occur on the beats of the music. That way, the music and pictures work together.

Unusual Situations in Matching Music to Images

The previous paragraphs described some general rules for matching special effects and music. But whenever possible, you should try to match an effect to whatever is going on in the music at a particular time. For example, going back to the baseball example, let's say you time an edit to occur just as a cymbal crash takes place. You could use a wipe, but how about a fast zoom open instead? The motion of this effect would heighten the impact provided by the cymbal. Keep your eyes open for these opportunities. These subtle touches add zing to your montages.

Learn the Rules, Then Break Them

As mentioned at the beginning of this chapter, there are few hard-and-fast rules for editing montages. What matters is the final piece and whether it reaches your audience. So after you get the hang of the more conventional ways of editing described here, experiment. Here are some styles you might want to try:

- **Dissolve through a color**: Place a solid-color matte between each shot, and dissolve between the shots and the mattes.

- **Intersperse black-and-white shots with color**: Use a filter to turn some of the shots into black-and-white images, and intercut them with color shots.

- **Gradually decrease the length of the shots**: This works best when the music builds to a climax.

- **Intersperse still images (freeze frames) with moving video**: You might also want to try freezing a shot at the end, fading to black, then fading up to the next shot that then freezes at the end, and so on.

- **Deliberately mix soft music with hard cuts**: This creates a tension between the pictures and the sounds.

- Use *swish pans* at transitions: A swish pan is a pan that moves so quickly that the image seems smeared. When inserted into a montage and dissolved in and out of, it adds a sense of motion to the segment.

Mixed-Format Basics

Mixed formats sit in the middle between the structured approach of continuity editing and free-flowing montage cutting. Here, you can focus on individual shots to add impact or specific information to a segment. For example, you might insert short sections of talking heads in the middle of several impressionistic shots, or you might use graphics containing text to deliver specific information.

But unlike a narrative segment, the shots in a mixed-format piece do not relate to each other in terms of a location or by continuity. There's no attempt to fabricate a reality.

So in a sense, the mixed format borrows some of the best features from the other two styles (continuity and montage). It can deliver specific information, but the piece isn't tied to telling a visual story. However, a disadvantage of this style is that without some kind of structure—a rough storyline or visual style—mixed-format pieces can end up as visual fast food: It looks good as you're watching it, but a minute later, you're left with no impression.

Turning a Montage into a Mixed-Format Piece

In many cases, you can transform a montage into a mixed-format piece by simply adding a talking head. For example, let's go back and review the nature montage discussed earlier (Figure 9-9). By adding some shots of a naturalist talking on camera about the cycle of life, death, and rebirth in a forest, we add specific information to the montage (Figure 9-11, pp. 236–237).

You don't have to show the person every time he or she talks. Once you show the person, you can then use his or her audio as a voice-over and cover the images of the person talking with some of the nature shots. Using voice-overs is discussed in more detail in Chapter 11.

Going back to the product review montage from before, you could put short quotes from industry pundits in between the shots of the headlines (Figure 9-12, p. 238). This way, you could combine the power of on-camera testimonials with the weight provided by a collection of print reviews.

Using Text in Place of Narration

An increasingly common type of mixed-format piece is one that uses graphic elements with text in place of narration. For example, let's say we are re-editing the software demonstration piece described in Chapter 8. Instead of using a salesperson, we take his or her words and place them in a graphic. These words can appear by themselves, or we can superimpose them over a shot of the computer screen.

The advantage of this style is its novelty. People aren't yet accustomed to seeing text interspersed with video. Sooner or later, though, the novelty will wear off, and you'll need to come up with a new trick or style to capture the audience's attention.

Experiment, Experiment, Experiment

The mixed-format style gives you a tremendous amount of freedom, so use it. Combine techniques from montage cutting with continuity editing. Intercut long shots with short shots. Place text in different parts of the screen. Have text carry over from a graphic shot into a piece of video.

The best place to get new ideas about mixed-format editing is television. Movies aren't generally edited in mixed-format style because they are trying to tell a story. MTV and commercials are a better source.

When you're looking for new ideas, put a tape in the VCR, and record what you're watching. That way, you're able to go back and step through the material shot by shot.

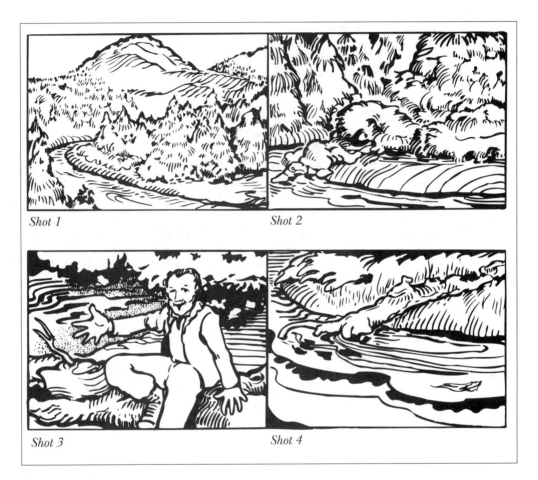

Figure 9-11. Mixed-format—nature segment. Shot 1: extreme long shot of a forest and stream establishes the scene. Shot 2: dissolve to long shot of forest and stream from slightly different angle. Shot 3: dissolve to naturalist describing the cycle of death and rebirth in a forest. Shot 4: dissolve to medium shot of stream showing dead log. This shot emphasizes the death of a tree in the forest.

Getting Advice

With continuity editing, there's a good chance that if you followed the basic grammar of visual storytelling, the audience will understand the scene and get your message. However, with montages and mixed-format pieces, you're working on a more impressionistic level and taking greater risks; so, you might be the only person who understands your

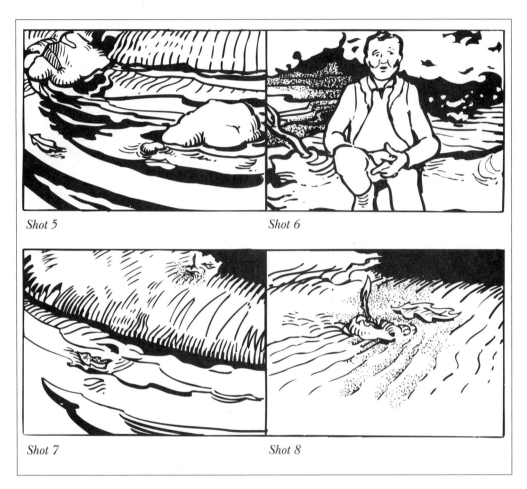

Shot 5 Shot 6

Shot 7 Shot 8

**Figure 9-11
(continued).**

Shot 5: close shot of leaf floating downstream represents the flow of nutrients from the dead log. Shot 6: dissolve to naturalist describing how nature is constantly in flux, with nutrients and energy constantly flowing from the dead to the newly born. Shot 7: close shot of stream bank showing leaf represents the movement of nutrients from the dead log to other plants. Shot 8: close shot of sprout. Life reborn.

brilliant idea or concept. Therefore, it's important to show your work to friends, colleagues, or people similar to the intended audience.

When you show your piece to these people, try not to argue or defend your work, just listen. You don't have to take their advice, but their opinions are important, especially if you don't like what they're saying. It's better to get negative feedback early, before you spend a lot of time on the piece.

Figure 9-12. Mixed-format—product demonstration. Shot 1: industry pundit talking about DataQuick product. Shot 2: special effect (push left) to newspaper article. Shot 3: close shot of newspaper article about the product. Shot 4: special effect (push left) to another industry analyst. Shot 5: medium shot of industry analyst talking about the product. Shot 6: close shot of magazine cover showing product.

Wrap-Up

Montage and mixed-format editing are powerful methods for creating impressionistic messages. Each style offers the editor a tremendous amount of freedom in the choice of images and pacing. But these types of segments only work for short periods of time; viewers can get overwhelmed or bored if the piece lasts too long. Used in small doses, they can embellish a narrative piece with powerful impressions and feelings.

Advanced Special Effects

T he power of the special effects programs that work with QuickTime is awesome. You can literally change any pixel, or groups of pixels, on any or every frame of your movie. You can blend movies, move them around the screen, and stack them in layers. The possibilities are endless.

Of course, you should have a plan, not only for what you want to create with a special effect, but also for the best, most efficient path to achieve your result.

This chapter provides a sample of some of the different techniques available to you. It also covers two special effects programs, VideoFusion and After Effects, to give you an idea of what they provide. But first, let's look behind the scenes to see what makes a lot of special effects possible—the Alpha channel.

Working with Alpha Channels

An Alpha channel, at its simplest, is a kind of stencil. It determines which part of an image is opaque and which part is transparent. White areas of the Alpha channel are opaque, black areas are transparent. For example, let's say we're working with a movie of a beach and the Alpha channel shown on the next page:

If the Alpha channel is applied to the clip, the result is:

If we use a more interesting Alpha channel, the value of all this becomes a bit clearer:

With the sky removed by the Alpha channel, we could drop in another sky:

 This is how time-lapse images of clouds are added to all those mood-inducing car commercials these days.

The border between the beach and the new sky is very ragged. This breaks the illusion we're trying to produce. Thankfully, there's a way of smoothing the edges of borders.

So far, we've been working with Alpha channels that included only black and white. But technically, an Alpha channel is an 8-bit grayscale image. White is opaque, light gray is slightly transparent, dark gray is mostly transparent, and black is totally transparent. For example, let's use a white-to-black gradient as an Alpha channel and blend the beach against another scene:

One scene blends into the other from right to left. The amount of background and foreground exactly matches the lightness of the Alpha channel. If we narrow the gradient, the effect becomes clearer:

You may have noticed that the background image isn't shown in these illustrations. Since the Alpha channel is being applied to the beach image, it doesn't matter what the background image is. The beach will blend smoother with whatever background you choose.

Let's go back to the beach and new sky example. We can now blur the edge between white and black in the Alpha channel to create a smooth transition. This blends the image of the beach and sky together better:

The value of an Alpha channel, then, is that it allows you to determine which part of an image you want to use and lets you blend that part seamlessly with any background.

If you read Chapter 5, you've already been working with Alpha channels. Most transitions are Alpha channels that change over time. For example, a title superimposed over a scene—even moving a clip in front of another—involves using an Alpha channel. And as you'll see in the next few sections of this book, Alpha channels make it possible to create some dazzling effects.

Creating Advanced Special Effects with Premiere

In Chapter 5 we explored some of the basic effects you can create with Premiere, such moving a clip, superimposing, and filtering. Here we discuss combining these different techniques to produce intriguing effects.

Combining Filters with Alpha Channels

Have you ever seen a commercial in which part of the image was in black and white and the rest was in color? Here's how it's done.

First, we import a clip into Premiere and place two copies of the clip—one in video track A, the other in the Superimpose track. The two clips are aligned in the Construction window so that they start at the same time (this is important). We then open the Transparency dialog box for the clip in the Super track and create a *garbage matte* (a particular region in the superimposed clip set as transparent):

Now we apply a filter to the superimposed clip. In this case, we'll use the Brightness & Contrast filter (the Black & White filter effect won't work here because the illustrations are in grayscale). We increase the brightness of the superimposed clip. The end result is a clip in which we've brightened every part of the image we selected with the garbage matte:

Working with Traveling Mattes

Let's get a bit more creative. This time we'll make the brightened area move around the image. To do this we need to work with a different type of key for the superimposed clip: the Track Matte.

The Track Matte key type (set in the Transparency dialog box) lets you assign an Alpha channel to an image. For starters we'll use a simple box-shaped Alpha channel and apply it to the beach clip.

First we add another video track to the Construction window with the Add/Delete command under the Project menu. Then we place the Alpha channel clip in the S2 track:

 The B track and the Transitions track have been hidden in this view of the Construction window.

Then we set the transparency of the beach clip in the S1 track to Track Matte (note that we're not setting the transparency of the Alpha channel clip). This tells Premiere to use the next track below the beach clip (track S2) as an Alpha channel.

Previewing the clip shows that we've creating a composite similar to what we did before with the garbage matte:

Now the fun begins. Because we're using a clip as an Alpha channel, when we move the clip, the portion of the image it affects changes as well. For example, if we apply motion to the Alpha channel clip in track S2 so that it moves from left to right, the brightened area will follow the same path in the final composite clip:

This technique works with any filter and Alpha channel. The key is to make sure that the two versions of the main clip (in this case the beach clip) are perfectly aligned in the Construction window.

Working with Multiple Layers

Premiere allows you to have up to 99 video tracks. This means that you can work with many different layers in an almost three-dimensional fashion. The bottom-most track in the Construction window (the track with the highest track number) is the top layer, or foreground. The A track is always the background. With clever use of these different layers you can create a seemingly three-dimensional scene.

Figure 10-1. By using several additional video tracks in Premiere, you can create different layers in your movie. In this example, the movie of the old woman starts as the foreground layer and switches to a midground layer as it passes behind the sphere.

We used this technique recently when creating a demo reel for our company, Red Hill Studios. A portion of the tape shows a video clip flying back into the background (Figure 10-1). Here's how this effect was created.

We first built the background image in a 3-D modeling/animation program called 3D Studio from Autodesk. To maintain the illusion of depth, we created several layers (tracks) in Premiere. Let's take a close look at a section of the Construction window to see how the different tracks were used:

We put the background image in Track A:

In this case, it included the computer but, in fact, that was unnecessary. Track S1 contained the computer, the plaque, and the filmstrip:

This was in a separate track because we wanted the background to show through the transparent filmstrip. The transparency of the filmstrip is determined by the Alpha channel associated with the image:

Track S2 contained the spheres that sit in front of the filmstrip:

This was in a separate channel because we wanted to dissolve them in after the filmstrip was already on screen. Track S3 held the video clip that we wanted to fly through the scene. Track S4 held a copy of the clip in Track S2.

How does it look? At first, the video clip is in the foreground. Then as we fly it back into the scene (using the Motion option and applying distortion), we add another layer on top of it (S4) to give the appearance that the video clip is flying behind the sphere. The timing of track S4's appearance is crucial. As soon as track S4 appears, the video clip ceases to be in the foreground (since track S4 now is) and becomes part of the midground. This creates the illusion that the video clip is flying behind the sphere.

This technique works best with scenes originally created in 3-D but will work with any scene that includes, or can be broken up into, several layers.

Rotoscoping

So far, we haven't tried to make graphic elements, such as titles, exactly match the movement of objects in the video. There's a good reason for that—it's extremely difficult to do with an editing program.

Let's say you want to combine a shot of a person pretending to throw a ball up and down with a computer graphic of a ball. You have to set a trajectory for the ball, preview the clip, and readjust the trajectory. Because you can't see the image of the person while you set the trajectory, it's hard to know how to set it except by trial and error.

The Motion dialog box allows you to see how a superimposed image interacts with the background. However, for detailed work you may need to use *rotoscoping*.

Rotoscoping lets you adjust the position of a graphic element (the ball) while you look at each frame of video. The actual placement of the ball doesn't take place in Premiere. You export the movie to Photoshop as a *filmstrip file*, which is a set of connected frames (Figure 10-2). Then you step through each frame, repositioning the ball. When you finish matching the movement of the ball with the person's hand, you export the connected frames back into Premiere, and *voilà!*, the ball is in synch with the person's movements:

Figure 10-2.

Filmstrip exported from Premiere for use in rotoscoping. Each frame is displayed individually so that you can modify the image in Photoshop.

This is how live-action film (or video) and animated characters are combined in movies such as *Who Framed Roger Rabbit?*

Creating Special Effects with VideoFusion

You can use VideoFusion to edit movies together, but where it really excels is in creating special effects. It has one of the most elaborate set of special effects of the editing programs. The following is a brief description of some of the tricks you can do with the program. Please refer to the user's manual for a complete discussion of VideoFusion's editing and special-effects features.

The following discussion assumes that you are already familiar with the basics of VideoFusion, such as moving clips into the Storyboard window.

Making Transitions

To create a transition between two clips, select the first clip by clicking on it, then press [Shift] and click on the second clip. Both clips are then selected:

Then choose the Transition option under the Combine menu. The Transition dialog box appears (Figure 10-3).

The various types of transitions are listed in the Categories scroll box. Each type of transition has several different varieties, as shown in the Transitions scroll box.

The length of the transition is set by the Duration slider at the upper right of the dialog box.

 This is similar to the amount of overlap in Premiere.

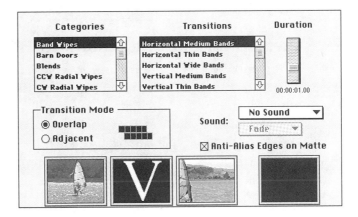

Figure 10-3. VideoFusion comes with a number of preset transitions grouped by category. Each category contains several variations of the same basic transition. In this case, we've chosen a medium-sized horizontal band wipe.

VideoFusion allows you to make either a direct transition from one clip to another using the overlap setting or between static frames of each image (using the Adjacent command). The latter creates a freeze frame based on the last frame of the first clip and another freeze frame based on the first frame of the second clip. The transition is then performed on these freeze frames. This is helpful when making transitions between short clips because the transition is completed before the actual clip runs.

You can see a rough facsimile of the transition by clicking on the Preview button. If you like what you see, you perform the transition by clicking on the OK button.

Unlike Premiere, VideoFusion creates a temporary Preview movie when you perform a special effect, such as a transition. The original clips are unaffected. You then have the option of replacing them with the Preview version or discarding the Preview movie and staying with the original clips.

Although it takes a bit more time to create the Preview movies, this feature allows you to create several different versions of an effect (each shown as a separate Preview movie) and then choose which version to use in the final movie.

VideoFusion provides a fairly standard set of transitions and a few unusual effects worth mentioning here, namely, the PZR transition.

Creating Complex Transitions with PZR Effects

PZR stands for Pan, Zoom, and Rotate. This type of effect moves, rotates, or zooms one clip (either the first or the second) to reveal the other clip.

For example, you can have the second clip appear as a small dot and then rotate while it zooms in (Figure 10-4). There are six different complex PZR effects, which give you a wide variety of ways to use this interesting transition.

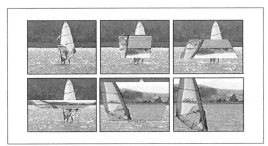

Figure 10-4.

The PZR transitions allow you to make complex transitions where the second clip rotates or zooms in (or out) over the first clip. Here we are zooming the second clip in while rotating it about the *x* axis.

Working with Filters

The word *filter* in VideoFusion is used to mean any special effect that is applied to a single clip (as opposed to two or more clips). Thus, it includes standard Photoshop filters (such as Blur and Pointilize), image adjustments (such as Threshold and Color Balance), and image motion settings (such as Pan, Zoom, and Rotate).

Another major difference between VideoFusion and the other editing programs (VideoShop and Premiere) is that all filters in VideoFusion are *progressive*: that is, you can vary the amount of the filter over the course of the clip. This is a crucial feature for applying filters to moving images.

There are too many different filters in VideoFusion to describe each one in detail here. Instead, let's focus on some of those that allow you to create effects that can't be performed in other editing programs.

Progressive Blurring

VideoFusion groups its filters under several different headings (Figure 10-5). The Convolve group includes image filters, such as Sharpen and Smooth (which is similar to the Photoshop Blur filter). We'll use the Smooth filter to show how the effect of a filter can be changed over the course of a clip.

Select a clip in the Storyboard and then choose the Convolve option under the Filter menu. A dialog box appears that shows the first and last frames of the clip (Figure 10-6). Choose the Smooth More option from the Filter pull-down menu.

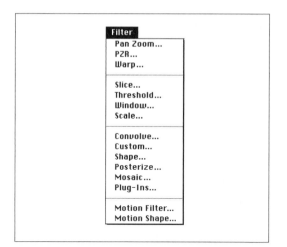

Figure 10-5.

Filter categories for VideoFusion

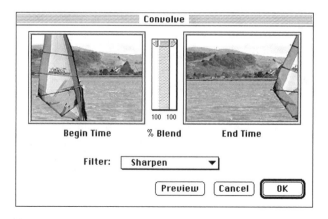

Figure 10-6. All filters in VideoFusion are dynamic. You set the amount of the filter for the start and end frames and the program automatically creates a gradual transition between the two.

In between the two clips is a *tweening slider* that allows you to set the amount of the filter for the first and last frames. If the amount of the filter is different for the first and last frames, VideoFusion automatically changes the filter amount gradually over the course of the clip.

In this example, we set the first frame to 100% blend (full filter) and the last frame to 0% blend (no filter). By clicking on the Preview button, you can see the effect of these settings on the first and last frames:

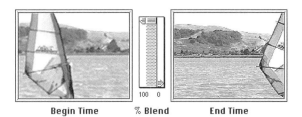

Begin Time % Blend End Time

Clicking the OK button creates a preview movie of the filter. Dragging the preview movie into the storyboard then adds the filtered clip to your movie.

 Additional filters must be added to a clip one at a time.

Pan Zoom

The Pan Zoom filter allows you to move a clip across the screen or zoom it toward or away from the viewer. The positions of the start and end frames are set in the Pan Zoom dialog box (Figure 10-7).

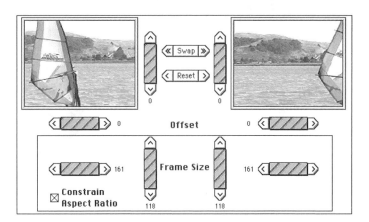

Figure 10-7. Fading out a Smooth More effect. The start frame is set with a 100% blend value, which applies the full Smooth More effect. The end frame is set with 0% blend, which applies none of the effect. The clip will start blurry and then gradually become less blurry until at the end it appears normal (unfiltered).

The start frame controls are on the left side of the dialog box; the controls for the end frame are on the right side. VideoFusion provides a multicolored grid, so you can see the effects of the Zoom and Offset settings.

For example, you could have a clip zoom in from the upper-right corner and fill the screen by taking the following steps:

1. Use the Frame Size scrubber to make the start frame smaller.
2. Use the Vertical Offset scrubber to move the start frame to the top of the window if it isn't already there:

3. Use the Horizontal Offset scrubber to move the start frame to the upper-right corner:

Because the end frame is already set to what we want, click on the Preview button to see how the start and end frames of the actual clip look.

Click on the OK button to create a preview movie of the filter. The clip starts in the upper-right corner and gradually zooms in to fill the screen:

You might want to perform complex filtering, such as a pan zoom, on a freeze frame of an image, rather than have the clip play during the effect. Copy the first frame of the clip (using the Time view). Then paste the single frame in the Storyboard view and change its duration (using the Set Duration option under the Movie menu) to the length of the filter operation (usually about 3 or 4 seconds). Position the freeze frame before the actual clip and perform the filter operation on the freeze frame. Now the filter affects the freeze frame, then the clip plays.

The Pan Zoom filter can also be used to change the window size of the clip gradually. For example, you could gradually compress a clip from a 160 by 120 pixel window to a 160 by 100 window with the following steps:

1. Click on the Constrain Aspect Ratio check box to deselect that option:

2. Use the Vertical Frame Size scrubber to reduce the vertical size of the end frame to 100:

3. Click the OK button to create the effect.

PZR Filter

The PZR filter is a complex but extremely powerful filter that allows you to move a clip around the screen in countless ways. It is similar to the PZR transition except that it works on only a single clip, as opposed to two clips.

Upon choosing the PZR option under the Filter menu, a dialog box appears that contains controls for manipulating the clip in three dimensions.

There are a number of preset PZR filters, which can be applied by clicking the Select button and choosing the appropriate filter from the scroll box (Figure 10-8).

But the true power of the PZR filter is that it gives you an amazing amount of control over the movement of a clip. The controls for the start and end frames work the same way, so we discuss only the start frame controls here:

- Vertical/Horizontal Offset scrubbers move the clip up, down, and sideways in the window.

- The Zoom tweening slider sets the size of the clip. The pointer on the left side of the slider adjusts the size of the start frame; the pointer on the right adjusts the end frame. If the sizes of the start and end frames are different, then the clip seems to move toward or away from the viewer as it plays.

- The XYZ rotation wheel allows you to change the rotation of the clip along three different axes. Click the radio button next to a particular axis (x, y, or z), and move the selector arm to set the

Figure 10-8. The Pan Zoom Rotate filter allows you to slide a video clip up, down, or sideways. You can also zoom a clip in or out by adjusting the frame size. Setting different pan and zoom values for the start and end frames causes the image to move (or zoom) while the clip is playing.

rotation. If the rotation settings are different for the start and end frames, VideoFusion creates a gradual movement between the settings. This is a powerful feature that allows you to create dynamic effects.

- The Perspective scrubber alters the view of a clip that is already rotated. Lower values make the image seem closer to the viewer; larger values make it seem farther away.

- The Animate button lets you see how the clip moves during the effect.

- The Preview button shows how the start and end frames of the actual clip look.

Independent control of zoom, rotation, horizontal/vertical position, and perspective gives you a tremendous amount of freedom in creating effects. Here are just a few examples of what you can do with the PZR filter:

- **Zoom In with Y-Axis Spin:** The clip starts in the upper-left corner and in the distance (zoomed out). It then spins in (rotating along the y axis) until it fills the window (Figure 10-9).

- **Zoom Out with X/Z-Axis Spin:** The clip starts at normal size. Then as it zooms out, it spins along both x and z axes (Figure 10-10). A little perspective is added (value 2) to enhance the effect.

- **Slide Back Flip:** This effect is used twice to make a transition between two clips. First, clip 1 is zoomed back and rotated along the y axis until it is just a single line (Figure 10-11). You then use the reverse of the effect (using the swap buttons) on the second clip. The net effect is that clip 1 slides back and rotates and then is replaced by clip 2 (Figure 10-12).

By using the Combine commands (discussed in the next section), you can replace the black background of the PZR filter with another clip or a background graphic.

 Although the PZR filter gives you a lot of control over the movement of a clip, it doesn't allow you to set a complex trajectory (as Premiere 2.0 does).

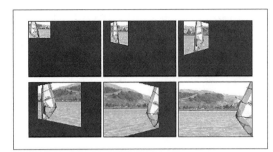

Figure 10-9.

The Zoom In with a Y-Axis Spin special effect. This effect is created by zooming out the start frame and flipping it 360 degrees along the *y* axis. As the clip plays, the image zooms in while rotating.

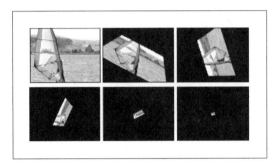

Figure 10-10.

The Zoom Out with X/Z-Axis Spin special effect. This effect is created by zooming out the end frame and flipping it 180 degrees along both the *x* and *y* axes. As the clip plays, the image zooms out while rotating in two directions.

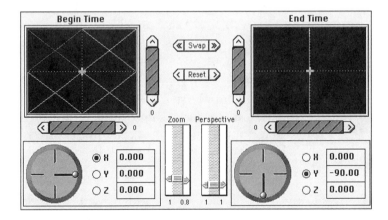

Figure 10-11. Creating the first part of the Slide Back Flip special effect. The end frame is rotated along the *y* axis until the frame disappears. This causes the clip to spin vertically until it becomes a thin line (as if it were pointed at the viewer). At this point you switch to the second video clip but the change isn't noticed because the frame is a thin line.

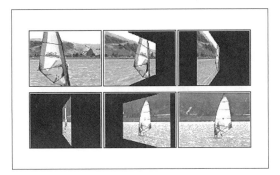

Figure 10-12.

The Slide Back Flip special effect. The first clip rotates along the *y* axis until it appears as a thin line. We then switch to the second clip, which also appears as a thin line. The second clip then rotates along the same axis to fill the window.

Blending Two Images

The standard way to blend two images, *superimposing*, is only one of the many methods offered by VideoFusion to combine clips. In addition to the Chroma key method, you can also blend and mix clips, or use a matte to composite two clips into one. As with the other VideoFusion features, the Combine commands are too extensive to cover in complete detail here. We focus on only a small sample of what is possible.

Merging Two Clips with the Blend and Mix Options

The Blend option allows you to specify the proportion of each of two clips (Figure 10-13). The pointer on the left side of the tweening slider sets the amount of blend at the beginning of the clip; the pointer on the right sets the blend amount at the end frame. The program automatically makes a gradual change between the two settings (if they are different).

The Mix option is similar to the Blend option except that the intensity of each clip can be varied independently (Figure 10-14). This allows you to mix several different clips (on multiple passes) and control the proportion of each clip. For example, you could create overlapping fades, where clip 1 fades out as clip 2 remains the same, and clip 3 fades in.

The main difference between the Blend and Mix options is that with the Mix option, the final image doesn't have to have 100 percent intensity. This allows you to add the intensities of different clips on separate passes in exact amounts.

Figure 10-13. The Blend option allows you to set the exact amount of blend between two clips for both the start and end frames. Here we start with just the first clip (the deer) by setting the blend amount to 0. The end frame consists of 40 percent of the first clip and 60 percent of the second clip (the mountain). Because the start and end frame blend settings are different, the clip starts with just the first clip and then the mountain clip gradually blends in.

Figure 10-14. The Mix option allows you to set the intensities of each of two clips independently. Here the intensity of clip 1 (the deer) in the start frame is 76 percent of normal and the end-frame intensity is 24 percent of normal. Over the course of the effect, the intensity of clip 1 drops. At the same time, the intensity of clip 2 (the mountain) increases from 35 to 56 percent.

Using the Composite Command to Merge Two Clips

The Composite command combines two clips, called the foreground and background clips, using a third movie called a matte or Alpha channel. The matte specifies how the foreground and background

clips are blended. The dark areas of the matte show more of the background; the light areas of the matte show more of the foreground.

Figure 10-15 shows how different mattes affect the combination of two clips.

A typical way to create a matte is to apply a filter to the foreground clip to convert it to a gray-scale clip. The Slice, Threshold, Window, and Scale filters extract a different part of a clip to create a matte. Because the matte was created from the foreground clip, it changes in synch with the clip during the composite blend.

 The matte can be a static gray-scale image, a gray-scale clip (as described previously), or a color movie. If the matte is in color, the final image is created as a composite of red, green, and blue channels. The red channel of the final image is a blend of the red channels of the foreground image and the background image, using the red channel of the matte to control the blend. The blue and green channels are calculated the same way.

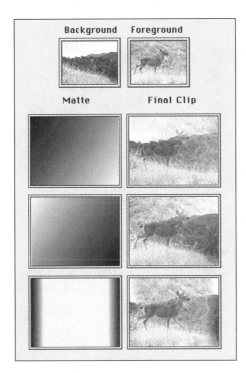

Figure 10-15.

The effect of various mattes using the Composite command. The white areas of a matte are transparent and reveal the background image. The black areas of the matte are opaque and show the foreground image. The gray areas combine the foreground and background images in proportion to the brightness or darkness of the matte.

You can also use an animated graphic to create moving, or *traveling*, mattes, which produce interesting special effects. In this type of effect, the clips aren't moved around the window (as in PZR effects). Instead, they are stationary and the matte moves around the window.

Here we use a black and gray still graphic to create the moving matte, as the next illustration shows:

The gray part of the matte allows part of the background to show through the foreground. Using a darker gray would allow more of the background to show through. Using solid white (in place of the gray) would make the foreground image opaque (with none of the background showing through).

Now, we make this matte move across the screen using the PZR filter:

1. Select the graphic by clicking on it and choosing the PZR option from the Filters menu.

2. Reduce the vertical size of the start and end frames to 102.

3. Use the Vertical Offset scrubber to move the start frame above the top of the window and the end frame below the bottom of the window (Figure 10-16). This makes the matte move from the top of the screen to the bottom.

4. Select the foreground, background, and matte clips by clicking on them while you hold down Shift.

5. Choose the Composite option from the Combine menu.

Figure 10-16.

Setting up for a traveling matte. Working in the Pan/Zoom filter dialog box, we move the gray matte up out of the start-frame window. We then move the gray matte down and out of the end-frame window. This causes the matte to move through the window from top to bottom.

The final clip starts with just the background clip. Then, as the matte moves from the top of the screen to the bottom, it reveals the foreground image of the deer (Figure 10-17).

You can have more than one traveling matte on a screen at a time. However, you need to work backward, laying one matte on top of another—similar to what we did in creating the parade of clips in Premiere. You create the matte that is farthest away from the viewer first. It then becomes the background for the next pass.

Figure 10-17.

As the traveling matte moves from the top of the window to the bottom, it shows the foreground image (the deer). The clips themselves aren't moving to different positions in the window, only the matte is.

Morphing

Morphing is one of the most bizarre effects you can produce on your computer. A *morph* is a short video clip in which a person's face or other object transforms into another object. Michael Jackson's music video, "Black and White," used this effect to switch from one person to another. A Chrysler commercial used this technique to transform an old model of a car into a new version.

Those effects were created on high-end computers and cost tens of thousands of dollars to produce. But you can create similar effects with VideoFusion on your Macintosh. You can morph between two still images (a static morph) or two moving images (a dynamic morph). We first look at how to perform a morph between still images of two people.

Creating Static Morphs Import two PICT images into VideoFusion and set their durations to one second each. Select both clips in the Storyboard. Choose the Morph option under the Combine menu to call up the Morph dialog box (Figure 10-18).

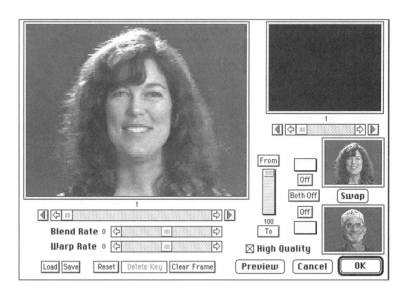

Figure 10-18. The Morph dialog box in VideoFusion. The large image is used to set control points on the start and end video clips. The small box in the corner is used to display the result of the morphing at any point during the transition.

Clicking the mouse on the large image sets a control point. This indicates the location of a particular feature (the tip of a person's nose, for instance). Set a number of points on the first image (the person's eyes, mouth, etc.):

Now you're ready to adjust these control points on the second image. Slide the bar on the From/To slider to call up the second image:

Click on one of the control points and drag it to the corresponding feature in the second image. For example, if the control point is set on the tip of the woman's nose, drag that control point to the tip of the man's nose. Adjust the rest of the control points. The movement of the control points during the movie is shown by a thin line:

Let's look at what we've done so far. Slide the preview bar (in the upper-right corner of the dialog box) to about halfway and click the preview button. The image shows what the middle frame of a 12-frame morph movie will look like:

The two faces have been merged, but the woman's hair and the man's ears are simply superimposed. This is because we didn't set any control points for these features.

Going back to the first image (using the From/To slider), we set another 30 or so control points and then adjust the position of these control points on the second image. Returning to the first image, we see that the control points for her hair move a lot during the morph:

This much movement usually causes a distracting imperfection called *smearing*. The simplest way around this problem is to delay the blending between the two images. This is done by moving the blend rate slider towards the right:

Press the OK button to create the morph movie. The woman's hair moves in towards her face and then quickly changes color to the man's face (Figure 10-19).

Figure 10-19.

End result of a morph. The woman's face first gradually widens as her hair disappears. Then the image borrows a bit from each person to create a composite. Finally the man's glasses and hat form out of the last pieces of the woman's hair.

 Morphing involves two effects you've already worked with: warping (called the Mesh filter in Premiere) and blending. Warping moves the pixels of the first image to match the second image. Blending changes the color of the pixels. The warp- and blend-rate controls give you a great deal of flexibility in performing a morph. Moving the blend-rate slider all the way to the right warps the first image to fit the features of the second image. The second image then appears. Moving the blend-rate slider all the way to the left blends the second image onto the features of the first image. The second image is then unwarped to produce the second image. The warp-rate slider works in a similar way.

Creating smooth morphs requires a lot of time and patience. Here are a few suggestions that may help:

- Make sure to use a lot of control points for a person's face. Use at least 4 points for each eye, 8 for the chin, 10 for the edge of the hair, and 8 for the hairline. The more points the better.

- Add points in the background and don't move them. These are called *anchor points* and they help VideoFusion distinguish between the foreground (the person) and the background.

- Use nondescript backgrounds or, better yet, draw in a solid background (using a photo manipulation program, such as Photoshop).

- If there is a lot of smearing in the morph image, add more points. This increases the amount of time it takes VideoFusion to create the morph, but the morph will look better.

Creating Dynamic Morphs The previous section dealt with only still images. You can also morph between two QuickTime movies. The main difference is that because the objects are moving, you need to readjust the control points (for the first and second movies) during the course of the movie so that the control points are positioned on the correct features.

For example, if the man tilts his head to the left, you have to move the control points for the edge of his cap so that they are kept positioned on the edge of his cap:

Frame 1 *Frame 9*

You then have to readjust the control points for the second movie. Sound like a lot of work? It is. Creating a dynamic morph is essentially the same as creating many static morphs.

Depending on the amount of movement in your movies, you may have to readjust the control points several times. Each time you adjust the control points of the first movie, you establish a key frame. VideoFusion automatically shifts the positions of the control points between key frames (so you don't have to).

The key to creating dynamic morphs is to make sure the two movies are already lined up. That is, if the person moves his or her head to the right, the person in the second movie also has to move his or her head to the right at the same time. This greatly reduces the amount of time you will spend readjusting the control points. The easiest way to determine if the two movies are moving in synch is to blend them using the Blend command. Adjust the timing of the clips by eliminating frames at the beginning of one of the clips. If the timing is still off, try changing the speed of one of the clips with the Vary Speed command (under the Movie menu).

Another software program called Morph (Gryphon Software Corporation) allows you to create static morphs. It has a number of features not contained in VideoFusion, which allow you to create more

interesting static morphs. Specifically, it allows you to adjust the warp and blend rate for individual control points. This lets you, for example, morph two people's faces first, and then morph their clothes.

The final word on morphing is that is requires a lot of computing horsepower, especially if you are working on large movies (320 × 240 pixels or larger). If you plan to do a lot of morphing, you will need either a Quadra or a lot of patience!

Creating Special Effects with After Effects

Unlike other editing or special-effects programs that are based on an editing timeline or storyboard, After Effects is more like an animation or modeling program. The final composition is created by combining a number of movies—each of which is treated as an object that can be moved and transformed within the viewing field. This allows you to position accurately and alter many different clips at the same time.

For example, imagine you are creating an animation sequence where two balls fly in from opposite sides of the screen and bounce off each other in the middle. Fairly straightforward stuff. Now imagine that instead of using balls, we're working with QuickTime movies. Each movie flies into the screen towards the middle; they then collide in the middle and bounce back.

Performing this type of effect would be difficult in one of the other QuickTime editing programs (Premiere or VideoFusion). With After Effects, this effect takes less than a couple of minutes to execute.

How After Effects Works

There are several windows in After Effects, as shown in Figure 10-20. The Composition window (top right) is where you assemble the composition of images and QuickTime movies. The Time Layout window (bottom) displays the clips and images used in the composition. The central concept behind After Effects involves *layering*. Each visual element is considered a different layer. This lets you decide which elements appear in front of or behind the others. There is no limit to the number of layers you can use in an After Effects composition.

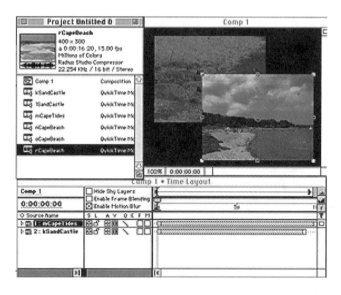

Figure 10-20. The main windows in After Effects. The Composition window is at the top right, the Time Layout window is at the bottom.

The top-to-bottom position of the layers in the Time Layout window matches the respective positioning of the layers in the composition. The first (top) layer in the Time Layout window thus appears in front of all other layers in the composition.

This is opposite to the order of superimposing channels in Premiere.

For each layer there are several properties that you can adjust:

- **Position:** the layer s horizontal and vertical placement in the composition
- **Scale:** how far the layer is zoomed in or out
- **Rotation:** how many degrees it is turned
- **Mask Shape:** how much and which parts of the layer are visible
- **Mask Feather:** how much feathering is applied to the mask
- **Opacity:** how transparent the layer is
- **Audio:** the audio level of the clip

A property can be set to a constant value over the entire duration of the clip or changed over time. To change a property over time, you first set a value of the property at one particular point in time (called a *key frame*). You then choose the method of changing the parameter over time (the *tweening* type) by clicking on the name of the property. Then you move to another point in time in the composition (by moving the blue slider on the top of the Time Layout window) and choose a new setting for the parameter. The program automatically creates a gradual transition between these two settings.

For example, let's say you wanted to start a composition with a full-screen image of a beach and then squeeze that image down and move it to a particular place. Here are the steps:

1. The scale and position of the movie is correct at the beginning of the composition so we don t have to change those values.

2. Choose a Linear tweening method for each parameter (scale and position).

3. Move to a new time in the composition and set new values for these parameters:

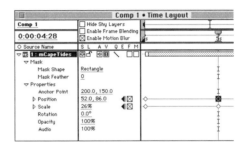

You can see how the movie changes position and shape at any point in the composition by simply moving the blue slider in the Time Layout window. The exact values of the scale and position parameters are shown for the particular frame you are viewing:

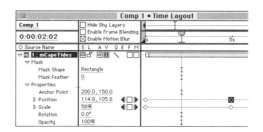

We used this effect to create a layered sequence involving several images for the *Seeing Time* project (Figure 10-21) described in Chapter 15. Each layer was squeezed back into an exact spot in the background. The precise positioning possible in After Effects was essential to create a smooth sequence.

Scale and position are only two of the many parameters you can change over time in After Effects. In fact, you can very all parameters in After Effects over time, including filters, image controls, rotation, mask shape, and feather. This gives you absolute control over how your image looks at any point in time.

The one drawback to After Effects is that it sometimes takes a long time to create your movies. This makes it difficult to edit sequences in which you are cutting clips to match narration. And when performing a series of complex effects, After Effects can be tediously slow. But that s the price you pay for all that control and power.

After Effects is also very useful when working with sets of still images. As part of the *Seeing Time* project, we created time-lapse movies of particular scenes over an entire year from a series of still images. The images were registered in After Effects and then carefully blended together to create the time-lapse movie shown in Figure 10-22.

We've barely scratched the surface of what is possible with After Effects. Although some people may balk at the price (around $1,800) and its lack of speed, there's no better program for creating professional quality sequences that use several layers of images.

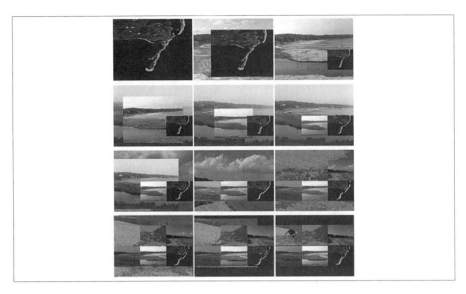

Figure 10-21. Composite sequence built in After Effects. This movie consists of seven layers—six movies and a background. By staggering the movements of each layer, a interesting sequence is created.

Figure 10-22. A time-lapse sequence of a year on a beach. Individual photos were aligned in After Effects and then gradually blended together.

Wrap-Up

The programs discussed in this chapter give you almost limitless power to alter, modify, change, or distort an image. The limit is your time and energy. Therefore, the key is knowing how to use these programs effectively. Before diving into a particular effects sequence, think about what you're trying to create. Then review your various options. Can you use an animated Alpha channel? Will a variety of filters work? Do you need to rotoscope?

Once you have a good idea of the tools and techniques at your disposal, estimate how long it will take for each technique. It won't matter that your first ten frames are insanely great if you don't end up with enough time to finish the three-second sequence!

PART III

BECOMING A PROFESSIONAL

You now have all the tools to create clear and informative QuickTime movies. But this is just the beginning. Through the use of various techniques covered in Part III of this book, you can improve your QuickTime movies and incorporate them in other formats, such as videotapes and interactive multimedia programs. Chapter 11 covers advanced audio-editing techniques. Chapter 12 is a comprehensive primer on video production. Chapter 13 explains how to convert your QuickTime movies to videotape. Chapter 14 covers the details of digital video. Chapter 15 discusses how to use QuickTime movies in interactive applications.

Advanced Audio-Editing Techniques

S ound is one of the great unsung aspects of video, primarily because most people think of video as solely a visual medium. True, the pictures attract people's attention. But the right soundtrack embellishes the visuals with presence and a mood. It can mean the difference between a merely average piece and a truly spectacular one.

Elements of Audio

The audio you hear in a QuickTime movie, or on a videotape for that matter, is not just one piece of sound. The audio track usually consists of a combination of many different sound elements. The most common elements are narration or dialog, background sounds, music, and audio special effects (Figure 11-1).

These different elements are mixed to produce the final audio track—the sound you hear in the finished piece. Sometimes as many as four or five elements are mixed for a single shot. The soundtrack for a feature film, for example, can consist of as many as 20 different sounds—all occurring at the same time.

Figure 11-1. There are four major types of sound elements that can be used
in a QuickTime movie: speech (either dialog or narration),
background sound, music, and audio special effects.

Each type of sound element poses unique challenges for the editor,
so we discuss each one in turn.

Dialog and Narration

Dialog and narration are the most important sound elements in any
segment in which they are heard. That's the point, isn't it? You are
putting them in so that the viewer can hear what the actor or narrator
is saying. The volume of these elements is set high enough so that they
are always the loudest, most easily heard elements.

Although both of these elements involve someone talking, there are
significant differences between them. One obvious difference is that
you don't see the narrator. His or her words are laid under the video
(if you are using a person as both an on-camera host and a narrator,
then the previous comment applies only to the narrated portions).

Another difference between narration and dialog is that a recording of dialog always includes some of the background sound of the recording location. This can be the hum of an air conditioner in an interior location or the buzz of traffic in an outdoor location. This extra sound is always there, although it can be minimized by the placement of the microphone and the choice of a quiet location.

In contrast, narration is usually recorded in an extremely quiet place. In professional productions, the narrator sits inside a sound-proof booth to make sure there is no extraneous noise.

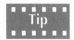 **If you are not going to be recording narration in a sound booth but still want to have clean narration—that is, without any extraneous sounds— you might not want to record directly into your Macintosh with a sound digitizer. This type of recording picks up the sound of your computer and hard drive. It's better to record the narration on a standard cassette recorder in a quiet room and then transfer the narration from the cassette tape to your Macintosh using a sound digitizer. Other sound-recording tips are covered in Chapter 12.**

Because narration does not usually include any ambience or background sound, video clips that are used with narration should have their own background sounds. This is why you should record audio when you are shooting a scene.

 Here's a quick exercise that points out the difference between narration and a piece of dialog. Record some narration in a quiet room. Digitize it and then import it into a video-editing program. Then import a clip of dialog and place it after the narration in the editing program. Remove the video portion of the dialog clip. Then listen to both clips. The difference you hear in the dialog clip is the background sound.

Using Dialog as a Voice-Over

You don't necessarily have to use a shot of dialog as a combined video/audio clip. A common technique is to use the audio portion of one part of a dialog shot as a voice-over. For example, let's say you shot a scene of two people talking at a restaurant. As the following illustration shows, the most straightforward way of editing this scene is to have each shot last as long as the dialog for that shot:

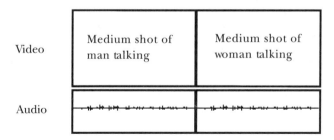

Another way to edit this scene that would make it more interesting is to cut to the shot of the woman before the man stops talking:

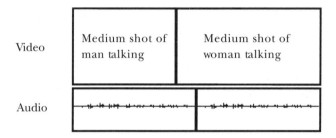

This way we can see her reaction before she starts to speak. In the television industry this is known as an *L cut* and it is used extensively to create smoother scenes.

Background Sound

As mentioned before, microphones pick up not only the primary source of sound such as a person talking but also the ambience that is present in almost all locations. We don't usually notice this sound, but it's there, and the microphone always picks it up.

The amount of sound that passes by us unnoticed is amazing. Our brains filter it out so that we can concentrate on what someone is saying. But because the microphone picks up all the sounds of a location, you need to become adept at recognizing background sounds. Here's a quick exercise that can help you to listen better:

1. Close your eyes and try to pick out as many different sounds as you can. Listen for at least 30 seconds to give your brain a chance to switch to a different mode of listening.
2. Turn your head and determine if the sounds change in intensity.
3. Try to locate the source of the sounds without opening your eyes.
4. Go to another location and repeat these steps.
5. If you haven't gone outside yet, step into an outdoor location and try to pick out the background sounds.

After a while, you should be able to pick up background sounds without closing your eyes. It's important to be able to hear the ambience of a location because it can add unwanted sounds to the interview or dialog and, ultimately, to the video piece.

For example, let's say you were interviewing your grandmother about her experiences during the Depression. She tells you a wonderful story about the first time she drove a car. You dig through the family album and find an old black-and-white picture of that event. You decide to combine the audio portion of her interview (as a voice-over) with the old photos. You carefully edit her words and the pictures together, only to find that the refrigerator hum (picked up during the interview) seems extremely out of place while you look at the shots of her behind the wheel.

You don't have to worry about background sound if the dialog is always going to be used as a combined video/audio clip. For some reason, our brains don't seem to mind hearing background sound when we see the person talking on the screen. But because you don't always know beforehand when you might want to use dialog as a voice-over, it's a good idea to conduct interviews in quiet locations.

Although every location has its own blend of background sounds, there are some standard problems that pop up regularly in various locations. Here are a few examples:

- **Office:** Air conditioning, computers, people talking nearby, telephones
- **Shopping mall:** Air conditioning (everywhere), escalators, fountains

- **Hospital:** Intercom, air conditioning, refrigerators and other machinery, people talking

- **City street:** Traffic (particularly motorcycles), fire engines, airplanes, subway rumble, people talking, construction

- **Suburban street:** Traffic, children playing, lawn mowers

You won't able to eliminate background sound in every circumstance, but you should to try to minimize it as best you can. You'll save yourself a few gray hairs when you get into the editing phase.

Using Background Sound

Although background sound is a nuisance when recording interviews and dialog, it is an essential part of video clips that don't include someone talking. Imagine a shot of a mountain stream without the gurgling sound of the water. Imagine a basketball game without the roar of the crowd, the squeak of the sneakers on the wood floor. Imagine the space shuttle lifting off without the thunder of its engines.

These types of background sounds, often called *nat sounds* (for "natural sound"), add texture and fullness to a video clip. For this reason, it's not uncommon to use a shot with rich nat sound to introduce a new scene. For example, you might use the sound of a stream (under a long shot of a mountain meadow) to introduce a scene of two people talking in a meadow:

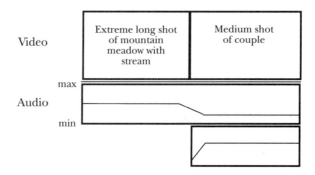

The sound of a stream works in concert with the establishing shot to set the scene. It is an audio cue that helps orient the viewer. Then just before the woman starts talking the volume, or level, of the stream

sound is dropped down, so it does not interfere with the woman's dialogue.

A nat sound that is used to start a scene can also be interwoven with the dialog for dramatic effect. Let's say you are editing a scene of a father and son starting a tense conversation in a kitchen. The scene begins with the father cleaning some tools in the sink (Figure 11-2). Let's step through each shot to explain how the nat sound of the water in the sink is integrated into the scene:

Shot 1: Father is at the sink. The sound of the water in the sink is used near full, or normal, to help set the scene (Figure 11-3 describes the conventions used for audio levels).

Shot 2: Son walks in. The sound of the water is continued through this shot. The sound of the son's footsteps is kept low so that the viewer can hear it. The implication is that the father hasn't.

Shot 3: Son sits down. The water sound continues; the sound of the son sitting down is set louder in this shot to set up the father's reaction.

Shot 4: Father turns and talks. The sound of the water in the sink continues under the father's dialog, which is used full.

Shot 5: Son doesn't respond. The sound of the water continues at the same level because it is the only sound in the scene.

Shot 6: Father turns off faucet. Here's the payoff. The sound of the water is increased because the faucet is seen in a close-up. This then

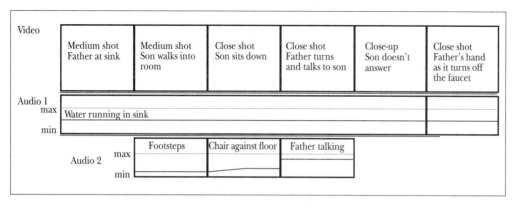

Figure 11-2. The background audio should continue through a scene to tie it together. Here the background sound of water running in a sink is continued under the shots of the son.

Figure 11-3. The optimal level for a final audio track is 0 db distortion. Audio peaks between 0 db and 9 db can be tolerated, but peaks at 9 db cause a type of distortion called *clipping.* Audio levels below 0 db sound quieter.

emphasizes the silence that occurs when the water is shut off. The obvious implication is that the father is upset.

A background sound, such as the faucet in this example, is usually kept at about the same level, unless, as in shot 6, the source of the sound is seen in a close-up. If we were to back away from the scene—for example, with a shot taken from outside looking in through a window at the father and son—then the sound of the water would be decreased.

The viewer is so used to hearing the water throughout the first five shots of the scene, that in shot 6 an element of tension is added when that sound is removed.

As you edit, keep an ear out for natural sounds that can be used to introduce a scene or to accentuate the storyline. Think of it as another dimension in which to work. Your viewers might not notice why a scene that integrates nat sounds works so well, but you will.

Maintaining a Smooth Background

In the previous example, we carried the sound of the water through the first five shots to maintain a smooth audio track that ties all the shots to that location (the kitchen). In reality, the shot of the son walking

through the door (shot 2) might have been taken in another place, at another time, so it would not have any of the sound of water in the sink.

Imagine what would happen if we didn't carry the water sound through shots 2 and 3, if we just used the background sound that came with each shot (Figure 11-4). At the end of shot 1, the water sound would stop suddenly. We would hear the footsteps, then the son sitting down. At shot 4, the sound of the water would suddenly be present again (underneath the father's voice).

Editing the scene this way prevents the shots from seeming like they were all of the same place. In addition, the sudden change in the audio (the water sound dropping out then back in) distracts the viewer. Differing levels of background sound also distract the viewer.

Difficulties in maintaining a smooth audio background can occur in many different situations. The following is a selection of common problem situations and ways to get around them.

Removing Unwanted Sounds

Let's say you are editing a scene of two people putting together a piece of machinery. The order of the shots is defined by continuity; i.e., the machinery is assembled in order, as shown by the illustration at the top of the next page.

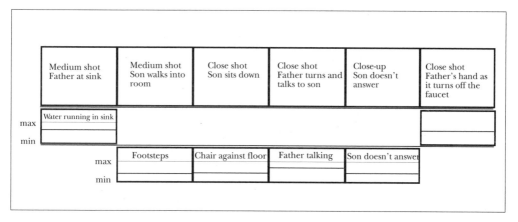

Figure 11-4. If a continuous background sound is not laid under an entire scene, then the audio changes with each shot. This emphasizes the edits and makes the scene seem choppy.

Shot 1	Shot 2	Shot 3	Shot 4
Audio 1	Audio 2	Audio 3	Audio 4

Unfortunately, the background sound for shot 2 includes the sound of the lunch whistle blowing. The easiest way to fix this is to get rid of the sound for shot 2 and replace it. You can use extra sound from shot 1:

Shot 1	Shot 2	Shot 3	Shot 4
Audio 1		Audio 3	Audio 4

You can also use extra sound from shot 3:

Shot 1	Shot 2	Shot 3	Shot 4
Audio 1	Audio 3		Audio 4

Either option involves a few steps, so let's go through how you do the first option in an editing program, such as Adobe Premiere.

The figures in this section were cropped to focus on the most important elements. Your screen probably looks different.

We start with the four shots lined up in order in the Construction window (Figure 11-5).

Figure 11-5.

At times you will need to remove a section of background audio because it contains a sound that distracts the viewer. In this case, shot 2 contains the sound of a lunchtime whistle, which doesn't appear in shots 1 or 3. The solution is to remove the background audio for shot 2 and replace it with audio from shot 1 or 3.

1. Make a copy of the audio portion of shot 1, which we call audio cut 1a, and place it in audio track B:

2. Delete the audio portion of shot 2 by selecting it and pressing ⌈Delete⌉:

3. Using the stretch pointer, extend audio cut 1a until it reaches the beginning of shot 3:

4. Delete the original version of audio cut 1 by selecting it and pressing [Delete]:

5. Move audio cut 1a into audio track A:

Now the audio for shot 1 extends through shot 2.

The reason you have to create a copy of the audio portion of shot 1 is that Premiere does not let you stretch an audio cut that is linked to the video if the video doesn't have room to be stretched. Try stretching the audio portion without making a copy, and you'll see the problem. Creating a copy of the audio portion gets around this problem because the copy isn't linked to the video. The disadvantage of this method is that because the video and audio aren't linked, they can get out of synch easily. You need to establish a synch point (either the In point or the Out point) and make sure that the synch points for the video and audio are lined up along the timeline.

Changes in Background Sound

Most of the time the background sounds for two shots are different—even if they were taken in the same place. Although these changes aren't usually apparent, there are some situations where a noticeable change occurs.

For example, let's say that in the previous example, the audio for shot 2 doesn't include the lunch whistle, but includes the hum of a different piece of machinery instead. If you simply cut from shot 1 to shot 2, the audio changes abruptly because of the new sound.

In this case, you don't need to get rid of the sound for shot 2; you need to smooth out the transition between the two audio portions. The easiest way to do this is to *cross-fade* the audio of shots 1 and 2. Figure 11-6 shows a completed cross-fade in Premiere. The audio of shot 1 is faded out as the audio of shot 2 is faded in.

Here's how you perform a cross-fade:

1. Make a copy (using the Copy and Paste commands) of the audio portion of shot 1 and place it in audio track B directly under the original:

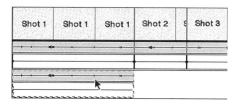

2. Make a copy of the audio portion of shot 2 and place it in audio track C directly under its original, as shown by the illustration at the top of the next page:

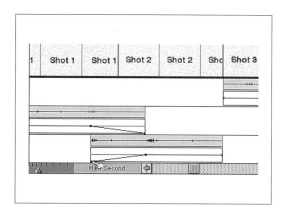

Figure 11-6.

Cross-fading the audio between two cuts helps even out any differences in background audio between them. In Premiere, you create a cross-fade by extending the audio for each cut so that they overlap, and then fade down the audio of the first clip while fading up the audio of the second clip.

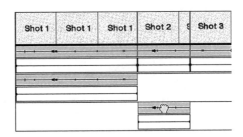

You might want to increase the resolution of the time ruler to make it easier to line up the new audio cuts.

3. Delete the original audio portions of shots 1 and 2:

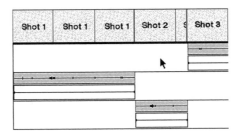

4. Using the stretch pointer, extend the right edge of the new copy of audio cut 1 to the right by 10 frames:

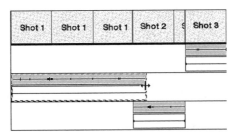

5. Extend the left edge of the new copy of audio cut 2 to the left by 10 frames. This creates a 20-frame audio overlap for the cross-fade:

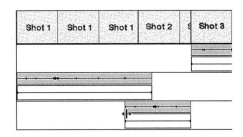

6. Create a handle in the new audio cut 1 at the point where the extended audio cut 2 begins:

7. Drag the handle at the end of audio cut 1 to the bottom of the level indicator box:

8. Create a handle in the new audio cut 2 where the extended audio cut 1 ends:

9. Set the initial audio level of audio cut 2 to zero:

Now the audio of shot 1 starts to fade out as the audio of shot 2 fades in. The cross-fade starts before the video edit occurs to smooth out the transition.

You could also cross-fade the audio between shots 2 and 3 in a similar way, only you wouldn't have to create a new copy of audio cut 2, because you already have one in track C.

 Make sure you don't slide the copy of audio cut 2 because that will take it out of synch with the video. Write down where it starts in the Construction window (using the Info window), so you know where to put it back in case you slide it by accident.

Missing Background Sound

If you're working with someone else's video clips or with material from a clip media disk, you might find that some of the clips don't have any background sound. As mentioned earlier, if one shot in a scene has any sound, then the rest of the shots in the scene should as well.

Let's say you edited the scene depicted in Figure 11-7. Shots 2, 3, 4, and 5 are without background sound.

Your first option is to try to extend the audio from a previous shot (as done in the section on removing unwanted sounds). This option works in a large number of cases but not this one. The audio for shot 1, the forest, won't fit any of the other shots because it doesn't include

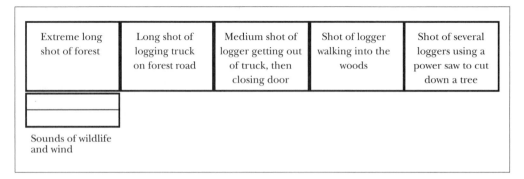

Extreme long shot of forest	Long shot of logging truck on forest road	Medium shot of logger getting out of truck, then closing door	Shot of logger walking into the woods	Shot of several loggers using a power saw to cut down a tree

Sounds of wildlife and wind

Figure 11-7. If one shot in a scene has background audio, in this case shot 1, then you need to create background sound for the rest of the scene.

the specific sounds needed for each shot (truck, door closing, foot-steps, and power saw).

Your second option is to avoid using background sounds entirely and use a piece of music throughout the whole scene. To do this, you need to choose a piece of music that suits the message or story you are trying to convey. If you are making a piece about the need for lumber, then you could use music that had a strong, upbeat mood to convey industriousness. But if you are making a video that is protesting against logging, then you might use music of a more ominous nature.

The use of music (without background sound) gives the scene a surrealistic quality. If that's what you're looking for, then using a single piece of music throughout the scene is an acceptable solution. But if that's not your goal, then you have to try to find a way to put in the appropriate sounds.

The third option is to find replacement audio for each shot that is missing it. Let's say you found another tape that has shots of a different kind of truck in another forest. It also has a shot of a different person using a power saw. You could borrow the audio from the alternate truck shot and put it under shot 2 (Figure 11-8). It doesn't have to be a perfect match, just close. Test it out and you'll know if it works.

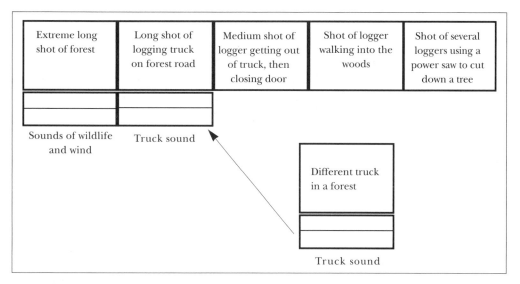

Figure 11-8. You can copy the sound of a truck from another shot and place it under the shot of the truck in this scene to create a segment of background audio.

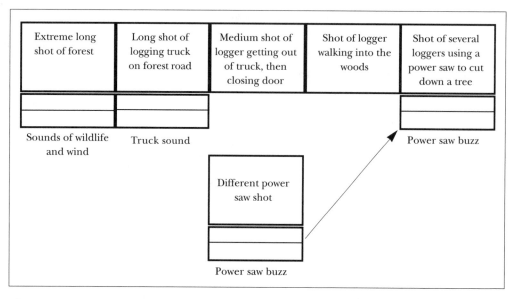

| Extreme long shot of forest | Long shot of logging truck on forest road | Medium shot of logger getting out of truck, then closing door | Shot of logger walking into the woods | Shot of several loggers using a power saw to cut down a tree |

Sounds of wildlife and wind Truck sound Power saw buzz

Different power saw shot

Power saw buzz

Figure 11-9. By using the sound of a power saw from another shot, you can create a background sound for the saw in this scene.

You could also borrow the sound of the alternate power saw shot and put it under shot 5 (Figure 11-9). In this case you need to synch the sound of the audio to match the movement of the saw (the sound of a power saw changes when it cuts into wood).

That leaves shots 3 and 4. These are a bit more difficult because they include actions that call for specific sounds: the closing of the truck door and the sound of the man's footsteps. Because you don't have alternate shots for these shots, you need to create the background sound for these shots from scratch with sound effects, which is the subject of the next section.

Adding Sound Effects

Creating sound effects is one of the most tedious, yet most magical parts of editing audio. The right sound effect can save a shot from the trash bin or add sparkle to an otherwise average shot.

In the previous example, we faced the problem of creating background sounds for two shots that didn't have any audio: a man getting

out of a truck and closing the door and a man walking in a forest. We look at each one in turn.

Adding the Sound of a Truck Door

The sound of a car door closing is fairly similar to the sound of a truck door closing; so all you need to do is find a quiet spot where there isn't a lot of background sound and close a car door several times (while you record). Try to close the door harder on each try to give yourself some options. Digitize those sounds and import them into your editing program.

You now need to synch the sound of the door closing to the action in shot 3. Here's how you do it in Premiere:

1. Open the sound effect in the Clip window.

2. Set the In and Out points so that there is only about 10 frames of pad before and after the door slam.

3. Drag the sound effect into the Construction window and position it somewhere under shot 3:

4. Set the time ruler to 4 frames to increase the resolution of the Construction window.

5. Position the sound effect so that the audio spike (which represents the door slam) lines up with the point in the video cut where the door closes:

6. Set the work area to include just shot 3 and preview the work area.

7. Adjust the position of the sound effect (right or left) until the door slam sound is in synch with the video.

Now that you've matched the specific action of the door closing, you can fill in the rest of the audio with a more general type of audio. Because the truck is in the woods, the basic background sound would be similar to the audio you used in shot 1.

Make a copy of the audio portion of shot 1 and place the copy in audio track B under shot 3:

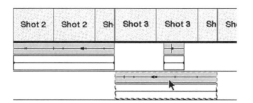

Preview the work area. Adjust the volume, or level, of the door slam audio so that you can hear it clearly, and it fits the video. That is, if the truck is a long way from the viewer (i.e., the camera), the sound should not be very loud. If the truck is close to the viewer, the sound should be louder.

Adding Footsteps

Creating a sound effect to match a person's footsteps can be fairly tricky. The difficult part is matching the pace of the steps. You could record the sound of one step and use that one sound for each step in the shot, but it would be better and would require less editing time to match the whole walk. That means that you have to *foley*, or imitate the person's walking speed, when you record the effect.

The easiest way to do that is to figure out how many steps the man takes over the course of the shot. Let's say in this case, the man takes six steps in five seconds. Then, when you are recording the effect, have your assistant (or whoever is the surrogate walker) walk at a pace so that he or she takes the same number of steps in the same amount of

time (six steps in five seconds). Record several versions to give yourself some options later on.

 A more involved method would be to play the tape of the man walking in the woods as your assistant is walking. Then, by listening to your assistant's footsteps as you're watching the tape, you could tell if the walks are similar.

Matching the pace is only one part of the solution—not all footsteps sound the same. The sound of high heels on a wood floor is dramatically different from work boots in a forest; so you have to try to match the situation when you record the sound effect. In this case, an obvious option is to find a patch of dry leaves. But let's say it's summer, and there isn't a dry leaf to be found. Now you have to get creative.

Every sound editor has his or her own war stories of improvised sound effects. In this case, having someone walking on a piece of carpet covered with potato chips would create a fairly close substitute for a person walking on dry leaves.

Once you're satisfied that you matched the pace and the tonal quality of the footsteps, you record the effect, digitize it, and import it into your editing program. Place the sound effect in an audio track under the shot in question, and adjust its position, right or left, until the effect is in synch with the video. If you haven't matched the pace of the walk exactly, try splitting the sound effect into two parts and adjusting each part. The holes in the sound are filled by the background sound of the woods.

Each tricky situation calls for a unique solution. But over time, you'll collect your own bag of sound effects tricks, and matching sounds will become easier.

Prepackaged Sound Effects

If you're going to be working with a lot of sound effects, you might want to look into acquiring a set of prepackaged sound effects. These are collections of typical sounds, such as closing doors, speeding cars, and fire engines. The BBC (British Broadcasting Corporation) has produced probably the most extensive collection, which offers every-

thing from the buzz of a World War I biplane to the sound of someone scraping toast.

Audio Sweetening

Sound effects aren't just for fixing problems. You can also use them to add sparkle and texture to particular shots or whole scenes. For example, if you edited a scene of two people talking at an outdoor cafe, you could introduce an artificial background sound of city traffic to make it seem as if they were in the middle of a city. This bed of sound would be played at low volume, so it did not conflict with the dialog.

You might wonder why you should go to all the trouble to eliminate background sound in dialog shots if you're going to put background sound back in. The reason is that you might want to use a different background sound in the final piece. By making sure the dialog is clean, you give yourself more options in the editing room.

You can also use sound effects to boost the sound for particular parts of a shot. For example, let's say you took a long shot of someone knocking on the front door of a house. Because it's a long shot, the audio for the shot probably won't pick up the sound of the door well (to do that, the microphone would have to be near the door, and it might be visible in the shot). You can fix this by replacing that part of the audio with a sound effect of a door knock.

How much sweetening you should do depends on where your piece will be shown, how much time you have, and how much money you have. Audio sweetening plays a big role in feature films, but the subtleties added by sweetening are lost if your piece is going to be played at a noisy trade show.

Adding Music

Of all the techniques in the sound editor's tool kit, music is the most powerful and manipulative. The right piece of music can turn an average scene into an emotional tour de force. In contrast, the wrong piece of music can deflate a powerful scene into a mishmash of conflicting signals.

Music works in mysterious ways. It somehow taps into a different part of our brain and creates associations that often work on a subconscious or subliminal level. Try to remember a scene from one of your favorite movies. It's likely that music played a major role in making that scene memorable.

Imagine *Star Wars* without John Williams' soundtrack (if you saw the movie, you can probably still remember the theme music). The haunting, threatening music of *Jaws* is burned in the minds of millions of Americans. "Lara's Theme" from *Dr. Zhivago*, the soundtracks for *Rocky*, *Chariots of Fire*, *The Sting*, the list goes on and on.

And from the world of television, it's scary how many of us can recall songs for old television shows. Anyone remember the theme songs to "The Jetsons," "Green Acres," the original "Star Trek," and "M*A*S*H"?

Film and video professionals have known for a long time that music can create a new experience for the viewer—one that is richer, deeper, and more memorable. Now it's your turn.

Setting the Right Mood

Every type of music produces a different mood. A classical piece can "color" a scene differently than hard-edged rock-and-roll; so you need to choose your music carefully.

Most of us are already familiar with how music can affect a scene. A tune in a minor key lends a somber or sad edge to the visuals. Soft, flowing music, maybe just a classical guitar or a flute, adds a peaceful sense to a scene. A loud and boisterous saxophone injects energy. A full orchestra, with its emphasis on stringed instruments, creates a sweeping sensation. A heavily synthesized piece, with lots of electronic sounds, imbues the scene with futuristic tones.

Because music can have such an impact, you need to match the mood of the music with the mood of the scene. You also need to consider the style of editing you are using. Music with a strong beat and fast tempo suggests a series of quick shots. A piece of music with longer notes and a diminished beat calls for lengthier shots.

 You should start thinking about what kind of music you'll use at the beginning of the production. Too many people leave it to the end when there isn't enough time.

Music as an Active Element

If a scene doesn't include narration or dialog, you have a lot of freedom in your choice of music. It can be majestic and sweeping, it can include lyrics, it can have a strong beat. If the ambience of a shot is important—say, the sound of a mountain stream—then the music should not be so loud and active that it clashes with the background sound. How loud is too loud? That depends on the situation. If you're editing a car chase scene, the music can be very loud because the background sound will be as well.

As was described in Chapter 9, in these types of sections the video and music are edited at the same time. You first lay down the music, then you edit the pictures (as opposed to laying the music in after the pictures are edited). The music's beat and tempo suggest ways to edit the video. This can complicate things if your video edit points are determined by continuity. In most cases, the visual continuity is more important.

In feature films, music is often added after the film is edited. The composer scores the music so that it fits the edited film. You might not have the budget to commission music specifically for your piece, so you should edit the music and visuals at the same time.

Give yourself a lot of time when editing scenes that use music as an active element. You might re-edit the same section several times before you are satisfied. Many times you may find out that that perfect piece of music wasn't so perfect after all, and you need to find another one that fits the images better.

Background Music

In scenes with dialog, the music takes a back seat to the words. Therefore, you should use music that doesn't compete with the dialog but supports it.

Generally speaking, background music is fairly simple; that is, it does not contain a large number of instruments. The type of melody involved varies from editor to editor and scene to scene. But the important point to remember is that the music is there to embellish, not to call attention to itself.

Although it does not play an active role in a scene, background music still can add a great deal to the mood. It can add an emotional element not present in the dialog (or in the acting). It can also serve to make a transition from one mood to another. For example, the scene of the two people sitting by a mountain stream discussed earlier could start with calm, soft music. Then, as the scene progresses and the people start to argue, the music could switch to a minor key to introduce a sense of tension and conflict.

 As with editing, the best way to learn how to use background music is to hear how it's used on television and in movies. Train yourself to listen for the music and hear how it sets the tone of a scene.

Incorporating Music

Unlike background sound, which is tied to a particular shot or scene, music can be introduced and removed at any point in time. You can use a piece of music to introduce a scene by starting the music just before the scene begins. You can also add a piece of music in the middle of a shot. For example, in the logging scene described earlier, you can fade up a piece of music halfway into the long shot of the forest.

Most of the time, you fade up a piece of music at the start and fade it down at the end. The length of a music fade can vary, but on average it lasts for at least one second and usually more.

If the music is an active element, then it should be played full, that is, at the 0 db level. Above that level, you start to get distortion. Background music should be set low enough that it doesn't overwhelm the dialog but loud enough that it can be heard.

Often a single piece of music is used as an active element in one part of a scene and then as a background element in sections with dialog. In these situations, you should start to fade the music down gradually so that it is at the proper level when the dialog begins.

Sources of Music

If you plan to use a piece of music from a record or CD you bought in a store, then it's probably copyrighted, and you must get permission from the copyright holder to use that music. Most of the time, the

music publisher holds the copyright, so you have to negotiate with the company over how much to pay for the permission.

An attractive option is to use *clip music,* also known as *needle drops.* This is generic music that was produced solely for the purpose of being licensed. A large number of these CDs have already been produced; you purchase the rights to use the material when you purchase the disc. Given the wide range of music styles available on clip discs, you should probably not consider using well-known songs unless you have a large budget for music.

Yet another option is to compose the music yourself. There are a number of new music-composing programs that let you create generic music of your own. These programs contain algorithms for different styles of music (samba, ragtime, big band, etc.). You can have the programs create compositions at random or by following the key, melody, or tempo you determine. The programs then create the music and store it as a digital file.

Your compositions won't sound as professional as store-bought music or even as good as clip music, but they probably sound a lot better than what you could bang out on a piano (unless, of course, you're a musician).

Mixing Several Audio Tracks

Combining several sound elements into a final, single audio track is as much an art as it is a science. In the film and television industry, this process is known as a *mix down,* and there are professionals who specialize in this process alone. Entire books have been written about the art of sound mixing. Here, we just examine the technical aspects of working with several tracks of audio.

On the face of it, sound mixing involves setting the level of each sound element so that it can be heard clearly among the others. The tricky part is making sure the various sounds don't clash or overwhelm one another. If you're working with only three elements, that should be a manageable task.

You can add up to 96 audio tracks by choosing the Add/Delete Tracks option under the Project menu.

Your main concern, not surprisingly, is with the primary audio. If someone is talking, you need to hear him or her clearly, so the level of dialog and narration should be set at 0 db (Figure 11-10).

Next you should set the level of any sound effect that needs to be heard clearly (i.e., that is not used as background sound). For example, if a door closing appears prominently in a shot, then you want to hear that sound. Most of the time, these types of sound effects occur between sections of dialog, so they won't interfere.

Third, adjust the level of the background sound so that it is present but low enough that it doesn't conflict with the dialog and primary sound effects. If you are working with a music track as well, drop the background sound level down a bit lower than you would otherwise (to make room for the music).

Last, adjust the music level. You might want to change the beginning and ending points of the audio fades at this point to accommodate the other audio tracks.

If you are going to be working with many audio tracks, you might want to consider exporting the various sound elements to a sound-editing program, such as SoundEdit Pro (by Macromedia). In addition to giving you more control over several audio tracks, these programs let you apply a wide range of special effects, such as filters, reverb, pitch shift, and tempo change. Once you mix down in the sound-editing program, import the mixed-down track into the video-editing program and place it under the appropriate shots.

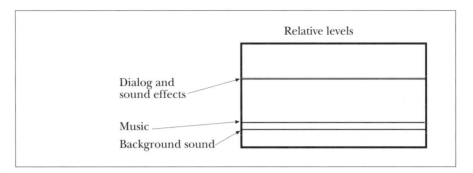

Figure 11-10. Dialog and narration are set near the 0 db level because you want to hear them clearly. Audio special effects that are tied to an action in the video are set fairly high as well. Background sound and music are set lower so they don't conflict with dialog or narration. However, if there isn't any dialog, music or background sound can be set at 0 db.

 Premiere does come with several audio special effects, but it does not offer you the same amount of control as a sound-editing program.

As with sound mixing, a detailed discussion of how to use sound effects is beyond the scope of this book. If you are interested in getting involved in this area of production, you should buy a book devoted to this issue (please refer to Appendix A for a list of books on video and audio production).

Wrap-Up

In this chapter we focused on how to make the audio portion of a QuickTime movie as compelling as the video part. Too often an after-thought, audio editing is an essential part of professional productions for producing the proper balance of dialog, background ambience, sound effects, and music. If you take the time to make the audio track support and enhance the video, your movies will stand out from the crowd.

Getting Good Stuff to Work With

No amount of editing can ever completely correct for poor camerawork, bad lighting, and shoddy sound recording. Starting with good material makes the job of editing much easier because you can spend more time fine-tuning your video segments and less time cutting around problems. In this chapter, we review some of the basics of proper camera, lighting, and sound-recording techniques.

Before the Shooting Starts

Production tends to be expensive. Unless you're acting as a one-person production team, you'll probably be working with two or three other people. And these people will probably want to be paid (you can only beg favors from friends for so long).

Even if you're not spending a lot of money, production is still time-consuming. A general rule in documentary production is that each day of shooting produces three minutes of edited video, that is, footage that ends up in the final piece. For scripted productions, such as a training video, you can get as much as five or six minutes of edited video per day; so, a 12-minute piece requires at least two days of shoot-

ing. And that's just an average for an experienced production team. You might need to spend more time in the field than that.

So it's a good idea to think about what you're going to shoot before you pack up the camera and start shooting.

Have a Plan

Earlier chapters discussed the importance of developing a shooting script for your production. This document is a kind of blueprint for the final piece. If you don't write a shooting script, at least write down a list of shots you think you'll need.

Such a list is invaluable if you have to shift your plans in the middle of a shoot day. You will be able to modify your plans more easily and more efficiently if you've got a good sense of what you have to shoot.

Scout the Location

If you have the time, you should try to scout all locations (places you're going to shoot) several days before the actual shoot day. This gives you time to identify and resolve any unexpected problems. There is a basic set of items to check for indoor and outdoor locations.

Indoor Locations

- The number of windows (this affects your lighting plan)
- The number of electrical outlets (the number of extension cords you need to bring)
- Whether the outlets are on separate circuits (this is especially important if you're going to be using many lights, because you shouldn't put more than three lights on one circuit)
- Background sounds (Can annoying appliances be turned off? Do special arrangements need to be made? Do you need to bring sound blankets to muffle the sound?)
- Parking (What is the best place to off-load your equipment so that you're close to an entrance?)

Outdoor Locations

- Position of the sun (with regard to your likely camera position and the time of day you'll be shooting)

- Background sounds (construction and traffic noise, again with regard to the time of day)

Some of these items might seem pretty trivial, but working out potential problems beforehand will make your shoot day go smoother, and that will lead to better material.

Check Your Equipment

You are totally dependent on your equipment. If it doesn't work, you might as well pack up and go home. Therefore, a cardinal rule is to make sure the equipment is working before you go out on location. That means putting in a battery, turning on the camera, and recording some footage and audio. Don't assume a cable works; make sure.

Video production equipment falls into two main categories: studio production and field (or remote) production. Most of the time you won't be working in a studio, so we'll focus on remote production equipment. Appendix A contains a list of books on video production, some of which focus on studio production.

The basic parts of a remote production system are discussed in detail in the following sections.

The Camera Package (Camera, Recorder, Tripod, Extras)

There are a wide variety of cameras and lenses that can be used for video work. You should make sure the camera you choose has at least an 8:1 zoom ratio (for more flexibility in framing a shot), a lens iris that you can set automatically or manually, and a white balance button. Most of the top-end cameras have these features.

In addition to the camera, you want to have the following items to round out the camera package:

- Recorder (if it is not attached)

- Batteries (enough for a full day of shooting plus two extras)

- AC adapter/battery charger
- Camera case
- Tripod
- Camera-tripod plate (This connects the camera to the tripod. Some tripods don't use plates, but if yours does, make sure you have it, or you won't be able to use the tripod.)
- Monitor
- Power cable for monitor
- Video cable to connect monitor to the recorder or the camera

The Lighting Kit (Lights, Light Stands, Power Cords)

The kind and number of lights you need depends on where and what you're shooting. A basic lighting kit, which meets the needs of most indoor and outdoor shooting, includes the following items:

- Four lights (two lights of 650 watts, two lights of 1,000 watts)
- Four light stands
- Two umbrella reflectors
- Extra bulbs
- A power cord for each light
- Extension cords
- Power strip (multiple outlets on a single extension cord)
- Gaffer's tape (2-inch wide gray tape, which is stronger than duct tape)
- White card reflector (large piece of white poster board)
- Flexfill (a flexible circle of aluminized plastic, which is used in outdoor situations)

The Sound-Recording Package (Microphones)

Although most camcorders come with a microphone attached, you should also bring along at least one other microphone. The on-board mike won't be close enough to the action to give you crisp, clear audio.

As with the lighting package, your particular sound-recording equipment needs vary according to your production. The following package covers most situations:

- Two Tram or Lavalier microphones (small microphones that can be clipped onto a person's shirt for an interview)

- Microphone batteries (the size depends on the mike; make sure you have at least two extras)

- Additional microphone (see optional-elements list that follows)

- Microphone cable and spare

- Headphones

That's the basic package, but if you want the audio in your piece to grab people's attention, then you should consider using one or both of the following mikes:

- Hypercardioid microphone, such as a Schoepps or a Sennheiser 416. (These microphones are designed to pick up sound from only a small region in the front of the mike. These are the standard mikes for getting natural sound. They are also a popular choice for recording interviews or scripted dialogs on a set. In these situations, the mike is hung from a boom.)

- Shotgun mike. (This microphone is designed to pick out sounds that are far away. It should not be used indoors because it picks up unwanted echoes.)

Extras (Videotape, Phone List, Appearance Releases)

You should always bring more videotapes than you need. They don't weigh much, and you'd hate to run out. You should also bring a list of phone numbers of people to contact in case you have trouble with the equipment.

If you are going to be shooting footage of people, you should bring along appearance releases. These are legal documents giving you permission to use a person's face or voice in your final piece.

Familiarity Breeds Contempt

After you've been shooting for a while, you might start to slack off on your equipment check-out procedure—not a good idea. Take a tip from professional camera operators. They check out their equipment every day, even if they shot with it the day before. Components malfunction, parts break, cables wear out, and people borrow pieces of equipment and don't return them.

Plan to spend 15 minutes checking out the equipment. That's a short period of time compared to the hours that can be lost when a key piece of equipment breaks or is forgotten.

Camera Basics

The basic goal of production is to get the material you need to convey your story or message. Beyond that, you should try to get the best material you can. It's not enough simply to mechanically tick off the shots on your shot list. You need to compose your shots so that they emphasize the right elements. You might want to perform camera moves and zooms to add movement to the shots. You need to take into account the vagaries of lighting (particularly in outdoor locations).

Many books have been written about the craft of videography. A partial list can be found in Appendix A. This section only covers some of the more basic rules of shooting. Then, we examine some common situations you're likely to face.

 The word "scene" is used here in the standard sense of a place or a location. the "frame" is the image in the camera's viewfinder at any point in time.

The composition of the image is as important in a video shot as it is in a still photograph. The balance of objects on the screen, how large or small something appears, affects how the viewer perceives the image. Deciding what kinds of shots to get with the camera and which elements to include in a shot (the framing of the shot) is the role of the director, and the director's decisions ultimately determine what the editor has to work with.

There are innumerable ways of shooting a particular scene, but a few classifications have been established so that directors, camera operators, and editors can use the same language when talking about particular shots. There are three basic types of shots:

- *Static shots*, which are taken without moving the camera
- *Camera moves*, which include zooms, tilts, and pans
- *Tracking shots*, where the camera (and the tripod) is moved during the shot

Static Shots

Most of the shots you take will be static shots. This doesn't mean you're stuck with only one particular composition or framing. Almost all video cameras come with zoom lenses that allow you to frame shots in a number of ways. The various types of static shots fall into five broad categories: long, full, medium, close, and close-up. In addition to these framing classifications, there are also several terms for describing the composition of people in a frame and the angle of the camera, such as three-quarter shots, reverse shots, and two-shots. The framing terms are described first.

Long Shots

In a *long shot*, the camera is usually located far away from the subject and establishes a scene, showing how the subject fits into the surroundings. The subject appears quite small, especially in a small (240 × 180 pixels) QuickTime window (Figure 12-1). This type of shot is used quite a bit in feature films that are shown in theaters. Unfortunately, in small or medium sized QuickTime movies, most of the details in a long shot can't be seen. Use this shot sparingly and only in scenes that contain a lot of bold features and few details.

Full Shots

The *full shot* is also used to establish a scene, but it shows more of the subject and less of the background. Full shots of people usually show their whole body (Figure 12-2). This shot is not good for seeing facial expressions because the images are just too small. However, a full shot is useful for capturing a complete motion, such as a person walking across a room.

Figure 12-1.

A long shot is used to establish a scene or show the subject within the context of his or her surroundings.

Figure 12-2.

A full shot focuses on the subject but also shows a good portion of the surroundings.

 Because most QuickTime movies are shown in small to medium sized windows, full shots should only a few, clearly visible objects in the picture: for example, two or three people.

Medium Shots

Medium shots are used to show a single person with some amount of his or her surroundings, or to show relationships between people. The basic framing for a medium shot of two or three people extends from their waists to about a foot over their heads. A medium shot of a single person covers from about waist-level to a little bit above the head (Figure 12-3).

This is a good shot to capture bold gestures and expressions. For example, if you are shooting an interview with a man who talks with his hands, a medium shot will capture all his body language.

Figure 12-3.

A medium shot is used to show a group of people or capture movement within a small area. Large facial expressions can be seen but not subtle ones.

Close Shots

The most common use of *close shots* is to show people's faces. The standard close shot for QuickTime movies is a bit tighter than what you see on television; it extends from about the shoulders to just above the person's head (Figure 12-4). In a close shot, you can clearly see the person's facial expressions and, through them, their emotions. If you are shooting this shot with a zoom lens, make sure that the camera is on a tripod; otherwise the shot will be jumpy once it is converted to QuickTime.

Close-Ups

This kind of shot is used to show fine details, such as the time on a person's watch. The exact framing for a close-up shot varies according to the material. A close-up of a person's face would extend from just below the chin to the top of the forehead (Figure 12-5). This shot focuses the viewer's attention on the person's eyes (which often reveal the most about a person's emotions or inner feelings). Close-ups are also good for showing subtle motions, such as a hand turning a door knob and a finger pushing a button.

Figure 12-4.

A close shot is the standard framing for shooting a person. The viewer's attention is focused on the person's face.

Figure 12-5.

A close-up emphasizes a portion of the person's face, usually his or her eyes. It can also be used to show subtle movements, such as a hand turning a doorknob or the second hand moving on a person's watch.

Composition of Groups and Camera Angles

As with framing, there are numerous ways to shoot a group of people. Certain types of shots occur frequently and have been given specific names.

Three-Quarter Shots

When you are interviewing someone and you don't want them to talk directly into the camera, position the interviewer, the subject, and the camera as shown in Figure 12-6. This will produce the shot known as the *three-quarter shot* because it shows roughly three-quarters of the subject's face.

Reverse Shots

The name of this shot describes the direction the camera is pointing as opposed to a particular framing. In an interview setting, the *reverse shot* shows the interviewer (the person asking the questions) instead of the person being interviewed (Figure 12-7). The camera position is reversed to show the reaction of the interviewer.

Two-Shots

The term *two-shot* simply describes a medium shot containing two people (Figure 12-8). It is often used to establish a scene where two people are talking to each other.

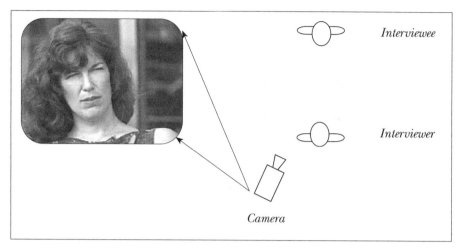

Figure 12-6. Camera layout and framing for a three-quarter shot: This shot is standard for interviews because it shows a lot of the person's face without having him or her look directly into the camera.

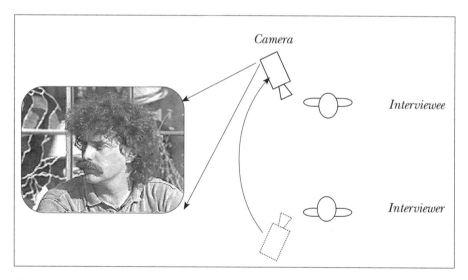

Figure 12-7. Camera layout and framing for a reverse shot: The camera is moved next to the person being interviewed to show the reactions of the interviewer.

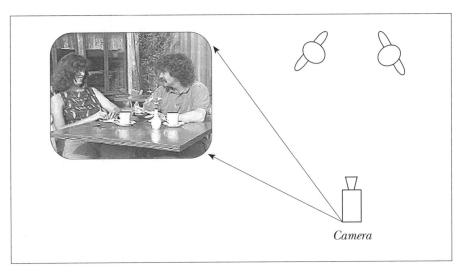

Figure 12-8. Camera layout and framing for a two-shot: This is a medium shot that shows both parties of a conversation.

Camera Moves

A *camera move* is a shot in which the framing changes in the middle of the shot. For example, you could gradually zoom out from a close-up to a medium shot. The shot begins with one framing (the close-up) and ends with another (the medium shot). There are a wide variety of camera moves; the basic ones are *zooming, tilting,* and *panning.* Any camera move involves three parts: the beginning framing, the move itself, and the end framing.

 It is especially important to use a tripod for these shots if you want the shots to look smooth and not bumpy after you digitize them. (For more information about why this is important, see the section "Considering the QuickTime disadvantage" later in this chapter).

Zooming

This technique involves pressing the zoom button on your camera while you take a shot. With a zoom, you can change the framing of the shot from, say, a full shot to a close shot. This allows you to focus the viewer's attention on a different element in the scene. For example,

let's say you are shooting a city street in a long shot, then you zoom in to one person next to a bicycle on the side of the street (Figure 12-9). The zoom shifts the viewer's attention from the entire street to the single person. Alternatively, if you start with a medium shot of the single person and then zoom out to show the entire street in a long shot, the focus of attention goes from the individual to the wider scene. A shot that zooms out is often called a *reveal* because it reveals the background or surroundings of the person shown at the beginning of the shot.

(a)

(b)

(c)

(d)

Figure 12-9. Zooming in: (a) The initial framing shows the entire street; the woman is barely noticeable. Then as you zoom in (b–d), the woman is emphasized more and more until you can't see the street anymore.

Tilting

In this type of shot, the camera is tilted up or down, as the name suggests. This is usually done to show things, such as tall buildings, that won't fit in a single static shot. Another use of this shot is to follow objects that are moving up and down, such as an elevator or machinery. You can also use tilts to shift the viewer's attention from one object to another. For example, say you are shooting two people talking: One person is standing in the street, and the other is leaning out a second-floor window. You could shoot this scene with two static shots, one of each person (Figure 12-10a), but a nice addition would be a shot that tilts up from the person on the ground to the person in the window (Figure 12-10b). This would show the gap between them (which would convey a subtle message if the people were having an argument).

Panning

In a panning shot, you are rotating the camera along a level line, left to right or vice versa. These types of shots can be used in a large number of situations.

First, you can use panning shots, or *pans,* to show subjects that are too wide to fit into one shot, such as a large house or a crowd of people. Sometimes you don't have enough room between the subject and the camera to get a full shot of a scene, in which case you can use a pan to show the same thing.

A related use of a panning shot is to show a group of objects in fine detail. One example would be a long jewelry case containing priceless diamonds. To see the whole case might require a medium or maybe even a full shot, but these shots wouldn't provide enough detail of the diamonds themselves. A more attractive alternative would be to shoot a close shot of several diamonds and then pan across the case to show the whole collection.

Another use of a pan is to shift the viewer's attention from one object or person to something else. Let's say you are shooting a woman leaving on a ship as she waves good-bye to her family on the dock (Figure 12-11). By placing the camera behind the family, you can easily pan from the woman on the boat to the family, thereby showing the relationship between the two and leaving the viewer's attention on the family (Figure 12-12). If you pan from the family to the woman, the viewer's attention is left on the woman.

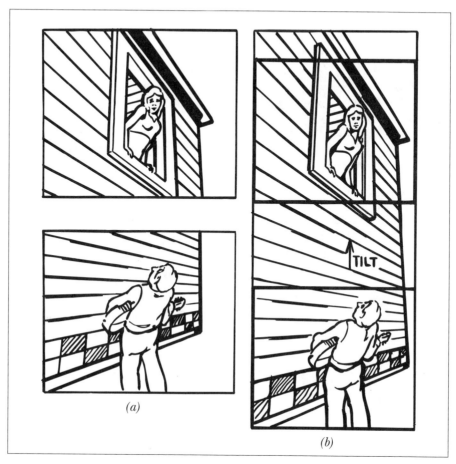

Figure 12-10. (a) This scene can be shot with just two static shots—a close shot of each person. (b) By tilting the camera, you can show the physical relationship between the two people in this scene. The shot starts with a close shot of the person on the ground and tilts up to show the person in the window.

Yet another major reason for using a panning shot is to follow motion or movement. Earlier in the chapter, the full shot was described as a good way to cover a motion, such as a person walking from left to right. However, if you want to see the person's face to catch her expressions, a full shot won't provide enough detail (Figure 12-13a). Instead, you could shoot the woman in a medium shot and then pan to the right as she walks (Figure 12-13b). This allows you to follow the motion but also lets the viewers see more of the woman's face than they would in the full shot.

Figure 12-11. Camera pan: The shot starts with a medium shot of the woman on board. Then as the camera pans left, we see a small section of the boat and then the family.

Figure 12-12. Camera layout for a panning shot: The camera is placed behind the woman's family on the dock. The shot starts with a medium shot of the woman on board, then pans left to show the family waving good-bye.

Figure 3-13. (a) Shooting someone walking with a long shot. (b) Shooting someone walking with a panning shot. The shot starts on a medium shot of the person. Then as the person walks from left to right, the camera pans to follow her.

Combining Camera Moves

Any of these three types of camera moves can be combined in a single shot (a zoom out with a pan, a tilt down with a zoom in, etc.). Sometimes a combination of moves is required when shooting a person's motion—a woman walking up a spiral staircase. Of course, these shots are more difficult to pull off than a shot that has only one type of move. This is particularly true if the camera moves have to start or finish at a particular point during the shot.

As an example, say you are shooting a woman walking out the bottom floor of a tall skyscraper. An interesting way to shoot this scene would be to start on a full shot looking up at the skyscraper (Figure 12-14). Then as you tilt down the building, you start to zoom in. The tilt and the zoom should be finished just as the woman walks out the door.

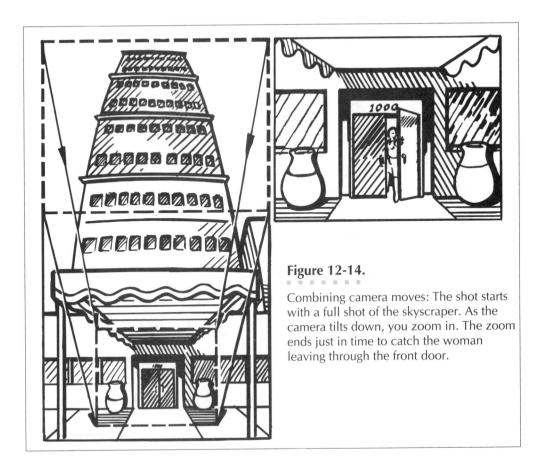

Figure 12-14.

Combining camera moves: The shot starts with a full shot of the skyscraper. As the camera tilts down, you zoom in. The zoom ends just in time to catch the woman leaving through the front door.

This shot requires three things: a smooth start and end to the tilt, a smooth start and end to the zoom, and perfect timing. If done well, this is an intriguing shot that can carry lots of messages (opening with a large foreboding building, tilting down to show how massive the building is, zooming in to focus on the solitary heroine's entrance to the street). If you are going to attempt anything this complicated, practice the shot several times before you actually record anything. Then, be prepared to try it again and again until you get it right.

Taking Level and Steady Shots

Whenever possible, use a tripod. Your shots will be much steadier, and you will be able to plan your compositions more carefully.

If your tripod comes with a level gauge, make sure the tripod is level first, then place the camera on the tripod. If you are working with a tripod that doesn't have such a gauge, find a true horizontal line in the scene and line the camera frame along that line.

If you are going to be shooting without a tripod—that is, *hand held*—try to steady yourself on a solid object (desk, chair, etc.) whenever possible. This is especially important if you are zooming into something because any movement on your part is exaggerated.

Deciding When to Use a Camera Move

You should have a reason for using a camera move in place of two static shots. Moves without a purpose confuse the viewers, leading them down the visual equivalent of a dead end. Plan ahead: Pick a beginning framing and an end framing before you start recording. If there is no movement in the shot other than that of the camera, choose the shot and the angle so that the middle of the shot is interesting as well.

For example, in the illustration of the woman on the boat and her family, if you place the camera at position A in Figure 12-15, the middle of the shot will show just the ship; then more ship; and finally, the family on the dock. Any connection you wanted to make between the woman and her family will be diminished by the long stretch of the ship. If, instead, you place the camera at position *B* in Figure 12-15, the shot will move quickly from the woman to the family.

When making any type of camera move (pan, tilt, zoom, or a combination), remember to *move slowly*. If you don't have much experience operating a camera, try following this simple rule: If it feels like you're zooming (or panning or tilting) at a reasonable speed, you're probably moving too fast. Slow down until it is *uncomfortably* slow.

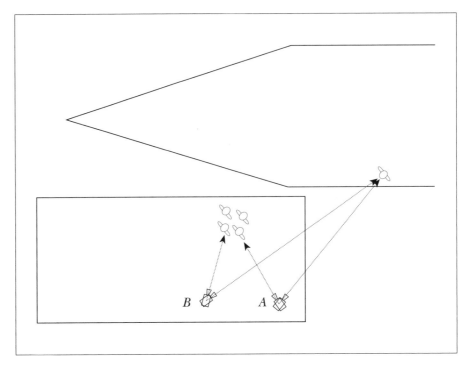

Figure 12-15. Camera placement can affect how a panning shot looks. When the camera is placed in position *A*, a good portion of the pan shows neither the woman nor her family, just the ship. By placing the camera at position *B*, the shot moves quickly from the woman to her family.

There are two reasons for doing this: One, *you* know what you're shooting and what's coming next; the viewers don't. You have to give them a chance to stay with you. The second reason is that when you convert from videotape to QuickTime, all camera moves become more jumpy and jittery. A slow pan or tilt jumps less in QuickTime format.

Another general rule to follow when shooting camera moves is that you should always extend the beginning and ending shots for at least five seconds and perform the move in both directions. Here's an example that demonstrates the proper method for shooting camera moves:

You are planning to zoom from a full shot of a crowd into a close shot of a woman in the center of the throng. At the beginning of the shot, you record five seconds of a static full shot of the crowd before

you start to zoom in. After you zoom in (slowly) to the close shot, hold the static close shot for five seconds (the tape still running). Then, zoom back out to the full shot and hold the full shot for yet another five seconds.

Although this might seem like a lot of work, using this method of shooting gives you many different shots to work with when you're editing the scene. You will be able to zoom in or out or use either the full shot or the close shot as a static shot. This method should be followed when doing tilting or panning shots as well.

Tracking Shots

Sometimes you need to move the camera from place to place to capture a particular motion. Let's say you're shooting a man as he walks down a corridor. You could shoot this scene by placing the camera at the end of the corridor, starting the shot on a medium shot of the man, and then gradually zooming out as he approaches you (this keeps his size within the frame constant as he approaches the camera). But you could also shoot this scene by walking backward in front of the man while framing him in a medium or close shot (Figure 12-16). A shot like this, where you physically move the camera (and yourself or the tripod), is called a *tracking shot*. There are several different types: *walking shots*, *dolly shots*, and *crane shots*.

Figure 12-16. A walking shot: The trick to making these shots work is to get very close to the subject. This allows you to use a wide-angle lens setting that minimizes the general shakiness of walking shots. You then walk backward as the subject walks forward.

 It is important to move slowly during a tracking shot so that the shot isn't too bumpy after you digitize it.

Walking Shots

As the name suggests, in walking shots you walk with the camera as you're shooting. If you've already tried to do this kind of shot, you know how difficult it is to hold the camera steady as you walk. In fact, one measure of a professional camera operator is how steady his or her hand-held shot is. One way to minimize the unsteadiness is to get close to the subject and shoot him or her with the lens zoomed out to the wide position.

Because any camera movement is exaggerated when you convert to QuickTime, you might want to use some sort of steadying device, such as the Steadicam Jr. (by Cinema Products), which can help smooth out the bumps. Try to keep the subject in roughly the same position in the frame throughout the shot. When the image of the subject moves all around the screen, it's difficult for the viewer to follow the action.

Dolly Shots

If you want to shoot a tracking shot and it needs to be steady, then consider using some sort of moving platform, or *dolly*. There are a wide variety of dollies that vary in performance and price. At the top of the line are professional dollies that have a seat for the camera operator and a special set of wheels that turn in unison. For your work, you might consider using a *doorway dolly*, which is simply a platform on wheels that can fit through a doorway. The tripod and camera sit on top of the platform, and the camera operator stands on the platform as well. You need someone to move the doorway dolly during the shot (in the film and television business, this person is called the *grip*).

If you don't want to spend the money to rent a doorway dolly (about $75/day), try using a wheelchair. Attach a board to the armrests to get a higher vantage point for the camera operator and *voilà!* you have a makeshift dolly. You won't get as smooth a shot from a wheelchair as you would from a doorway or professional dolly, but the shot will be steadier than what you'd get from walking with the camera.

Depending on where you're shooting, there may be other ways to shoot a tracking shot. If you're in an airport, you can put the camera and tripod on a moving sidewalk and have your subject walk alongside.

If you're in a hospital, try using a gurney with the camera operator sitting on top. Keep your eyes open for these possibilities because although tracking shots can be difficult to get, the movement they provide can add a lot to the final production.

Crane Shots

If you need to follow someone or something that is moving up or down, and you don't just want to tilt the camera, you need a device called a crane. It is unlikely that you will have the need or the budget to use a crane shot, but just in case you've got aspirations of being the Cecil B. deMille of QuickTime, here's some basic information.

A crane used for film or television work is like the cherry picker used by telephone repair companies to fix overhead phone lines. The camera sits in the basket of the crane and moves up and down under the control of the crane operator. If you want to move the crane to a new position, you need a crew to do so. Sound expensive? It is. Just to rent the most basic crane and hire the crew to operate it costs about $800 a day (only the major studios actually own their own cranes). If you really need a crane shot, be prepared to spend a lot of money. And if your budget is that high, plan on hiring a video producer or director to direct the shot.

Considering the QuickTime Disadvantage

Some of the shots described in the previous sections might not look very good when converted to QuickTime and shown in a small window. A small (240 × 180 pixel) QuickTime window just doesn't show all that much detail. With QuickTime 2.0, you can work with larger window sizes (up 320 × 240 pixels) and this helps a bit. But even with this window size you won't have enough pixels to show all the detail in a wide shot. So, unless you've got the necessary hardware compression-decompression boards (see Chapter 14), which let you show QuickTime movies on a full screen, you should concentrate on the basic shots (medium and close shots, close-ups, zooms, tilts, and pans). But try the other types of shots anyway; sooner or later full-screen technology will be less expensive, and you might as well fool around with the various shots in the meantime.

As mentioned several times in the previous sections, if you are shooting scenes for QuickTime movies, keep the camera steady and move the camera *very gradually* during camera moves. The reason for this is that when QuickTime digitizes video, it often drops intermediate frames.

For example, say you're using a IIci with a VideoSpigot board. This equipment allows you to digitize, or *capture*, video at 15 frames per second (as opposed to 30 frames per second for the original video). The QuickTime movie consists of every other frame (frames 1, 3, 5, 7, 9, etc.). The frames in between (frames 2, 4, 6, etc.) are dropped during conversion.

These intermediate frames help smooth out any motion or camera move. Without them, the QuickTime movie would be jumpy. It is kind of like the herky-jerky motion of people on a dance floor bathed in strobe lights. The only way around this is to make sure that the movement between the frames that end up in the QuickTime movie (1, 3, 5, etc.) don't change much; i.e., the camera moves very slowly.

Getting the Best Composition

The standard composition for a shot follows the *rule of thirds*, which is shown in Figure 12-17. Key elements in a shot, such as people, are placed along lines that divide the screen into three equal parts or at their intersections.

You can experiment with other compositional schemes, such as dividing the screen into fifths and placing key elements along the two-fifths and three-fifths lines. But you should avoid placing people directly in the center of the screen because that creates a boring image (with the exception of someone talking to camera; see section entitled "Shooting Someone Talking to Camera").

Figure 12-17.

Whenever possible, the major element in a shot should be positioned off-center along imaginary lines that divide the screen into thirds.

With video, what you see is *not* what you get. The image in the camera's viewfinder includes more than what is seen on a normal television. This is because most televisions enlarge the picture slightly to make sure that the picture fills the screen; so you should maintain a 10 to 15 percent safety border for all shots (Figure 12-18).

Some of the newer camcorders indicate the safe action area in the viewfinder. If not, you have to remember to avoid placing important elements at the edge of the screen.

You should avoid flat compositions. These usually occur when the key elements are the same distance from the camera. Either move the camera or move one of the elements to add depth to the scene. Another way to add depth is to include an interesting background or a piece of the foreground in the shot. But the foreground or background should not interfere or conflict with the key elements. For example, you should make sure that the background doesn't contain any bright sources of light that might attract the viewer's eye.

Lens Aperture and Exposure

The lens in a video camera is similar to one in a still camera. You control how much light comes in by adjusting the aperture. Almost all video cameras have an *auto-iris* feature that automatically adjusts the lens aperture to optimize the exposure. This works fine as long as you're shooting a fairly static scene. But if the lighting changes for some reason (the sun goes behind a cloud, a bright object moves into the frame), the auto-iris might not react quickly enough or in an undesirable way. You should be alert to these situations and control the aperture manually.

← *Safe action area* →

← *Viewfinder frame* →

Figure 12-18.

The safe action area is the portion of the screen that appears on a standard television set.

Although a video camera seems to take realistic pictures, it is no match for the human eye or even a film camera. The main difference is its limited ability to record information from bright and dark areas simultaneously (areas of high and low tonal value). The human eye can discern tones over a range of 100 to 1; that is, the brightest element is 100 times brighter than the darkest one. By contrast, most video cameras have a tonal latitude of only 20 to 1 (Figure 12-19).

 One way to get a sense of what the camera is seeing is to squint your eye. This approximates the tonal range of the camera.

When faced with a scene that has high tonal contrast, you must choose which part of the tonal spectrum you will focus on. You can *stop down* by decreasing the aperture, which will provide more detail of bright objects, but the dark areas will blend together (the top image in Figure 12-19). This is equivalent to underexposing in a film camera.

You can *open up* by increasing the aperture, which gives you more detail of the dark elements (the bottom image in Figure 12-19). This is generally not a good idea because the bright areas will be overexposed and will bleed into other parts of the picture.

The best solution is to position the camera or use lights to decrease the tonal range of the scene. Avoid bright objects in the background. Use reflectors or lights to lighten up dark areas. Other techniques for getting the best picture out of a video camera are discussed in "Lighting Basics" later in this chapter.

Focusing

Most camcorders come with an automatic focus feature. This helps reduce the amount of work you have to do in shooting footage, but you should wean yourself off this feature as soon as possible. The device that controls the automatic focus doesn't know what is the most important element in a shot and, therefore, what should be in focus.

This can be a problem when there are a number of elements at different distances from the camera, i.e., a scene with depth. The automatic focus often emphasizes the largest or brightest element in the frame.

It might take you a while to get familiar with *manual focusing*—which way to turn the focus ring to bring things into focus. But by focusing the camera yourself, you'll know that the key elements are in focus.

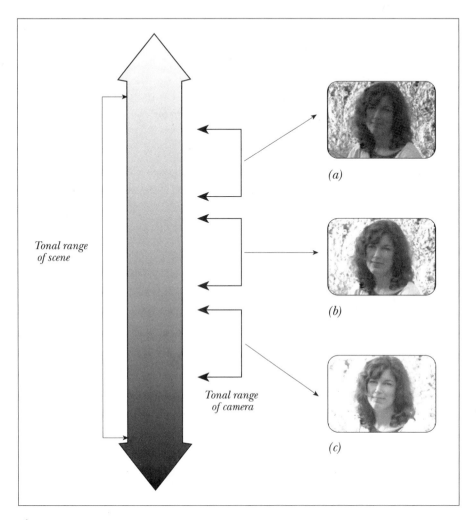

Figure 12-19. A video camera has a limited tonal range; it cannot accurately depict both the extremely bright and dark areas of a scene. In a scene with a bright background and dark foreground, the position of the iris determines which part of the scene will be properly exposed.

(a) Stopping down the iris provides a good exposure for the bright areas, but you lose detail in the dark regions of the shot.

(b) Setting the iris in a middle range provides a fair amount of detail for both bright and dark regions of the shot.

(c) Opening up the iris provides good detail of the dark areas of a shot, but the bright areas become too bright. This is generally not a good idea because overly bright areas bleed into other parts of the shot.

Depth of Field

Another thing you need to consider when shooting a scene that has depth is that most of the time some of the elements are out of focus. Each configuration of *lens angle* (the position of the zoom lens) and aperture produces a different *depth of field*—a certain range of distances in which objects are in focus.

 If you are an experienced still photographer, you can skip the next two sections. the relationship between depth of field, lens angle (focal length), and aperture is the same for still and video cameras.

Aperture and Depth of Field

Basically, a large aperture creates a short depth of field and vice versa (Figure 12-20). This means that with a large aperture (low *f*-stop), the key element is in focus, but the background is not. With a small aperture, both the key element and the background are in focus.

Figure 12-20. Effect of aperture on depth of field. A wider aperture produces a shorter depth of field.

 The practical result of this is that you probably want to shoot with a fairly low aperture ($f5$ to $f8$) to keep the background in focus. Unfortunately, this means that you need to have a lot of light to get a correct exposure, which can be difficult in indoor locations (that's why television lights are so bright).

Lens Angle and Depth of Field

The basic rule is the wider the lens angle, the greater the depth of field (Figure 12-21). This means it is easier to keep the key element in focus if you are shooting with a wide angle, particularly if the key element is moving in the shot.

 On a camera with a zoom lens, the wide-angle lens position is the one that shows the largest area; so, you "zoom in" from a wide angle to a tight angle.

Figure 12-21. Effect of lens angle on depth of field. A wider camera lens (zoomed out) produces a larger depth of field.

The depth of field changes as you zoom in or out of a shot. As you zoom in, the depth of field decreases; as you zoom out, the depth of field increases. As a practical matter, this means you should always zoom in to the key element in a scene, focus, and then zoom back out. That way, you are able to zoom in and know that the focus is correct.

Changing Focus

The viewer's attention is drawn to whatever is in focus in a shot. You can shift the viewer's attention to other elements in a shot by changing which elements are in focus.

For example, let's say you have a shot that involves two people: One in the foreground, the other in the background (Figure 12-22). Because of the distance between them, you can't have both people in focus at the same time. Instead, you can start the shot with the foreground person in focus and then change the focus, or *rack focus*, to bring the background person into focus. The person in the foreground then goes out of focus.

This shot does not work if you are shooting with a small aperture; i.e., shooting with a lot of light. You need to have a short depth of field, which requires a large aperture and, therefore, a moderate amount of light.

Some of the more recent camcorders come with a "shutter" feature. This allows you to decrease the amount of light entering the camera, independent of the aperture. By setting a high shutter speed, you are able to use a larger aperture than normal (lower f-stop), which helps when trying to create a small depth of field.

In a static shot, like the one of the two people discussed earlier, you decide where you want to move the focused plane. But if you are shooting a person who is walking toward the camera, then the focused plane is defined by the distance between your subject and the camera. You need to gradually adjust the focus to keep the person in sharp detail (Figure 12-23).

One of the most difficult camera shots to perform is of a person walking toward the camera as you zoom out to keep the person's size

Figure 12-22. Rack-focusing between two people. The shot starts with the foreground person in focus. The lens focus is then changed so that the person in the background comes into focus and the foreground person becomes blurry.

approximately the same within the frame, and you move the camera to keep the person in the center of the frame. For example, let's say you are shooting a man as he walks down a hallway (toward camera) and then turns right down a connecting hallway. This shot involves a zoom out, a rack focus, and a pan (as the man turns).

This type of shot is accomplished by having an assistant change the focus as you control the zoom and the camera movement. The assistant marks the beginning and ending focus points (on the focus ring) and then gradually adjusts the focus as the subject comes forward. Although this seems complicated, it is often more practical than the alternative of using a dolly and tracking in front of the person as he or she walks down the hallway.

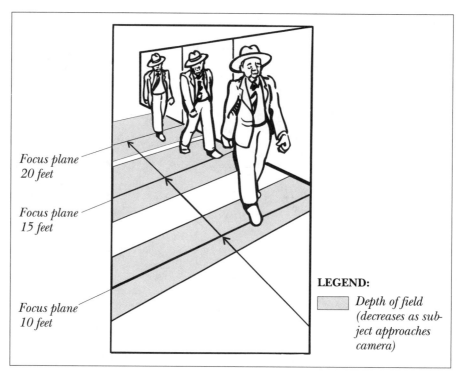

Focus plane
20 feet

Focus plane
15 feet

Focus plane
10 feet

LEGEND:

Depth of field
(decreases as sub-
ject approaches
camera)

Figure 12-23. When someone is walking toward the camera, you need to
readjust the focus to match the person's position. Shooting with
a wide lens angle gives you a larger depth of field and requires
less focus readjustment

You can deliberately throw a shot out of focus to produce an inter-
esting special effect. Record 5 to 20 seconds of the subject, then
quickly rotate the focus ring until the image of the subject goes com-
pletely out of focus. When coupled with a dissolve in editing, this shot
can produce an interesting transition.

Camera Height and Angle

Most of the time, you position the camera at the same level as your
subject (Figure 12-24). This is the most natural viewpoint for the cam-
era (and ultimately the viewer). Shooting down on a subject can
minimize its importance or, in the case of a person, to indicate a lack
of authority. A low angle makes the subject seem more powerful and

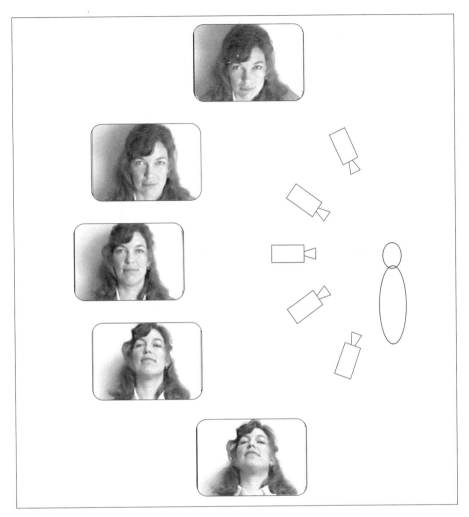

Figure 12-24. Most of the time you want to have the camera at the same height as the subject. This produces the most natural-looking image. Camera angles from above tend to make a person look small and insignificant. Low camera angles make a person seem more imposing.

imposing. However, you should not use this camera angle when shooting a close shot of a person's face because it exaggerates the person's neck and emphasizes unwanted elements, such as nostrils.

Camera Moves (Tilts, Pans, and Zooms)

When you move the camera during a shot, do it slowly, more slowly than you think is necessary. After you review your footage in the editing room a few times, you'll get a better idea of the proper speed.

You should practice a camera move once or twice before you start recording. This saves you from having to sift through a bunch of worthless takes in the editing room.

When *tilting* or *panning* (going up/down or side to side), you should frame the beginning and end of the camera move ahead of time. Don't just start moving and decide where to end on-the-fly. You should also make sure that the middle of the shot is interesting. If there is a lot of dead space in the middle, change the position of the camera so that dead space is minimized (Figure 12-25). Another way to correct for dead space in the middle of a pan is to follow an object (such as a car or a person) during the pan. This distracts the viewer from the dead space in the middle of the pan.

Using a Monitor

It's often a good idea to bring a color monitor along. You will get a better idea of the colors in a scene. The monitor will also point out when key elements are in danger of being lost outside the safe action area.

Shooting Tips for Common Situations

Every situation has its own challenges, some more difficult than others. The following sections describe how to shoot some of the more typical shots. You should deviate from the suggestions given for any particular example as your needs warrant.

Shooting Someone Talking to Camera

Most of the time, people do not talk directly into the camera and, thus, directly to the viewer. They are usually looking at someone else. The exceptions are as follows:

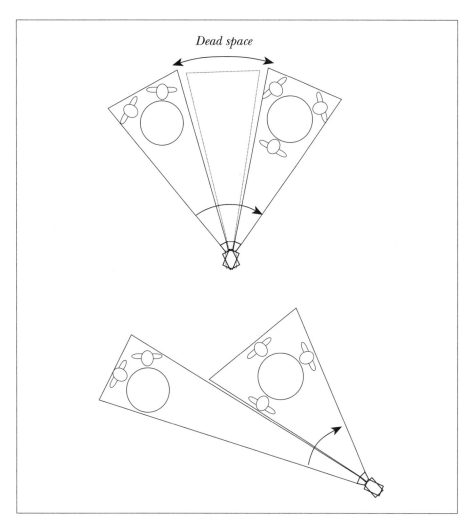

Figure 12-25. When panning between two different elements—in this case,
two groups of people sitting at tables—position the camera so
that there isn't too much dead space between the two elements.

- A host of a program
- A television news reporter or anchor
- Someone making a televised address, such as a politician
- A salesperson in a commercial

Because of the special nature of these situations, a person talking to camera is usually placed in the middle of the frame (Figure 12-26). The only time the subject moves off center is when graphic elements are used, as in the case of a graphic appearing over the shoulder of a television news anchor (Figure 12-27).

Shooting Interviews

The typical camera setup for an interview is shown in Figure 12-28. The person being interviewed, the interviewee, is placed to one side of the frame and looks across the center line. The camera should be at the same level as the interviewee's eyes. The interviewer should sit as

Figure 12-26. When a person is speaking directly at the camera lens (talking to camera), he or she should be positioned in the center of the frame.

Figure 12-27.　　When incorporating a graphic with a person talking to camera, position the person to one side of the frame.

close to the camera as possible so that the interviewee is looking toward the camera (but not directly into it). There are four standard framings for an interview: a full or wide shot, a medium shot, a close shot, and a close-up. These framings are shown in Figure 12-28.

The *wide shot* is generally used to establish the scene. Because it lacks the intimacy of the closer shots, you should not use this shot when the interviewee is saying something important. This shot often includes a portion of the interviewer.

The *medium shot* is used when a person talks with his or her hands or moves about in the chair. These movements would extend beyond the frame in closer shots. Because of the small size of current QuickTime movies, you should use this shot sparingly.

The *close shot* provides an intimacy with the interviewee but is not so close that the viewer feels uncomfortable.

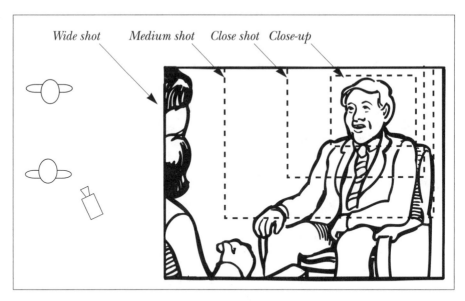

Figure 12-28. Typical camera setup for interview. The interviewer sits close to the camera. The interviewee looks at the interviewer, not at the camera.

A *close-up* adds a sense of drama and tension. If the person is not saying something all that important, stick with a close shot.

Another shot that is often taken in interview situations is the *reverse shot*, which shows the interviewer (Figure 12-29). If you want the final piece to look like a conversation between the interviewee and the interviewer (as opposed to just a set of answers), then you should shoot the interviewer's questions again on the reverse shot.

 Remember to stay on the same side of the line of interest (discussed in Chapter 6) when shooting the reverse shot.

Now for a brief digression on interviewing techniques: Here are a few tips that can help you get good "sound bites" from interviews:

■ Make sure the interviewee looks at you. Wandering eyes can make the person look devious.

■ Ask the person to incorporate your question in his or her answer. For example, if the question is, "How long have you

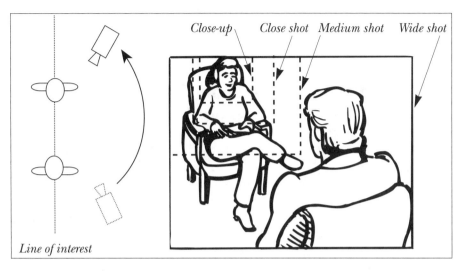

Close-up Close shot Medium shot Wide shot

Line of interest

Figure 12-29. A reverse shot shows the interviewer looking towards the
interviewee. The camera position must be on the same side of
the line of interest.

been working on product XYZ?" the person's answer should be
something like, "We've been working on product XYZ for more
than three years," not "more than three years."

- If the person gives an incredibly long answer, ask the question
 again. You'll be surprised at how much people can improve their
 answers on retakes.

- Try to develop a conversational style in asking your questions.
 Don't be afraid to digress into other areas if it helps make the
 interview seem more like a conversation.

- It's not particularly comfortable sitting in front of all those lights
 with a camera pointed at your head. Try to make the interviewee
 feel as relaxed and at ease as possible.

Shooting Groups of People

You have two main concerns when shooting a group of people: keep-
ing up with the flow of the conversation and getting enough cutaways.
The first concern deals with making sure the camera catches people
talking (as opposed to just after they finish talking). The easiest way to

do this is with multiple cameras. But because you might not have that kind of a budget, the following discussion assumes you are shooting with only one camera.

Primary Placement of the Camera

The best way to cover the action is to place the camera in front of the group of people and near the center. For example, let's say there are three people talking at a table. The primary camera placement, shown in Figure 12-30, allows you to get six different kinds of shots: a three-shot, two different two-shots, and three close-ups.

You would gradually switch between these shots as the conversation moves from person to person. Let's say you are shooting the person on the right (person 2) in a close-up (shot 4). That person stops talking, and the person in the middle starts to talk. You would zoom out while you pan left until you are framed for a two-shot that includes the middle person (shot 3). Then you could stay on the two-shot, or if the middle person talked for a while, you could zoom in to a close-up of him (shot 5).

You would continue in this fashion, zooming in and out while panning, to cover the people talking. This is better than moving the camera quickly from one person to another. This technique also allows the editor to use the camera moves instead of always having to switch to a new shot when someone starts talking.

This technique is used for unscripted conversations. If you laid out exactly who is going to talk when, then you would use the same camera position, but you would reframe the camera before each new piece of dialog. You would shoot all the shots from this camera position, before moving to the other camera positions.

Getting Cutaways

This type of scene needs lots of cutaways. Even with smooth camera moves between the speakers, you still won't catch all the action. Unless you're working with professional actors, it is hard for speakers to repeat their words; so it's best just to have the speakers talk naturally while you shoot reaction and listening shots for cutaways.

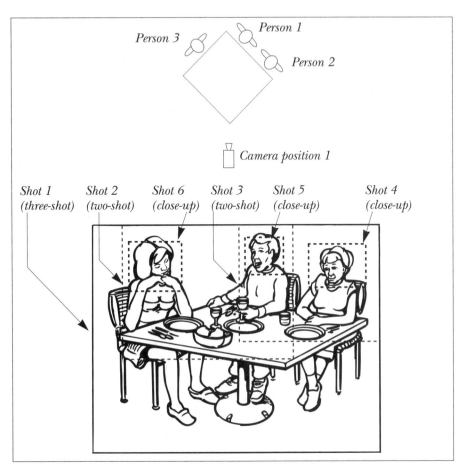

Figure 12-30. Primary camera placement for shooting a group of people. A direct shot provides a good overview of the scene. You can also get cutaways of individual people from this angle.

You can get listening shots from all three close-ups (shots 4, 5, and 6 in Figure 12-30). Make sure you get several shots of people turning their heads from one person to another (i.e., following the conversation).

In addition, you should shoot cutaways from two other camera positions (Figure 12-31). From the framings shown in the figure, you get the following shots:

■ **Cutaway 1, shot 1:** Person 1 listening to person 3

- **Cutaway 2, shot 1:** Person 1 listening to person 3 (closer shot)
- **Cutaway 2, shot 2:** Person 1 turning head toward person 2
- **Cutaway 3, shot 1:** Person 2 listening to person 1
- **Cutaway 3, shot 2:** Person 2 listening to person 3

You get a similar set of cutaways from camera position 3.

 You must stay on the same side of the line of interest when shooting cutaways.

These cutaways not only give you plenty of options when you get into the editing room, but they also help you get out of binds when the camera missed something important.

Shooting a Person Handling a Prop

The main trick to shooting this type of scene is getting shots that allow the editor to focus on the action quickly. You also need to provide shots that allow the editor to condense time in case the action takes a long time.

Let's assume we're shooting a man playing a piece of music on a piano (Figure 12-32). From camera position 1 you shoot the entire performance from beginning to end. This is called a *master shot* because it is a verbatim recording of the entire action. The master shot should start with the person walking into the frame and sitting down and end with the person walking out of the frame. As long as the entire action (the performance in this case) doesn't last too long, it's a good idea to get a master shot because it gives you more options in editing. After the master shot is complete, you can then get cutaways from this camera position using shots 3 and 4 (Figure 12-33).

 Some film purists suggest that you can edit your piece in the camera, that is, shoot exactly the shots you'll need and no more. This is efficient in terms of the amount of videotape you shoot but a poor use of resources and your time. Videotape is cheap; production is expensive. It is much wiser to cover yourself by shooting extra material and picking the best shots when you are editing the piece together.

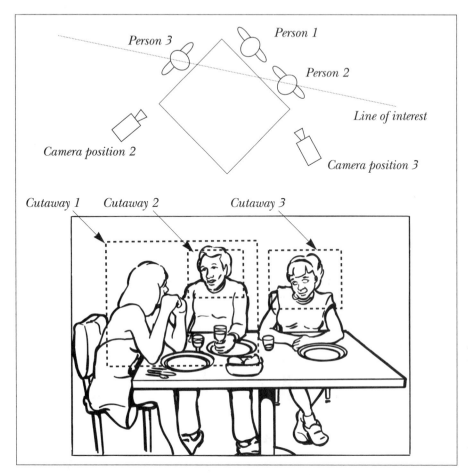

Figure 12-31. The best cutaways are shot from a different position than the primary camera position. In this case, the camera is moved to the left to get various cutaways of the group. Moving the camera to the right, camera position 3, would produce a similar set of cutaways.

Next, you move to camera position 2 and have the man repeat the performance, this time getting shots 5, 6, and 7 (Figure 12-34).

Last, you move to camera position 3 and get close shots and close-ups (shots 8, 9, and 10) of the man's hands as he plays (Figure 12-35). When you take close-ups of particular actions (finger playing a single key, etc.), make sure the shot starts with the man's hand out of frame. This gives you a lot more leeway in terms of matching continuity later on.

Figure 12-32. Camera positions for shooting a pianist at a piano. Camera
position 1 provides the master shot for the scene. Camera
positions 2 and 3 are used to shoot cutaways.

Figure 12-33. Various shots from camera position 1. This is the most natural view
of the scene (as if you were in the audience). You should shoot a
master shot of the entire performance from this camera position.

Shot 5 *Shot 6*

Shot 7

Figure 12-34. Various shots from camera position 2. This camera angle allows
you to focus on the pianist.

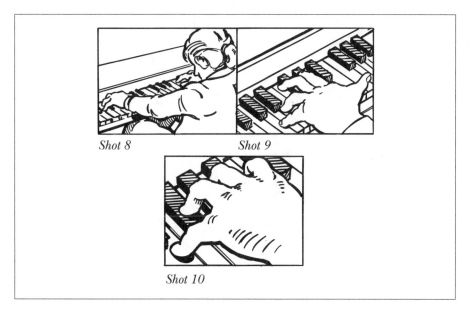

Shot 8 *Shot 9*

Shot 10

Figure 12-35. Various shots from camera position 3. This camera angle allows
you to focus on the piano and the pianist's hands.

A typical sequence that could be edited from these shots is shown in Figure 12-36.

The basic technique of shooting a master shot, a reverse shot, and then close-ups works for a wide variety of situations, such as a person at a computer, a person using a shovel—basically any scene where a person is interacting with a prop.

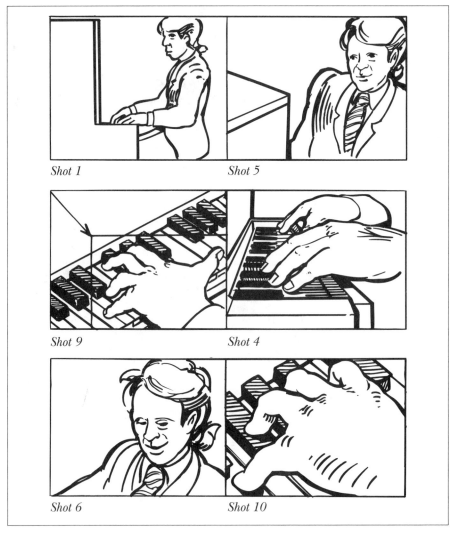

Figure 12-36. By shooting the performance from several camera angles, you can create an edited segment that has a lot of visual variety.

 You might get bored with this standard technique after a while, so experiment with different camera angles (high or low). Try shooting a person's reflection in a computer screen or on the varnish of a piano, use tilts and pans–anything to inject something new into the sequence.

Movement into and out of the Frame

When you are shooting a walking shot in which a person is shown walking into or out of somewhere (a room, a house, a car, etc.), there are several things to keep in mind.

Entering and Leaving the Frame

You should always make sure that the person is not in the frame either at the beginning or end of the shot. This makes it easier to edit the shot into a sequence of other shots. If possible, the shot should include the person entering and leaving the frame (Figures 12-37 and 12-38). Later you can always use just the part of the shot with the person already in the frame if you want.

Figure 12-37.

When an element in a scene is moving, in this case a person, you should try to have the shot begin with the moving element out of the frame. The moving element then moves into the frame and exits the frame before the shot ends. Shooting the shot this way gives you more options during editing.

Figure 12-38.

Even if you are certain that you want a shot to start with a person in the frame, in this case a person walking down a hallway, try to start the shot without the person in the frame. It takes a little more time to shoot a shot this way, but it will give you more flexibility later on in editing.

Providing Internal Edits

It helps to give the editor a way to shorten the shot. Let's say you're shooting a woman leaving an apartment and walking to her car (Figure 12-39). That shot would last about 20 seconds, but the editor might decide to spend only 10 seconds getting the woman from the door to the car. By shooting a close-up of the woman's face from the front (Figure 12-40), you give the editor the option of condensing the action, as shown on the next page.

Figure 12-39. Shooting a woman walking to a car in one continuous shot. There is no easy way to shorten the duration of this shot.

- **Shot 1:** Woman leaving apartment (3 seconds)
- **Shot 2:** Close-up of woman's face (3 seconds)
- **Shot 1:** Woman getting into car (4 seconds)

Any close-up of the person (feet, hands, etc.) will give the editor this option.

Figure 12-40. Shooting an internal cutaway. Shooting a close-up of the person's face gives a cutaway that you can use to shorten the panning shot in Figure 12-39.

Another way to shoot this action is to break it into two shots. In shot 1, the woman leaves the apartment and exits the frame (Figure 12-41). In shot 2, she is already in the frame as she walks toward the camera (and the car). Now, because the shots are from different angles and because the woman leaves the frame in shot 1, the editor can start shot 2 at any point without worrying about a break in continuity (although it helps to match her stride).

Shot 1

Shot 2

Figure 12-41. Shooting a woman walking to a car in two shots. After you have established the woman in shot 1, you can cut to any point in shot 2 to finish the scene.

Remembering the Line of Interest

When a person leaves the frame in one shot and re-enters the frame in a different shot, he or she should come in from the opposite side of the frame in which he or she left. This way, the person keeps moving in the same direction. This is a variation on the line-of-interest rule for shooting cutaways. Let's say you're shooting a person walking across the screen. You break the walk into three shots (Figure 12-42). The line of interest is the line of the person's walk, so all the camera positions are on the same side.

It gets a bit more confusing when the person walks toward and past the camera as he or she goes out of the frame (Figure 12-43). The person should still enter the frame on the opposite side in the next shot.

If there is an intermediate shot between two walking shots, such as a close-up of the person's face or something not connected with the person at all, then you can cross the line of interest without confusing the viewer.

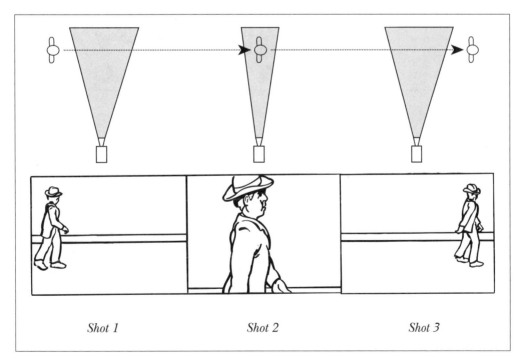

Shot 1 *Shot 2* *Shot 3*

Figure 12-42. Line-of-interest example 1. The camera remains on the same side of the person for all three shots.

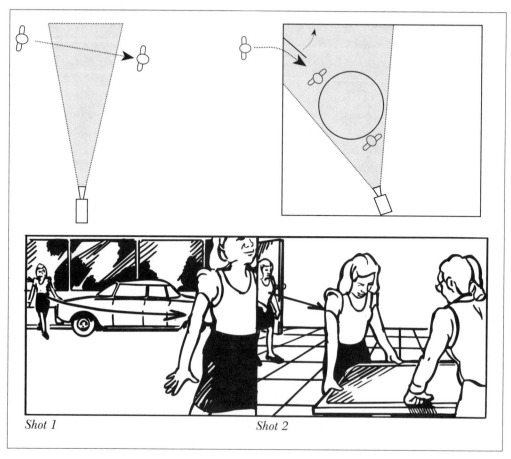

Shot 1 *Shot 2*

Figure 12-43. Line-of-interest example 2. If a person leaves the frame in one shot, he or she should enter on the opposite side of the frame in the next shot. This way the person will continue to move in the same direction, in this case from left to right.

Unusual Situations and Techniques

Here's a collection of short tips for particular situations. Use whatever fits your needs.

Shooting Computer Screens

If you are shooting a computer and want the viewer to read what's on the screen, try to make the room as dark as possible to eliminate

reflections in the screen. If there is still too much reflection of the room, move the camera as close as possible to the screen and hold a large dark cloth behind the camera.

Most computer screens roll or flicker when shot with a video camera. This has to do with the refresh rate of the computer and the frame rate of the tape deck, which is 29.97 frames per second.

Verité

Some situations don't occur in a controlled way. These include protest marches, sporting events, and community meetings. You probably won't be able to get someone to repeat what he or she did or said in case you missed it the first time, so you have to get what you can at the moment, constantly keeping an eye out for cutaways that will help you edit the scene together.

For a cutaway to work, it shouldn't be tied directly to the action or event because it will be hard to match continuity. Shots of onlookers work well, as do signs.

This type of shooting is called *verité*, and it is demanding, both on the camera operator and the director. And if you're acting as both, you need to take your eye out from behind the viewfinder from time to time to see what is going on outside the camera's viewfinder.

Another thing to keep in mind is that the line-of-interest rule still holds. The protest marchers can't suddenly march in the other direction! The easiest way to cover yourself is to take neutral shots (in front or behind the march) that will allow you to cross the line during editing.

The Poor Man's Tracking Shots

You should be alert for any type of people mover that can act as a dolly. These include wheelchairs, carts, escalators, and moving sidewalks. Put yourself on the people mover and let it move you through a location. You can also have a person walk alongside. The advantage of this shot is that it conveys a sense of motion while it maintains close connection with the subject.

Special Effects in the Camera

By exaggerating a camera move (a tilt, pan, or zoom), you can create a kind of special effect that adds a sense of visual excitement to a sequence of shots:

Swish Pan: This is a pan that moves so fast that the image is blurry. By intercutting a swish pan between two static shots, you can give the impression of simultaneity, that you just whisked the camera from one place to the other.

Snap Zoom: This is a zoom that moves so quickly from a wide-angle shot to a close-up (or vice versa) that the middle of the shot is smeared; only the beginning and the end of the shot can be seen clearly. With a sound effect added, this shot can bring a strong punch or climax to a scene. You must turn the zoom lens manually to perform a snap zoom. The motorized zoom doesn't move fast enough.

Vertigo Shot: This bizarre shot is a combination of a zoom with a dolly forward or backward. When executed correctly, the main subject remains the same size (as if nothing is changing), while the background expands or contracts (Figure 12-44). Alfred Hitchcock's *Vertigo* shows this effect very well.

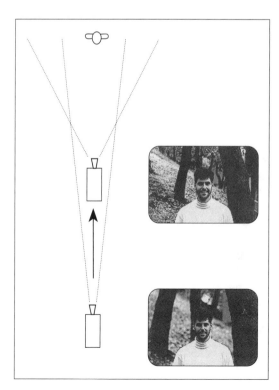

Figure 12-44.

In a vertigo shot, the camera is dollied back while the lens is zoomed in (or vice versa). The main subject in the scene stays the same size in the frame, but the perception of depth in the background changes significantly.

Wiggle Cam

This style of shooting, made popular by AT&T commercials several years ago (and now found in any "hip" ad or program), involves a constantly moving camera. The camera weaves and bobs throughout the shot, never settling on a particular framing. The theory behind this style is that a constantly changing image is more likely to hold the viewer's attention. If you're facing a situation where getting and holding the viewer's attention is likely to be a problem, then you might consider using this technique. A disadvantage of this type of shooting is that it can't be easily edited together with footage shot in more traditional ways.

Common Directing and Shooting Mistakes

If you follow the advice mentioned in the previous sections, you'll probably stay clear of most of the obvious mistakes. But some mistakes occur so often, even to professionals, that we mention them again here.

Not Enough Cutaways

When it comes time to edit your material, it seems as if you never have enough cutaways. Of course, figuring out what is a useful cutaway is difficult in the field. That's why you should plan the shoot carefully.

Shots That Don't Last Long Enough

You can edit a shot to make it shorter, but you can't make it longer (at least not easily). Make sure your shots last for at least 5 seconds (10 seconds is better).

Starting Too Soon

Once you turn on the camcorder, it takes five seconds before the deck comes to speed and you can record usable video. This doesn't apply if you put the camera in pause mode (but that chews up batteries). Get in the habit of counting down from five to one after turning on the camera before you ask someone a question or cue someone to move. If you're directing a camera operator the dialog goes like this:

Director: "Roll tape!"

Operator (after five seconds): "Speed!"

Director: "Action!"

Lighting Basics

There is an infinite number of ways to light any particular scene. We cover the most standard ways here, but once you get the hang of these techniques, feel free to experiment.

The primary goal of lighting is to make sure there is enough light on your subject that it can be seen clearly on the videotape. Sometimes this can be accomplished with *available lighting,* that is, the light naturally occurring at a location. Outdoor scenes shot in the early morning and late afternoon don't usually need additional lighting; the available lighting is sufficient.

 Sufficient lighting doesn't mean that your camera tells you it's bright enough to shoot. It means that your subject (a person or an object) is bright enough that it can be seen clearly and with detail. Most camera light meters evaluate the entire frame, not individual items within it. You could place your subject against a bright wall, and the camera would say there's enough light, even though your subject would be almost black.

The other functions of lighting are to emphasize or conceal particular elements in a shot, to add a sense of depth to a shot, and to even out the range of bright and dark objects in the shot to compensate for the limitations of video cameras.

A basic fact of video production is that the camera is no match for the human eye in terms of picking out detail in bright and dark objects. Professional cameras get close, but they cost $30,000. Consumer camcorders, particularly Hi-8 models, are getting better. As mentioned earlier, the main problem is that video cameras have a narrow tonal range, that is, the ratio between the brightest and the darkest object in which detail can be seen (shown earlier in Figure 12-19). The human eye has a tonal range of about 100 to 1; a video camera can manage only about 20 to 1. The solution is to reduce the

tonal range of the shot by avoiding bright objects and backgrounds and by using lights to brighten dark areas.

Terminology

Lights come in a dizzying array of sizes and types. In addition, there are a number of ways a light can be used in a particular scene (and well-defined terms for each type of use). Here's a quick rundown on some basic lighting terms.

Available Light

This is the light occurring naturally at a location. It can be sunlight; a fluorescent, incandescent, or halogen lamp; fire or a candle; or a mixture of any of these types.

Hard Light vs. Soft Light

Hard light is direct light that throws strong, distinct shadows. Hard light is used to define surfaces and features and increase the overall illumination of an object. Direct sunlight is an example of hard light.

The opposite of hard light is diffuse, or soft, light, which casts soft shadows. *Soft light* is used to diminish the strong shadows produced by hard light. It can also even out the lighting in a scene. Sunlight on an overcast day is an example of soft light. Figure 12-45 illustrates the difference between hard and soft light.

With professional lighting equipment, any light that projects directly onto the subject will cast hard light. By putting a piece of acetate (known as a *diffuser*) between the light and the subject, you turn the hard light into soft light. Another technique for creating soft light is to bounce a light off a reflector, such as a lighting umbrella or a large piece of white poster board.

(a) Hard light *(b) Soft light*

Figure 12-45.

(a) Hard light emphasizes edges and produces dark shadows. (b) Soft, diffuse light produces even lighting. People generally look better under soft light.

Lighting Placement

The placement of a light in relation to the subject dramatically affects the appearance of the subject. Figure 12-46 shows the effect of different lateral placements of a light, and Figure 12-47 shows the effect of different vertical placements. Lighting that is overhead and in front of the subject tends to be the most natural. Low lights tend to make a person seem dark and sinister.

Most professional lighting setups use several lights in different positions to create a mix of hard and soft light that adds texture to a scene.

The Key Light

This is the primary light for illuminating the subject. It is often referred to as just "the key," as in, "We'll use sunlight as the key." Typically, the key light is the strongest light: It is placed to one side of the camera, set fairly high, and is often used as a direct source of light (light 1 in Figure 12-48).

Figure 12-46. The position of the key light dramatically alters the look of a shot. A key light to the far right or left produces a dramatic, moody shot. The most common position is just off center to the right or left.

Figure 12-47. The vertical position of a light changes the mood of a shot. A
light directly over a person is generally not used because it casts
shadows over the eyes. A low light position tends to make the
person seem dark and sinister.

The Fill Light

This light evens out the light on the subject by casting a soft light that soft-
ens the hard shadows created by the key light (light 2 in Figure 12-48).

The fill is usually placed on the opposite side of the camera from the key light and has a lower wattage than the key.

The Back Light

This light is used to cast light on the back edge of the subject. It is also known as a *rim light* because it provides a rim of light around the edge of the subject (light 3 in Figure 12-48). A back light helps separate the subject from the background. It is usually placed on the opposite side of the camera from the key light.

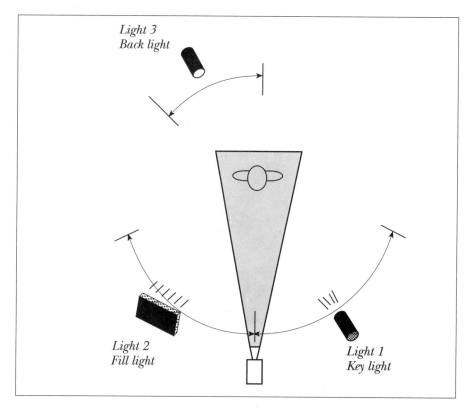

Figure 12-48. The key light is usually placed to one side of the camera and the fill light is placed on the opposite side. This allows the fill light to fill in the shadows created by the key light. The back light is usually placed on the same side as the fill light but behind the subject. If the subject is not looking directly into the camera, then the key light should be placed so that the person is looking toward the key light.

Diffusers, Scrims, and Gels

There are a number of attachments that can be applied to lights to alter their lighting characteristics. As mentioned earlier, a diffuser is a translucent piece of material that converts direct light into diffuse light (hard to soft). A *scrim* is a piece of wire mesh that decreases the overall intensity of a light without diffusing it. A *gel* is a colored filter that adds color to a light. A translucent gel can also act as a diffuser.

Color Temperature

Lights differ in the color of the light they produce. Our eyes and brains filter out these differences, but the camera doesn't. That's why normal light bulbs look orange when compared to sunlight in a video camera.

A light is defined by its *color temperature*, which is related to the actual temperature of the light-emitting element (Table 12-1). Lights with high color temperatures look blue in contrast to lights of lower color temperatures.

 Most lights used in video production use tungsten elements.

Table 12-1. Light Sources and Their Color Temperatures

Source	Temperature (in K)*
Candle	1,930
Tungsten lights	3,000
Halogen lights	3,200–3,400
Fluorescent	3,200–5,000
HMI arcs	5,600–6,000
Sunrise, sunset	2,000–3,000
Midday sun	5,000–5,400
Overcast sky	6,800–7,500

*K = Kelvin; 273K = 0° C

White Balance

Although the camera picks up all the shades of color in various types of light, you can get around this problem by tuning the camera to one particular type of light. This is done with the white-balance adjustment on the camera. By pointing the camera at a white piece of paper and then pressing the white-balance button, you are telling the camera "this is white." Thus, if you are shooting outside, the camera is then tuned for the bluish cast of sunlight. If you move indoors, you must white-balance again, so the camera is tuned to the lower-temperature white produced by the tungsten elements (otherwise, your video will have a strong orange cast and almost no blue).

Camera Filters

Unfortunately, the white-balance adjustment won't correct for the entire range of color temperatures between sunlight and indoor lights. Some consumer camcorders and all professional video cameras come with a set of filters for different lighting situations. By using the correct filter and setting the white balance, you can accommodate almost any type of lighting situation.

Tips for Outdoor Lighting

The main advantage to outdoor shooting is that it doesn't take long to set the lights. In most cases, you just pick a camera position and start rolling. The disadvantage is that your production is subject to the vagaries of weather.

The primary thing to keep in mind when shooting outside is to shoot with the sun behind you, preferably over one shoulder, not directly behind. Having the sun off-axis a bit creates a more interesting picture by creating shadows on the subject.

You should also position your subject so that he or she is not in front of a bright background. The viewer's eyes are drawn to the brightest object on the screen, and that should be your subject, not the background.

 The exception to this is a *silhouette* shot where you are trying to focus on the contrast between the dark subject and a bright background.

The color and quality of sunlight changes over the course of the day, and this can have a dramatic effect on the overall look of the shot.

The Magic Hour

If you are shooting scenic shots, be they of a natural scene or of a city, try to shoot during one of the magic hours. The *magic hour* is the hour just after sunrise or just before sunset. There's a wonderful warm quality to light at this time of day. In addition, you don't have to contend with harsh shadows as long as the sun is behind you.

Death at High Noon

This is the least flattering time to shoot people because direct overhead lighting creates dark shadows on a person's face. Even if you turn the person so that the sunlight strikes them at an angle, part of his or her face will be dark and without detail because of the limited tonal range of video cameras. One solution is to use a reflector (a white card or Flexfill) to bounce light into the darkened area (Figure 12-49).

A better solution is to avoid high noon altogether and shoot in the morning or afternoon when the sun is lower in the sky. You might still need to use a reflector, but the shadows won't be as difficult to work with.

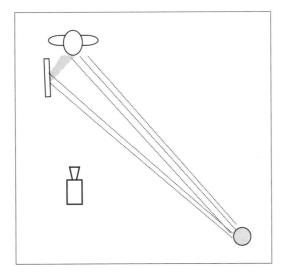

Figure 12-49.

When shooting outdoors, use a reflector to fill in shadows caused by the sun (acting as the key light).

 The middle of the day is a good time to shoot if you want to emphasize edges and contrasts.

Sun Guns

If you are going to be doing a lot of outdoor shooting, you might want to rent a small, battery-operated light known as a *sun gun*. You use the sun gun as a fill light to soften the harsh shadows produced by sunlight. It can also be used as a back light to separate your subject from the background.

 Make sure you rent extra battery belts for the sun gun if you are going to be a long way from electrical power.

Cloudy Days

A fully overcast day gives you even lighting, which works well for interviews or scenes with people. There is a restful quality to shots captured on an overcast day.

But a partly cloudy day can wreak havoc with a production. You have to choose which lighting situation (cloudy or sunny) you want to use and then shoot only when that lighting situation occurs. You also have to be aware of how the background changes as the clouds come and go.

Tips for Indoor Lighting

With an indoor location, you are able to control the lighting to a much greater extent. Of course, it takes time to set up and adjust several lights, so you need to plan extra time in your production schedule for indoor locations.

The following are several examples of typical lighting situations. Your location will probably be different, but the techniques described apply to many scenarios.

Lighting for One Person (Interviews)

The simplest lighting setup that produces a textured image involves two lights: a key and a back light (Figure 12-50). This only works in situations where the available light level is fairly high; otherwise, the background will be dark.

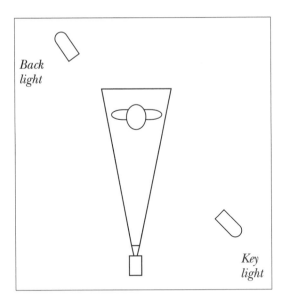

Figure 12-50.

When shooting a person with only two lights, use a key and back light. Move the key light closer to the camera to remove any unwanted shadows.

A shot where none of the background is visible is called a *limbo shot* because the person is not situated within a background, i.e., in limbo. This shot is accomplished with the two-light setup shown in Figure 12-50, with the exception that the key light is rotated a bit more to the side to decrease the amount of light that falls on the background.

The disadvantage of a two-light setup is that sometimes the background will be dark. To accomplish that, you need to add a third light.

A typical three-light setup is shown in Figure 12-51. The fill light softens shadows on the person's face and helps illuminate the area behind the subject.

For most situations, these are all the lights you'll need to use. But if you have the time, adding a light to emphasize part of the background helps add depth to the shot. The most natural way to do this is to include a regular lamp in the shot and use a 150- or 200-watt light bulb in it (Figure 12-52).

If the scene has a particularly deep background (more than 20 feet), a 200-watt bulb won't throw off enough light. A clever cheat is to add a light (out of frame) that illuminates the background behind the lamp (Figure 12-53). This creates the illusion of a brighter lamp.

Figure 12-51.

The typical lighting setup with three lights. If the person is looking off camera, position the key light so that the person is looking toward the key light.

Figure 12-52.

Adding a lamp in the background helps add depth to a shot.

Note The intensity of a light decreases dramatically with distance (technically, as the square of the distance). This means that a light paced twice as far from the camera will seem one-fourth as bright.

Figure 12-53.

If the background lamp is far away from the camera, it might not seem bright enough. You can augment the brightness of the lamp by pointing a light at the wall behind the lamp. This produces the illusion that the lamp is brighter.

If the background is plain—e.g., a flat wall—you can add artificial texture to it by throwing a diagonal slash of light across it (Figure 12-54). It often helps to add a gel to this light to create a colored slash of light.

To create a slash you need to use a *close-faced light,* one that comes with a *Fresnel lens.* This lens concentrates the light into a narrow beam. Trying to produce a slash with a normal light adds a broad swath of color to the background, not a well-defined slash.

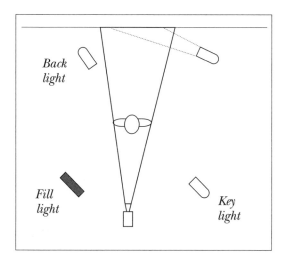

Figure 12-54.

You can turn a blank wall into an interesting background by pointing a closed-face light (with a Fresnel lens) at the wall and narrowing the light's barn doors to create a slash.

Lighting for Two People

Generally speaking, the more people you add to a scene, the more complicated the lighting setup becomes. A lot depends on the relative positions of the people (which way they are looking and how close they are together). Let's look at a fairly simple situation of two people standing near each other and at right angles.

The most complete way to light this scene is to use six lights: a key, a fill, and a back light for each person (Figure 12-55). You need to use close-faced lights; otherwise the key light for the first person might spill over into the fill of the other (which would cause unusual shadows and unnecessarily flat lighting).

If you don't want to set up six different lights, there are a number of other setups that provide adequate lighting. You can light the two of them as if they were one person, with one key, one fill, and one back light (Figure 12-56). This generally works better if the people turn a bit more toward the camera.

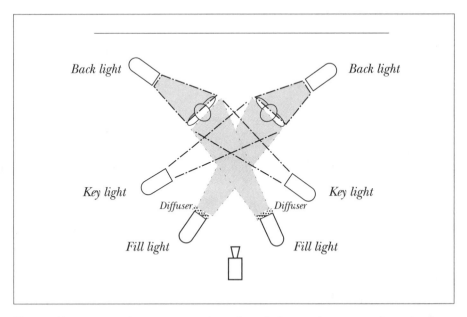

Figure 12-55. Lighting two people with six lights. Each person is lit with a key, a fill, and a back light. You might need to use close-faced lights to prevent one light from interfering with the others.

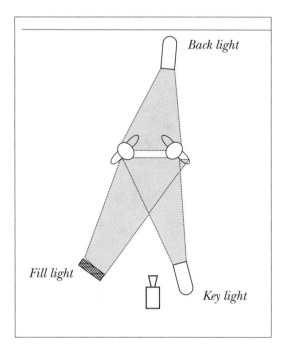

Figure 12-56.

Lighting two people with three lights. If you only have three lights to work with, treat the two people as one unit and light them accordingly with a key, a fill, and a back light. In this situation, the back light needs to be hung from the ceiling; otherwise its light stand will be visible in the shot.

Another option is to have the fill light for each person act as the back light for the other (Figure 12-57). You may have to put a half scrim on each key light to decrease the intensity of the light falling on the people's shoulders. You then just need to light the background.

Adding another person to this scene makes for an even more complicated situation. Unless you want to spend hours lighting, you might want to think about lighting the entire room, which is discussed in the next section.

Lighting a Large Area

The quickest and easiest method for lighting a large area or an area where people are moving around a lot is to bounce a light, or lights, off the ceiling. This raises the overall brightness of the room. You can then add lights to brighten particular parts of the scene.

If the ceiling is high enough, you can simulate sunlight coming into the room by building a wall of lights (Figure 12-58). Depending on the size of the room, you may need to pump in more than 5,000 watts of light to create this effect.

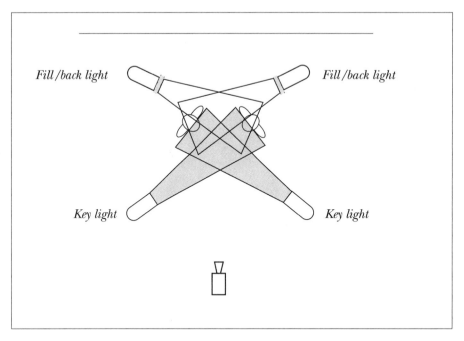

Figure 12-57. Lighting two people with four lights. In this case, each back light serves as the fill light for the other person.

Tips for Indoor/Outdoor Lighting

The color temperature of sunlight is so much hotter than indoor light-ing that you can't mix the two without some modification. In addition, sunlight is much more intense than a typical light. So the direction of the sunlight with respect to the camera position will affect how you light an indoor/outdoor situation.

Sunlight as a Key Light

This is the least complicated way of using sunlight in a shot since it uti-lizes the sun's intensity to provide the main lighting for the shot. A typical setup is shown in Figure 12-59.

Because of the color temperature difference between tungsten lights and sunlight, you need to add blue gel to the fill and backlights. Otherwise, they will cast an orange light on the scene.

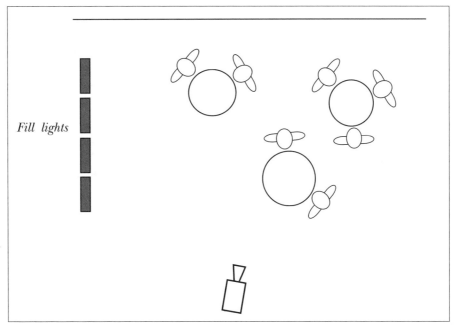

Figure 12-58. When you are shooting a large scene and don't have time to light each element independently, a quick solution is to create a wall of light with three or more large lights (2,000 watts or more). The lights should be diffused to create soft, even lighting. They must be set high off the ground. This mimics diffuse sunlight coming through a bank of windows.

Sunlight as a Fill Light

Sometimes you will want to use sunlight as the fill because you want to include a certain part of a background in the shot (Figure 12-60). This requires a fairly powerful key light because the fill light (the sun) is so strong. The key has to be covered with a blue gel to match the color temperature of the sun, which makes matters worse because that cuts down on the intensity of the key light. It's not uncommon to use a 2,000-watt key light in this type of situation.

An alternative is to use a light that produces light similar in color to sunlight. The best known of these lights is the HMI. The advantage is that because you don't have to gel these lights, their intensity is much higher.

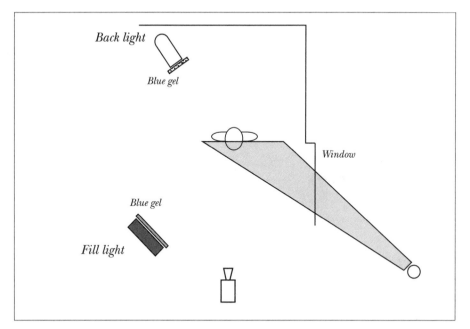

Figure 12-59. When using the sun as a key light, add blue gels to the fill and back light to match the color temperature of sunlight.

Sunlit Backgrounds

This is by far the most complicated situation. Sunlight is just too strong to overcome when it is lighting the background. For example, let's say you're shooting in an office that has two picture windows overlooking the New York skyline. That's a great background, so you decide to include it in the shot.

Instead of converting the indoor lights to match sunlight, you do the reverse: You cover the windows with a gel that decreases the brightness of the background and converts the sunlight to match the interior lights. The gel used for this job, called ND (for *neutral density*), comes in wide rolls of varying thicknesses (the thicker the gel, the less light that gets through). The trick is to apply the gel evenly on the windows, because ridges and bubbles reflect the key light and produce unwanted points of light in the background. The best way is to spray the windows with water and then smooth out the gel with a squeegee.

You then set up a key and a fill light in a typical configuration, but without blue gels (Figure 12-61). As you might guess, this is a lot of work. It had better be a pretty amazing background to go through all this trouble!

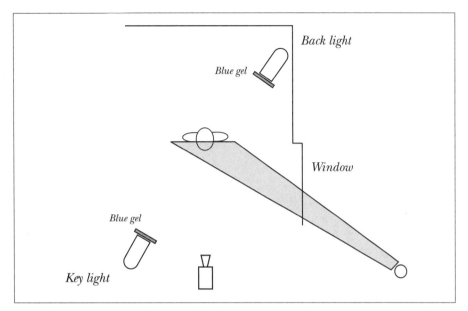

Figure 12-60. Using the sun as a fill light. Because sunlight is so strong, you probably have to use a very intense light (2,000 watts or more) as the key light. The key and back light should be gelled with daylight blue gel to match the color of sunlight.

Other Situations

Even when sunlight does not play a major role in the shot, if it is present to any degree, it adds a bluish cast to certain objects in the shot. You won't see the bluish casts in the black-and-white viewfinder of the camera, which is why it helps to bring a color monitor along on your shoots. You can either try to eliminate the sources of sunlight (through open windows, half-closed blinds, etc.) or gel all your lights and reset the white balance for sunlight.

Common Lighting Mistakes

The choice of a camera position and the lighting are invariably linked. Too often, people pick the shot first, then try to light the scene to make the shot work. The end result is often a well-composed shot that is poorly lit.

You can also run into trouble if you've overscheduled the shoot day and haven't left enough time to light properly. Here are a few general

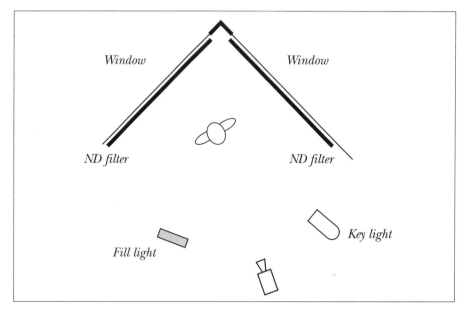

Figure 12-61. If the shot has a sunlit background, you will not be able to overcome its brightness. Instead, you should cover the windows with a gel that decreases the brightness of the background.

rules for how long it takes to set up lights under different lighting conditions:

- **Indoor/Outdoor:** at least an hour, more if the window area is particularly large

- **Indoor:** 30 minutes for a one-person setup, 45 minutes for a two-person setup, 60 minutes or more if you want to light the background

- **Outdoor:** 5 minutes or less, as long as you're not trying to shoot against a bright background

After a while, you'll develop your own sense of how long it takes you to set lights for particular situations.

The following are some common mistakes that are often caused by overscheduling.

Indoor Locations

- Failing to notice sunlight entering the scene
- Failing to make the subject stand out from the background (This is usually caused by the lack of a backlight but can also happen when the key light is set too low and lightens the background.)

Outdoor Locations

- Shooting the subject against a bright background
- Failing to remove harsh shadows with a reflector
- Causing a flare when direct sunlight hits the camera lens

Sound-Recording Basics

The main goal is to get the sounds you want and avoid the sounds you don't. It's better to get clean tracks of several sound elements in a scene and then go back and mix them in the editing than to record them as one track in the field.

Types of Microphones

There is a wide variety of microphones, each suited for a specific task:

Camera mike: This is a fair mike for collecting background sound but fairly worthless for recording someone talking because it is just too far away from the person.

Lavalier or Tram mike: This is the standard microphone for recording interviews. It is clipped onto the person's clothes (usually a tie, lapel, or collar). It does a pretty good job and works for most situations. The disadvantage is that it can pick up the sound of clothes rustling if the person moves about in his or her chair.

Hypercardioid mike: This is the standard mike for recording dialog or people outside an interview setting. It is designed to capture sound from a small area around the front tip of the mike. It is often

placed inside a wind screen. It can also be used to record interviews when it is hung from a boom above and slightly in front of the person's head.

Shotgun mike: This microphone is extremely directional, which makes it good for picking out sounds that are far away. You should not use this microphone indoors because it picks up echoes well. Use a hypercardioid mike instead.

Tips for Recording Sit-Down Interviews

The main concern in recording interviews is to make sure there aren't background noises that will pollute the audio. Besides air conditioning, machinery, telephones, and other devices, people talking nearby can be a problem. Don't be afraid to ask them to be quiet; you won't be recording for long.

At the end of the interview, you should record 30 seconds of silence. This isn't really silence but the *room tone*, a sample of the background sound of the location. This allows you to add natural-sounding pauses in the person's interview when you are editing.

Tips for Recording People On-the-Fly

If you are recording someone talking outside the controlled situation of a sit-down interview, it's a lot harder to control background sounds. Therefore, you should get the microphone as close to the speaker as possible. Work with the camera operator. If he or she is shooting a close-up of the person's face, you can move the microphone within a foot of his or her mouth.

If you are going to be shooting one person in the middle of a group of people, you might want to rent a *wireless microphone*. The microphone is connected to a radio transmitter that is placed in the person's pocket. A separate unit, called the receiver, is operated by the sound recordist. It picks up the signal from the transmitter and then sends it to the tape deck.

Group Scenes

If you are shooting scripted scenes of a group of people, such as three people talking at a table, or people moving about in a room, use one or more hypercardioid mikes suspended from above. The mikes are either placed on extension arms called booms, which are supported by mike stands or are hung from the ceiling. The microphones are placed as close to the subjects as possible without being in the shot.

 Using a lightweight boom, you can hold a mike above the subjects with your hand, but it had better be a short shot. The microphone bets heavier when placed at the end of a long boom. A better option is to use a mike stand.

Natural Sound

Most people do not spend enough time getting good natural sounds. They are worried about the pictures, and as soon as they get them, they move to the next location. Take a few minutes to collect the particular background sounds from a location. It allows you to add texture to the audio track during editing.

You should be particularly aware of any actions in a shot that produce a sound, such as a door slam, a glass breaking, or a gun shot. Sometimes you won't be able to get the mike as close to the source of the sound as you would like because of the camera framing (you don't want the mike to be in the shot). In those situations, you should redo the action on a close shot, so you can move the mike closer and get better sound.

When recording general background sound, such as the sounds from a particular piece of machinery, a stream, or city traffic, point the microphone in different directions. Don't settle for any old sound, try to get the best possible.

Avoiding Common Sound-Recording Mistakes

Simply by paying attention to the sound being recorded, you can avoid many of the most common sound-recording mistakes. If you have a set of headphones, plug them into the output of the tape recorder. That

way, you monitor what is actually being recorded, not a signal in between the microphone and the deck.

Wrap-Up

Video production is a craft that requires patience, attention to detail, and creativity. It's easy to be mediocre. It takes hard work to produce great pictures. You won't be an expert shooter on your first production, but if you keep trying to enhance your technique, the images you get will improve and that will lead to better movies.

CHAPTER 13

Going to Tape

So far we've been focusing on making QuickTime movies that are shown on a computer screen. These are fine for the distribution of video segments to people who have computers or for use in interactive applications in a public information kiosk. But to reach a large number of people, particularly those who don't have computers, you're going to have to transfer your QuickTime movies to videotape.

Unfortunately, the small size of the current QuickTime window (240 × 180 pixels) doesn't look impressive when transferred directly to tape. We're used to seeing full-screen images on television, not small windows of video that fill only one-sixteenth of the screen. In addition, the average viewing distance for television is about six feet (compared to a foot and a half for a computer). This means that much of the detail in a standard-size QuickTime movie wouldn't be seen.

All is not lost. You can still use your Macintosh to create a preliminary version of your movie (in QuickTime or other digital video format) and then use the preliminary movie as a template, or blueprint, for a videotape version. There is a bewildering array of techniques and hardware to do this, so before we begin, let's preview what we cover in this chapter.

In "Editing for QuickTime and Videotape with Premiere," we review the basic steps to take if you are starting to edit a QuickTime movie with Premiere and also want to produce a full-screen version on videotape. It explains how timecode is used to create a list of the edits

in your movie. It then steps through a typical video-editing session to produce the final segment.

In "Tape Formats and Online Editing Systems," we describe the various types of tape formats you can use to produce the final product (Beta, 1-inch, ³/₄-inch, Hi-8, etc.). The section also discusses some of the differences in online editing systems.

"Adding Timecode" describes in detail how timecode works and the various methods of adding timecode to a videotape.

In "Editing the Final Product on Your Macintosh," we describe several techniques for creating a full-screen digital movie on your Macintosh, which is then transferred directly to tape. These methods require a lot of expensive computer hardware (at least a Quadra, hardware video compression, and gigabytes of memory), but they give you total control over all parts of the editing process.

Editing for QuickTime and Videotape with Premiere

Although a small-size QuickTime movie doesn't look impressive when transferred to videotape, you can use it to plan what the videotape will look like. There are five basic steps:

1. Add timecode to your original tapes (or copies of the originals).
2. Create digital video clips.
3. Edit a QuickTime video segment.
4. Create a list of all the edits, called an *edit decision list*, or *EDL*.
5. Use the EDL to re-edit the video segment on a computer-controlled, online video-editing system.

This process is shown graphically in Figure 13-1.

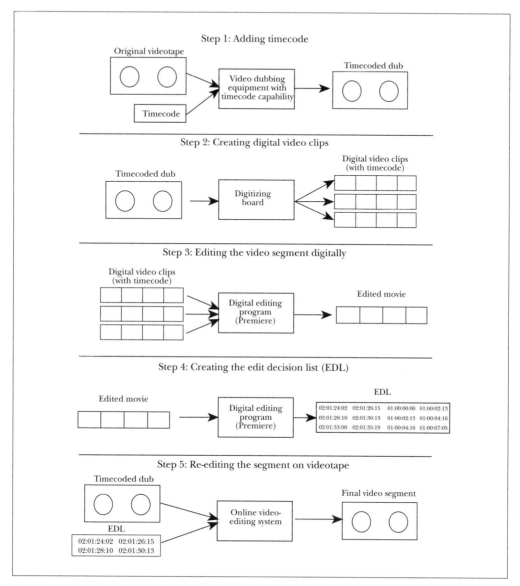

Figure 13-1. Steps in using Premiere to create an EDL for online editing. Step 1: Timecode is added while the original tape is dubbed. Step 2: Clips from the timecoded tape are digitized. Step 3: A video segment is edited together in Premiere. Step 4: An EDL is created based on the timecodes of individual clips and their placement in the Construction window. Step 5: The EDL is used with the timecoded tapes to produce the final video segment on an online editing machine.

Adding Timecode to Your Original Tapes

You might remember from Chapter 7 that *timecode* is a system of identi-
fying each frame on a videotape with a unique number using the
format of *hours:minutes:seconds:frames*. This makes it easier to find a par-
ticular cut on a videotape. But one of the main reasons timecode was
invented back in the late 1960s was to facilitate the creation of EDLs.

Timecode can be stored in a variety of places on a videotape (see
"Adding Timecode" later in the chapter for a complete description). If
you already shot your footage, then the best path to take is to copy, or
dub, your tape onto another videotape (also called "the dub") and add
timecode to the dub during the dubbing process. You then use the
timecoded dub when digitizing clips.

Timecode generators allow you to specify the initial timecode for each
tape. Each of your tapes should have a unique hour (i.e., tape 1-hour
1, tape 2-hour 2, etc.). This helps you find particular shots more easily
later on.

Creating Digital Video Clips

Digitizing clips with timecode is similar to what you did before, except
that the starting timecode for each clip is automatically added to the
clip (Figure 13-2).

You can see the timecode for a clip in Premiere 4.0 in the Clip
Timecode dialog box, using the Timecode command under the Clip
menu (Figure 13-3).

Editing a QuickTime Video Segment

Now you can go about editing your video segment as you would nor-
mally. You don't need to worry about timecode, as the editing program
takes care of that for you.

Creating an Edit Decision List

When you are satisfied with the video segment, the next step is to create
an EDL. This specifies where each cut comes from (on the timecoded
dub), how long it lasts, and its position in the edited video segment.

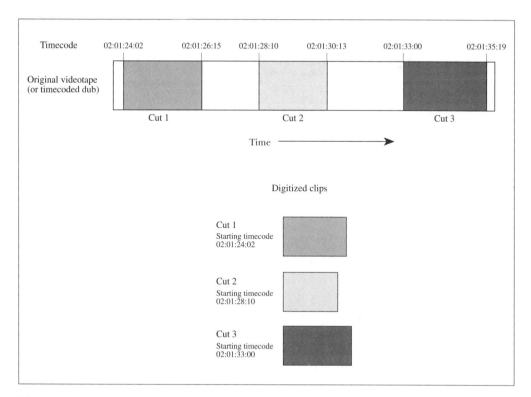

Figure 13-2. At top you see the timecode for several sections of video positioned on the videotape. The timecode for particular sections of videotape is transferred with the clip when it is digitized and imported into an editing program (shown at bottom).

To create an EDL in Premiere, you choose the Export command under the File menu. You then select the EDL format that matches the type of online editing system you'll be using to create the final video segment. Premiere then creates an EDL and stores it in a file on your Macintosh (Figure 13-4). You can then take that file (on disk) to the online editing facility, where they can load the EDL into their editing system.

 Not all online editing systems can read Macintosh disks. Call ahead to make sure.

Clip Timecode

Timecode:

`01:02:02:10` is 01:02:02:10

Frame Rate: `30 fps` ▼

Format: `Non Drop-Frame` ▼

Reel Name / Description:

`201`

[Revert to Original] [Cancel] [**OK**]

Figure 13-3.

By selecting the Timecode command in the Clip menu you can view the timecode associated with a particular clip. You can also enter the timecode for a clip that does not have one.

You don't need to learn the insides of an EDL to transfer it to an online system. Just give the file to the online editing facility. But if you're curious about how an EDL works, read on.

A timeline in a typical digital editing system shows how long each cut is and its position in the movie (Figure 13-5). From this, you could create a rough list of the edits. But this list does not indicate where the

Edit #	Tape #	Edit type	Source In	Source Out	Record In	Record Out
001	102	V	02:02:15:19	02:02:21:16	01:00:00:00	01:00:05:27
002	202	AA	00:10:10:25	00:10:14:23	01:00:00:00	01:00:03:28
003	202	AA	00:10:14:23	00:10:18:08	01:00:03:28	01:00:07:13
003	201	AA	01:02:02:10	01:02:05:25	01:00:03:28	01:00:07:13
004	103	V	03:10:02:08	03:10:07:10	01:00:05:27	01:00:10:29
005	202	AA	00:10:18:08	00:10:21:20	01:00:07:13	01:00:10:25

Notes:

Edit type: V, video edit; A, audio; AA, two tracks of audio

Source In: The beginning of the cut on the original videotape

Source Out: The end of the cut on the original videotape

Record In: The beginning of the cut in the final movie

Record Out: The end of the cut in the final movie

Figure 13-4. A portion of an edit decision list

cuts are located on the original videotape. This is where timecode comes in.

Let's say your original videotape has timecode (or you are working from a timecoded dub). When you digitized the clips you wanted to use, the timecode for those clips was also imported with the clips. Now when you assemble your movie in Premiere, you can determine where the cuts came from (Figure 13-6). Notice in the figure that the duration of a cut is the same on the original videotape as in the edited movie.

You could give the list of cuts shown on the bottom of Figure 13-6 (the EDL) to someone else, and without looking at the edited movie, the editor would be able to create an exact duplicate of the movie just by using the numbers. He or she would start by going to the beginning of cut 1 on the original videotape (02:01:24:02) and then make an edit that lasts for 2:13. Then the editor would move to the beginning of the second cut on the original tape (02:01:28:10) and make an edit that

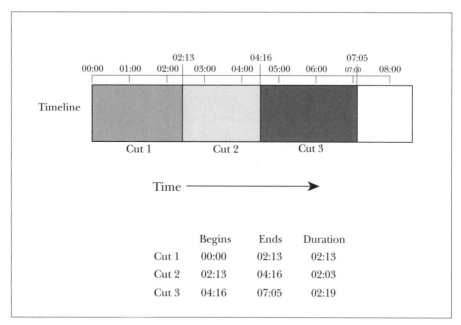

Figure 13-5. Creating a rough edit list from an editing timeline. The numbers indicate when particular clips appear in the final video segment, but they don't indicate where the clips are located on the original videotapes.

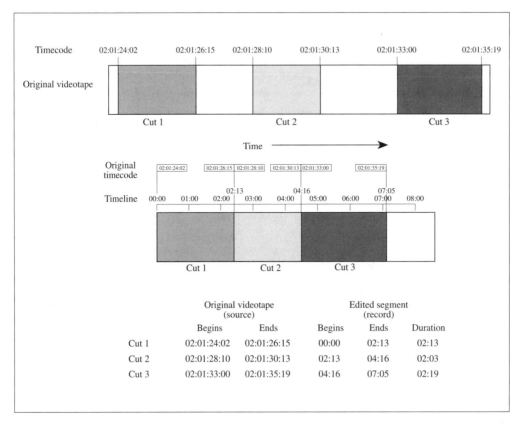

Figure 13-6. Creating an edit decision list from an editing timeline. By adding timecode to the digitized clips, you can create a list that not only shows when a clip appears in the final video segment, but also where the clip is located on the timecoded videotape.

lasts 2:03, and so on. The editor would not need to know anything about the actual images in the cuts, only the numbers.

This example involves only video cuts, but the same system works when there are also audio cuts. Let's step through a slightly more complicated segment that was edited in Premiere 2.0 to show how audio and video cuts are handled in an EDL.

The segment includes two video cuts and two overlapping audio cuts (Figure 13-7). The cut in audio track A starts part way through the segment (at 3:28) and stops before the end of the segment. To make an EDL for this segment, you choose the Export command under the File menu. Then in the dialog box that appears you choose whichever

EDL format you need for the online editing system you'll be using (in this case, a CMX 3800). Premiere then creates an EDL based on the cuts in the Construction window (Figure 13-4).

Although it might be a bit difficult to decipher, the EDL provides all the information an online editing system needs to re-create this segment on videotape. In case you're curious, here's an explanation of the edits in the EDL:

- **Edit 1:** Record the first video cut (from 00:00 to 05:27).
- **Edit 2:** Record the first portion of the audio in track B (to 3:28).
- **Edit 3:** Record both tracks of audio from 3:28 to 7:13.
- **Edit 4:** Record the second video cut (from 5:27 to 10:25).
- **Edit 5:** Record the rest of the audio in track B (from 7:13 to 10:25).

The exact format of the EDL depends on the online machine you use to create the finished video segment on videotape.

Special effect transitions, filters, and motion and speed settings are not recorded in an EDL. If your segment includes these modifications to a clip, you should write them down on a piece of paper. You will then use this list to perform these effects during online editing. (Several companies, led by Avid Technology, are trying to create a standard for digital editing systems, called the *Open Media Framework*, which would include information about special effects in an EDL.)

Figure 13-7.

Construction window showing edit points used in an edit decision list

03:28
Audio in
track A
starts

05:27
Second
video cut
starts

Re-editing the Video on an Online Editing System

The first thing to realize about an online editing system is that you are no longer working with digital video. To make an edit, you need to record material from your original tape to the final version of your segment, also known as the *edited master*. No more moving icons along a timeline. The advantage, of course, is that you are working with full-screen video at 30 frames per second.

A basic online editing system (Figure 13-8) includes the following items:

- Two or more video decks to play your original material (the *source decks*)

- A video deck for the edited master (the *record deck*)

- An *edit controller* used by the editor to create the final segment (the edit controller follows the edit plan contained in the EDL)

- A device for combining several video signals (a *switcher*)

- A television monitor to view material on any of the decks

- A computer monitor that displays the EDL

- Some type of controllable audio playback machine, such as a $1/4$-inch tape deck

- A character generator for creating titles

- One or more digital video effect devices for creating special effects

You don't need to learn about the details of an online editing system (unless you're interested). Armed with an EDL and your original tapes (or timecoded dubs), you can start editing.

The actual editing is done by the online editor. He or she loads your EDL into the online system and then recreates the video segment based on the EDL. Your job, as the producer, is to review each edit as it is performed. Because you already created a preliminary version of the segment in Premiere, you shouldn't have to make many changes at this point. But if you don't like a particular edit, change it right away. Unlike digital editing, it's not particularly easy to change a cut in the middle of a segment.

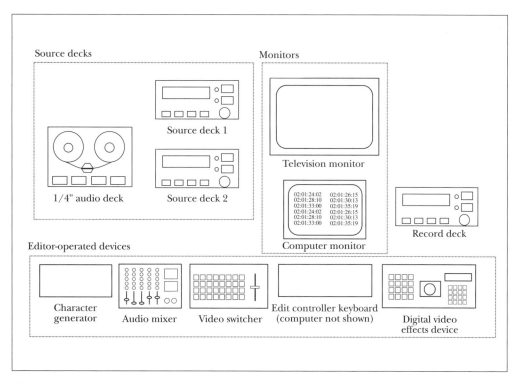

Figure 13-8. Elements of a typical online editing system. The main elements are the source decks that play the timecoded videotapes, the record deck that records the edited master, and the edit controller that controls the source and record decks and uses the EDL to edit the piece together.

Be forewarned! Online editing can be a slow and tedious process. Depending on the complexity of your production, you can expect to edit between 30 to 90 seconds of finished video per hour of online editing. So a three-minute piece might take you between two and six hours of online editing.

In addition to reviewing the edits as they are performed, you might also do the following:

- **Add special effect transitions**. If you used special effect transitions in your QuickTime movie, you can recreate those effects during the online session. Describe the transition to the editor, and he or she will perform the transition. Some of the more

complex transitions offered by Premiere (such as Funnel, Zoom, and Page Turn) require digital effect devices.

- **Mix several audio tracks**. Online systems include an *audio-mixing board* that allows the editor to adjust the volume of any audio track. Most systems also include an *audio equalizer* to modify the sound of the audio clip.

- **Correct the color balance and intensity of a shot**. The color balance (hue and saturation) and intensity (brightness) of the shots in your segment should be fairly similar in the edited master. The editor can adjust these before making an edit.

- **Adjust the speed of a shot**. This is similar to the Motion feature in Premiere. In the video world, this is known as *dynamic tracking* or *motion memory*.

- **Add digital effects to a shot**. These are similar to the filters in Premiere. The particular types of effects you can do depend on the digital video effect device you use. Ask the online editing facility for the types of digital effect devices they offer and the types of effects they can perform.

When you finish editing the program, watch it once more from the beginning to make sure there aren't any mistakes. It's a lot easier and cheaper to fix mistakes now, than later on. That's because there is usually a minimum charge for editing on an online system. So a mistake that takes you five minutes to fix now would cost you an hour of time later.

Make a copy of your edited master (a *dub master*) as soon as possible. Many producers make the dub master on the online system during the final review. Then label and store the edited master in a safe place, and use the dub master for making additional copies.

You should never—repeat never—lend your edited master to anyone. Lend them a copy from your dub master, or if you're in a hurry, lend them your dub master. If you lose your edited master and the dub master, you will have to recreate the video from scratch.

You should also get a copy of the final EDL from the online session. This will include any editing changes you made during the online session. Store a copy of the EDL (disk and paper form) with the edited master. This makes it easier to change the video later on if you need to.

Tape Formats and Online Editing Systems

There are more than six different videotape formats that differ in price and quality. Your choice of tape format also determines the type of video deck and, therefore, the kind of online editing system you use (i.e., you can't edit Hi-8 tapes on a Betacam editing system).

Because your tape format determines your editing system, you should generally try to edit on the highest-quality format you can afford. The standard tape formats used in editing are shown here in order of decreasing quality:

- **D2**: This is a digital video format (the rest are analog) and the highest quality available. It is used only in top-end editing systems and usually only for the record machine.

- **Betacam SP:** This is one of the standard formats for professional video editing. It uses a component video signal that helps maintain image quality during editing. It also comes in nonmetal format, called Betacam (no SP) or, more simply, Beta. Note that this is not the consumer Beta format Sony tried to market a decade ago.

- **1-inch:** This is another standard format for professional video editing. It produces about the same image quality as Beta SP.

- **$3/4$-inch SP:** This format is a notch below Beta SP and 1-inch in terms of image quality. It is used primarily for nonbroadcast productions.

- **Hi-8:** This format is similar to $3/4$-inch SP in image quality (some editors feel it is superior). However, Hi-8 is prone to defects in random video frames (called *drop-out*).

- **S-VHS:** This is a small notch below $3/4$-inch and Hi-8 in terms of image quality. It uses a component video signal that helps maintain image quality during editing.

In general, editing systems based on higher-quality tape formats (Betacam, 1-inch) offer more sophisticated editing features and cost more to rent. Conversely, editing systems for lower-quality formats (Hi-8, S-VHS) have fewer bells and whistles and cost less.

You don't necessarily have to edit on the same tape format you shoot on. You can transfer your footage to a higher-quality format when you add timecode. In fact, it is common practice for professional camerapersons to transfer, or *bump-up*, Hi-8 footage to Beta SP.

Once you settle on a tape format, you have to consider what kind of online system you need. The basic elements of an online system are shown in Figure 13-8. The cost depends on your tape format, but the basic system can cost between $75 and $250 an hour to rent.

Those costs only cover the basic equipment. Additional equipment, such as a character generator (for creating titles) or a digital effect device (for creating special effects) costs extra. It's like eating à la carte at a restaurant—you pay for what you use. However, the cost of these extras can sometimes equal the cost of the basic equipment.

A Beta SP system with a character generator and a *Harry* (a high-end graphics and digital effect device) costs about $500 an hour to rent.

Evaluating all these options can get a bit confusing, so here are a few key points to keep in mind when deciding which editing system to use:

- **The size of your audience:** Generally speaking, the larger your audience, the more you should spend on editing. If a lot of people are going to see your work, then you should spend a bit more money to increase the quality of the final product. The incremental cost per tape won't be that much.

- **Complexity of production:** If you want to use complicated digital video effects (such as motion, speed, filters, and complex special effect transitions), then you have to edit on a Beta or 1-inch editing system.

- **Audio editing:** If you are going to be working with a large number of audio effects, then you should make sure the online system has a digital audio-editing system or a multitrack analog system. This greatly increases the quality of the audio.

- **Cost:** S-VHS online systems rent for as little as $50 an hour, whereas Beta SP systems run about $250 an hour (around $350 an hour with standard extras). Using a rough estimate of one hour of online editing time for each minute of edited material, a 10-minute segment will cost about $500 to edit on an S-VHS system and about $3,500 on a Beta system.

Once you settle on a tape format and an online editing system, shop around for the best price. If you are going to be working on a large segment that requires several days of online editing, ask for a discount.

Adding Timecode

As mentioned earlier, to create an EDL you need to have timecode on your original videotapes. Timecode is simply a chunk of data that is added to every frame of video. There are several different ways to add timecode to a tape. One way is to encode it as an audio signal and place it in one of the audio tracks. However, because most video recorders only have two audio tracks, this leaves you only one audio track for recording sound.

Another, more common method is to put the timecode data in a special part of the video signal called the *address track*. This method doesn't affect the audio tracks.

A third method, called *VITC* (pronounced "vit-see"), puts the timecode information in the vertical interval in the video signal (this is the black bar you see when the picture rolls on your television set). This method is most often used in online editing systems. The advantage of this type of timecode is that it can be read by an edit controller when the video deck is in pause; the other types of timecode can't.

You can either add timecode to the tape during the original recording or afterward.

Adding Timecode in the Field

All professional video decks and some "prosumer" (professional-consumer) camcorders allow you to add timecode to the address track while you record. You set the initial hour, minutes, seconds, and frames, and the recorder automatically increments timecode as the videotape plays. This is the best method for adding timecode to your field tapes because it doesn't require an audio track.

Adding Timecode after Recording

Once you record material on a videotape, it is fairly difficult to add timecode to the address track. Instead, you can either add timecode to one

of the audio tracks, or you can make a copy of your original (a dub) and add timecode to the address track of the dub. You then digitize material from the dub (because it has timecode and the original doesn't).

In the video world, it is common to make a copy of a timecoded tape with the timecode shown in a window on the screen. This type of dub, called a *window dub*, is used for preliminary editing.

Types of Timecode: Drop Frame and Non-Drop Frame

A standard video signal does not run at exactly 30 frames of video per second. For a variety of technical reasons, it actually runs at 29.97 fps. This means that standard timecode, which runs at 30 fps is not completely accurate (it's off by 0.1%). This doesn't matter much for short sections of video, but after a few minutes, the inaccuracy adds up. For example, if you play a section of videotape with timecode and stop it when the timecode reaches 5 minutes, in reality, the video has only played for 4 minutes, 59 seconds, and 21 frames (9 frames off). An hour-long program (by timecode) is off by 108 frames (3 seconds and 18 frames).

Because of this inaccuracy, another type of timecode, *drop-frame* timecode, is used for finished video segments because it matches the actual frame rate of video. It does this by dropping frame numbers every so often, hence its name. It drops the :29 and :00 frames for each minute (except every tenth minute). For example, if you are looking at a videotape with drop-frame timecode, one frame at a time, the timecode looks like this:

```
01:02:59:27  01:02:59:28  01:03:00:01  01:03:00:02
```

Now if you are trying to figure out the duration of a short clip using drop-frame timecode, you have to take into account whether or not frames were dropped during the middle of the clip. That's why most source material (i.e., original footage) is timecoded with standard, *non–drop-frame* timecode.

Why does all this matter? Well, the online editing system needs to know which type of timecode is used for each source videotape. If you're only working with original videotapes, then they should all be timecoded in non–drop-frame format. But what if you are using a portion of

someone else's videotape? If it was edited on an online system, chances are it has drop-frame timecode, and you have to note that on your EDL; otherwise, the timings for the edits will be wrong.

Most high-end video decks read timecode, and they indicate which type of timecode is used on the tape. If your machine doesn't indicate the timecode type, another way to tell is to look at how the timecode changes when a new minute is reached. If the timecode jumps (from 59:28 to 00:01), then it's drop frame; otherwise, it's non–drop-frame timecode.

Editing the Final Product on Your Macintosh

As mentioned at the beginning of this chapter, the current size of QuickTime movies (280 × 180 pixels) doesn't look good when transferred to videotape directly. But what about a full-screen QuickTime movie? It looks pretty good, almost as good as videotape. And if you can afford the equipment to edit full-screen digital movies on your Macintosh, you are able to control all aspects of the editing process. You digitize the video clips, create the movie in digital format, and then output to tape directly. There is no need to go back to videotape for the final version.

All-digital editing taxes all parts of your computer system because each frame of video is displayed at full size. This means that your computer system not only has to work harder to pull information off your hard disk and display the images, but also has to store massive video files.

A 10-second, standard-size QuickTime movie takes up about 38MB (uncompressed). A full-screen, full-motion version of that movie requires seven times the amount of storage, about 276MB. And that's just 10 seconds of video!

Obviously, an all-digital editing system must use some sort of hardware video compression to reduce the size of the video files. Hardware compression, which requires an additional board (or boards), is more efficient than software compression and handles the burden of compressing and decompressing the images, which frees up the computer's central processing unit (CPU) to do other things (a detailed discussion of hardware compression can be found in Chapter 14).

Today there are two different methods of all-digital editing: one based on QuickTime and the other based on a proprietary digital video format, Avid's Media Suite. We discuss the QuickTime-based method first.

All-Digital Editing with QuickTime Editing Programs

Although we're all familiar with the current QuickTime window (240 × 180 pixels), in fact, a QuickTime window can be any size. The drawback to the full-screen movie, however, is that it takes 7 times as much computing power to pull the video information from a hard drive, decompress it, and display it on the screen. So the limitation isn't in QuickTime, it's in the computer.

As is discussed in the next chapter, you can add hardware video compression-decompression boards, or *codecs*, to your computer and still work with QuickTime files. The codec takes care of the compressing and decompressing and the screen display, which frees your computer to do other things (like run a video-editing program).

Several codecs have been developed, most notably Videovision Studio from Radius and MoviePak2 from RasterOps. These products digitize video clips, compress and decompress video, and also transfer digital video movies to videotape.

Transferring a digital image to videotape is a fairly complex task, involving a specific piece of equipment called an *encoder*. This device converts the color of each pixel in the digital image (which uses the RGB—red, green, blue—system for representing color) to the television color standard, NTSC (which represents a color as a combination of hue and saturation). The encoder then converts the digital information to an analog waveform. Finally, it adds several calibration pulses to the data and outputs a standard NTSC video signal.

With a powerful codec you can edit full-screen, full-motion (30 fps) movies with a QuickTime-based editing program such as Premiere. The actual editing is done with the standard-size thumbnails, which in this case represent full-screen images.

A big advantage to creating full-screen, full-motion digital movies and then transferring them directly to tape is that you can apply special effects, filters, motion, and superimposed titles and have these

effects appear in your final movie. When you are creating a preliminary version in a QuickTime editing program, those modifications are not stored in an EDL; you have to re-create them from scratch in the online session.

The major disadvantage is that you're talking about a lot of expensive equipment. The basic elements of an all-digital editing system (with their estimated costs) are shown in Table 13-1.

The complete cost—around $20,000—might seem like a lot of money (and it is), but it is less than one tenth the cost of a basic Beta online editing system (about $250,000). And although video segments transferred to videotape from digital movies aren't as good as segments edited on Beta editing systems (at least not yet), for many applications the lower equipment cost makes up for slightly lower quality.

 You will want to purchase a SCSI-2 board, which allows you to transfer data to hard drives at rates higher than the current SCSI limit of 2MB. A higher allowable data rate will require less compression and, therefore, be of higher quality. The drawback is that higher data rates also mean larger files.

So if you plan to edit a lot of digital video segments and then re-edit them on an online editing system, you might want to consider the all-digital route. It costs a lot more in terms of equipment, but you won't have to rent the online editing system later on.

All-Digital Editing with Avid's Media Suite Pro

Another option is to use the Media Suite Pro digital editing system from Avid. Essentially, Media Suite Pro is a packaged version of some of the hardware and software described in the previous section. The system includes a video codec capable of handling full-screen, full-motion video; an encoder; a souped-up disk controller for getting information to and from a hard disk faster; and an editing software program. You have to provide the Macintosh Quadra, hard disk, optical disk, and monitor. The editing program is similar to the Media Composer editing system described earlier.

As with full-screen QuickTime movies, the final product from Media Suite Pro isn't as good as a videotape edited on a Beta SP or 1-inch online editing system. It's about the same as a $^3/_4$-inch videotape, but for many nonbroadcast applications, this level of quality is sufficient (e.g., training tapes or in-house video communications).

Media Suite Pro costs about $14,000. When you add in the cost of the Quadra 950 and storage, the total price for the system is just over $20,000.

The Future of Video Editing

The future of video editing is digital. Computers are becoming cheaper and more powerful. New compression methods are making it easier (and cheaper) to handle full-motion, full-screen video. Memory is becoming less expensive as engineers find new ways to cram more bits on a sliver of silicon. IBM is currently developing a 256-megabit RAM chip; that's right, 256 megabits—in RAM!

This means that the current bottlenecks in all-digital editing (computer speed, compression technology, and storage) will all fall away. So

Table 13-1. Elements and Cost of an All-Digital Editing System (in U.S. $)

Device	*Cost*
Macintosh Quadra 950	3,000
64MB of RAM	2,400
Large-capacity, fast hard disk (2GB)	1,700
Tape drive	1,000
Video codec (and encoder)	3,000
Video deck	3,000
21-inch computer monitor	2,500
16-inch television monitor	1,000
Miscellaneous (keyboard, software, etc.)	1,000
Total	19,200

when will you be able to buy an all-digital editing system for less than $10,000? It depends on whom you talk to. Some experts see it happening in 1995. Others say it's at least two years away. Of course, by that time, we'll all be working with high-definition TV and struggling with the new bottlenecks it will create.

Wrap-Up

There are several different ways you can use your Macintosh to help create a polished segment on videotape. Depending on your production and your budget, one of the following solutions will fit your needs:

- Editing a preliminary version of your movie in QuickTime format with Premiere, creating an EDL, and using the EDL to re-edit the movie on an online editing system

- Editing the final movie on an all-digital editing system and transferring the full-screen, full-motion digital movie to videotape directly

Although it might seem like a lot of work to create a videotape version of your QuickTime or digital movie, the benefit of distributing your work to a much larger audience often outweighs the hassle involved.

Working with Digital Video—Compression, Input, and Final Format

V ideo was never intended to be stored or manipulated in digital form; there's just too much data. There's too much data to send from place to place inside your computer, and there's too much data to store on your hard disk or other storage device. That's why, until recently, the only place you'd find people working with digital video was in expensive video post-production facilities.

Cheaper memory, faster computers, and most importantly, video compression have now made it possible for hundreds of thousands of people to create, edit, and display digital movies on their computers. Previous chapters discussed how to work with compressed video files. This chapter focuses on video compression itself and how it affects the process of converting video to digital files, and how compression affects playback from the final format (type of storage device) for your movie.

Managing the Data Deluge

A single frame of video is made up of 525 lines, although only 483 are used to create the image on the screen (the other lines are used for

calibration purposes). Each line contains 720 pixels. When converted to a digital file, a single frame of video consists of 480 lines, each consisting of 640 pixels across. This amounts to a total of 307,200 pixels per frame.

To accurately represent the color of an individual pixel in digital form, you need 24 bits of information (8 bits each for red, green, and blue). This means that one frame of video requires 921,600 bytes (307,200 × 24 bits × 1 byte/8 bits). And that's just one frame. One second of video (30 frames) requires 27.6MB; one minute of video, 1.66 gigabytes (GB); a one-hour videotape, 99.5GB. Gets out of hand kind of quickly, doesn't it?

There are a number of ways to reduce this flood of data to a reasonable level:

- Reduce the size of the video window
- Reduce the number of frames of video that are displayed per second (*frame rate*)
- Apply some kind of image compression

Reducing the Size of the Video Window

Part of the reason why a frame of video requires so many bytes is that it consists of 307,200 pixels (640 × 480). By reducing the number of pixels, you immediately reduce the size of a video clip. Table 14-1 shows the effect of reducing the size of the video window for a 10-second

Table 14-1. **How Window Size Affects File Size**

Window Size	Fraction of Total Screen	Number of Pixels	File Size (MB)
640 × 480	1	307,200	276.5
320 × 240	$^1/_4$	76,800	69.1
240 × 180	$^1/_7$	43,200	38.9
160 × 120	$^1/_{16}$	19,200	17.3

video clip in 24-bit color. That's one reason why the current QuickTime window measures 240 × 180 pixels. By squeezing the image into a smaller box, you reduce the file size by almost seven times.

You can increase the size of a video clip and still keep the same image quality by capturing it in a larger video window (see "Digitizing Your Clips" later in this chapter), but then you're working in reverse, making your files larger.

Reducing the Frame Rate

Normal video runs at 30 frames per second (fps). You can reduce the size of a file by simply showing every other frame (15 fps), every third frame (10 fps), or even fewer frames per second. The reduction in file size for an uncompressed video clip is directly proportional to the reduction in frame rate. Table 14-2 shows the relationship between frame rate and file size for a 10-second clip at 24-bit color in a 160 × 120 pixel window.

In Premiere 4.0, the frame rate is set in the Compression Settings dialog box (Figure 14-1) by selecting the Compression Options from the Make menu.

For most situations, 15 fps is sufficient to capture most of the motion in a clip. However, if there is a lot of action in a shot, you may need to use 30 fps; otherwise, the movement will occur in jumps.

Table 14-2. How Frame Rate Affects File Size

Frame Rate (fps)	File Size (MB)
30	17.3
15	8.64
10	5.76
5	2.88

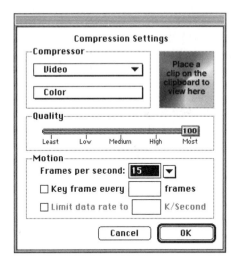

Figure 14-1.

Setting the frame rate. A lower frame rate reduces the size of the movie file. However, frame rates lower than 10 frames per second may look too jumpy.

Applying Image Compression

QuickTime comes with seven different image-compression schemes that you can use to reduce the file size of a video clip:

Nearly all editing and video capture programs use the standard dialog box provided by Apple, although some offer additional features. We're primarily interested in video compression, so we look first at the None and Video compression schemes.

Using the None Compressor

The None compressor doesn't apply image compression, but it does allow you to set the number of colors used in an image:

| Black & White |
| 4 Colors |
| 4 Grays |
| 16 Colors |
| 16 Grays |
| 256 Colors |
| 256 Grays |
| **Thousands of Colors** |
| Millions of Colors |
| Millions of Colors+ |

The highest image quality is achieved by using the Millions of Colors setting (the Millions of Colors+ setting won't increase the image quality). But you can get good results with video at the Thousands of Colors setting. If your video clips will only be seen in 8-bit color, you should adjust the color setting accordingly (at 256 colors, the file is one-third the size of a 24-bit movie).

Figure 14-2 shows the effect of the number of colors on image quality and file size. Notice the similarity between the Thousands of Colors and Millions of Colors examples.

Using the Video Compressor

With the Video compressor, you can reduce the size of a file from 2 to 25 times, depending on the amount of compression applied and the content of the image.

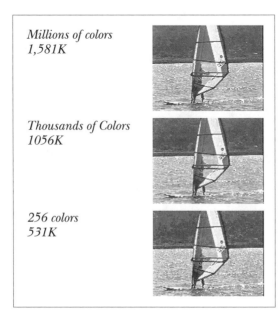

Millions of colors
1,581K

Thousands of Colors
1056K

256 colors
531K

Figure 14-2.

Reducing the number of colors in a movie reduces the size of the movie file. Most movies look fairly good at Thousands of Colors. Computers that don't have 24-bit color boards will show movies using only 256 colors.

There is a general relationship between compression and both quality and file size:

Higher compression = lower quality = smaller file size
Lower compression = higher quality = larger file size

The overall goal is to set the compression as high as possible (to reduce file size) and maintain an acceptable level of quality.

There are two basic techniques of image compression: spatial compression and temporal compression. *Spatial compression* decreases the amount of information required for a single image or frame of video. *Temporal compression* compares two frames of video and stores only the differences between the frames.

Adjusting Spatial Compression The amount of spatial compression isn't set directly. Instead, you choose a quality level in the Compression dialog box:

The Video compressor then adjusts the compression level accordingly. By default, the quality setting is set to Normal, which usually achieves about a 75 percent reduction in file size.

Note Another way of evaluating compression is to talk about the *compression ratio*, which is defined as the file size of an uncompressed file divided by the size of the file after it is compressed. For example, a 75 percent reduction means the compressed file is one-fourth as large as the uncompressed file, for a compression ratio of 4 to 1 (or simply 4).

The exact relationship between quality, compression, and file size varies from clip to clip. Figure 14-3 shows the effect of five different quality settings on the same clip as compared to the uncompressed clip. Note that the quality doesn't change much between the settings (but the file size does).

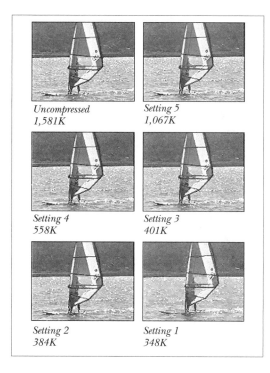

Uncompressed 1,581K *Setting 5 1,067K*

Setting 4 558K *Setting 3 401K*

Setting 2 384K *Setting 1 348K*

Figure 14-3.

The relationship between quality setting, image quality, and file size varies from clip to clip. Clips with nondescript backgrounds, such as this one, can be compressed at a low quality setting and still look fairly good (with substantial savings in file size).

But with another clip you get a different story (Figure 14-4). Now there is a huge difference between quality settings 2 and 3. The relationship between quality setting (spatial compression) and compression ratio for these two clips is shown in Figure 14-5.

Generally speaking, if a clip contains large areas of similar colors, you can use higher compression settings. For example, a person standing against a solid-color wall retains good quality under high compression.

Compression artifacts (image imperfections caused by compression) become more noticeable in large video windows (larger than 240 × 180 pixels).

You should try several different settings for a particular clip or movie to determine the most appropriate setting (highest compression at acceptable quality). Because a movie generally consists of several clips, you should pick a quality setting that produces the best average result for all the clips.

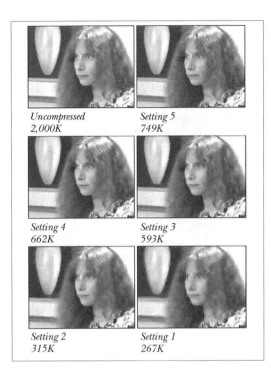

*Uncompressed
2,000K*

*Setting 5
749K*

*Setting 4
662K*

*Setting 3
593K*

*Setting 2
315K*

*Setting 1
267K*

Figure 14-4.

The image quality of clips that include people or detailed backgrounds falls off dramatically at lower quality settings. In general, use a quality setting of 3 when working with clips that contain people.

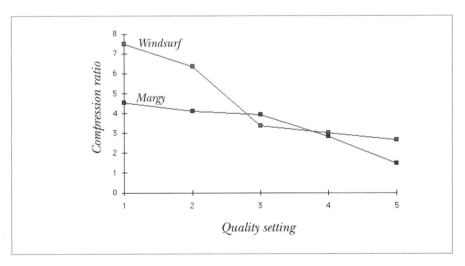

Figure 14-5. In general, lower-quality settings yield higher compression ratios. However, the relationship between quality setting and compression ratio changes from clip to clip. The windsurfer clip has a higher compression ratio at the low- and high-quality settings than the clip of the woman.

Adjusting Temporal Compression As mentioned earlier, temporal compression works by comparing two frames and storing the differences between the frames. One frame is the reference, or *key*, frame; the other frame is called the *difference frame* (Figure 14-6). Key frames are stored as complete frames, whereas difference frames are stored only as the difference between them and the previous frame.

For example, if you have a shot of a person walking in front of a solid-color wall, the difference frames would contain only the image of the person, not the background (which remains the same).

After a number of difference frames, the accumulated differences don't accurately reproduce an image, which then degrades the image quality. At that point, a new key frame is used, and the process starts all over again.

The check box next to the word *Key* in the compression dialog box must be checked to apply temporal compression. When the box is not checked, only spatial compression is applied:

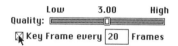

You adjust the amount of temporal compression by changing the frequency of key frames within the movie. More frequent key frames usually improve the quality of the image but also reduce the amount of compression. Less frequent key frames usually reduce the image quality but decrease the file size.

The exact relationship between temporal compression (frequency of key frames), image quality, and file size varies from clip to clip.

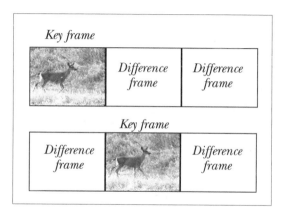

Figure 14-6.

Key frames are stored as complete frames. Difference frames hold only the differences between that frame and the previous key frame. When the differences between a frame and a key frame exceed 95 percent, a new key frame is stored.

Figure 14-7 shows how the compression ratio varies with the key-frame frequency for two different clips. The curves in the figure reflect the fact that the Video compressor automatically inserts key frames if a difference frame deviates by 95 percent from the previous key frame.

Generally speaking, static camera shots that don't include a lot of movement, such as the shot of the woman in Figure 14-4, can withstand a large amount of temporal compression. Shots with camera moves (tilts, zooms, or pans), such as the pan of the windsurfer, degrade quickly with increasing temporal compression.

Besides affecting the quality of the image, the frequency of key frames can strongly affect how a movie is played back on someone else's machine. Please see "Choosing the Final Format" later in this chapter.

Using the Cinepak Compressor

Versions 1.5 and later of QuickTime offer another compressor, the Cinepak compressor. With this compressor, you can create quarter-screen (320 × 240 pixels) movies that can be played back smoothly

Figure 14-7. Increasing the number of frames between key frames increases the amount of temporal compression. However, the exact relationship between the amount of temporal compression and compression ratio differs from clip to clip. The panning shot of the windsurfer contains a lot of movement, which requires many key frames (even if you don't set them yourself). The shot of the woman is static, which allows for more temporal compression and, hence, higher compression ratios.

from a CD-ROM. Unlike the Video compressor, the Cinepak takes much longer to compress an image than to decompress it. It can take as long as 20 minutes to compress a 10-second clip. This makes the Cinepak compressor unsuitable for compressing movies while you're working with them. The real benefit of this compression technique comes when you compress your final movie. You can achieve much higher quality, at lower data rates, than with any other compressor.

Using Other Apple Compressors

QuickTime comes with three other compressors—Photo-JPEG, Animation, and Graphics—that are generally used for media other than video.

Compressing Still Images The Photo-JPEG compressor is a sophisticated compression scheme designed specifically for still images. It uses a spatial compression scheme developed by the Joint Photographic Experts Group (JPEG). Compression ratios as high as 20 to 1 can be achieved without noticeably affecting image quality (although this is heavily dependent on image content).

JPEG uses a complicated algorithm to achieve compression (and decompression) and is, therefore, fairly slow—generally too slow for video clips. However, because it can achieve high quality at sizable compression ratios, it is useful for archiving video clips.

 JPEG is the standard for hardware compression and decompression.

Compressing Animations The Animation compressor is designed for compressing and decompressing animations and computer-generated graphics. It can be set to use spatial compression, temporal compression, or a combination of both. You can also set the color-bit depth to achieve further reductions in file size.

Using the Graphics Compressor The Graphics compressor is similar to the Animation compressor except that it is tailored for 8-bit graphics. In addition, the algorithm favors fast compression speed at the expense of decompression speed. Therefore, it is not necessarily a good choice when playback speed is crucial (i.e., off a CD-ROM; see "Storing on CD-ROMs" later in this chapter).

 The compression schemes offered by QuickTime are software compression methods, meaning that your computer's central processing unit (CPU) performs the compression and decompression. Hardware compression is provided by add-on boards and typically yields much faster compression while it frees your CPU to handle other tasks.

Lossy vs. Lossless Compression

Some of the compressors mentioned earlier do not change the basic quality of the image during compression and decompression. This is called *lossless compression* because nothing is lost. The Animation and Graphics compressors are lossless when only spatial compression is used and the number of colors is not changed from the input value. The None compressor is lossless only when the number of colors is unchanged.

The opposite of lossless is *lossy compression*, where data is lost or removed from an image or video clip during compression. When the image is decompressed, there is a variable amount of change in the image. If the amount of lost data isn't large, then you probably won't notice the change (see the bottom two frames in Figure 14-3).

However, when a lossy compression scheme is used over and over on the same clip, minor changes can build up, leading to a noticeable effect. This can occur when you are compositing several effects or filters on the same clip. In that case, you should use the None compressor to avoid any image degradation. Once you create the composited clip, apply compression to reduce the file size.

Digitizing Your Clips

Digitizing video is no small task given the immense data rates for video. So far we've been concerned with the size of the files needed for video clips, but the speed at which video information streams into a digitizing board is tremendous. Every second, another 27.6MB. Even if you are only capturing to the standard QuickTime window (240 × 180 pixels), it's still 1.7MB per second.

To give you a perspective on what your computer and digitizing board are trying to do, let's look at what happens after you decide to capture a section of video. You click the mouse to start the digitizing process (time 0):

- **0 to 0.03 second:** Your finger has barely moved. Into your digitizing board and onto your CPU, 129,000 bytes have streamed—the equivalent of a 60-page document. Along the way, the full 720×525 pixel video screen was shrunk (through millions of calculations) to one-seventh its normal size.

- **0.03 to 0.06 second:** Your finger begins to move up. The first frame of data is on its way to your hard drive. The second frame, another 60-page document, has raced through the digitizing board and is on its way to the CPU.

- **0.06 to 0.1 second:** You finally released the mouse. In just one-tenth of a second, nearly 400,000 bytes coursed through the board and the CPU and onto your hard drive. And how long was that segment you wanted to digitize?

There are essentially two different ways to handle this flood of data: capturing as much as you can in real time (as the videotape is playing) or capturing as large a window as you can and making repeated passes over the same section of videotape to capture the frames you missed. We look at real-time capture first.

Real-Time Capture

With *real-time capture*, your digitizing board grabs as many frames as it can while the videotape plays. There are three major factors that affect how fast a frame you can get out of your digitizer:

- **The capabilities of the board itself:** Various boards use different methods to convert an analog video signal into digital information.

- **The size of your capture window:** A 320×240 window requires nearly twice as much data throughput as a 240×180 window.

- **The speed of your CPU:** A Quadra is able to grab a 320×240 window at 15 fps, whereas a Macintosh IIci would only get 15 fps in a 240×180 window (with the same digitizing board).

Achieving the Maximum Frame Rate

There are a few techniques and procedures you can follow that help you get the maximum frame rates possible for your particular system:

- Don't have any other programs running while you digitize video. These programs take up RAM, and in some cases, they can actually put a load on your CPU (which uses every clock cycle it can for digitizing).

- Turn off any Desk Accessories or Control Panel applications that might put a load on the CPU (such as screen savers).

- If you have a lot of RAM (more than 8MB), try recording directly to RAM. This is faster than recording to your hard drive.

- If you are recording to a hard drive, partition your disk and defragment the partition regularly. If the drive has to go looking for space, then it can't be writing to the disk. An even better solution is to have a dedicated hard drive just for recording video clips.

Maximizing the Image Quality

Achieving a high frame rate is only part of the battle. You also need to get good quality images. Most digitizing boards come with a variety of color and image controls that can improve image quality:

- **Hue:** This is similar to the tint control on your television set. It is generally used to overcome any artifacts (image imperfections) caused by the video deck.

- **Saturation:** This is similar to the color control on a television set. The normal setting usually works best. However, if you are digitizing from a VHS tape that is a copy of a copy, you might want to reduce the saturation slightly.

- **Brightness:** This increases or decreases the overall brightness of the video image. You can use this control to lighten a dark image, but this will turn black areas in an image gray. In this case, you should also increase the contrast to compensate. This control, however, won't decrease the brightness of an entirely white region of an image (see the discussion on white level in the next bulleted list).

- **Contrast:** It's generally a good idea to use a medium- to high-contrast setting when digitizing. This increases the *tonal range* of the image (the range between brightest and darkest pixels) and, thus, yields a more detailed picture. A good tonal range also improves image quality during compression.

In addition to the basic image controls just listed, some digitizing boards offer the following:

- **Black level:** This controls the blackness of the dark areas of an image. It can be used in conjunction with the brightness control to lighten a dark image. To set the proper black level, increase it slowly until you start to lose details in the dark regions of the image. Then back off a bit until the details reappear. The proper black level improves image compression by removing noise from the video signal.

- **White level:** This controls the whiteness of the bright areas of an image. It should be used in place of the brightness control for darkening an overly bright image.

Tip Abbate Video sells a useful batch-capturing program called Video Toolkit, which works with Adobe Premiere. It allows you to enter a list of In and Out points for clips you want to capture (using SMPTE timecode). The program then captures each clip in order (while you go out and have dinner). All you need is a video deck that exports timecode. Video Toolkit comes with all the necessary cables.

Controlled Capture

Controlled capture is a clever way to get either a higher frame rate, a larger window size, or both from the same equipment (computer and digitizer). Instead of trying to keep up the flood of data, a software program grabs one frame, processes and stores it, and then gets the next frame that's available. This continues to the end of the video segment. Then the computer goes back to the beginning of the video segment and gets another set of frames (different from the first set). By making several passes over the same section of video, you eventually get a complete digitized version of the segment (Figure 14-8).

Note To use controlled capture, you need to use an accurate video deck that can be controlled by a computer, such as the JVC 411 (VHS), the Panasonic AG-7650 (S-VHS), the Sony EVO-9800 (Hi-8), or any Sony $3/4$-inch deck in the BVW or BVU series. You also need to add timecode to your original videotape so that the software program can accurately control the tape.

 Higher-quality images and movies can be obtained using an animation controller, such as the DQ-ANIMAQ from Diaquest, Inc.

Comparing Real-Time and Controlled Capture

Because controlled capture requires expensive, frame-accurate video decks, it is only warranted if you plan to mass-distribute your work, e.g., by pressing a CD-ROM. Then, the additional quality is worth the pain and expense. Working with controlled capture pushes every part of your system. You need better decks, a timecode generator, fast CPUs to run larger files, and much larger hard drives.

If, however, you are only planning to make several copies of this material, and the highest quality is not necessary, then real-time capture with any of the common hardware digitizers is sufficient.

Digitizing Audio

Compared to video, digitizing audio is fairly easy. Some digitizing boards come with an audio capture capability built in; with other boards you need to use a separate audio digitizer, such as MacRecorder.

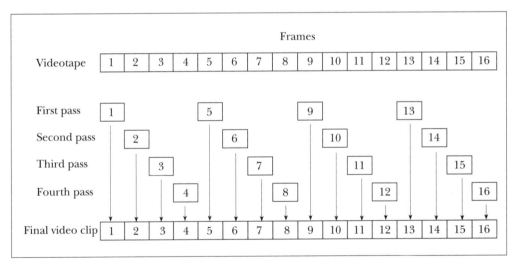

Figure 14-8. Controlled capture programs make multiple passes over a portion of a videotape to capture high-quality frames. The number of passes is lower for faster computers (e.g., the Quadra 950).

Certain Macintosh computers (the IIsi and Quadra) come with built-in audio digitizers.

Digitizing audio involves two steps: setting the audio level controls and choosing the level of audio resolution.

Setting the Audio Levels

Your goal is to produce digital audio with as little distortion as possible. Most digitizing boards and devices allow you to listen to the digitized audio sound before actually recording it (audio play-through).

 With some digitizing boards, notably VideoVision, you should turn off the audio play-through option when recording. This eliminates audio pops that sometimes occur when play-through is activated.

There are two basic types of distorted audio: clipped and muffled. *Clipped audio* sounds harsh, with a lot of crackle and hiss. *Muffled audio* sounds, well, muffled.

Avoiding Clipped Audio Clipping occurs when the audio is digitized at too high a volume. This can occur because the audio output from the video or audio deck is too high or because the digitizer volume control is set too high.

If your audio or video deck has an output volume meter, the audio volume should be set so that it falls within the middle range of the meter (near the 0 db level). If the volume is much higher than that, reduce the volume to the proper level.

 If your deck doesn't allow you to adjust the output volume, then your only adjustment is provided by the digitizer volume control.

If you still have distortion, reduce the volume setting on the digitizing board.

The reason for adjusting the output volume on your deck first is that it is nearly impossible to remove distortion once it's been added. Therefore, you should always start at the beginning of the data path and remove distortion when it is introduced, not later.

Avoiding Muffled Audio Muffled audio occurs when the audio is digitized at too low a volume. Again, this can be caused by either the output of the video or audio deck or by the digitizing board. The procedure for correcting this problem is the same as with clipping, except that you are looking for audio volumes that are too low (far below the 0 db level).

 If your original material is distorted (either muffled or clipped), you won't be able to improve it during digitizing. See "Sound-Recording Basics" in Chapter 12 for information on proper audio-recording techniques.

Setting the Audio Resolution

Two parameters affect the quality of the digitized audio and the size of the audio file: bit depth and sampling rate. These are analogous to color depth and frame rate for digitizing video.

Setting the Audio Bit Depth The standard bit depth for Quick-Time is 8-bit audio. There are, however, several devices that can produce 16-bit audio, which yields superior sound compared to 8-bit audio. The file sizes for your audio clips are twice as large, but the improved quality is worth it.

Setting the Audio Sampling Rate The sampling rate determines how often an analog audio signal is cut up to make a digital audio clip. Higher sampling rates yield better quality. Most digitizing devices allow you to digitize at either 8 kHz, 11 kHz, or 22 kHz (8,000, 11,000, or 22,000 samples per second). Whenever possible, you should digitize at 22 kHz to maximize audio quality. You can always reduce the sampling rate when you compress the file later.

There is, however, a direct trade-off between sampling rate and file size. A clip digitized at 22 kHz takes up twice as much room on your hard drive as the same clip digitized at 11 kHz.

Sampling at 22 kHz also increases the data rate through the digitizing board, which can reduce the maximum frame rate for the video capture.

Evaluating Digitizers

There are several different digitizers available to capture your clips. Rather than go into a description of the current options, which would get out of date pretty quickly, we'll describe some of the major features that affect a digitizer's performance.

Audio Capture

A good digitizer allows you to capture sound as well as video. This not only simplifies the operation but also prevents you from having to buy a separate audio digitizer. Boards can capture in 16-bit or 8-bit samples; 16-bit samples produce better quality sound.

Hardware JPEG

High-end boards (such as Movie Pak II and Radius Videovision Studio) provide JPEG compression in hardware. This allows you to capture large-sized movies at high frame rates. This is essential when producing video segments that will be laid back to tape. These boards also speed up the editing process because the compression is handled by the board, not the CPU.

 The A/V Quadras and A/V PowerMacs do not provide JPEG compression in hardware.

Encoders

To send a video clip out to tape, you need to convert the RGB signal of the computer into an NTSC signal that your video deck can record. If recording your work to tape is important, you should buy a digitizing board that has an encoder built in or plan on buying an external encoder.

Choosing the Final Format

You've made your movie and now it's time to put it in a form that others can see and use. The best storage format for your particular movie depends on the size of the movie (or movies), the size of your audience, the probable delivery platform (playback device), and cost.

Your basic choices are floppy disk, hard disk, removable media (magnetic or optical), and CD-ROM. Creating videotape versions of your movies is covered in Chapter 13.

Storing on Floppy Disks

This option only works for small movies (less than 10 seconds), slightly longer movies (less than 30 seconds) that are heavily compressed, or animations. To reduce file size, you can reduce the frame rate and reduce the quality setting on the compressor.

The advantage of this option, of course, is that every Macintosh can read a floppy disk (though the end user still needs QuickTime to view the movie), so it's a good format for video postcards and other short clips.

Storing on a Hard Disk

If you are going to be displaying the movie on a dedicated machine, as in an information kiosk, then you can simply store the movie on your hard drive. Be sure to defragment your hard disk (or your partition) before you make the final movie so that the movie is stored as one uninterrupted string of data.

If possible, you should try to use a fast hard drive to play back the movie—one that is capable of transferring data at around 2MB per second. This helps eliminate any stutters or pauses while the movie plays.

If you are going to play large-window movies, then you should consider using an extremely fast drive (at least 10MB per second) and purchasing a fast SCSI-2 board, which can transfer data to and from your hard drive at 10MB per second. You need both items because the maximum data transfer rate is set by the slowest component. You can also use the Cinepak compressor to reduce the data-transfer rate of your movie. Another option is to use the MovieShop program offered by Apple to match the data transfer rate required by your movie to your hard drive's capabilities. MovieShop is discussed in "Storing on CD-ROMs" later in this chapter.

Storing and Distributing on Removable Media

If the intended audience is likely to have a large hard drive and the capability of using removable media such as a Syquest removable hard drive or a Sony floptical drive, then distributing on these formats might make sense.

You can store as much as 44 or 88MB on a removable hard drive (depending on the format). You're better off using a 44MB removable drive because it can be read by an 88MB drive but not vice versa.

Flopticals, small magneto-optical disks, can store as much as 21MB of data. Although this medium costs less in terms of dollars per megabyte, there aren't as many floptical drives as there are removable hard drives.

You should use a limited amount of temporal compression. Different machines (Quadra vs. IIci) play the movie back at different rates. More frequent key frames make it easier for the CPU to display a smooth sequence of frames.

Neither of these devices (floptical or removable hard drives) should be used for playback. The data transfer rates are usually much slower than with a hard drive. The intended users should be instructed to copy the video files to their hard drives before playing the movies.

 The latest removable hard drives (such as the Syquest 270MB) have greatly enhanced data-transfer rates and can be used for playback.

 If your movie must be playable from a removable hard drive or floptical drive, use the MovieShop program described in the next section to match the movie's required data transfer rate to the removable or floptical drive's capabilities.

Storing on CD-ROMs

If you intend to distribute your movies to a large number of people (more than 100), then you should consider producing a CD-ROM. A single CD can hold roughly 650MB of information—more than enough for most QuickTime applications. In addition, the cost of pro-

ducing a hundred CDs works out to a couple of dollars per CD—not that much more expensive than a floppy disk.

However, there are two main disadvantages with storing and distributing movies on a CD-ROM: seek time and data transfer rate.

CD Seek Time

Seek time is the amount of time it takes a CD player to find a particular file or portion of data on the disc. Depending on the CD player (some are faster than others), the average seek time is somewhere between 0.2 and 0.5 seconds. If you are distributing a collection of stand-alone movies, then a long seek time won't matter that much. But if your video files are part of an interactive application, then half a second can seem like an incredibly long period of time.

CD Data Transfer Rate

Once the CD player finds a particular video file, the quickest it can read the data off the disc is 150K per second for single speed drives—twice that for double-speed drives. This means that for your movies to play off a CD-ROM smoothly—that is, without pauses or huge jumps in the video—the data transfer required by your movie (video and audio) can't exceed the maximum data transfer rate of the drive (150K or 300K). For a number of technical reasons, the maximum practical rate for a single speed drive is 90K/sec. and for a double speed it is 200K/sec.

If you are making movies that will be played on a PC, the generally accepted maximum data rate for a double-speed drive is 120 140K/sec. The proper way to figure out the best rate for your situation is to make a test CD with your movie compressed at different data rates. Then play the test disc on a PC and decide which data rate works best for your particular system.

The actual data transfer rate required to play a movie accurately (at its desired frame rate) is determined by a number of different parameters, including window size, frame rate, compression level, color-bit level, and how the audio is *interleaved* with the video on the CD. Fortunately, the QuickTime team at Apple has produced (but no longer supports) a useful application called MovieShop that automatically compresses movies to a desired data rate (Figure 14-9).

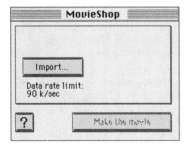

Figure 14-9.

MovieShop allows you to compress your movies to a specific data rate. This ensures that your movies will play well from a CD-ROM.

Using MovieShop to Create CD-Playable Movies

Nearly everyone producing a commercial CD-ROM uses MovieShop to compress their movies. The reason is simple: there's no other product out there that does what MovieShop does, at least not yet.

MovieShop is both a simple and complex program. Using the default settings, MovieShop is fairly easy to use:

1. Select the type of compression you want to use from the Video Quality Preferences dialog box (Figure 14-10).

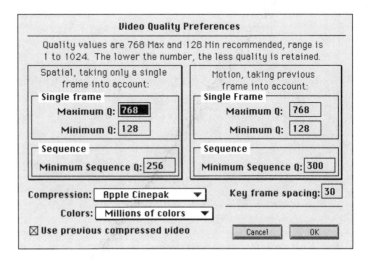

Figure 14-10. The Video Quality Preferences dialog box. MovieShop allows you to set the maximum and minimum amounts of compression that are applied to frames in your movie.

2. Set the maximum desired frame rate in the Methods and Data Rate dialog box (Figure 14-11).

3. Click on the Make the Movie button, give the new movie a name, and MovieShop starts on its magic.

Watching MovieShop work is a good way to learn about compression. The program steps through the movie one frame at a time. If a frame requires too much data, MovieShop gradually increases the amount of spatial compression to reduce the amount of data needed (Figure 14-12).

It continues increasing the amount of compression until the data needed for the frame falls below the desired rate. If the frame still requires too much data, even with the maximum amount of compression, MovieShop steps back a few frames and adjusts the previous frames to maximize the effect of temporal compression (Figure 14-13).

If a frame is still too large, MovieShop will drop a frame so as not to exceed the desired frame rate. This may seem a little weird—after all, the whole purpose here was to avoid losing frames on playback. But dropping a frame now—when you know you need to—is preferable to having the computer drop the frame later. When the computer drops a frame on its own, it gets "confused" for a while and may end up dropping more than one frame.

MovieShop performs its magic automatically. So if you don't want to get into all the technical aspects of MovieShop, simply choose a compression method, choose a data rate, and let MovieShop handle the rest.

To get the most out of MovieShop, you'll have to get your hands a little dirty. Let's go back to the Video Quality Preferences dialog box (Figure 14-10). Here you can set the maximum and minimum amounts of spatial and temporal compression. Setting lower minimum values gives MovieShop more latitude when reducing the size of a frame. This is particularly important for large (320 x 240) movies. Essentially you're letting MovieShop reduce the quality of a frame instead of forcing it to drop the frame entirely. Setting high maximum values improves the quality of the image, as long as the frame doesn't exceed the desired rate.

Don't forget the audio. Different versions of QuickTime prefer different methods of interleaved audio/video. QuickTime 1.6.x prefers a 1.50 second Video to Sound setting, while QuickTime 2.0 prefers a 0.50 second Video to Sound setting. You can set this parameter in the Sound Preferences dialog box (Figure 14-13).

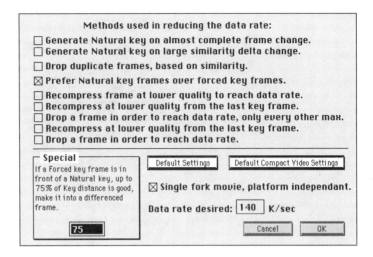

Methods used in reducing the data rate:

☐ **Generate Natural key on almost complete frame change.**
☐ **Generate Natural key on large similarity delta change.**
☐ **Drop duplicate frames, based on similarity.**
☒ **Prefer Natural key frames over forced key frames.**
☐ **Recompress frame at lower quality to reach data rate.**
☐ **Recompress at lower quality from the last key frame.**
☐ **Drop a frame in order to reach data rate, only every other max.**
☐ **Recompress at lower quality from the last key frame.**
☐ **Drop a frame in order to reach data rate.**

Special
If a Forced key frame is in front of a Natural key, up to 75% of Key distance is good, make it into a differenced frame.

[Default Settings] [Default Compact Video Settings]

☒ **Single fork movie, platform independant.**

Data rate desired: [140] **K/sec**

[75] [Cancel] [OK]

Figure 14-11. The Methods and Data Rate dialog box. Entering the desired data rate at the bottom sets the maximum data rate for your movie.

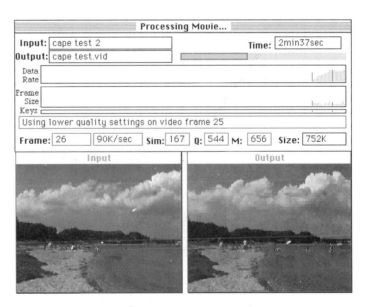

Processing Movie...

Input: cape test 2 **Time:** 2min37sec
Output: cape test.vid

Data Rate
Frame Size
Keys

Using lower quality settings on video frame 25

Frame: 26 90K/sec **Sim:** 167 **Q:** 544 **M:** 656 **Size:** 752K

Input Output

Figure 14-12. As MovieShop processes the movie, it increases the amount of spatial and temporal compression to reduce the movie's data rate until it is below the required rate.

Figure 14-13. Different versions of QuickTime prefer different settings for the Video to Sound parameter. This parameter is set in the Sound Preferences dialog box of MovieShop.

Let's go back to the Methods and Data Rate dialog box (Figure 14-11), which allows you to choose the different methods MovieShop uses to achieve the desired frame rate. There are two default settings: one for Cinepak (called Compact Video in this version of MovieShop) and

Figure 14-14. You can adjust the various methods that MovieShop uses to limit the data rate. Changing the Drop Duplicated Frames setting to 254 is particularly useful for animations containing small moving objects.

standard default settings. The default Cinepak standards essentially let Cinepak handle all the difficult work. This works in most situations.

However, in some situations, such as animations that include small pieces of art moving around the screen, the standard default settings are better. If the pieces of art in the animation are really small, you may want to change the parameter for the Drop Duplicate Frames setting to 254. This tells MovieShop to drop only a frame if it is exactly the same, pixel for pixel, as the previous frame. Values less than 254 allow MovieShop to ignore minor changes, such as the movement of a piece of art. Set this parameter to different values and see what works best in your situation.

 When running tests with MovieShop, you don't have to compress your entire movie, but you do have to include enough so that you re performing a representative test. Make sure you run your test on any segments of your movie that include a lot of edits or movement.

Wrap-Up

QuickTime would not be possible without image compression. It not only reduces the file sizes of digital video, it also reduces the data transfer rates between your computer and hard drive.

The correct amount of compression varies from clip to clip and depends on the final format (storage device) for your movie. In general, you should try to digitize with little or no compression so that you are working with the highest-quality video clips in your editing program. You can then apply compression when the edited movie is finished.

At some point, however, there is a trade-off between the level of quality you desire and the size of your hard disk(s). A good option is to use a removable drive, which allows you to add memory easily.

CHAPTER 15

Video and Interactive Multimedia

QuickTime opens up almost unlimited possibilities for the use of video in interactive multimedia. In the past, multimedia developers who wanted to include video in their presentations had to produce a videodisc and use a videodisc player to play the video. Now with QuickTime, developers can incorporate digital video without the time and expense of using videodiscs.

The field of interactive multimedia is huge and getting larger all the time. A thorough treatment of the topic is beyond the scope of a single chapter—it requires a whole book. Instead, this chapter discusses how video can be used within a multimedia presentation, examines some of the basic issues in interactive design, and offers a number of examples of the use of video in interactive programs.

What Is Interactive Multimedia?

First, let's get our terms straight. A *multimedia presentation* incorporates sounds and images (still images, text, animation, or video); so television is multimedia and so is a slide show put to music.

Interactive multimedia involves the use of a computer, which allows the user to affect or control the presentation. The interaction between

the user and the program transforms the experience from a passive one (such as television) to an active one, which can be more engaging and enriching.

Examples of Interactive Multimedia

In the past decade, thousands of interactive multimedia presentations or programs have been created. The presentations themselves differ widely; practically the only thing they have in common is that they are interactive.

The following sections give brief descriptions of a few basic interactive presentations. They are intended to give you a sense of what interactive multimedia can do. They by no means cover the complete spectrum of what is possible.

Example 1: A Business Presentation

The marketing manager for company XYZ has to talk at a large trade show. Two years ago, she produced a set of slides for a similar conference. But this time, she produced an interactive presentation that includes the following:

- An animation of the XYZ company logo
- An animated outline for her talk
- Various animations, text screens, and graphics describing the company's product
- Testimonials from customers (on video)
- A closing animation

At the conference, she controls the pace of the presentation by clicking the mouse to move to the next section. She has already prepared several additional short programs in anticipation of likely questions. In response to particular questions, she calls up the appropriate "answer" by clicking on an on-screen button.

Example 2: Patient Information

Hospital ABC cares for a predominantly older population. As such, it has a tremendous need to educate patients about chronic illnesses that

affect senior citizens, such as heart disease, cancer, high blood pressure, and diabetes. In the past, it produced patient information videotapes for each of these subject areas.

The hospital's public services director decides to use interactive technologies to supplement the videotapes. He supervises the production of several public information kiosks that sit in the waiting areas of the hospital's large clinics. The kiosks include basic information about various conditions and diseases. Patients can learn more about any particular condition (symptoms, possible treatments, complications) that interests them. They can also view short patient case studies (on video) that offer much of the same information in a more personal format.

Example 3: Educational Products

The Educational Film Group, a video production company specializing in educational materials, has decided to produce interactive products based on its nature and science documentaries. The company re-edits its videos to produce 15 three-minute segments. It then incorporates these video segments into a text- and graphics-based interactive program. The students can read about a particular subject, see a graphic that describes it further, or view a video segment in which leading experts talk about the subject.

Why Use Video?

The examples just described all use video segments in some way, either to add credibility (business example); present information in a more personal way (hospital example); or tell short, encapsulated stories (educational example).

These are all good reasons for using video within an interactive presentation. But as discussed in Chapters 13 and 14, there are drawbacks to using video:

- Digital video uses up a tremendous amount of memory on your hard drive. You can use CD-ROMs, but the access time is slower, which causes distracting delays in an interactive presentation.

- The current QuickTime window is small (240×180 pixels to 320×240 pixels) which limits the amount of visual detail that can be shown in the video.

- Although video is not as expensive to produce as it once was, it is still expensive compared to other media (still images, graphics, text, etc.).

 Because of the current limitations of digital video, many interactive programs still use videodiscs. Videodiscs, which store video in analog form, can provide full-screen, full-motion video for a fraction of the cost of digital video systems. This situation, however, is changing rapidly, and many people feel that videodiscs will no longer be an attractive option by late 1995.

Because of these drawbacks, you should have a good reason for using video in place of other media. Some justifiable reasons for incorporating video include the following:

- It is a personal form of communication. People like to see other people. We are used to hearing and seeing people talk to us (even if it is through the medium of video). You should make sure that your video has good production values (i.e., camerawork, lighting, sound, and editing).

- Video is particularly good for demonstrating procedures in training or educational projects because it shows how something moves over time.

- A visual story is a powerful means for delivering information with context. You not only can provide the details of a subject or situation but also can show how these details relate to larger issues, be they business, education, or personal.

- Using video adds a touch of novelty to your productions that can provide a competitive advantage. This novelty will wear off within a few years, but the early adopters can take advantage of this window to establish their reputations.

Designing Interactive Multimedia

There are countless ways to use video in an interactive program, but the best results will be achieved if you can focus on what you are trying to accomplish with the program (and how video fits into that goal). Some of the questions you might want to consider are:

- Will the users be expected to make a lot of choices about what to see next?

- How often will users have to make a choice?

- Are you trying to deliver a specific set of details (as in training)?

- Will users be able to explore the material freely without a particular goal?

- Will video segments be short, for example, 10- to 20-second footnotes to other material?

- Will they be longer segments that form the core of the program?

- What is the amount of time a person is likely to spend using the program?

- How familiar is the average user likely to be with computers?

These are the types of issues interactive designers have to address when developing an interactive program. One way of approaching these issues is to evaluate the program in two ways: how much interactivity is required and how will information be organized (the conceptual layout).

Level of Interactivity

Interactive multimedia differs from television and other passive media in that the user controls the flow of the program. The extent to which the user controls the program, the *level of interactivity*, however, can vary from program to program. And this can affect how often the user is expected to interact.

Spectrum of Interactivity

A simple, yet revealing measure of interactivity is the number of interactions per minute.

With television, your only choice is to watch or not to watch. And if you skip to another channel, you will have missed something when you come back. With a taped program, you gain a bit more interactivity (you can replay a section or skip past the commercials), but most of the time you are just watching, not making any choices.

Interactions per minute: less than 1.

Higher up on the spectrum of interactivity would be business presentations; for example, the business example discussed earlier. Here, the presenter controls the flow and pace of the presentation, moving from one segment to the next. Depending on the length of each segment, the presenter might make 10 to 20 choices for a 10-minute presentation.

Interactions per minute: 1-2.

Information kiosks offer a bit more interactivity. Here you are trying to present a large amount of information to the user. The user doesn't need—or want—to see all the information. Therefore, a well-designed kiosk allows him or her to find any particular piece of information quickly. Depending on how long it takes the user to find and then absorb a particular piece of information (an *info bite*), the number of decisions, or interactions, the user has to make for a single, 5-minute session, might range from 20 to 50.

Interactions per minute: 4-10.

Interactive programs for training and educational purposes can vary widely in their interactivity. If you are providing a lot of disconnected information (encyclopedic information), then the length of an info bite might be fairly short. But if you are presenting detailed information about particular subjects, the user might spend a long time (1–3 minutes) in the same area. Within each area, however, you can allow the user to control the flow of information.

Interactions per minute: 5-15.

At the high end of the interactivity spectrum are computer games, the original interactive multimedia programs. Pong included images and sounds. A typical shoot-'em-up game can involve more than 100 interactions per minute. A more sedate game, such as a simulation game like SimCity, might still require 10 interactions per minute. Even an educational game—such as Where in the World Is Carmen San Diego?—involves at least 30 interactions per case, which last for about 5 minutes each.

Interactions per minute: 6-100.

The levels of interactivity for various programs are shown graphically in Figure 15-1.

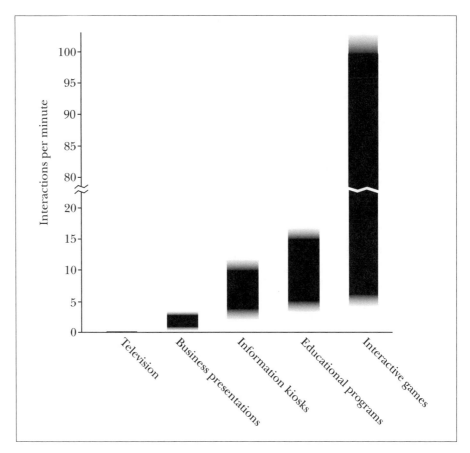

Figure 15-1. Multimedia programs differ in the amount of interaction they require of the user. Games demand a lot of interaction, whereas business presentations require very little. (This chart is based on a presentation by Trip Hawkins at the January 1992 meeting of the International Interactive Communications Society in San Francisco.)

 A general trend that seems to exist in this culture is that younger people tend to enjoy higher levels of interactivity than older people. Whether this is the result of exposure to fast-paced editing on television (MTV, etc.) or the prevalence of computer games, you should consider this trend when designing for your particular audience.

Video and Interactivity

Now, what does all this have to do with video? Well, video is inherently noninteractive (there are a few exceptions; see "Navigable Scenes" at the end of this chapter). You generally watch a video clip from beginning to end. If you stop and pause in the middle of a clip and then start it again from the same point, it can be difficult to pick up the flow of the segment immediately, even if the pause is brief.

Because a video segment will generally be seen in one large block, you need to consider the length of your video segments in light of the level of interactivity. If you are designing a business presentation in which there are long periods without any interaction (low interactivity), then a fairly long (2-minute) video segment will seem natural. The same-length video segment will seem exceedingly long in the middle of a highly interactive game.

This doesn't mean that all the info bites within an interactive program have to be the same length. There is something to be said for providing a sense of pacing within an interactive program. But you need to consider the mix of your info bites and have a reason for making some longer than others. You should also make the user aware of the differences.

Choosing a Conceptual Layout

There are many different ways of organizing and compiling information. For example, consider the difference between an encyclopedia and a book on a particular topic. Even if you pull out of the encyclopedia all the parts related to the book's topic, the information is still organized alphabetically. On the other hand, the book organizes the subject material in a clear and understandable way (if it is written well), often at the expense of leaving out a lot of material.

In addition, there can be different strategies for searching for a particular subject or piece of information. For example, a table of contents and an index both allow the reader to find a particular topic. One offers a subject-oriented approach (the table of contents), whereas the other is strictly alphabetical.

With interactive multimedia, the organization and the search strategy are intimately linked. It is unlikely that the user will start at the beginning (if it is even defined that way) and go straight through to

the end. Instead, the user will navigate through the information space along the pathways created by the interactive designer.

 Although we've been talking about organizing and finding information, we could just as easily be talking about parts of an interactive game.

This is like creating trails within a wilderness area for others to use. What parts of the wilderness do you want them to see (the waterfall, a beaver's nest, a lake, etc.)? How many paths do you want to create? Do you want there to be several key paths so that everyone sees the same things? Or do you want a myriad of paths so that each person ends up taking his or her own route?

This analogy ultimately breaks down because with interactive multimedia, you are not limited to three dimensions as in the real world. The information space you create can have as many or as few dimensions as you like. Going back to the wilderness analogy, you could allow the person to jump immediately from one part of the wilderness to another, without having to walk the usual path between the two points.

The terms *conceptual layout* or *conceptual architecture* are often used to describe how an information space is organized and what types of pathways are used. A number of standard conceptual architectures have already been developed for interactive multimedia projects.

Types of Conceptual Architectures

Creating the conceptual architecture is often the first step in developing an interactive project. It lays an overall framework that is tied to the goals of the project. The following architectures differ widely in the types of user experience they allow.

 The figures for the various architectures are inherently inaccurate because they are two-dimensional representations of what are, in reality, three- (or more) dimensional information spaces.

Multibranched Tree Architecture This allows the user to navigate to any particular piece of information (info bite) quickly (Figure 15-2). In some ways, it is like a layered table of contents. This architecture is often used for public information kiosks and training programs where a typical user is interested in only one particular part of the program and wants to find it quickly.

Figure 15-2. The multibranched tree structure allows the user to retrieve any particular piece of information quickly. Many public information kiosks use this type of architecture.

Cross-Linked Architecture Here the user can move to any element from any other one (Figure 15-3). This architecture is useful when the amount of information isn't particularly large and ease of use is important. Marketing presentations often use this type of architecture because they will be used by a wide range of people with varying levels of computer sophistication and familiarity.

Figure 15-3. A cross-linked architecture allows the user to move easily between different parts of the interactive program. Generally used for programs that do not contain a lot of information.

Open-Exploration Architecture This is similar to a cross-linked or branched-tree architecture that is extended to three dimensions (Figure 15-4). The user can jump from any info bite to a number of other info bites, either within the same general area (the same plane) or in a remote part of the architecture. An example of this architecture would be an online thesaurus.

The advantage of this architecture is that it allows the user to make complex connections between different pieces of information. However,

Figure 15-4. The open-exploration architecture gives users the maximum amount of freedom in exploring the interactive program. An online thesaurus uses this type of architecture, as do many educational programs.

a key concern with this type of architecture is making sure the user knows where he or she is within the program (i.e., within the multi-dimensional information space).

This type of architecture is often used for certain types of educational projects where the emphasis is on exploration as opposed to structured learning.

Linear-with-Branches Architecture

In contrast to the previous architectures, this leads the user along a particular path (Figure 15-5). The user can gain additional information along the way, but the overall direction is set.

This type of architecture can be used to convert standard, linear, educational material into interactive presentations. The branches can contain video, animation, or additional text material that supports the main pathway.

Multiple-Pathways Architecture

This also leads the user in a distinct direction. But instead of a single path, the user can travel—or be sent—along any one of many pathways. One example of this type of architecture is a tutorial that automatically offers additional information to those who need it (Figure 15-6). An example of where the user chooses the pathway is a program on history in which the user can view different perspectives of the same event (Figure 15-7).

LEGEND:

☐ Branch point

○ Info bite

— Path

Figure 15-5. A linear path with branches moves the user along a particular direction, while allowing the user to take side trips to explore various topics.

Figure 15-6. Multiple pathways allow the user to take one of several parallel paths through particular parts of the program. A tutorial program that allows users to choose the speed at which they learn particular concepts is an example of a program that uses this type of architecture.

The conceptual architecture need not be visible to the user. You can create a metaphor that ties into the physical world or a fictionalized world. The user then interacts with the metaphor, not the architecture itself. This involves issues of interface design that are closely linked with the conceptual architecture.

Building upon the Conceptual Architecture

You may have noticed that the previous discussion barely mentioned which types of media would be used. That's because a conceptual architecture is only a blueprint for the project, not what the user will actually see. Depending on your particular project and your design constraints (amount of memory, type of computer, etc.), you can use whichever medium works best at a specific point in the program.

Figure 15-7. A second type of the multiple-pathways architecture sets up several parallel paths that run the length of the program. At various points in the program, the user can choose to switch pathways or stay on the current one. An educational program that provides alternative perspectives of an historical event is a good example of this type of architecture.

The mix of media you choose to use usually affects the conceptual architecture to some degree; in which case you need to modify the structure to suit the media. The advantage of starting with the conceptual architecture first is that it helps you determine the goals of your program and keeps you focused on your objectives.

Working Video into the Conceptual Architecture

Now, once again, what does all this discussion about conceptual architecture have to do with video? Again, the answer is that video is primarily a linear medium. Therefore, it can be used as an info bite in a linear portion of a conceptual architecture, or at the end of a branch. But it is difficult to include it as a branch point; if the user has to think about making a choice, then he or she is not concentrating on the video.

 Visual Databases, described in a later section, are an exception to the notion of video as a linear medium.

Advantages and Disadvantages of Various Media

When deciding which type of media (video, stills, animation, sound, text, etc.) to use in a specific part of a program, you should perform a kind of cost-benefit analysis: What am I gaining by using this medium, and can this topic be covered in another, less expensive way? The expense involves both the cost of producing or acquiring the material and the amount of memory it requires.

If you have an extremely large budget and unlimited hard disk memory, then you don't need to weigh these issues. But for those of us who feel these constraints, deciding which elements of the production are displayed in which media becomes a zero-sum game. Ultimately, you run out of memory (on your hard disk or CD-ROM), run out of money, or both.

The following is a review of the various media and their respective benefits and drawbacks. See Table 15-1 for a comprehensive view of the various media.

Video

The benefits of using video are that it is a personal form of communication, it can show emotion and motion better than most other media, and it can add a touch of novelty to your program (at least for a while).

Unfortunately, digital video requires an enormous amount of memory, many times more than any other medium (in terms of bytes per second). In addition, it is expensive to produce. And until hardware compression and decompression become cheaper, it won't be practical to present full-screen, full-motion video clips.

Therefore, unless you plan to store your video segments on videodisc (which is not digital video), you should use video only when it adds something that cannot be achieved with other media (motion and emotion as mentioned before).

Table 15-1. **Advantages and Disadvantages of Different Media and Their Approximate Storage Requirements**

Media Type	Storage (KB/sec)	Advantages	Disadvantages
Video	$\approx350^1$	Realistic, personal; conveys motion and emotion	Memory hog, expensive to produce
Stills	$\approx15^2$	Realistic; can convey emotion	Static, moderate memory requirement
Animation	$\approx170^3$	Displays certain types of information better than other media	Can be a memory hog, can be expensive to produce
Audio	$\approx22^4$	Creates a more complex experience; music affects mood and tone	Moderate memory requirement
Text	0.033^5	Descriptive; cost per byte extremely low	Static, nongraphical

[1]160 × 120 pixel window, 24-bit color, 30 fps, compression ratio of 5
[2]320 × 240 pixel window, 24-bit color, compression ratio of 5, user views still for 3 seconds
[3]160 × 120 pixel window, 24-bit color, 30 fps, compression ratio of 10
[4]22 kHz sampling rate, 8-bit sample size, no compression
[5]Reading speed 400 words/minute, 5 characters/word, 1 byte/character

Still Images

Still photographs can provide a sense of realism, as video does, but without the same memory requirements. When used with an engaging soundtrack, still images can sometimes be more powerful than video because people look more deeply at the images, rather than allowing the moving images of video to wash over them.

The drawbacks to using stills are that they are static, and they cannot convey movement or the passage of time (although a series of stills can provide some). Another minor drawback is that even a still image requires a fair amount of memory (as much as a megabtye). You can reduce the memory requirements by decreasing the size of the image and/or using an image-compression scheme, such as JPEG.

Animation

It's difficult to evaluate a typical animation because there isn't one. Simple 2-D animations don't require much memory and can be produced inexpensively. Complex 3-D animations can cost thousands of dollars per second and require as much and sometimes more memory than video.

However, there are certain concepts, particularly those dealing with science, that cannot be covered adequately by any other medium. If you intend to use such segments, be prepared to use a fair portion of your resources (memory and money) on these animations.

Sound

Nearly all interactive multimedia projects include some kind of sound. So it's not a question of whether or not to use sound; it's a matter of what kind of sound to use.

Audio feedback for an interaction, such as a beep when the user clicks a button on the screen, is an essential part of a good user interface. It helps connect the user with the program. And don't settle for simple sounds (like a beep); try using exotic sounds and sound effects, such as bird chirps, various musical instruments (triangle, tubular bell, flute, etc.), rasps, scraping sounds, and champagne corks. Get creative!

Music can dramatically improve an interactive program. Even short, five-second, musical cues enhance the user's experience. A typical use of musical cues is to introduce a new segment or make a transition to another part of the program. If you are going to be using a lot of music, you might want to consider using MIDI audio, which is stored as a score of notes and then recreated live during the presentation.

Digitized audio of speech or music can require a lot of memory, not as much as video but a large amount nonetheless—around 10MB per minute for CD-quality sound (stereo), about 2.5MB per minute for Macintosh-quality audio.

Text

Last, there's humble old text. If you're going to be presenting a lot of detailed information, there's no better medium. It's cheap, easy to produce, and gets the point across.

Exploring the Possibilities

Perhaps the greatest impact of QuickTime is that it allows thousands more people to experiment in the intriguing and rich field of interactive multimedia. Sure, the video windows are small. But when compared to text or a still photograph, a QuickTime movie can provide a much deeper experience for the user.

What will be produced? Who knows. What new forms of interactive multimedia will emerge? The possibilities are just now being explored.

This section offers some examples intended to demonstrate how video can be used to enhance interactive presentations. The section concludes with a new form of interactive multimedia made possible by digital video—navigable scenes.

This review is not meant as a definitive list. It's provided with the hope that it will encourage you to go beyond what is presented here.

Scientific Communication

Scientific communication often includes still images that are snapshots of dynamic phenomena; for example, a graphic of how the earth's climate may change as global temperatures rise. With digital video, you can present a much richer picture of the dynamics of the system.

Technical Information

The program would start with an animation showing one prediction of how the climate might change over the next 20 years. This animation would include an explanation from the presenter (in voice-over). Following this short introduction, the user would be able to see additional information about the animation, such as:

- A technical paper about global climate change
- The technical details of how animation was created
- References to pertinent literature
- A summary of the technical paper written for the layperson

The program would also allow the user to replay the animation, forward or backward, at several different speeds.

Multiple Case Studies

A more comprehensive program would offer, in addition to the features just mentioned, several predictions based on differing basic assumptions for the climate model. By viewing the different cases, the user would be able to see the effect of various parameters and assumptions on the model's predictions.

Medical Information

With new medical discoveries and advances occurring nearly every day, it's almost impossible for patients (and doctors) to stay current with the latest information. Interactive programs can help manage this flood of data by giving people the information they need in a form they can use.

Patient Information Kiosk

The program would provide information on a number of different conditions (such as heart disease, cancer, and alcoholism). The users could choose to see a variety of different types of information about their condition. They could read about typical symptoms and possible treatments. They could also view case studies, in video segments, of real patients undergoing the procedure.

By using the kiosk, patients would be able to learn about the general issues regarding their condition. This would allow them to spend more time talking with the doctor about their particular situation.

Medical Procedures

One of the fastest-growing areas of medicine involves the use of sophisticated procedures. An interactive program could not only provide detailed explanations of a procedure but also include video segments showing the procedure itself. A more comprehensive version of the program could show the same procedure from several different camera angles. It could also present examples of typical problems that arise during the procedure. This program could be used in conjunction with a training course.

Educational Programs

The possibilities in the field of education are deep and profound. Interactive technologies could allow students to learn about particular topics in greater and richer detail. They could also offer a number of different methods for learning, which would be better geared to the different ways that people actually learn. Rather than replace the invaluable contribution of a teacher, these programs could shift education from a system of mass production to more intimate learning.

Intelligent Tutors

These programs would analyze a student's responses and modify the learning program to meet the student's needs. The student would be able to choose from a selection of tutors that would appear in a video segment and provide help. The selection of tutors could include people of different races, ages, and backgrounds.

New Perspectives on Social Studies

History and social studies have often been taught from one perspective—the one supported by the status quo. With interactive programs, you could allow students to review several different perspectives of the same issue, event, or period of time and come to their own conclusions. A set of uncontested facts would be presented and then the various perspectives on them could be viewed; for example:

- Views from Israelis and Arabs about the Mideast conflict
- Solutions from police and civil libertarians for reducing drug abuse
- Arguments for and against abortion
- Perspectives from Native Americans and Early American settlers about the expansion of white people across the continent

The last example refers to a prototype, developed by Abbe Don and others at Apple Computer for *Grolier's Encyclopedia*, that uses dramatized historical characters.

Business Uses

How a company manages its information is becoming as important as how it produces its products. Interactive programs can facilitate business communication in a number of important areas.

Training

According to some reports, the amount of in-house training done by companies equals the sum total of public education in this country on a yearly basis.

Interactive programs could be used to tailor the training materials to the specific needs of individual workers. The program could also provide on-screen help in the form of helpers, or guides, who would offer encouragement and advice. The helper segments would be video segments of actors portraying different types of characters. The worker would be able to call on whichever character he or she preferred.

Based on the situation, the program might also include the following:

- Humorous comments from the helper to create a more friendly and relaxed atmosphere

- Video segments showing how to use a particular piece of equipment or a software program

- Simulations of complex machinery or software programs that allow the worker to learn by trial and error

- Self-paced tests, which could be used for wage increases based on merit and skill

Marketing

The potential uses of interactive multimedia for marketing are too numerous to count. Here are some examples of existing programs.

Point-of-Sale Kiosks These interactive programs give potential buyers a detailed look at a company's product. They often include flashy animations and customer testimonials.

Promotional Materials Several companies have produced CD-ROMs that demonstrate and explain the company's services. They often include examples of recent projects.

Interactive Résumés (Personal Marketing) An interactive résumé not only presents information about your background and talents but also indirectly demonstrates your use of interactive multimedia.

Visual Databases

Video is a linear medium, one frame follows the next. Digital video, however, doesn't have to be linear you can randomly access different frames of the movie. This opens up a world of possibilities for using digital video in new ways.

One of the more interesting uses of non-linear digital video is in navigable movies. These are HyperCard programs that run a special QuickTime movie that is organized in a particular way. The user inspects a scene by moving the mouse. The video image changes in response to the mouse movement. It s as if you were connected to a remote-controlled camera and changing its directions.

For example, let's say you are viewing a navigable scene of a kitchen (Figure 15-8). At first, you are looking straight ahead. By moving the mouse to the right, you see the right side of the kitchen. Moving the mouse downward, you see the stove and the floor.

 This is different from virtual reality because these are real scenes shot on video.

Figure 15-8.

Navigable scenes allow you to view different parts of a scene by moving the mouse in different directions. In this example, by moving the mouse to the right, you see the right side of the kitchen. Moving the mouse down shows the stove.

Navigable scenes are based on a branch of interactive multimedia called *surrogate travel.* Back in the early 1970s, a group of people at the Massachusetts Institute of Technology developed a walking tour of the town of Aspen, Colorado. The user could "walk" down particular streets of the town and see what a person would actually see if he or she were in the town. Since that landmark experiment was conducted, a number of other surrogate travel programs, using videodiscs, have been developed for a variety of places, including the San Francisco Bay Area; parts of the city of Paris, France; and an Aztec ruin in Mexico called Palenque. These programs broke new ground in the use of video with interactive multimedia. Until recently, they required videodiscs or video compression.

Navigable scenes, which were developed by the Human Interface Group at Apple Computer, are similar to surrogate travel programs in that they use video of real scenes. But instead of moving the user through a space, they provide a kind of surrogate view of a scene. And because they are based on digital video (QuickTime), they can be produced for a lot less money.

The procedure for shooting video material for a navigable scene is fairly straightforward, but it demands close attention to production details (and can be tedious).

You position the camera at a particular point in the scene. You then map out a grid that covers all the possible ways of viewing the scene (Figure 15-9). The intersections of the lines of this grid specify video frames that need to be shot. This is accomplished by systematically adjusting the position of the camera to move to a point on the grid, shooting a few seconds of video, and then moving to another point on the grid.

Figure 15-9.

Camera grid for navigable scene production. The lines indicate various tilt and pan settings for the tripod. Video is shot at the intersections of the pan and tilt lines. When digitized, the video frames make up a two-dimensional, visual database of the scene.

In practice, this is accomplished using an accurate tilt/pan head on a tripod. The tilt/pan head has markings showing the exact angle of tilt (or pan). You start at one tilt setting, move a set amount of pan (set angle), shoot a short section of video, adjust the pan again, shoot another short section of video, and so on. When you reach the maximum amount of pan, you start the process again at a slightly different tilt setting.

Once you cover the grid, you then digitize the video material and pull out individual frames for each point on the grid.

 The process can be simplified somewhat by capturing video directly into your computer. This way, you capture only one frame at each grid point (as opposed to recording several seconds of video). Of course, this means you have to take your computer into the field.

What you now have is a two-dimensional visual database, each record in the database corresponding to a video frame with a certain amount of tilt and pan. With some clever programming (in HyperCard or another authoring program), you use the position of the mouse to determine which video frame is displayed.

There are several navigable scenes on the QuickTime Developer's CD-ROM as well as a HyperCard stack (that has all the basic scripts you need).

 Apple has developed a new technology, called QuickTime VR, that may replace navigable movies. Instead of using multiple frames of a QuickTime movie for each of the views, it combines all these frames into a special two-dimensional image. Moving the mouse causes a different portion to be displayed.

The same technique used in navigable movies can be applied to other situations. Our company, Red Hill Studios, recently completed a museum kiosk called *Seeing Time*, which used a version of the navigable movie technique for the main interface.

The project involved seeing changes that occur over different periods of time. We wanted the interface to be as simple as possible since the kiosk was going to be in a museum, and used by people with varying degrees of computer experience. The design we developed is based on a metaphor of a circular tower. The user stands in the center of the tower looking out toward the walls (Figure 15-10). By moving

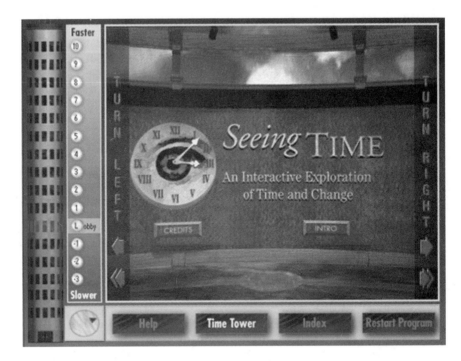

Figure 15-10. Interface screen for *Seeing Time* museum kiosk. Using the
metaphor of a circular tower, the user sits in the center of the
tower looking out towards the walls. By moving the cursor onto
the "turn left" or "turn right" bars, the user can rotate to see
other sections of the wall.

the cursor onto one of the vertical bars ("turn left," "turn right"), the
user rotates to view the other walls of the tower. The user clicks the pic-
tures on the wall to view a QuickTime movie of a specific event over
time—seconds, hours, days, months, etc.

When rotating in the tower, the user is actually just playing a movie
forwards (to rotate right) or backwards (to rotate left), as shown in
Figure 15-11. The scenes in this circular movie were created on a PC in
3D Studio (Autodesk). The files were then brought over to the
Macintosh and assembled into a QuickTime movie.

Seeing Time **was developed under a grant from the National Science
Foundation. My main co-conspirators were Mathew Fass, Marabeth
Harding, Todd Reamon, Rich Hone, and Paul Shain.**

Figure 15-11. Rotation movie for *Seeing Time* museum kiosk. This sequence of images mimics what the user sees when he or she rotates to a new wall within the interface. The user is actually viewing a QuickTime movie. There are 20 frames of animation between each main section of the wall.

The interface and navigable movies work by allowing the user to navigate a real or imaged space. At their core, they are both visual databases. The tower rotation is a one-dimensional database, while the navigable movie is a two-dimensional database (Figure 15-12).

The concept of a visual database can be extended to three dimensions (up/down, forward/backward, left/right) or even more dimensions. In a recent CD-ROM, *Shoot Video Like a Pro*, several colleagues and I developed a virtual studio that lets the user adjust the levels of four individual lights to illuminate a scene in any one of 256 ways.

Each light can be set to one of four different values. We shot all possible combinations with a video camera (4 × 4 × 4 × 4 = 256). These individual frames were then digitized and combined into a QuickTime movie in a very organized way—as a four-dimensional visual database (one dimension for each light). The user doesn't see this database but does view different parts of the database when choosing different settings for the four lights (Figure 15-13).

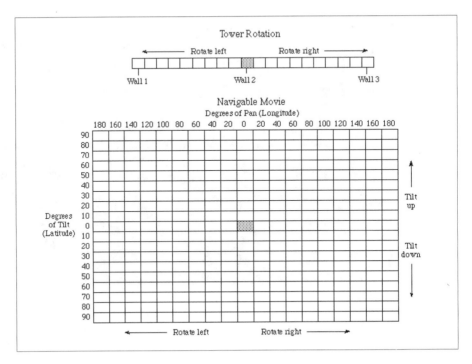

Figure 15-12. Visual database layout for *Seeing Time* interface and navigable movies. The interface uses a one-dimensional array of frames. Each navigable movie uses a two-dimensional database. Each cell, or record, in the database corresponds to a particular combination of tilt and pan (latitude and longitude). The program jumps to a new cell depending on the direction the user wants to go.

 The production team on *Shoot Video Like a Pro* included Todd Reamon, Maria Marchetti, Paul Shain, Celina Alaniz, and many others.

Wouldn't it be easier to just call up a PICT file for each of the lighting possibilities? No, for two reasons: size and speed. QuickTime not only provides a more convenient data storage format, but it also allows programs such as MacroMedia Director to access the images much more quickly than calling up individual PICT files.

This technique applies to any situation in which you want to let a user explore different physical spaces or variations in a scene.

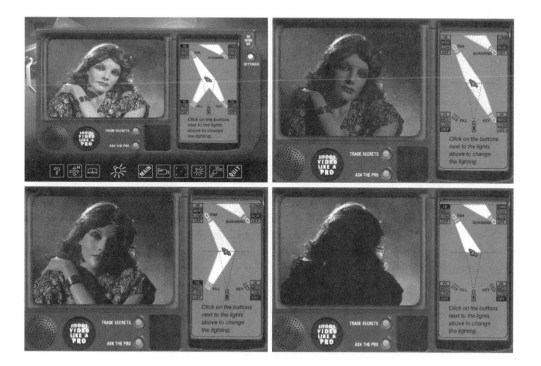

Figure 15-13. Virtual studio module in *Shoot Video Like a Pro* CD-ROM title. This module uses a visual database to allow the user to light a scene in 256 ways. By adjusting the levels of four independent lights, the user can create a wide variety of shots. Each combination of the four lights yields a different image. The program displays a particular record from the visual database depending on the light settings that the user selects.

Wrap-Up

This chapter has barely touched upon the exciting possibilities in the field of interactive multimedia. The arrival of QuickTime has opened the door to new means of communication—not just with digital video, but with rich combinations of text, audio, video, and animation all interweaved in interactive programs.

In such fast-moving times as these, it's often difficult to see how much things are really changing. But someday people may look back and say, "You mean they once made computers that only worked with words and numbers?"

PART IV

APPENDIXES

The following section is a resource guide for you to learn more about digital video, software, and hardware products. Appendix A is an annotated bibliography of books and magazines that provides additional insights on the topics covered in this book. Appendix B lists the addresses and phone numbers of companies that offer digital video products.

APPENDIX A

Suggested Reading

Ambron, Sueann, and Hooper, Kristina, eds. *Interactive Multimedia.* Redmond, WA: Microsoft Press, 1984. One of the first thorough treatments of interactive multimedia, this book still provides a lot of insight into the challenge of producing interactive programs. Discusses numerous case studies. Examination of technology issues is dated.

Anderson, Carol J., and Veljkov, Mark D. *Creating Interactive Multimedia.* Glenview, IL: Scott Foresman and Company, 1990. A clear overview of the process of producing an interactive multimedia program. Discusses the importance of including various experts in your production team.

Arijon, Daniel. *Grammar of the Film Language.* Los Angeles: Silman-James Press, 1976. A thorough explanation of editing theory. Chapters three through seven provide detailed descriptions of how to shoot and edit common situations. Extensively illustrated with somewhat-sexist diagrams.

Biedny, David, and Monroy, Bert. *The Official Adobe Photoshop Handbook.* New York: Bantam Books, 1991. A comprehensive review of the features of Photoshop, which provides a solid background for working with special effects. A must read for anyone primarily interested in digital video effects programs (such as VideoFusion or After Effects).

Dmytryk, Edward. *On Film Editing*. Boston: Focal Press, 1984. An entertaining and informative description of the film editing process. As both an editor and a director of numerous Hollywood films, Dmytryk gives an insider's view of the art of editing. Provides a good framework for people entering the editing craft.

Millerson, Gerald. *Lighting for Video*, 3d edition. Boston: Focal Press, 1991. An exhaustive compendium of lighting techniques for studio and remote locations. Clear explanations make it a good primer. There's even something for experienced video directors.

Millerson, Gerald. *Video Camera Techniques*. Boston: Focal Press, 1989. A comprehensive guide to the essentials of working with a video camera. Includes an extensive review of camera techniques and suggestions for common problem situations.

Reisz, Karel, and Millar, Gavin. *The Technique of Film Editing*, 2d edition. Boston: Focal Press, 1991. The definitive book on film editing. Provides both a solid underpinning of editing theory and explanations of editing techniques. Includes an intriguing account of the history of film editing from its beginnings at the turn of the century. An essential book for anyone seriously interested in film or video editing.

Rubin, Michael. *Nonlinear*. Gainesville, FL: Triad Publishing Company, 1991. A complete but somewhat technical overview of nonlinear editing. Rubin, a multiformat editor (film, offline, and online videotape), has been an active player in the development of nonlinear editing systems. Contains an interesting historical review of the advent of videotape editing and nonlinear editing.

Speed, Austin H. *Desktop Video*. New York: Harcourt Brace Jovanovich, 1988. A practical layperson's guide to video production and analog editing. Discussion of technical issues somewhat dated.

Wilson, Stephen. *Multimedia Design with HyperCard*. Englewood Cliffs, NJ: Prentice-Hall, 1991. Provides a basic overview of producing interactive multimedia with HyperCard. Discusses the use of different types of media in an interactive program. Does not discuss the use of QuickTime in HyperCard stacks.

In addition to these books, there are a number of magazines that cover the rapidly changing field of QuickTime and multimedia.

New Media Magazine
Hypermedia Inc., 901 Mariner's Island Boulevard, Suite 365
San Mateo, CA 94404
415-573-5170

Although this magazine is not devoted strictly to QuickTime or the Macintosh, it does provide a good overview of what's happening in interactive multimedia. Coverage tends to focus more on products than techniques or analysis.

Macworld
Macworld Communications, 501 Second Street, 5th Floor
San Francisco, CA 94107
415-243-0505

Tends to run a lengthy story on QuickTime or QuickTime programs about every other month. Articles are well researched and provide in-depth analysis.

MacUser
Ziff-Davis Publishing Company, 950 Tower Lane, 18th Floor
Foster City, CA 94404
415-378-5600

In addition to thoughtful coverage of the QuickTime field, this magazine also provides great product reviews. Lab articles provide objective, benchmark comparisons of hardware products.

APPENDIX B

Company Information

Adobe Systems, Inc. (Premiere, After Effects)
1585 Charleston Road
Mountain View, CA 94039-7900
800-833-6687

Apple Computer, Inc. (QuickTime, HyperCard)
20525 Mariani Avenue
Cupertino, CA 95014-6299
800-776-2333

Avid Technology (Media Composer, Media Suite Pro)
1 Park West
Tewksbury, MA 08176
508-640-6789

DiaQuest Inc. (DQ Animaq video deck controllers)
1440 San Pablo Avenue
Berkeley, CA 94702
510-526-7167

Gryphon Software Corporation (Morph)
7220 Trade Street, Suite 120
San Diego, CA 92121
619-536-8815

Macromedia (MacroMind Director, SoundEdit Pro)
600 Townsend Street, Suite 310 West
San Francisco, CA 94103
415-252-2000

Radius, Inc. (VideoVision capture and display board, VideoFusion)
215 Moffett Park Drive
Sunnyvale, CA 94089
408-541-6100

RasterOps Corporation (24STV, MxTV, and MoviePak boards)
2500 Walsh Avenue
Santa Clara, CA 95051
408-562-4200

GLOSSARY

A

A/B roll A type of video editing in which two inputs are merged through a special effect, such as a wipe or dissolve. Used most often in analog editing.

Address track timecode A type of timecode that is laid down while a shot is recorded. *See also* Timecode.

All-digital editing A method of editing a full-screen, full-motion video segment in digital form on a computer.

Audio special effects 1. Additional sound, either natural or produced, that enriches a soundtrack. 2. Filters applied to an audio clip to modify its sound. *See also* Special effects.

Authoring systems Applications that allow you to create, or author, interactive multimedia programs.

Auto-iris A common camera feature that automatically adjusts the lens iris to maintain proper exposure for a shot.

Available light The existing light in a scene. In outdoor locations, the sun. In indoor locations, the everyday lighting for the scene.

B

Barn doors A metal frame attached to a light consisting of four flaps that block parts of the light beam.

Back light A light placed behind a subject. Often used to create a rim of light around the edge of a subject, which helps the subject stand out from the background. Also called a *rim light*.

Blue screening A video production technique in which the main subject is shot against a dark blue screen. The screen is then made transparent during editing. Standard technique for incorporating video footage with animation. *See also* Chroma blue.

Boom mike A microphone that is hung from a long pole, called a *boom*, over a subject.

Branch point In an interactive multimedia program, a part of the program that allows the user to make a choice.

Bump up The process of transferring video from one tape format to a higher-quality format, as in "bumping up from Hi-8 tape to Beta SP."

C

Camera framing The image inside the viewfinder of a camera.

Camera move A shot where the camera framing changes. *See also* Pan; Tilt; Zoom.

Chroma blue A blue color of a specific hue, saturation, and intensity used for superimposing a person or object over animation or another video shot.

Clip A segment of digital video.

Clip music Generic or background music, usually available on a compact disc, that doesn't require prior permission. Also called *needle drop*.

Clipping A type of audio distortion caused by too much volume.

Close shot A camera framing that focuses on a particular object. In shooting a person, a close shot extends from several inches above the person's head to the top of the person's shirt.

Close-faced light A light that is covered by a Fresnel lens. Produces a concentrated beam of light.

Close-up A camera framing that focuses tightly on a particular object. When shooting a person, a close-up usually extends from the top of the person's hair to just under his or her chin.

Codec Short for "compression/decompression technique." A codec can be a piece of hardware equipment or a software program.

Color temperature A measure of a light's color based on the temperature of the light-emitting element.

Compositing An editing technique in which individual elements are added to a video clip one at a time.

Compression The process of reducing the amount of information required to store an image or a segment of digital video. *See also* Lossless; Lossy.

Conceptual architecture A blueprint for an interactive multimedia program. Specifies how a user will access different parts of the program. Also known as a *conceptual layout*.

Constant-effect filter In Adobe Premiere, a filter that produces dynamic effects, but the level of the effects does not change over the course of a clip.

Continuity editing A style of editing that attempts to create the illusion of reality by making people's motions and positions seem accurate and plausible. During production, the process of making sure that an actor's position or appearance does not change from take to take. *See also* Mixed-format editing; Montage editing.

Crane shot A shot that is taken from a camera platform at the end of a crane. Generally used to follow upward motion or to provide a different vantage point of a scene.

Cross-fade An audio-editing technique used to blend two audio clips at a transition. The first audio clip is faded down or out while the second audio clip is faded up or in.

Crossing over the line The act of crossing the line of interest in a scene, which switches the positions of the subjects on the screen. *See also* Line of interest.

Cut 1. A portion of a digital video clip, as defined by an In and an Out point. 2. A simple edit where one video clip follows another without a special effect. 3. To perform a simple edit.

Cutaway A shot taken from a different camera angle or with a different camera framing than the main camera shot. *See also* Master shot.

Cutting Performing a simple edit, as in "cutting from shot 1 to shot 2."

D

Decompression The process of creating a viewable digital image or video clip based on a compressed file. *See also* Compression.

Depth of field The range of distances where a subject is seen in focus.

Dialog cutting A type of editing involving human speech.

Difference frame In temporal compression, a frame that is stored as the difference between it and the previous key frame. *See also* Key frame.

Diffuser A translucent material placed in front of a light to convert hard light to soft light. Can also be used to reduce the intensity of a light.

Digitize To convert an analog signal, such as video or audio, into a digital file.

Dolly shot A shot taken from a moving camera. The camera and tripod are placed on a moving platform called a *dolly*.

Drop-frame timecode A type of timecode used in online editing systems for final video segments. It follows real (clock) time by dropping two frames every minute. *See also* Non–drop-frame timecode; Timecode; Timecode generator.

Dropout A black spot or spots in a video image caused by imperfections in the videotape.

Dub 1. A copy of a videotape. 2. The act of making a copy of a videotape.

Dynamic filter In Premiere and VideoFusion, a filter whose effect changes over the course of a clip.

Dynamic tracking A device used in online editing systems that allows you to play a videotape at frame rates other than 30 frames per second.

E

Edit controller An analog editing device that controls two or more videotape machines to produce edits.

Edit decision list A list containing all the editing information needed to create a video segment on an online editing system. Contains the In and Out points for source material, the In and Out points on the record machine, and the type of edit (video and/or audio).

Edited master In analog editing, the original version of an edited video segment or program.

Encoder A device that converts an RGB (red, blue, green) signal into an NTSC signal. Used for recording digital video clips onto videotape.

Establishing shot A shot that depicts the main elements of a scene and the background. Most often, a long or full shot used at the beginning of a scene.

Even field One of the two fields that makes up a frame of interlaced video. Consists of all the even-numbered lines in a television image. *See also* Field; Interlaced video; Odd field.

F

Fade control In Adobe Premiere, an audio control that allows you to adjust the volume or level of an audio clip.

Fade in To increase the level of an audio clip from zero to an audible level.

Fade out To decrease the level of an audio clip until it can't be heard.

Field One half of an interlaced frame of video. The odd field is made up of lines 1, 3, 5, etc.; the even field consists of lines 2, 4, 6, etc. *See also* Even field; Interlaced video; Odd field.

Filter A visual transformation that is applied to a video clip or still image to modify its appearance. *See also* Constant-effect filter; Dynamic filter; Progressive-effect filter; Static filter.

Fill light A light used to fill in the shadows produced by a key light. Usually a soft light.

Finger In Adobe Premiere, a hand-shaped cursor used to adjust an audio or motion handle.

Fix list A list of jump cuts or other problem edits to be fixed during the final edit.

Foley An audio special effect technique in which you try to create a set of footsteps that match a person's steps in a video clip.

Frame A single image of a continuous video segment. In analog video, a frame lasts $1/30$ second.

Frame rate The number of video frames displayed per second. Videotape is played at a constant 30 frames per second (fps). Digital video frame rates range from 1 to 30 fps.

Framing The image inside the viewfinder of a camera. Also called the *camera framing*.

Freeze frame A still frame created from a segment of video. Often used in special effect transitions.

Fresnel lens A lens placed over certain types of lights to create a concentrated beam of light.

Full shot A shot that shows a person's entire body.

G

Gel A piece of transparent, colored plastic placed over a light to alter the color of the light.

H

Hand held A camera technique in which the camera is placed on the camera operator's shoulder or is carried in his or her hands (as opposed to set on a tripod).

Handle In Adobe Premiere, a point created along the audio fade control line that is used to alter the level of an audio clip. Handles are also used in Premiere's motion feature.

I

In point The beginning of a cut. Also known as the *In*.

In synch A situation in which the audio and video are matched in time. *See also* Synch.

Incremental progression In Premiere, a technique of changing the effect of a filter over time in a stepwise fashion.

Info bite In an interactive multimedia program, a unit of information that is absorbed in a continuous period of time. *See also* Branch point.

Information space A multi-dimensional space consisting of particular pieces of information and the links between them.

Interactive multimedia A presentation consisting of images and sounds that is controlled by the user. *See also* Multimedia; Surrogate travel.

Intercut An editing technique in which shots from two different cameras are interwoven. The material from each camera can be of the same scene or different scenes.

Interlaced video An analog video signal consisting of alternating odd and even fields. *See also* Even field; Field; Odd field.

J

Jump cut An edit in which a person or an object seems to move abruptly or in an unnatural motion.

K

Key frame In temporal compression, a frame that is stored as an entire image.

Key light The main source of light in a scene. It is usually the strongest of the three common types of lights: key, fill, and back. *See also* Back light; Fill light.

L

Layer To add a new element on top of a video image. Often used in conjunction with compositing, as in "to layer another element during compositing."

Level The volume of an audio clip or source.

Level of interactivity In an interactive program, the average amount of interaction required of the user per unit of time.

Limbo shot A shot in which there is no visible background. Usually created by moving the key and fill lights to either side of the subject so that they don't illuminate the background.

Line of interest An imaginary line that runs through the central elements in a scene. Once you determine a line of interest for a scene, you must keep the camera on one side of the line or else the main subjects will switch positions in the shot. *See also* Crossing over the line.

Log 1. To write down the position and content of video shots within a videotape. 2. A list of the positions and content of video shots within a videotape.

Long shot A camera framing that shows the overall layout of a scene. Is often used to establish a scene and its main elements. Also called a *wide shot.*

Loop In audio editing, to repeat a section of audio; for example, to repeat the sound of a police siren several times.

Lossless A type of image compression in which there is no loss of image quality after decompression.

Lossy The opposite of *lossless* compression—image quality is decreased through compression and decompression.

M

Master shot A shot showing a major part or all of a particular scene, action, or procedure. Provides the main view of an action or scene.

Match length When matching an event in a video clip with a particular sound in the audio track, the amount of time from the last edit to the video event.

Medium shot In most general terms, a camera framing between a full shot and a close shot. When shooting a person, a shot that usually extends from about a foot over the person's head to just above his or her waist.

Mix down In audio editing, the process of adjusting the levels of several audio sources or clips to achieve the optimum balance.

Mixed-format editing A style of editing that combines impressionistic images with text; graphics; and, often, narration. Often used for commercials and music videos. *See also* Continuity editing; Montage editing.

Montage editing A style of editing in which there is no attempt to create the illusion of reality. Emphasis is placed on the impressionistic and emotional value of images and the juxtaposition of the images. *See also* Continuity editing; Mixed-format editing.

Multimedia A presentation consisting of images and sounds. *See also* Interactive multimedia.

N

Nat sound Short for "natural sound." The sound naturally occurring in a scene. Also known as *wild sound*.

Needle drop Music that can be used in a video segment or multimedia presentation without prior approval. When contained on a compact disc, it is often called *clip music*.

Neutral shot In continuity editing, a shot directed along the line of interest of a scene. It is used to establish a new line of interest.

Non–drop-frame timecode A numbering system that assigns a unique number to each frame of video in the format *hours:minutes:seconds:frames*. Because video runs at 59.997 frames per second, non–drop-frame timecode is not exactly the same as clock time. *See also* Drop-frame timecode.

Noninterlaced video The standard form of images on a computer. The monitor displays the image by drawing one line after another from top to bottom. *See also* Interlaced video.

NTSC The color and timing standard for an analog television signal. Short for "National Television Standards Committee," the group which sets the standards for broadcast television.

O

Odd field One of the two fields making up a single frame of video. Consists of all the odd-numbered lines in an image. *See also* Even field; Field; Interlaced video.

Online A sophisticated editing system used to create the final version of a video segment. Usually includes frame-accurate video decks that are controlled by an edit controller and a switcher that allows the editor to mix two video sources.

Open Media Framework A standard for digital video effects introduced by Avid Technology.

Open up To increase the aperture of a camera lens, which increases the overall brightness of a shot.

Out point The end of a cut. Also called the *Out*.

Overlapping In Adobe Premiere, a situation in which two video or audio clips are located on different tracks but share the same part of a timeline. *Video overlaps* are used to create special effects. *Audio overlaps* are used to cross-fade the audio between two clips.

P

Pad In audio editing, the amount of time between when a person starts talking and the In point of the clip, or the time from when a person stops talking and the Out point of the clip. Usually 5–7 frames long.

Pan A camera move in which the camera rotates from side to side.

Panning The act of making a camera pan.

Paper cut A rough outline of a video segment created on paper. Usually the second step, after making the log, in preparing to edit a video segment.

Pass In *compositing*, one step in the process of adding elements to a video clip. The addition of each new element results in a pass.

Pixel Short for "picture element." One of the small dots on a computer screen that makes up an image. A standard 13-inch computer screen consists of 307,200 pixels (640 columns by 480 rows).

Progressive-effect filter Filter whose effect can be changed over the course of a video clip.

R

Rack focus A camera technique in which the focus is changed during the shot. Used to shift the viewer's attention from a foreground element to a background element in a scene (or vice versa).

Raw video Uncompressed digital video.

Receiver In audio recording, a device that receives a signal from a wireless microphone.

Record deck In analog editing, a video deck that records video signals provided by source decks. *See also* Source deck.

Refresh The process of redrawing an image on a computer monitor. Most monitors refresh the screen 60 times a second.

Reverse shot A shot showing a subject from the opposite angle. In an interview situation, a shot showing the interviewer.

Rim light A light that produces a rim of light around the edge of a subject. Also called a *back light.*

Room tone The natural ambience of an interior location.

Rough assembly The initial rough edit of a video segment. Sometimes called a *rough cut.*

Rule of thirds A standard method of composing a shot in which the screen is divided into thirds, and the central element is placed along one of these divisions.

S

Scratch narration A rough, preliminary narration used while editing the rough cut. It is usually recorded in the edit room during editing.

Scrim A wire screen placed over a light to reduce the light's intensity without affecting its color.

Scrubbing In Adobe Premiere, a technique for previewing an edit by moving the mouse along the time ruler.

Seek time The amount of time it takes a CD-ROM player to find a particular piece of data on a CD-ROM disc.

Shot A video clip displaying a continuous segment of action.

Simple dissolve In Adobe Premiere, a technique for fading a filter in or out by dissolving between the filtered cut and an unfiltered copy.

Sound bite A short video and audio segment of a person talking. Usually lasts between 5 and 30 seconds.

Source deck In analog editing, a video deck that provides a video signal for editing. *See also* Record deck.

Special effects There are two types of special effects: video and audio. *Video special effects* are used to create transitions between two adjoining video cuts. *Audio special effects* are additional sounds, either natural or produced, used to enrich a soundtrack.

Split screen A visual effect in which two video images appear in different halves of the screen, most often side by side.

Static filter In Adobe Premiere, a filter whose effect does not change over the course of a clip.

Stop down To reduce the aperture of a camera lens, which decreases the overall brightness of a shot.

Storyboards Rough sketches depicting an edited scene. Used during pre-production to determine how a scene will be shot.

Stretch pointer In Adobe Premiere, a cursor consisting of two vertical lines and arrows pointing outward. Used to change the duration of a cut.

Sun gun A small, portable light often used in outdoor locations as a fill light.

Super 1. An image that is placed over a video image. Part of the overlaid image is transparent. 2. To place an image over a video image and make part of the overlaid image transparent.

Surrogate travel A type of interactive multimedia that allows a user to view another place as if he or she were really there.

Switcher In analog editing, a device that combines two input video signals into a single output signal. Often includes the capability to combine the input video signals in a number of ways, such as with a dissolve or wipe.

Synch Short for "synchronize." To adjust the timing of an audio and video clip so that the audio matches the action in the video. *See also* In synch.

T

Take One of several repeated shots of a particular action or scene.

Talking head A person talking in a shot.

Three-quarter shot A standard camera framing for an interview in which three-quarters of the person's face is seen.

Thumbnail In Adobe Premiere, a reduced-sized version of a video clip used in editing.

Tilt A camera move in which the camera is tilted up or down.

Time ruler In Adobe Premiere, a timeline at the top of the Construction window that indicates the position of clips in the final video segment.

Timecode A numbering system that assigns a unique number to each frame of a videotape using the format: *hours:minutes:seconds:frames. See also* Drop-frame timecode; Non–drop-frame timecode.

Timecode generator A device used to add timecode to a videotape. *See also* Timecode.

Time-unit selector In Adobe Premiere, a control that allows you to adjust the resolution of the time ruler.

Traveling mattes Semitransparent mattes that move across the screen. Used to superimpose or composite two or more video images.

Treatment A statement of the goals and purpose of a video segment. Often the first step in producing a video piece.

Tweening slider In VideoFusion, a control that allows you to adjust the amount of a filter applied to a video clip.

Two-shot A shot containing two people. Often used to separate two people within a larger group.

V

Verité A production technique in which the action is shot as it happens, and no attempt is made to control or affect the action. Often used in documentaries.

Vertical interval timecode A type of timecode that is placed in a particular part of the video signal (the vertical interval). Abbreviated *VITC.*

VITC Vertical interval timecode.

Video capture board A device that converts an analog video signal into digital information. Often consists of a circuit board that is placed inside a computer.

Video special effects Transformations used at the transition between two video clips. *See also* Special effects.

Voice-over An audio clip of someone talking that is used without the video portion.

W

Walking shot A shot in which the camera operator walks with the camera during the shot.

Waveform A representation of an audio signal or clip. Indicates the volume of the clip over time.

Wide shot *See* Long shot.

Wild sound *See* Nat sound.

Window dub A copy of a timecoded videotape that displays the timecode in a window laid over the video image.

Wireless microphone A microphone that does not require a wire between the microphone and the recording device.

Work area In Adobe Premiere, a portion of the Construction window. It is the part shown during a preview.

Z

Zoom A camera move in which the camera framing becomes larger or smaller, as in "to zoom out from a close shot to a medium shot."

INDEX

Prima Computer Books

Available Now!

Computers Don't Byte	$7.95
Create Wealth with Quicken	$19.95
Cruising America Online	$19.95
Free Electronic Networks	$24.95
Internet After Hours	$19.95
Mac Tips and Tricks	$14.95
PageMaker 4.2 for the Mac: Everything You Need to Know	$19.95
PageMaker 5 for the Mac: Everything You Need to Know	$24.95
A Parent's Guide to Video Games	$12.95
The Slightly Skewed Computer Dictionary	$8.95
The Software Developers Complete Legal Companion (with 3$^1$/$_2$" disk)	$32.95
SuperPaint 3: Everything You Need to Know	$24.95

To order by phone with Visa or MasterCard, call (916) 632-4400, Mon.–Fri., 9–4 Pacific Standard Time.

To order by mail fill out the information below and send with your remittance to: Prima Publishing, P.O. Box 1260, Rocklin, CA 95677-1260.

Quantity	Title	Unit Price	Total
_____	_____	_____	_____
_____	_____	_____	_____
_____	_____	_____	_____
_____	_____	_____	_____
_____	_____	_____	_____

Subtotal _____

7.25% Sales Tax (CA only) _____

Shipping* _____

Total _____

Name _____

Street Address _____

City _____ State _____ ZIP _____

Visa/MC# _____ Exp. _____

Signature _____

* $4.00 shipping charge for the first book and 50¢ for each additional book.